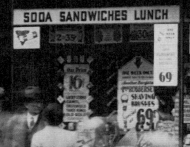

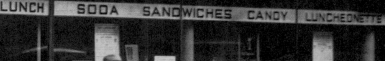

SEPARATE CINEMA

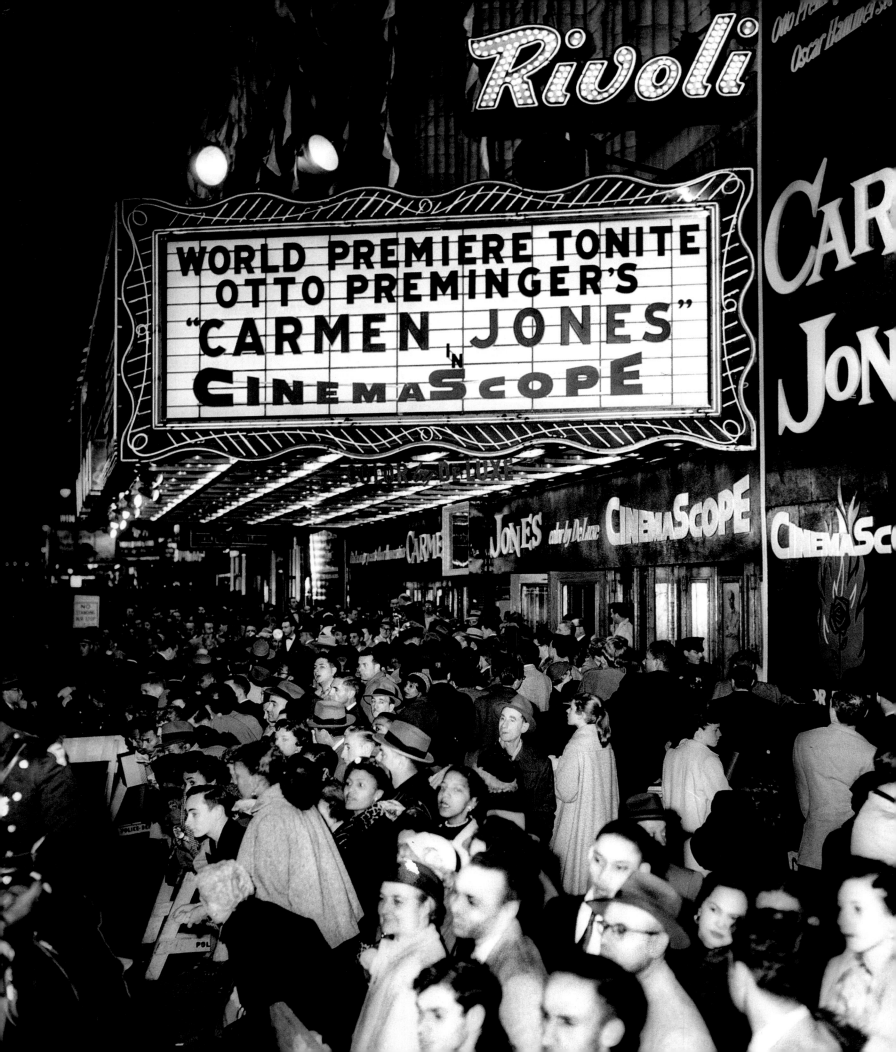

SEPARATE CINEMA
THE FIRST 100 YEARS OF BLACK POSTER ART

JOHN DUKE KISCH

REEL ART PRESS

FOR TEE

EDITED BY
John Duke Kisch
Tony Nourmand

TEXT BY
John Duke Kisch
Peter Doggett

ADDITIONAL TEXT BY
Michael Simmons
Barbara Tepa Lupack
Alison Elangasinghe

FOREWORD BY
Henry Louis Gates Jr.

AFTERWORD BY
Spike Lee

ART DIRECTION BY
Graham Marsh

LAYOUTS BY
Joakim Olsson

Foreword by Henry Louis Gates Jr.

A SHORT HISTORY OF BLACK FILM AND THEIR POSTERS

From the dawn of the silent era to movies screening digitally around the world today, black film, like any medium, reflects the journey of African Americans in society. And the posters these films generate and inspire constitute their own art form and pattern of representation, like a parallel visual universe, mirroring (not literally but figuratively, as acts of interpretation) what an artist or a producer felt to be the dominant message about race in America that these films contained: ninety minutes, say, reduced to one image, an image that over time, became both an icon and a work of art of its own. And to understand more fully the history of the century of images that *Separate Cinema* so beautifully contains, I want to chart here a short history of the films both by and about black people over the past century that these posters so vividly represent.

At times, film has served as a weapon of propaganda to maintain blacks' marginalized position; at other times, it has promoted, quite powerfully, a counter-narrative challenging the status quo. Within the medium itself, we see a progression toward ever greater completion—of filling in the picture both of the black self and of the black experience—to reveal a fuller and far more complicated *American* experience. In his entry on the subject for *Africana: The Encyclopedia of the African and African American Experience* (Second Edition), film historian Thomas Cripps frames this arc as "the struggle to define a place in the wider American life and the effort to maintain an authentic black presence in American culture."

Uncle Tom's Cabin, the nineteenth century's best-selling novel, was, with its long history on the theatrical stage, a natural draw for adaptation to the screen. Yet despite the book's unmistakable anti-slavery themes, the first film version by Edwin S. Porter (of *The Great Train Robbery* fame) for the Edison Motion Picture Co. in 1903 diluted the message by distinguishing the sins of slavery from their legacy in Jim Crow America—race-based segregation—so that the tragically faithful black servant at the heart of the story was played by a white actor in blackface and a black suit while the supporting cast danced the cake-walk and played craps moments before they were sold at auction, some of them cheerfully clothed. Even when Uncle Tom is whipped to the point of death at the climax of the nineteen-minute reel, there are only a few lashes that cannot be heard or felt through his shirt. Keep in mind: this was one of the more benign portrayals of black Americans on early film. Still, eleven years later, when Sam Lucas was cast as Uncle Tom in a second adaption, making him the first black actor cast in any major motion picture, there was little he could do to prevent excessive sentimentalism from numbing the senses to the real history it masked.

Fast-forward to 2013's groundbreaking film by the black British filmmaker Steve McQueen, *12 Years a Slave*, based on the 1853 narrative of Solomon Northup, a free black man kidnapped into slavery (ironically, Northup dedicated his book to the author of *Uncle Tom's Cabin*, Harriet Beecher Stowe), in which the screen seems to disappear and we are up close with the protagonist-slave's perspective, feeling, hearing, seeing, almost smelling the horrors he and those around him experience as the ceaselessly degraded property of degraded white men. In McQueen's *12 Years*, it is impossible for the audience *not* to feel the master's whip or the heavy breathing of his rapacious mouth, or to avert the eyes from the nakedness of the slaves as they are inspected at market by men who look but do not see their humanity. One retired English teacher coming out of a recent screening was overheard saying he would have paid to bring his former inner-city students to the theater, because "if they don't see this movie," he said, "they will never know."

The inverse could have been said about the original *Uncle Tom's Cabin* in 1903: if that was all audiences saw of black life, they would *never* know. The only way to understand what happened in between these two milestone films—to make the latter possible and the former seem absurd—is to explore the broader arc of black film history and the turning points that shaped it beyond the frame, and beyond the posters that, as it were, "framed" the films in advertisements and on their marquees.

THE SILENCED ERA

We begin with film historian Thomas Cripps, who, in his 1977 book, *Slow Fade to Black: The Negro in American Film, 1900-1942*, shows how the silent era of film was a silencing era for blacks on film. In his literary masterpiece, *The Souls of Black Folk* (published in 1903, the same year as that first *Uncle Tom's Cabin*), W. E. B. Du Bois predicted that "the problem of the twentieth century [was going to be] the problem of the color line;" but in film, the problem posed was that of the long shadow cast by what Cripps calls "the earlier infusion of moviemaking with Southern lore." It was perfected to a diabolical degree by D. W. Griffith's *The Birth of a Nation* (1915), which, set against a rapidly industrializing and urban nation, suggested that had Americans been spared the Civil War and Reconstruction, the former slave population would have remained faithful servants praying for their white masters instead of corrupt politicians and over-sexed predators threatening the honor of white women. The white knights of Griffith's revisionist history were the white-robed riders of the Ku Klux Klan, whose reign of terror the film helped re-energize with a screening at Woodrow Wilson's White House. And the more it exalted them, the more it recast blacks as brutally stupid and lazy, a plague on the nation that had to be beaten back across the color line. The film and era's greatest weapon: nostalgia for a South that never existed.

Donald Bogle, a contributor to my recent PBS series, *The African Americans: Many Rivers to Cross*, categorized the painful stereotypes that followed in the

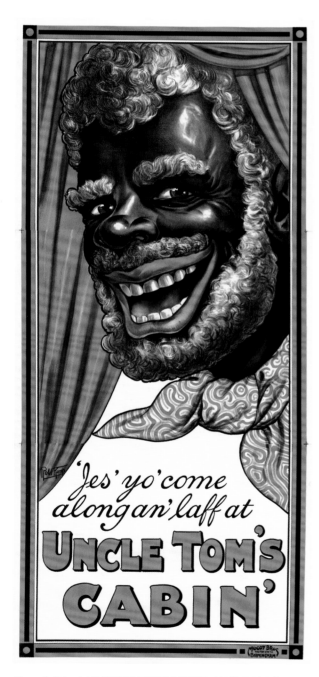 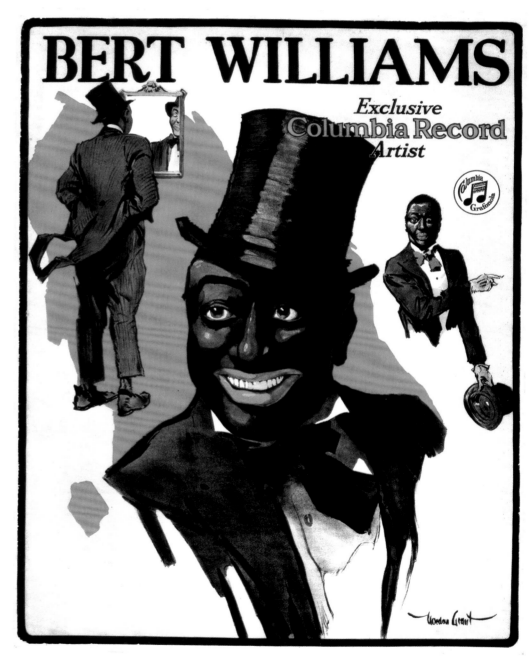

Above (left to right): UNCLE TOM'S CABIN (c.1910), British Stage Production; BERT WILLIAMS (1919), Columbia Records Promotion

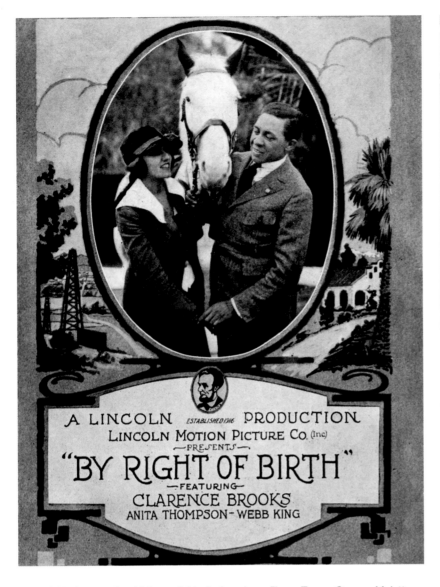

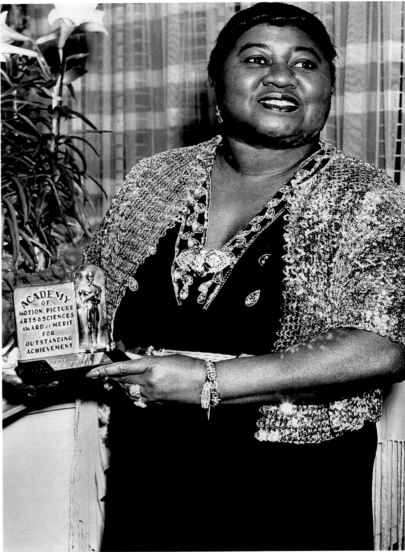

title of his interpretive history of black American films, *Toms, Coons, Mulattoes, Mammies & Bucks* (1973). From Thomas Edison's *Watermelon Contest* in the 1890s to Sigmund Lubin's *Sambo* series in 1909 to Farina in Hal Roach's *Our Gang* series (1918), it would be impossible to list all the films that reinforced these negative stereotypes, but the fact that we can conjure them in our minds shows their pervasiveness. At the time, black America's most brilliant dance, musical, and comedic performers, such as Bert Williams, Lincoln "Stepin Fetchit" Perry, and William "Bojangles" Robinson— couldn't find their way into the frame unless they were willing to play these roles. Some did it masterfully and made great wealth from it, but in the process, alienated black audiences, which in the South, were already repelled at having to enter theaters through "Colored Only" entrances and sit in segregated balconies. This disconnect between supply and demand only reinforced the vicious cycle of mainstream films depicting blacks through white lenses for white audiences, including waves of new immigrants from Europe whose introduction to black life was what they saw for a few cents at the nickelodeon.

THE COUNTER-NARRATIVE AND THE LIMITATIONS OF CONTROL

But it is important not to overstate this monolith. There was from the start, Cripps explains, a counter-narrative, a resistance, and not just in the newly launched NAACP's protesting of *Birth of a Nation* at its premieres around the country and in its demands for edits, but in the determination of early black filmmakers to create their own aesthetic through their own cameras and for their own audiences as part of the awakening known as the New Negro Movement. Before his death, Booker T. Washington was hoping to attract financing for an adaptation of his memoir, *Up from Slavery*. His protégé, Emmett Scott, pushed on with the film *The Birth of a Race* in 1918, which, despite being mangled by the influence of too many white investors, was a noble attempt to push back on the grotesqueries of D. W. Griffith. And it was anything but the only one. In 1910, ex-vaudevillian and booking agent William "Bill" Foster launched his Foster Photoplay Company as the first black-owned film company, releasing a string of short comedies, and in 1915 The Lincoln Motion Picture Company was organized as a full-service black studio in Los Angeles with a focus on racial uplift in such films as *The Realization of a Negro's Ambition* (1916) and *By Right of Birth* (1921). The Lincoln Company may have survived had it not been for "stinting budgets" that "put the angle of selling the films purely on the basis of racial pride," Cripps writes—not to mention "a ranging influenza epidemic" that gripped a war-weary nation.

But the granddaddy of all was Oscar Micheaux who, following the publication of his 1918 novel, *The Homesteader*, became a pivotal black independent filmmaker and, under the Oscar Micheaux Corporation, churned out over thirty films that took on some of the race's most pressing challenges, including lynching, a direct confrontation with Southern mythology. "An effective self-promoter, he would personally take the film prints around the theater circuit and talk the owners into investing a portion of the money made from the screening into his next film," S. Torriano Berry and

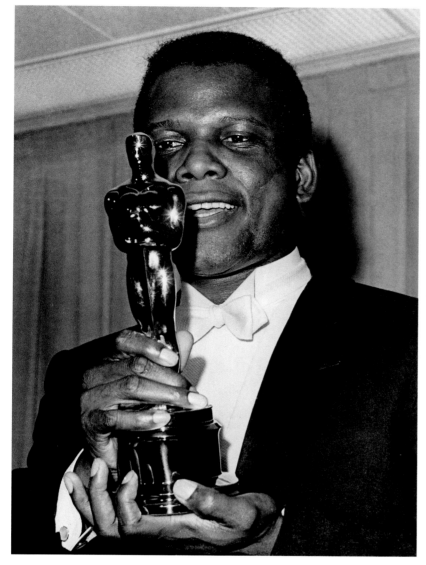

Venise T. Berry write in their *Historical Dictionary of African American Cinema* (2007). His most well-known film also introduced his generation's most respected black actor, Paul Robeson, in 1925's *Body and Soul*. Yet even the great Micheaux ended up filing for bankruptcy during the Depression (converting to talking films was expensive) and, to survive it, had to join forces with two white theater owners in Harlem to continue making his films. Despite the valiant efforts of these black film pioneers to portray a black self that, if not complete, was respectable, the obstacles remained: financing, distribution, and building and sustaining audience support. As a result, the era of film before World War II was typified by the first talking picture, *The Jazz Singer*, with Al Jolson performing in blackface, and 1939's *Gone with the Wind*, with its whitewashed portrayal of plantation life that showed the persistence of the Southern Lost Cause myth of the cared-for, maternal, and satisfied slave. Reconciling herself to these painfully incomplete black roles, Hattie McDaniel, the first black Oscar winner for her portrayal of Mammy in *Gone with the Wind*, said, as Edward Mapp notes in his 2008 book, *African Americans and the Oscar*, "I'd rather play a maid for $700 per week than to be one for $7 per week."

THE AGE OF POITIER

According to Cripps, the turn of the story came in 1942, the first full year of America's engagement in World War II, with its increasing pressures to position the United States as the land of democracy in more than just words. At home and abroad, the Double Victory campaign waged by black citizens and soldiers for equal rights reached the land of dreams, Hollywood, California, where, with prodding from NAACP negotiators, the major studios began to address the discrimination faced by black Americans previously invisible on screen. As Cripps explains, as a result of the NAACP's lobbying efforts at a pivotal point in the propaganda phase of the war, "[t]he studios agreed to abandon pejorative racial roles, to place Negroes in positions as extras they could reasonably be expected to occupy in society, and, to begin the slow task of integrating blacks into the ranks of studio technicians." There are countless examples of the changes this produced in film, but all of these are evident in the iconic performances of one man whose remarkable body of work over the next two decades led Cripps to call the next era in black film history "the age of Sidney Poitier." Poitier, with his erect bearing and punctuated diction, made it impossible for audiences to see him as the butt of a joke. He was elegant and dignified. His characters were sensitive and safe yet simmering in their righteous anger at a system the actor's brilliant talents exposed as unjust; and he appeared in settings where audiences were used to seeing black men as only servants before, including Spencer Tracy and Katharine Hepburn's living room in the 1967 film, *Guess Who's Coming to Dinner*, in which Poitier marries a white woman over the objections of two sets of parents. But to me, having grown

Opposite (left to right): **BY RIGHT OF BIRTH** (1921); **HATTIE McDANIEL,** February 29, 1940
Above (left to right): **SIDNEY POITIER,** April 13, 1940; **SONG OF THE SOUTH** (1946), James Baskett

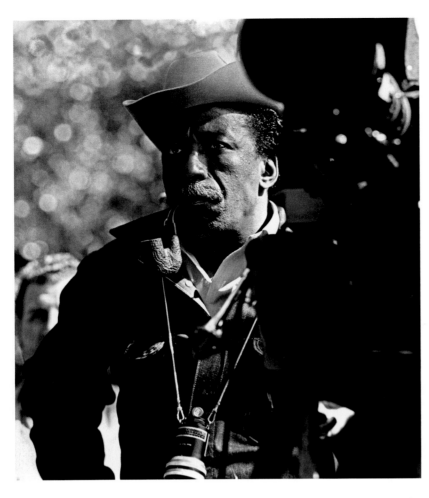

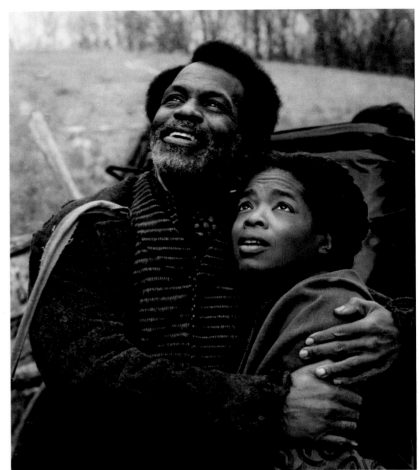

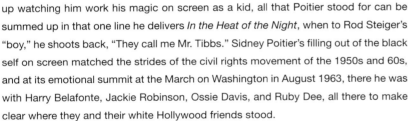

up watching him work his magic on screen as a kid, all that Poitier stood for can be summed up in that one line he delivers *In the Heat of the Night*, when to Rod Steiger's "boy," he shoots back, "They call me Mr. Tibbs." Sidney Poitier's filling out of the black self on screen matched the strides of the civil rights movement of the 1950s and 60s, and at its emotional summit at the March on Washington in August 1963, there he was with Harry Belafonte, Jackie Robinson, Ossie Davis, and Ruby Dee, all there to make clear where they and their white Hollywood friends stood.

BLAXPLOITATION AND THE NEW BLACK CINEMA

But it was in the wake of that movement, with the assassination of Dr. King and the ensuing violent confrontations in American streets, that rage become part of the black self on film—and with it machismo and a filmic assertion of black (especially male) sexual identity repressed since *Birth of a Nation*. Three years after Gordon Parks became the first black artist to direct a full-length studio film, *The Learning Tree* (1968), Melvin Van Peebles broke out with his *Sweet Sweetback's Baadasssss Song* (1970), kicking off the furious, albeit short, blaxploitation era of films, which in rapid succession included Gordon Parks' *Shaft* (1971), Gordon Parks Jr.'s *Super Fly* (1972), and some sixty other B-films through 1974. For the first time, black filmmakers portrayed black actors as superheroes kicking white behinds not only with their fists but also with their own soundtracks (think Isaac Hayes and Curtis Mayfield) and their own ways of asserting black manhood. While some of those films left much to be desired when it came to portraying black women and homosexuals, a point explored in the recent collection of essays Mia Mask edited, *Contemporary Black American Cinema: Race, Gender and Sexuality at the Movies* (2012), they represented an assertion of black identity that firmly rejected the past and helped create a new market for black films, segmented as it was. In this way, they had more in common with the "race pictures" of

the 1920s and 30s than they did with the integrationist hits of Sidney Poitier.

This phenomenon spawned the next generation of black filmmakers who, for the first time, graduated from the country's elite film schools and were steeped in filmmaking history, theory, and technique. At their best, this new crop of black storytellers in the late 1980s and early 1990s forced audiences to confront a more complicated reality that had less to do with adventure or cable news headlines than exposing structural inequalities at the core of American society—works of art without easy resolutions. Think of John Singleton's *Boyz n the Hood* (1991), Spike Lee's *Do The Right Thing* (1989) and *Malcolm X* (1992), his epic biopic of the 1960s pivotal—and controversial—Black Muslim leader with Denzel Washington, a bonafide box-office star, in the leading role. Yet, despite critical raves and a slew of nominations, these talented and prolific black filmmakers have struggled at times to attract financing and crossover audiences and to shed the label of "race picture."

BLACK FILM TODAY

The new millennium is witnessing a flowering in black cinema both on screen and behind the scenes. There are established black box-office movie stars and ceiling smashers at major award shows. There are one-man and one-woman African-American media empires and hit TV show runners. And there are an increasing number of established white directors eager to tackle black subjects in nuanced ways (think Steven Spielberg's *Amistad* and *Lincoln*, and Quentin Tarantino's *Django Unchained*), and perhaps most striking, well-known white actors jumping at the chance to play supporting characters—even to grab cameos—in films centering on black protagonists with black points of view. We are also witnessing a new era of the black auteur, artists like Lee Daniels and Steve McQueen, who, on a global scale, are leveraging serious (but not enormous) financial backing from major studios and who combine

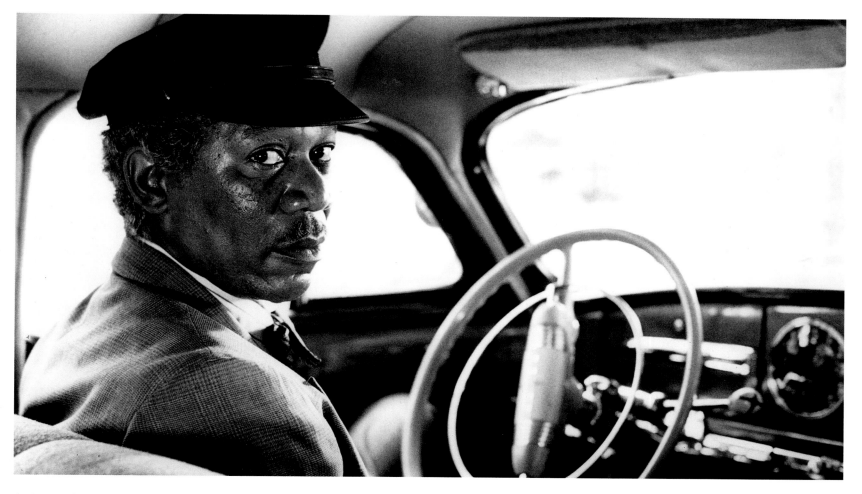

the best of Oscar Micheaux, Gordon Parks, and Orson Welles, by writing, directing, producing, and casting films that present a more integrated, complete black self while repopulating the historical American landscape with authentic and fully formed—even flawed—white and black characters who speak in vernacular, struggle with moral choices and present various faces to each other behind and beyond what Du Bois famously described as "the veil" of race. In these films, when white slave owners whip a black woman or man at the post, not only do they feel it with exposed skin; we feel it with exposed hearts and minds, so that we are no longer let off the hook by whites in black face dancing the cake-walk but instead, in a complete inversion of the earliest black films, see how the inhumanity of the master brings into focus the humanity of the slave. This is nothing short of a revolutionary achievement in a society that, aided by the inspiration of the creative arts, has twice elected a black man to the nation's highest office, where this year he said he teared up watching *Lee Daniels' The Butler* in the same White House where his predecessor once screened *Birth of a Nation*.

The question now, as it has always been for black film, is this: how to sustain the recent critical and commercial success of these films, how to institutionalize this, yet another "renaissance" of black film. We can never escape the reality that film is where art and commerce intersect, a point we see so clearly in the marvelous collection of black film posters assembled in this catalog. Before they go on to become collectors' items, the main function of film posters is advertisement to attract an audience—to sell tickets—for an industry that lives and dies on that first weekend's box office returns. Viewing them together in this collection helps us trace, in a novel way, the evolution of both the genre of black film (including films by black directors and films about black people), and the representation of the black self *in* the history of film—from the most hideous and demeaning caricatures to noble images of central characters, played by leading A-list actors. These posters also trace the importance of the audience and

auteur in creating demand and demanding change in our most public, and perhaps our most immediately affecting, art form. Remember what that retired English teacher said leaving *12 Years a Slave*: if our kids in this generation don't see it on film, they won't know. And posters, as ads, play a key role in getting bodies into the theaters, in filling seats, or encouraging people to watch films on Netflix.

Film posters constitute an art form about an art form, and as well, in the case of the black cinema tradition, a quasi-Black History lesson. I think I first realized this when I was about to interview Spike Lee at his 40 Acres and a Mule production company in Fort Green. As I waited for our interview to begin, I became enamored—entranced, really—by the marvelous historical posters that Spike had on the walls of his office. I was green with envy and decided to start collecting black film posters as avidly as I could afford. I thought of that feeling of exhilaration that I experienced that day in Spike's office a few weeks ago when Nasir Jones ("Nas") visited the Hip Hop Archive, founded by Professor Marcyliena Morgan, in the Hutchins Center for African and African American Research at Harvard. When we showed him the dozens of black film posters hanging on the walls of the Center, part of the Henry and Celia McGee Black Film Poster Collection, Nas declared that "I want a collection just like this one!" The images gathered here in *Separate Cinema* provide a brilliant overview of the last century of film poster art that every student of film and every student of African American history and culture should experience. And perhaps you, too, will be moved, like I was in Spike's office, to begin collecting them on your own. For they are a national treasure.

Opposite (left to right): **GORDON PARKS** (1969); **BELOVED** (1998), Danny Glover and Oprah Winfrey
Above: **DRIVING MISS DAISY** (1989), Morgan Freeman

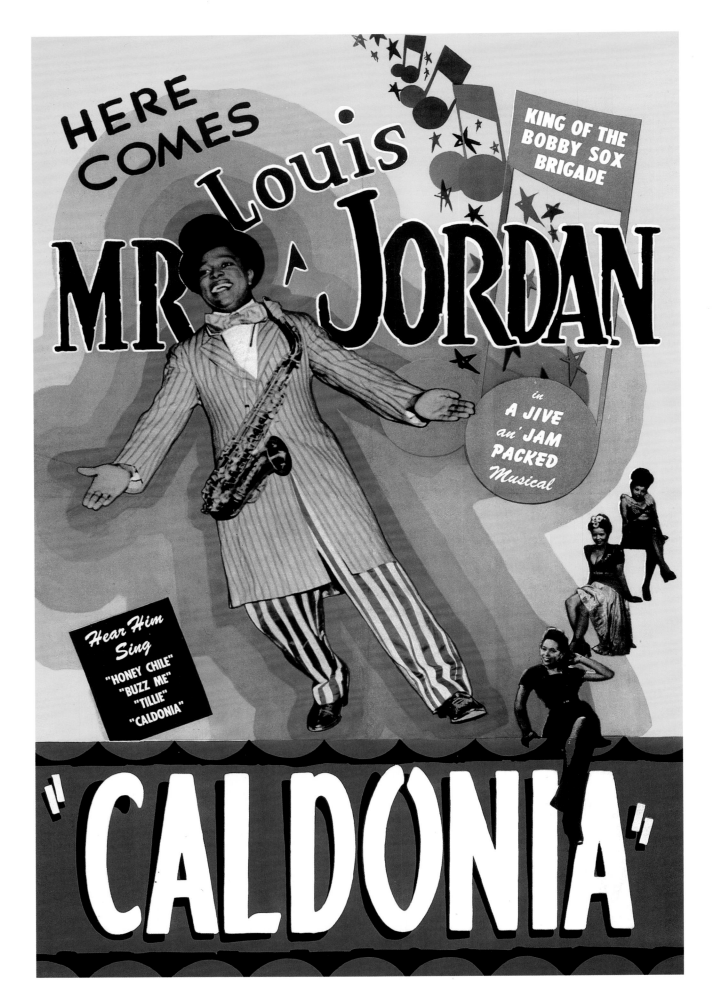

Separate Cinema
by Michael Simmons

Like most kids coming of age in the 1960s, John Duke Kisch took to the twin inspirations of music and film. Rock and soul music were our pulse—our lifeblood—and the insistent rhythms and loud hollers explicitly encouraged us to throw off society's straitjackets that our parents, teachers, and politicians deemed "normal." No accepted American convention was more odious than legal apartheid, and, like our music, film reflected our rejection of that as well. Kisch was thirteen in 1967 when *To Sir, with Love*, starring Sidney Poitier, came out. "Poitier was a great subconscious segue for me as a kid in the understanding of black film," remembers Kisch. "In *To Sir, with Love*, they enticed us with music—these British Invasion tunes—but the heart of the film is a black man who's the smartest guy on screen and can communicate with these teenage English ruffians and get them to call him 'sir.'"

As the 1970s began, many of us were investigating the roots of the British Invasion and learning about the granddaddies of rock 'n' roll. Kisch fell in love with rhythm and blues and the honking saxophonists of the 1940s and 50s, particularly Louis Jordan—saxman, bandleader, singer, songwriter, comedian, and actor. In 1973, a friend gave Kisch his first film poster. From the 1945 Jordan vehicle *Caldonia*, its primary colors surrounded an open-armed Jordan as if to scream "WELCOME!" It graced Kisch's dorm room at Bard College and he was hooked.

After becoming a successful New York music and fashion photographer, Kisch continued to add to his growing poster collection. "Shooting musicians gave me the chance to travel. The night schedule freed up my days, so I combed antique stores and comic book shops. There was a store down the street from the Lorraine Motel in Memphis. I'd take $1000 with me, slap it down on the guy's table and ask, 'Can you close the shop for the weekend?' And I'd leave with posters."

In 1982, a serendipitous meeting changed his life. "I was in my photo studio in Manhattan and [actor] Brian Doyle-Murray brought sportscaster Ahmad Rashad up. Ahmad had just married Phylicia Rashad who was on *The Cosby Show* at the time. He looks around the walls at the posters and he points to Bill Pickett in *The Bull-Dogger*—the first black cowboy. He says, 'I wanna buy that.' I said it's not for sale. 'You have to sell that to me,' he says. Phylicia's mother in Houston had built an homage to the black cowboy behind her house. He says 'If I walk out of here and give her that poster, I'll be in my mother-in-law's good graces for the rest of my life.' [laughs] He's staring at me and pulls out this wad of cash and—still staring at me—starts peeling off $100 bills. A friend of mine who was there kicked me under the table. Eventually I stopped him and said 'Sold.'"

But that wasn't the end of the story—it was the beginning. "Rashad pointed to a Paul Robeson poster and he said, 'You know about the history there?' I honestly didn't. 'You need to learn your history,' he told me. And so I did. I never forgot that."

An exhibition of Kisch's posters at Greenwich Village hangout, Marylou's, drew celebrities and coverage from the *New York Times*, *NY Post*'s Page Six, and CNN. Kisch and film historian Donald Bogle then created a twelve-page spread for the Film Society of Lincoln Center's magazine, *Film Comment*. "We labeled it 'A Separate Cinema.' That was the beginning." In 1992, the book, *A Separate Cinema*, by Kisch, Bogle and Edward Mapp, was published by Farrar, Straus and Giroux's Noonday Press to unanimous acclaim, feeding a public hungry for these heretofore secret treasures.

Over four decades later, The Separate Cinema Archive has grown to become the world's largest privately owned collection of black film memorabilia, containing more than 38,000 rare film posters, lobby cards, and photographs originating from over thirty countries. It functions as an educational resource for everyone from scholars to schoolchildren and items from the collection have been displayed at film festivals and museums. The archive maintains traveling exhibits that are either historical overviews or defined by themes such as Jazz on Film, Blaxploitation, and The Black Athlete.

What began as a personal passion has shotgunned Kisch into situations unimaginable to the kid forty years ago with a deep dig for rhythm and blues. "Praise comes in different ways. It might be a phone call from an actor who you never thought you'd hear from, saying 'I just got your book—great stuff! I'd like to buy a poster and begin collecting.' You're not just talking to a movie star, you're talking to a fan who wants to learn what I learned. I appreciate being able to help people."

While unearthing an overlooked chapter in American history, Kisch is still the collector who simply loves the posters. "They're artwork but they're also advertising. They've got a cleverness that you don't see in a run-of-the-mill museum exhibit. These pieces have graphics and words, certain color schemes and type font. Each poster is an ad—a cacophony of stuff that compels viewers to buy the product, see the film, dig the music, enjoy the show. These images are ticket sellers. That's very American and very seductive."

Opposite: **CALDONIA (1945)**

100 Years of Black Movie Posters by Tony Nourmand

During my years as a movie poster consultant and dealer, I was aware of important collections worldwide, including John Kisch's *Separate Cinema* archive. We have been friends for over twenty years and I believed I knew what the archive contained, however, it was not until we sat down to work on this book that I began to fully realize its vast depth. The collection's detailed overview of black cinema, since its inception in the early 1900s to modern day, is staggering.

An exciting and exhaustive treasure-trove, the archive was a true eye-opener. I have been looking at movie posters my whole life, yet there were pieces in John's collection that I was seeing for the first time; thousands of items of historical and social importance, with a powerful visual impact. The reality of the task at hand—editing this seemingly infinite collection into just one coffee table volume—also hit home. One of the most difficult and time-consuming elements of this project has been narrowing the selection down to a comprehensive summary that reflects the subject matter and wealth of material. Even if we had one thousand pages to play with, we would still barely scratch the surface of the archive's contents. John and I made the decision early on to focus almost exclusively on the posters, which narrowed our options … slightly. Our second important decision was to focus on the artwork, ultimately making our decision on what to include based on design. The final, edited selection in these pages is therefore a delicate balance between representing an overview of the most important milestones on the journey of black cinema in the past one hundred years, and also an aesthetic appreciation for the poster art that accompanied this voyage. It is meant to represent a flavor; a visual summary. It is not an exhaustive encyclopedia of every important black film, director, and performer, and should not be viewed or used in this way.

The posters on these pages represent different styles, periods, and countries. They reflect themes in poster design that are common across a breadth of genres—the abstract artwork favored by Eastern Europe, the more painterly style of the Italians and French, the 'classic' look of early American big studio releases. However, one of the elements that distinguishes the genre of black cinema is the fact that it existed outside of the Hollywood mainstream for so many years. Many of the posters were printed with very little money and with crude designs. Ironically, it is some of these posters that have withstood the test of time in terms of design more than their mainstream counterparts, and are seen today as striking examples of graphic art that would not look out of place in the chicest of modern loft apartments. The posters for *Black and Tan* or *Harlem is Heaven*, for example, were made "on the cheap" by unknown artists, yet they are some of the most stunning posters of the period, across any genre.

Many poster artists—both inside and outside Hollywood—never signed their work. This was especially true in America, which makes the task of assigning authorship almost impossible. The few notable exceptions were usually well-established "name" designers, such as Saul Bass or Paul Rand. What can be said with a fair degree of certainty is that at least until the second half of the twentieth century (likely even later), the vast majority of these poster artists were white; white men working to the design specifications provided by white male studio bosses. This often led to stereotypes making their way into artwork, or alternatively, the 'whitening' of leading black stars, for example Lena Horne on the American poster for *Stormy Weather*, which was a major studio release. It affected the way films were represented. Even 'liberal' films, where race was an important theme being sensitively explored, often shied away from announcing such an overt fact on the poster—for example Bass's design for *Edge of the City*, which simply shows two pairs of stylized (bright red) legs, or Rand's *No Way Out*—an abstract design that makes no reference to the racism explored in the film. Bass and Rand represent the pinnacle of mid-century graphic design talent and are celebrated for their innovative work, which influenced generations of designers. Rand's *No Way Out* poster is one of the defining posters of the 1950s. However, if a poster fails in its key objective of representing the themes and subject matter of a film, then there is perhaps a question to be asked about how good it really is.

Even today, this disturbing trend is evident—most recently in the shocking Italian campaign for *12 Years a Slave*, which received worldwide condemnation for only showcasing the film's white stars on the posters. Brad Pitt and Michael Fassbender were shown as large head shots—this despite Pitt only being in the movie for ten minutes—while the film's main star, black actor Chiwetel Ejiofor, was relegated to a tiny photographic afterthought in the corner of the design. (These posters did not merit page space in this book.)

The development (or lack of, in Italy's recent case) of the artistic approach to representing black cinema through the medium of poster art over the past one hundred years reflects the same journey—with its struggles, acceptance and rejection—as black history itself. To misquote Oscar Wilde, "Life imitates Art as much as Art imitates Life."

There have been countless books and articles written about black cinema and such dialogue is part of an ongoing and important conversation. However, there has never been a book addressed from this angle and covering the whole history of black cinema. In my genesis from movie poster gallery owner to publishing house editor-in-chief, it seems fitting to be exploring such a significant world-class archive in print, and I am immensely proud to be publishing this book. It is an in-depth and fascinating overview, another way of telling this story, of how these movies were sold to the public, and a stunning visual tome. Enjoy!

Opposite: **UNDERWORLD (1937)**

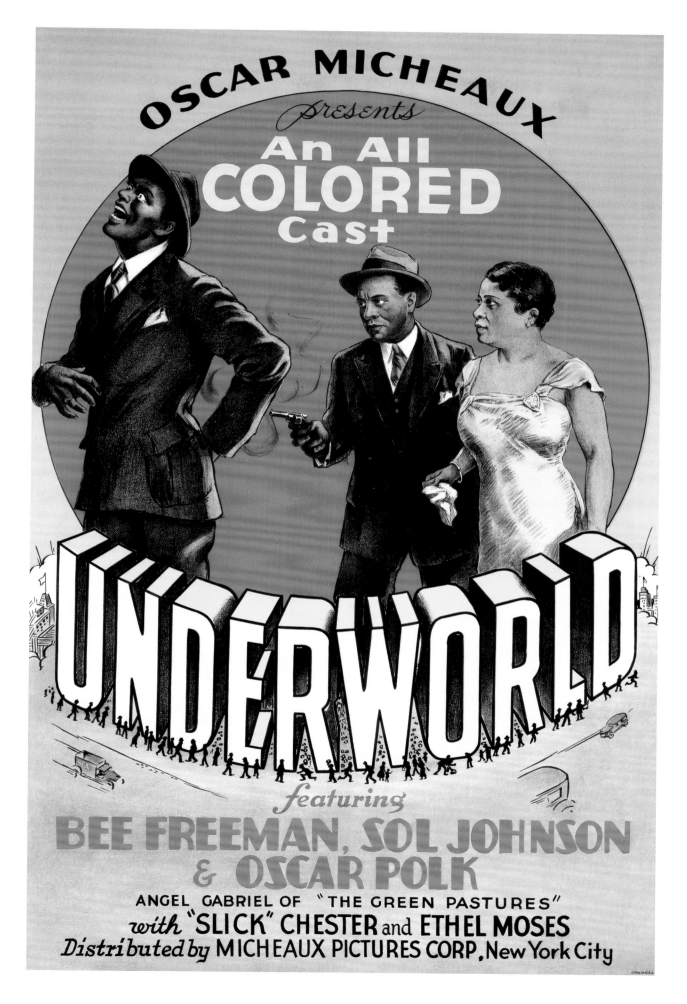

The Birth of a Nation

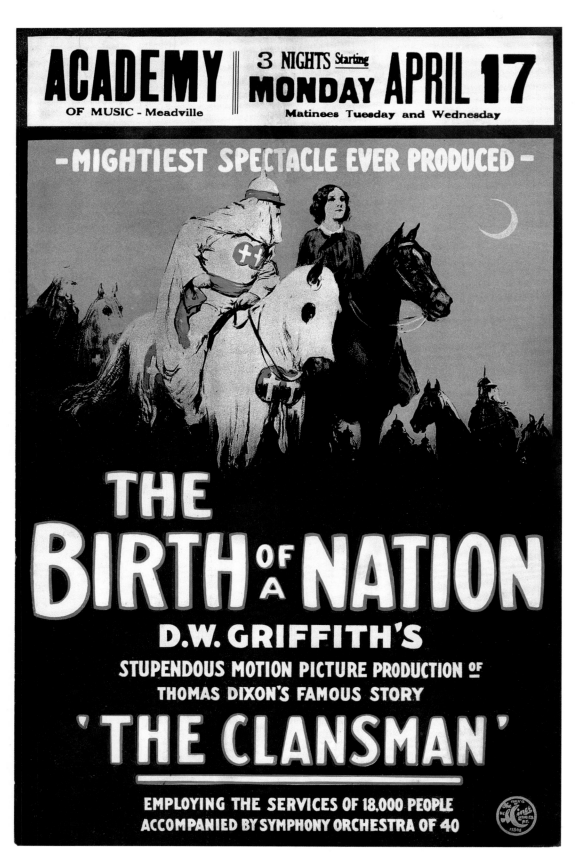

The Birth of a Nation (1915) is a classic of American cinema. Its director, D. W. Griffith, employed innovative editing techniques, close-ups, and parallel storylines to create a film more sophisticated than anything that had previously been screened. But Griffith also used his epic to reinforce pernicious stereotypes about African Americans, with the result that The Birth of a Nation is one of the most racist films ever given commercial release.

The film was based on the 1905 novel and play The Clansman, which Southern evangelist Thomas Dixon wrote in response to the book Uncle Tom's Cabin. Dixon's purpose was to portray what he called "the awful suffering of the white man during the dreadful reconstruction period" that had followed the Civil War and the abolition of slavery. He wished "to demonstrate to the world that the white man must and shall be supreme."

In Griffith's rendering of this tale, the black characters are either gentle, loyal servants or fiery renegades, lusting for power and, in some cases, white women. One notorious sequence shows a black character (actually a white actor in blackface) pursuing a fragile young white woman. She refuses to submit to him, preferring to throw herself off a cliff to preserve her Southern honor. Perhaps no other film has ever articulated so powerfully the bigoted white American nightmare of black aggression and male sexuality.

A spectacular epic lasting three hours, the film attracted huge audiences amongst white Americans, who reveled in Griffith's filmic brilliance and his unashamed racial prejudice. By contrast, African-American viewers were so outraged that the National Association for the Advancement of Colored People (NAACP) launched an organized protest against the film, in the hope that it would be boycotted or even banned. When that failed, a new generation of black filmmakers emerged, determined to redress the balance.

Left: THE BIRTH OF A NATION (1915)
Opposite: THE BIRTH OF A NATION (1915), Re-release 1921

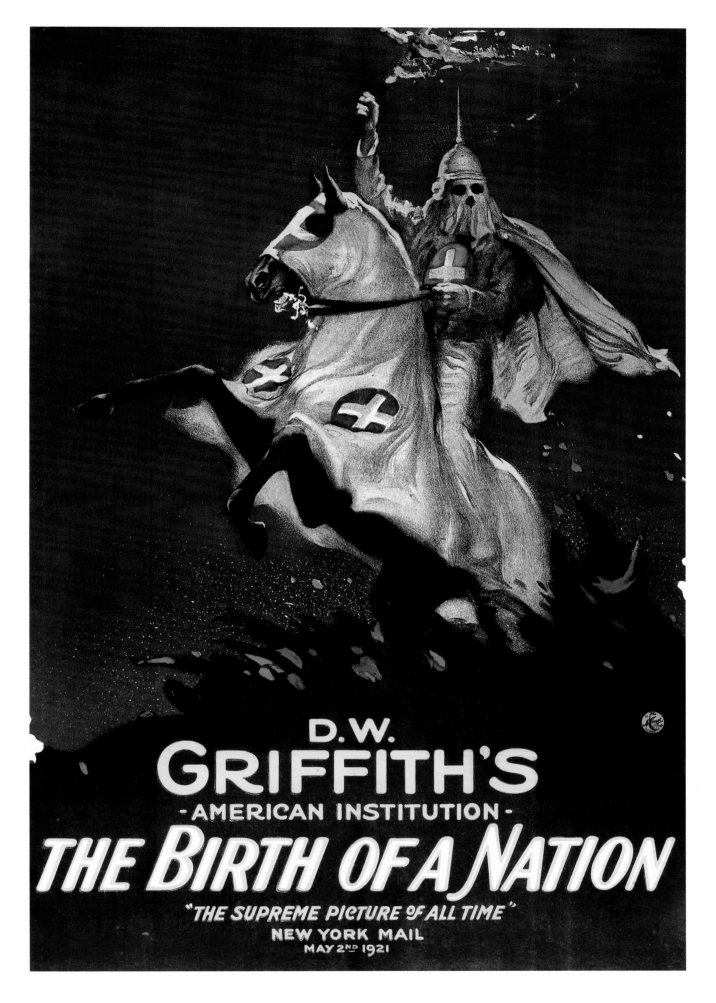

Early Independents

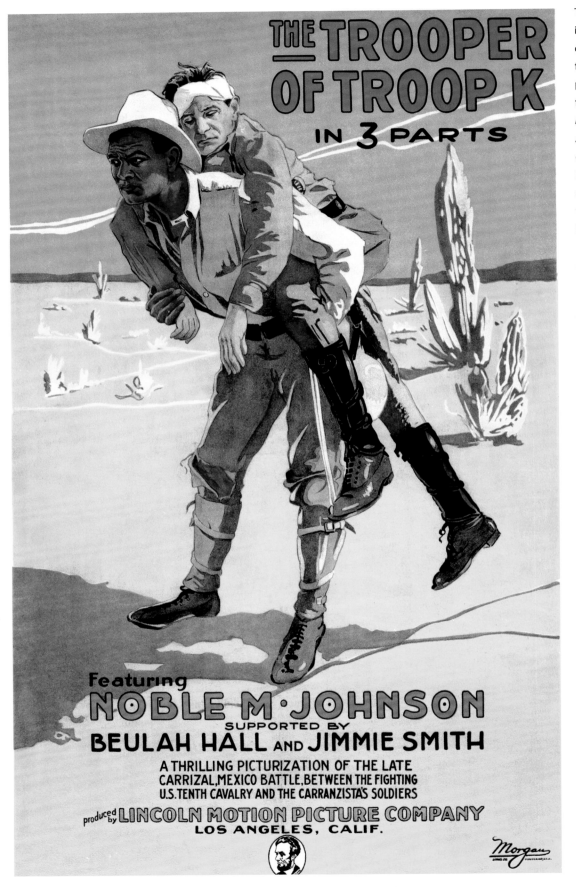

THE TROOPER OF TROOP K

IN 3 PARTS

Featuring
NOBLE M. JOHNSON
SUPPORTED BY
BEULAH HALL AND JIMMIE SMITH

A THRILLING PICTURIZATION OF THE LATE
CARRIZAL, MEXICO BATTLE, BETWEEN THE FIGHTING
U.S. TENTH CAVALRY AND THE CARRANZISTA'S SOLDIERS

produced by LINCOLN MOTION PICTURE COMPANY
LOS ANGELES, CALIF.

The success of *The Birth of a Nation*, and its effect upon its audience, was a vivid demonstration of the power of the new medium of cinema. In a bid to counter the film's negative stereotypes of blacks, Emmett J. Scott, personal secretary to Booker T. Washington, sought financial support to make a short film, tentatively titled *Lincoln's Dream*, to promote the accomplishments of African Americans and to be played in theaters before each showing of *The Birth of a Nation*. It could have been one of the first independent black films, however, after Scott was unable to raise enough money through the Birth of a Race Film Company that he founded, he was forced to turn to white backers for funding to produce the film. Of course, they had their own ideas about a storyline. Multiple script rewrites and filming problems plagued the entire production and, in the end, *The Birth of a Race* became convoluted in its message. The final film contained almost no black actors at all. A disaster, it flopped at the box office.

Much more profound was the impact of a group of independent black filmmakers who sought to make their own motion pictures. The most successful and prolific was Oscar Micheaux. But he was not the first of these pioneers. In 1916, Noble Johnson—a character actor with Universal Pictures—and his brother, businessman George P. Johnson, founded the Lincoln Motion Picture Company in Omaha, Nebraska. A year later, they moved the company to Los Angeles. It was the first black-owned and operated company to produce films by, for, and starring African Americans, and to portray them in anything other than humiliating roles. Noble Johnson himself starred in the earliest releases, *The Realization of a Negro's Ambition* (1916), *Trooper of Troop K* (1917), and *The Law of Nature* (1917). The national demand for Lincoln product grew quickly. By 1918, it proved to be so successful that Universal demanded that Johnson resign as president of Lincoln, as their contract with him did not permit the competition. He was prohibited from having any further involvement with the company.

A Man's Duty (1919), the most successful of the company's productions, played to packed houses in the United States, Cuba, and the Bahamas, breaking all attendance records for black theaters. The film starred Clarence Brooks, who replaced Johnson as the lead actor in Lincoln's films.

Left: **TROOPER OF TROOP K** (1917)
Opposite: **A MAN'S DUTY** (1919)

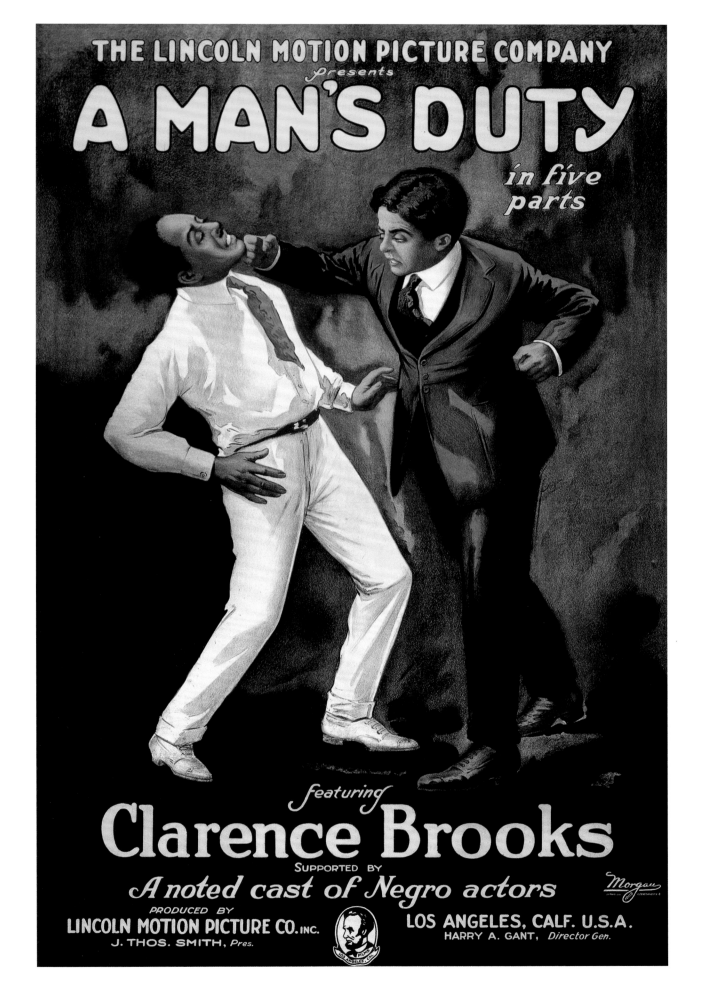

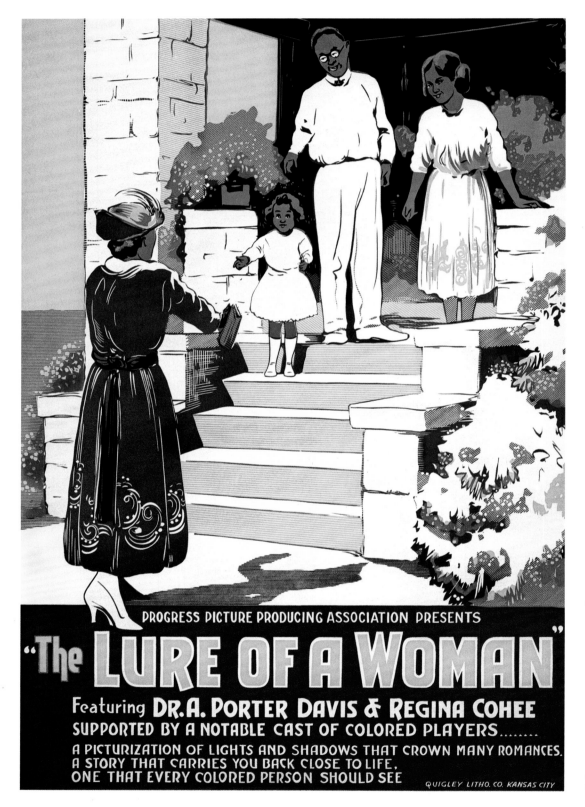

PROGRESS PICTURE PRODUCING ASSOCIATION PRESENTS

"The LURE OF A WOMAN"

Featuring DR. A. PORTER DAVIS & REGINA COHEE
SUPPORTED BY A NOTABLE CAST OF COLORED PLAYERS.......
A PICTURIZATION OF LIGHTS AND SHADOWS THAT CROWN MANY ROMANCES.
A STORY THAT CARRIES YOU BACK CLOSE TO LIFE,
ONE THAT EVERY COLORED PERSON SHOULD SEE

QUIGLEY LITHO. CO. KANSAS CITY

Financial backing for the foundation of the Lincoln Motion Picture Company had been provided by the Negro Business League of Kansas City, Missouri. When Noble Johnson chose to base his business in California, Missouri was left without a black-owned production company. Four separate concerns emerged to fill this gap, and only two of them actually made any films: the Andlauer Film Company's *As the World Rolls On* (1921), which starred boxing champion Jack Johnson; and the Progress Picture Association's *The Lure of a Woman* (1921).

As the poster for the latter illustrates, African-American filmmakers attempted to offer a more balanced picture of black family life than their early white counterparts, by introducing new character types and situations that challenged racist representations.

Meanwhile, there was still heavy demand for melodramatic pictures starring black actors, such as Monarch Productions' *The Flaming Crisis* (1924). Monarch was a black-owned production company from New York City, credited with having produced only this one film.

Despite their initial success, other independent black film companies, including The Ebony Film Company, The Foster Photoplay Company, Reol Productions, The Colored Players Film Company, and Rosebud Films, struggled to survive in the less lucrative climate of the 1920s, when the cost of moviemaking rose to outstrip the financial returns. Even the Lincoln Motion Picture Company fell by the wayside, ceasing operations in 1923 a few weeks after it had announced production of another starring vehicle for Clarence Brooks. Sadly, *The Heart of a Negro* was never completed.

Left: **THE LURE OF A WOMAN (1921)**
Opposite: **THE FLAMING CRISIS (1924)**

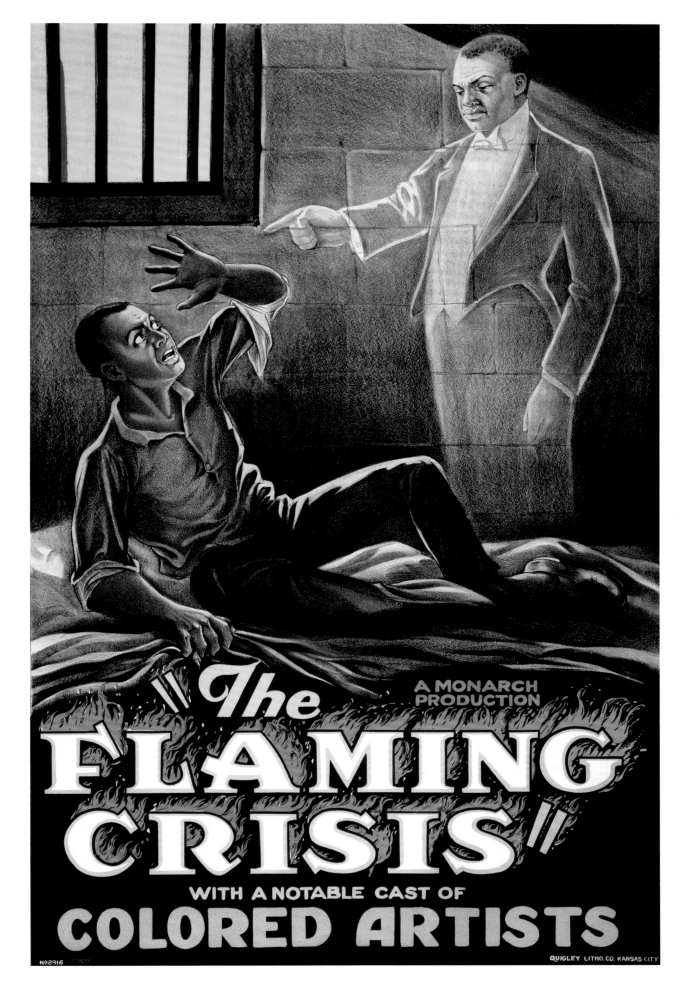

Norman Films

"There is not a white man in the cast, nor is there depicted in the entire picture anything of the usual mimicry of the Negro. This photoplay has been endorsed by the most prominent colored people of America as being the greatest picture of its kind."

Those proud words were used to promote *The Green Eyed Monster*, the first of a remarkable run of seven feature films produced and distributed by the Norman Film Manufacturing Company of Jacksonville, Florida. The films were remarkable not just for their immense popularity, or for their superb technical quality (easily on a par with those of Norman's more famous rivals), or because they starred African-American actors in pictures aimed at African-American audiences, but also because they emerged from a business founded and run by a white man.

He was Richard Norman, who took over the Eagle film laboratories and studio in the early 1920s and gave it his own name. This was an era when the Northeast region of Florida had become something of a playground for America's rich and famous, among them the leading players of the young motion picture industry. By the time that Norman's premises in the neighboring district of East Arlington were ready for operation, Jacksonville and its surrounds were already renowned as the "Winter Film Capital of the World." More than thirty film companies were based in the city, but arguably none of them left a greater mark than Norman's.

His enthusiasm for the movies was no flash in the pan. He entered the business around 1912, as an industrial photographer and film developer, and by 1915 began experimenting with filmmaking—persuading rural locals to act in skits for his cameras. Between 1916 and 1919, he experimented with longer movies and soon afterwards shot a prototype (white-cast) version of a script he called *The Green Eyed Monster*. Though he did not yet own the studio, he resolved to remake that picture with an all-black cast. Initially he intended it as a comedy drama, before being persuaded that the comic scenes detracted from its hold over its audience. When the picture finally opened in 1920, moviegoers were shocked by the spectacle of a train crash (which reportedly cost $80,000 to stage), gripped by the fight scenes staged in a railroad yard, and relieved, finally, when the heroine was rescued from abduction after a nerve-tingling chase scene "on a steel monster," as the publicity described it. Norman had a higher purpose in mind beyond the need to entertain: his carefully chosen characters were intended to "suggest the advancement of the colored race along educational and financial lines." Racial stereotyping was strictly taboo in his movies.

Nothing illustrated Norman's willingness to escape cliché more than his pair of cowboy movies, *The Bull-Dogger* (1922) and *The Crimson Skull* (1922). Hollywood traditionally portrayed the West as an all-white landscape, but the truth could not have been more different. Whether they were escaping the oppression of slavery for the open skies and freedom of the old West, or whether they simply moved there after Emancipation, African Americans contributed significantly to its development. For the first time, many of them were able to control their own lives, lay down roots, and build families in a land where their skills were more important than the color of their skin.

Some histories estimate that as many as thirty percent of early cowboys were black. So it was fitting, perhaps, that arguably the most famous rodeo performer of all time was an authentic black cowboy: Bill Pickett. He is credited as the father of "bull-dogging," the art of biting the tender part of a steer's lip and wrestling it to the ground (a trick he learned from his dog, Spike). Nicknamed "The Dusky Demon," Pickett worked alongside Will Rogers and Tom Mix at the famous Miller Brothers' 101 Ranch in Bliss, Oklahoma, and toured with their Wild West Show across North America, down through Mexico and farther South, and even to England. He was therefore the ideal star for Norman's westerns, working with the likes of Anita Bush (known as "The Little Mother of Colored Drama") and Lawrence Chenault (who played multiple roles in *The Crimson Skull* and who appeared in more films than any other black actor of the silent era).

With *Regeneration* (1923), Norman's team moved from the Western plains to "A Romance of the South Seas." Given its inspirational title, filmgoers might have expected a profound story of spiritual rebirth, but the picture was actually a black melodrama in the tradition of Robinson Crusoe. It delivered, as the publicity material promised, "A Girl, A Man, Cast Upon an Uninhabited Island, A Garden of Eden, Then the Serpent," complete with romance, villainy, mystery, and action. Notably, however, in "an all star Colored Cast," the hero and heroine had light complexions; the villain was noticeably darker-skinned.

The Flying Ace (1926) promised to be the most thrilling aviation film ever made, although there was more actual flying on the poster than there was on the screen: for reasons of both finance and logistics, the action was shot entirely on the ground. The film starred Kathryn Boyd as Ruth Sawtelle, a female daredevil, and Laurence Criner as Captain Billy Stokes, a war hero and fighter ace who is required to solve a mystery. In her most daring escapade, Boyd is seen supposedly climbing a slender rope ladder suspended from a plane a mile above the ground to escape from its burning fuselage, although the actual location of her stunt was somewhat closer to earth. While heartily acclaimed in its press screenings, this first silent film to offer segregated theaters a glimpse of airplane flight failed to attract a wide black audience.

A notable era of black film history ended with the 1928 release of *Black Gold*, which reunited the stars of *The Flying Ace* in a tale of the oil business. The entire "all-colored city" of Tatums, Oklahoma, took part in the filming, in a crucial fight between hero and villain that was shot on Main Street. Laurence Criner survived the fight, and the film, to continue as a star of stage and screen for more than two decades, but Kathryn Boyd's career did not endure beyond the advent of the talkies. Nor, sadly, did the Norman Film Manufacturing Company, one of many independents that failed to weather the transition to a new era of American filmmaking. Although Norman would maintain his ties to the industry with Camera-Phone, the nonsynchronous sound system that he developed, and other promotions, he never made another feature film.

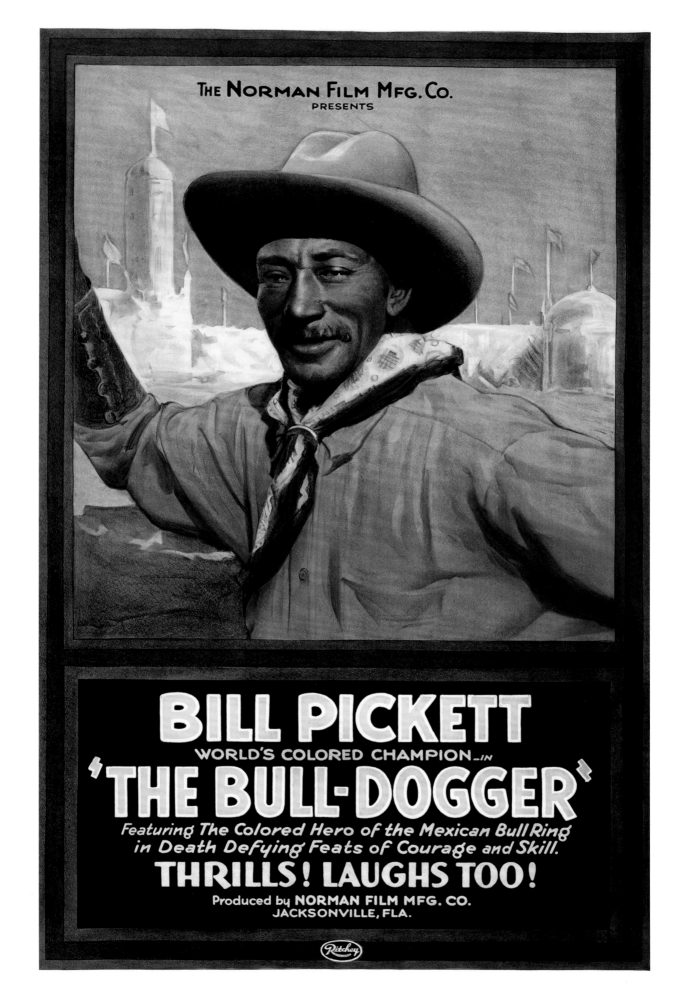

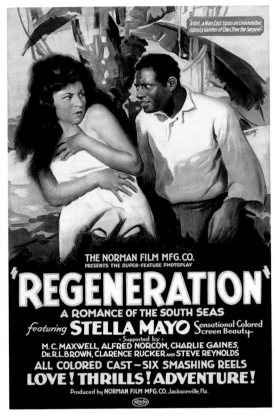

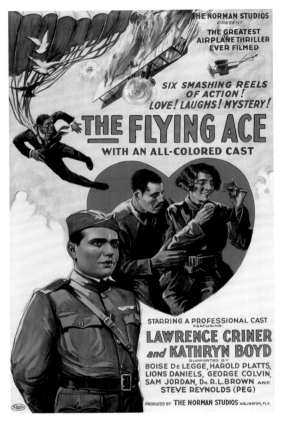

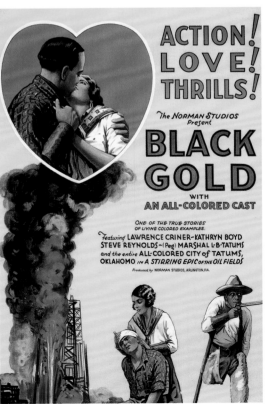

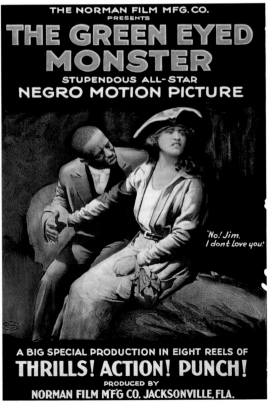

Previous: THE BULL-DOGGER (1922)
Left: REGENERATION (1923); THE FLYING ACE (1926);
THE GREEN EYED MONSTER (1920); BLACK GOLD (1928)
Opposite: THE CRIMSON SKULL (1922)

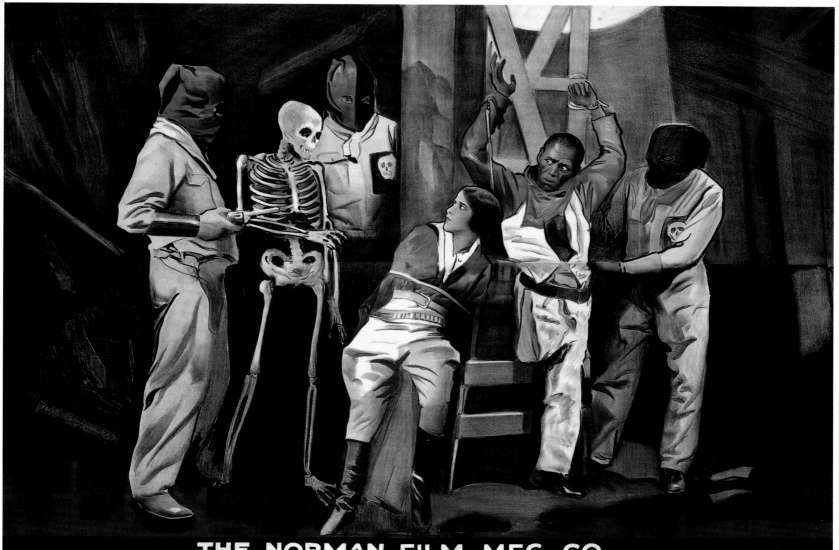

THE NORMAN FILM MFG. CO.
PRESENTS

"THE CRIMSON SKULL"

Baffling, Western Mystery Photoplay
CO-STARRING

Anita Bush
LITTLE MOTHER of COLORED DRAMA

Lawrence Chenault
PLAYING A TRIPLE ROLE

Supported by Bill Pickett, World's Champion Wild West Performer,
The One Legged Marvel, Steve Reynolds *and* 30 Colored Cowboys.

ALL COLORED CAST
Produced by
NORMAN FILM MFG.Co.,
Jacksonville Florida
6 SMASHING REELS

Oscar Micheaux

Often called "the first black film auteur," Oscar Micheaux's impact on the history of African-American cinema was substantial. In a career that spanned almost thirty years, Micheaux became the most successful early black independent film producer and director. Between 1918 and 1948, he made more than forty films of various lengths, not all of which have survived. He also wrote over a dozen published and unpublished novels, often based on his own life, and some of which provided the scenarios for his films. More noteworthy still was the entrepreneurial tenacity and zeal that enabled him to write, direct, produce, and distribute his movies.

Born in Metropolis, Illinois, in 1884, Micheaux worked as a Pullman porter before moving to South Dakota. In 1913, he sold copies of his first novel, *The Conquest*, door-to-door. Five years and two further novels later, his book *The Homesteader* came to the attention of Noble and George Johnson, the executives of the Lincoln Motion Picture Company, who offered to buy the film rights. When the two sides disagreed about the small print, Micheaux decided to form his own production company and make the film himself, financing it by selling shares in the finished product. As a result, *The Homesteader* (1919) was the first full-length feature to be directed, written, and produced by an African American.

Micheaux worked prolifically and successfully for the next decade, thanks largely to the promotional techniques he had developed in selling his novels. With script in hand, he would solicit advances from theater owners, thereby circumventing the cash-flow and distribution problems faced by other all-black companies with much briefer lifespans.

The disadvantage was that he was often forced to work on a very low budget, which necessarily affected his technical standards. He rented equipment by the day, frequently shooting scenes in the homes or offices of his friends, or in empty, outdated studios. Retakes were a luxury he could not afford, and editing was minimal. In some of his films, he could even be overheard whispering the next line of dialogue to his actors. His most lavish productions rarely cost more than $20,000 to make, years after D. W. Griffith had spent $100,000 on *The Birth of a Nation* in 1915, and the 1927 Universal Studios' production of *Uncle Tom's Cabin* had been allotted a budget of $2 million.

Yet Micheaux's features were usually far superior to those made by other independent black studios, largely because he took a familiar Hollywood genre and gave it a distinctive African-American slant. Committed to "racial uplift," he cast black characters in non-stereotypical roles, as farmers, oil men, explorers, professors, Broadway producers, or Secret Service agents. He said that he intended his films to be "propaganda," which was designed "to further the race, not hinder it." This mission was achieved as early as 1920, when he made two movies designed to counteract the insidious effect of *The Birth of a Nation*: *The Symbol of the Unconquered*, about the Ku Klux Klan; and *Within Our Gates*. He brought to the screen diverse social issues that faced black America, and also portrayed an ideal world in which blacks were affluent, educated, and cultured. In the 1930s, his films represented a radical departure from Hollywood's portrayal of African Americans as jesters and servants.

That decade saw the virtual demise of independent black cinema, under the stress of a variety of adverse factors: the advent of sound and its high costs; the Depression; and Hollywood's decision to move into the production of all-black musicals at the end of the 1920s, such as *Hearts in Dixie* and *Hallelujah*. Micheaux alone survived. *The Exile*, released in 1931, was the first "all-black talkie" made by an African-American film company. Although it was banned in Pittsburgh theaters because it involved a "somewhat inter-racial" love affair, the film was hugely successful at the box office in other major cities.

Micheaux's subsequent films ranged widely in style and subject. After making a gangster movie, *Underworld* (1937), he filmed a musical, entitled *Swing!* (1938). He had often used music in his dramatic pictures, to keep the audience's feet tapping while he waited to deliver the social message. In *Swing!*, however, the music came first—which didn't always sit easily alongside a plot concerned with marital infidelity.

Micheaux's later films were less commercially successful, as audiences tired of their repetitive themes. His final picture, *The Betrayal* (1948), based on his novel *The Wind from Nowhere*, proved to be a financial failure. He died in 1951, and for many years his contribution to American cinema was overlooked. More recently, however, his work has been rediscovered because of its quality and quantity, its command of social issues, and his pioneering example as an African-American entrepreneur. In 1986, the Directors Guild of America posthumously recognized Micheaux with a Golden Jubilee Special Award; and in 1987, he received a star on the Hollywood Walk of Fame.

Opposite: **SWING! (1938)**

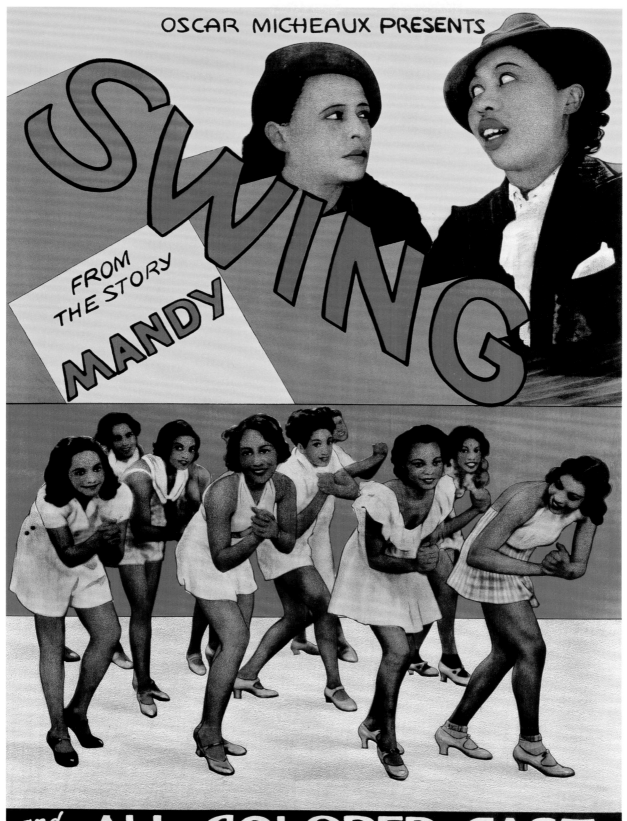

OSCAR MICHEAUX PRESENTS

SWING

FROM THE STORY MANDY

and ALL COLORED CAST

WITH CORA GREEN
HAZEL DIAZ
CARMAN NEWSOME
DOROTHY VAN ENGLE
ALEC LOVEJOY

Distributed by
MICHEAUX
PICTURES CORP.

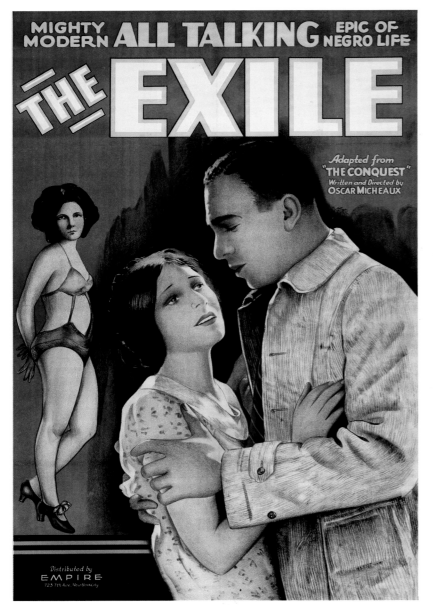

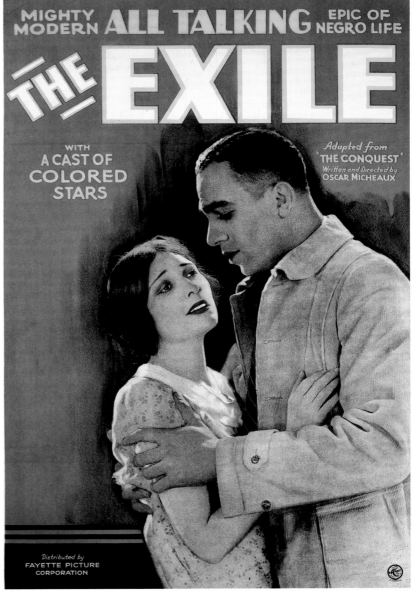

A milestone in American film history, *The Exile* (1931) was the first all-black-cast, independently produced "talkie." Based on Micheaux's autobiographical novel, *The Conquest* (1913), it follows the adventures of Jean Baptiste, an ambitious, "decent colored man," who travels to South Dakota to establish his own homestead, and falls in love with a woman, Agnes (Nora Newsome), whom he believes to be white. The film, which enjoyed a successful run in New York, was censored by the Pennsylvania Board of Censors, which objected to a scene of Baptiste kissing a white woman (who is later revealed to have "Negro blood") and to another scene, eventually cut, of a black man thrashing a white man for ungentlemanly conduct. Although the film generated much contentious debate, it gave hope to other filmmakers that black films could compete in the new market of sound movies.

Controversy surrounded the project from start to finish, mostly inspired by the theme of (apparent) interracial love, but also provoked by Micheaux's unhappiness with the performance of Stanley Morrell, his leading man. Other tensions surrounding the project were reflected in the film's posters: one portrayed a skimpily-clad dancing girl, apparently posing a threat to the central romance; a second printing omitted the provocative figure and concentrated on Jean Baptiste and Agnes.

The first of those posters—probably intended for use outside the South, and crediting a New York distributor—bore no printer's logo, as if those responsible did not wish to be associated with such a risqué assignment. The second—presumably meant for the Southern states, to judge from the name of the distributor—was sufficiently uncontroversial for the printer's logo to be displayed in the bottom right corner.

Above: **THE EXILE (1931),** *(left)* **for Northern distribution;** *(right)* **for Southern distribution**
Opposite: **THE EXILE (1931)**

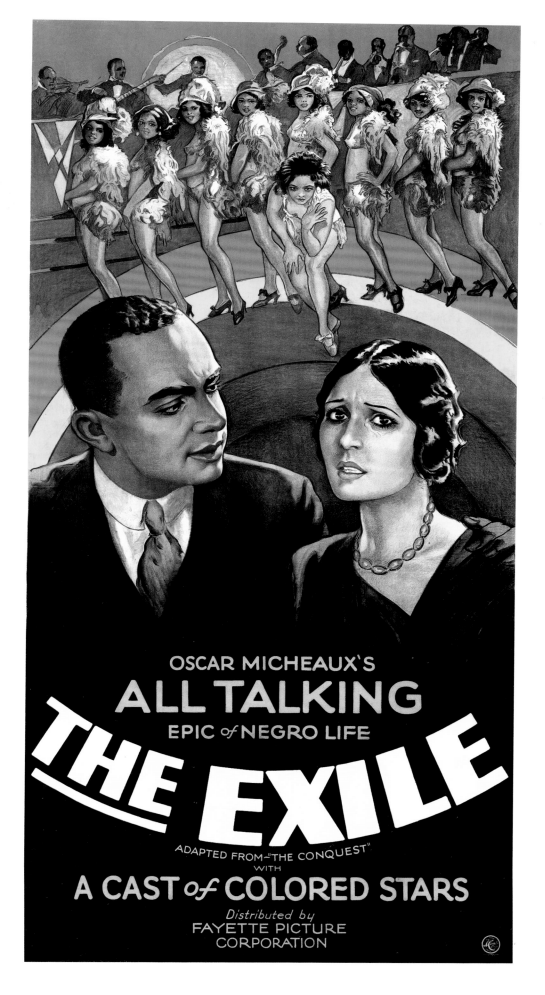

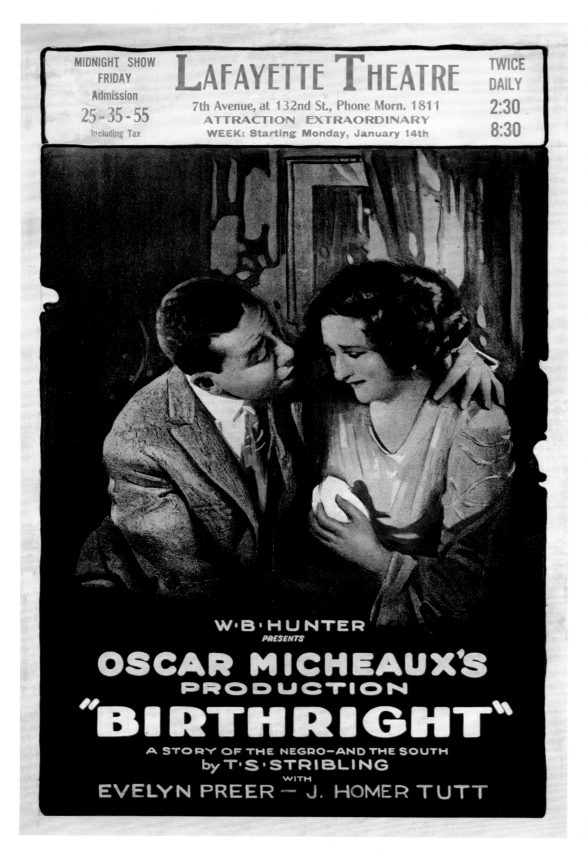

Micheaux filmed Pulitzer Prize-winning author T. S. Stribling's second novel, *Birthright*, twice: in 1924 as a silent movie, and again in 1939 with sound. *Birthright* follows Peter Siner, a well-educated mixed-race student who graduates from Harvard and returns to his small hometown in Tennessee. The virulent racism he encounters during his efforts to found a school for black children frustrates and disturbs him until he succumbs to the white hatred and oppression, marries and heads north where he hopes to find the opportunities denied him in the South.

The silent film starred Evelyn Preer, the preeminent black stage actress from the Lafayette Players in Harlem, a dramatic stock company founded by Anita Bush in 1915. Known as "The First Lady of the Screen," Preer appeared in ten Micheaux features, including her debut in his first film, *The Homesteader* (1919). In 1924, she married Lawrence Chenault, another Lafayette Players' veteran, frequently known as the "dean of black film actors," who also appeared in nearly a dozen Micheaux films.

The 1939 "talkie" version of *Birthright* includes several notable musical numbers, including the famous Duke Ellington hit "Caravan," penned by Juan Tizol; and two songs co-written by one of the greatest lyricists from the golden era of the American popular standard, Gus Kahn.

Left: BIRTHRIGHT (1924)
Opposite: BIRTHRIGHT (1939)

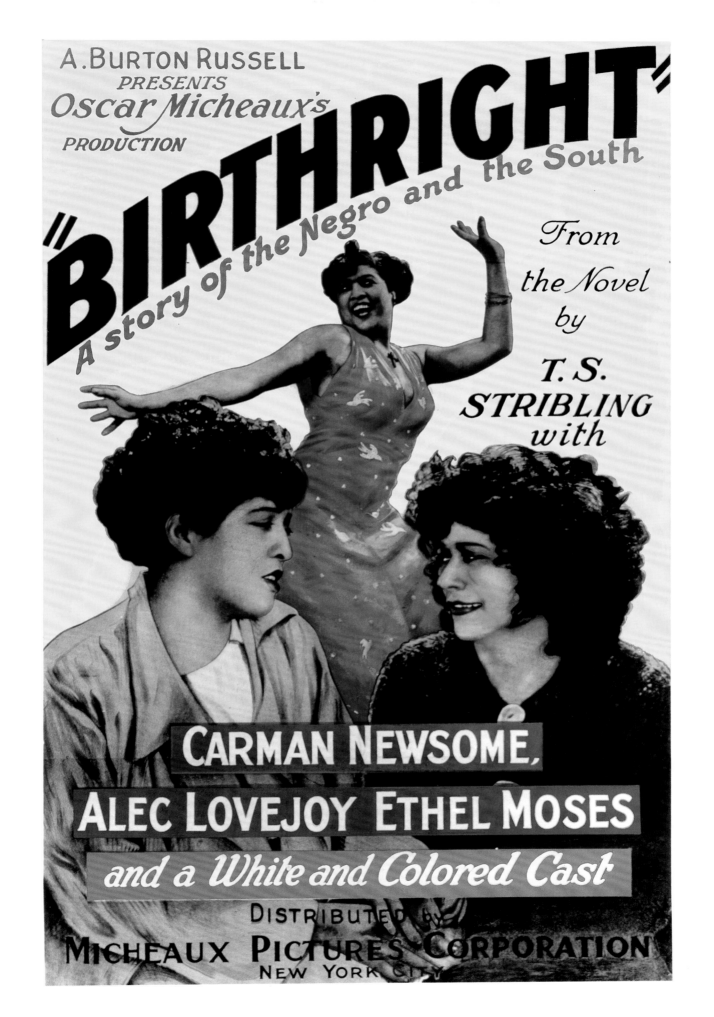

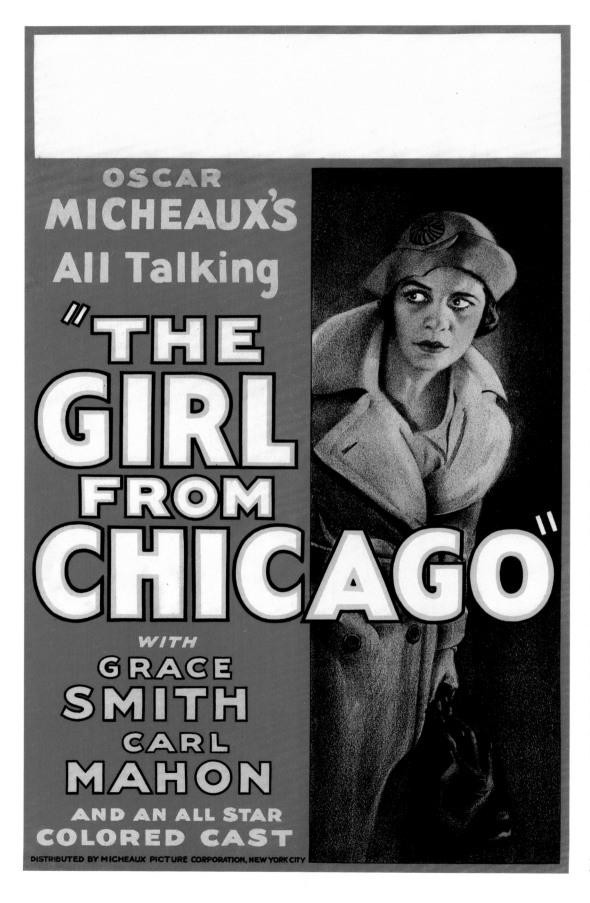

Left: **THE GIRL FROM CHICAGO** (1932)
Opposite: **MURDER IN HARLEM** (1935)

Crime has provided fertile material for the motion picture industry from its inception. So it is not surprising that several of Oscar Micheaux's movies dealt with the temptations and consequences of the criminal act.

In *The Girl from Chicago* (1932), which is based on Micheaux's unpublished short story *Jeff Ballinger's Woman*, he returned to a plot line tackled in his 1926 silent film, *The Spider's Web*. (Bizarrely, the two films claim to have been drawn from different literary sources, despite sharing exactly the same plot.) The "talkie" version was hampered in its execution by the director's need to keep his stars within reach of the microphones hanging just out of the camera's view. Carl Mahon stars as Alonzo White, a Secret Service agent in love with Norma Shepard, a schoolteacher played by Starr Calloway. Through a complex and highly melodramatic sequence of events, Mahon becomes involved in a murder case that directly affects his girl before happily marrying her at the film's conclusion. Juano Hernandez, who would later gain recognition in MGM's *Intruder in the Dust* (1949), appears as a Harlem "numbers" man, in his feature film debut.

It is interesting to note that the poster for *The Girl from Chicago* supports the allegation that many of Micheaux's stars were chosen for their (in the vernacular of the day) "high yellow" skin color.

Murder in Harlem was a remake of Micheaux's 1921 silent film *The Gunsaulus Mystery*. Both were based on his own novel *The Story of Dorothy Stanfield*—which in turn took inspiration from the true crime case of Leo Frank, a Jewish man wrongfully accused and convicted of killing a girl in Atlanta. The 1935 sound version, originally released as *Lem Hawkins' Confession*, concerns a black nightwatchman who discovers the body of a young white woman. In classic flashback style, a tale of spurned love, murder, and bribery unfold. Lambasted by critics due to continuity errors, poor camerawork and lighting—Micheaux can even be heard on the soundtrack ordering "cut" as an actress walks out of the frame—the film was re-cut and re-released a year later as *Murder in Harlem*.

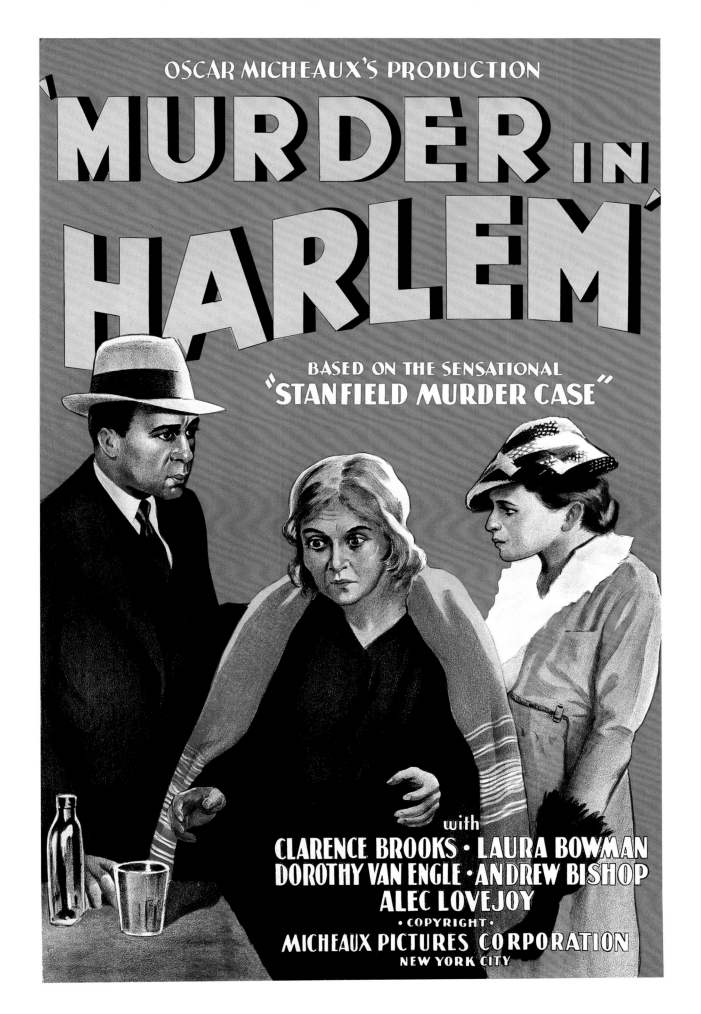

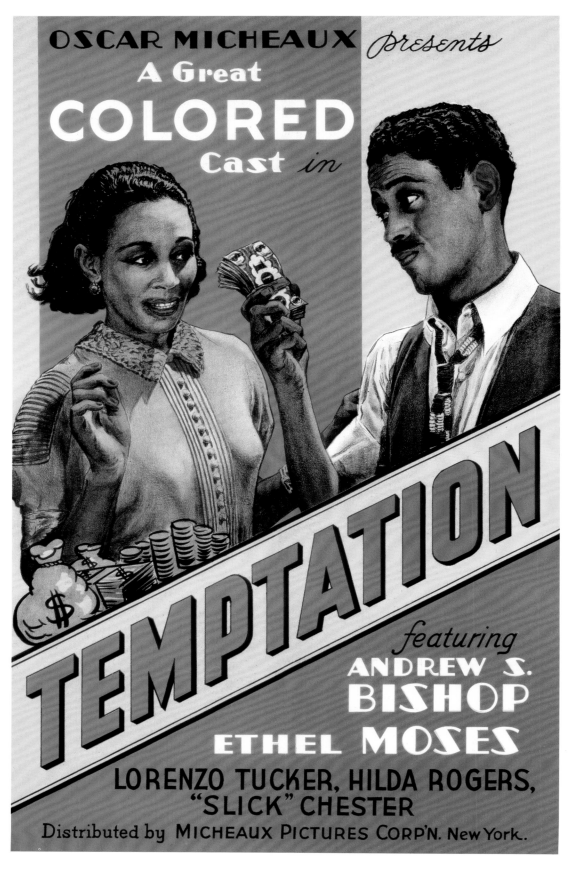

As with several of his underworld crime pictures, *Temptation* (1936) found Micheaux eager to reflect genres and plots that were proving popular in Hollywood. The movie, made on a minuscule budget of $15,000, was a clear attempt to imitate the sophisticated and seductive melodramas starring Jean Harlow. Indeed, Micheaux promoted his star, Ethel Moses, as the "Negro Harlow," and her co-star, Lorenzo Tucker, as the "Black Valentino."

God's Step Children (1938) again focused on the issue of racial identity, examining from a black perspective the dangers of "passing"—the process whereby light-skinned African Americans would allow themselves to be considered white. A young girl named Naomi spurns her racial heritage, and slides from one misadventure and peril to the next as she pretends to be white. When she finally comes home, she sees her foster-brother, Jimmie, happily married and raising a large family, whereas she has lost all chance of achieving black middle-class respectability. Sunk in despair, she commits suicide by jumping into a river.

The contrast between the self-loathing Naomi and the industrious, striving Jimmie are obvious: her attempts at racial repudiation isolate her from both black and white society, while his adherence to his mother's virtues and pursuit of his own middle-class aspirations result in a full and rewarding life. Yet the film generated considerable controversy. Picketers railed against what they claimed was a racist distinction between dark-skinned ("bad") and light-skinned ("good") blacks; and censors insisted on the deletion of certain scenes. Micheaux complied with these cuts, welcoming the publicity, and insisting that he was trying to expose rather than condone racial prejudice. Like most of the films that Micheaux made over his long career, *God's Step Children* offered a compelling vision of contemporary black life, particularly of interfamilial and race relations, and of race ambition.

Left: **TEMPTATION (1936)**
Opposite: **GOD'S STEP CHILDREN (1938)**

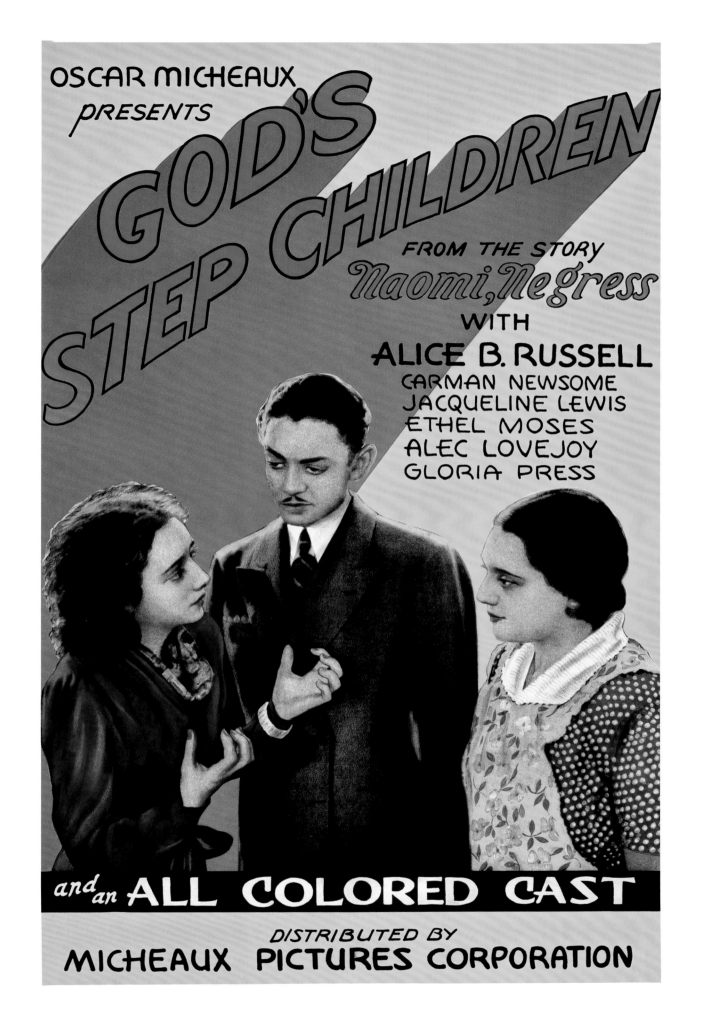

Josephine Baker

No country in the world was more receptive to the revolution sparked by African-American music in the 1920s than France. Its enthusiasm for what it called *Le Jazz Hot* offered a loyal audience and, in many cases, a second home to black performers who were often struggling to rise above the racism they endured in the United States.

For the next fifty years, American jazz performers could be assured of a warm response whenever they crossed the Atlantic and landed on French territory. But the most fevered welcome of all was reserved for a woman who was not, in fact, a jazz musician, although she came to symbolize all the glamour and excitement of what F. Scott Fitzgerald dubbed "The Jazz Age."

Josephine Baker could hardly have had a less auspicious start to her life: she was born in St. Louis, Missouri, in 1906, not knowing her father, and under the solitary care of her mother, who scraped a living as a washerwoman. She survived the deadly East St. Louis Race Riot of 1917 with a determination to leave everything it represented far behind. A self-taught dancer, by the age of sixteen, Baker had worked her way to New York and a place in the chorus line of Eubie Blake and Noble Sissle's hit musical comedy *Shuffle Along* (1921)—a show that also featured two other future stars, Adelaide Hall and Paul Robeson. Two years later, she conquered Broadway again in Blake and Sissle's *Chocolate Dandies* (1924), and performed a comedy routine with a trombone at the Plantation Club in a floorshow that also starred Ethel Waters.

French impresarios regularly travelled to New York in search of American talent that they could export to Europe, and at the age of nineteen, Josephine was offered a staggering $250 a week to move from Harlem to Paris to star in the show, *La Revue Nègre*, at the Théâtre des Champs-Elysées. Her erotic dancing, for which she appeared all but naked, caused such a sensation that she was soon poached by the management of the prestigious, but notorious, cabaret, *Les Folies Bergères*. All of fashionable Paris flocked to see her *Danse Sauvage*—shocking not just because of her lascivious movements, but because she was clad in little more than strategically placed feathers and a G-string made of bananas. Ernest Hemingway described her as "the most beautiful woman there is, there ever was, or ever will be."

As newsreel cameras clamored for footage of her raw energy and highly sexualized routines, Baker was now, arguably, the most famous American in Europe. It was inevitable that the offer to appear in full-length cinema productions would follow. In 1927, she made her film debut in the silent picture *La sirène des tropiques*, a romantic comedy that was dismissed by the critics, but relished by the public. Baker played the part of Papitou, an island girl who falls in love with a visiting Frenchman who chooses to remain faithful to his girlfriend back home. She bursts onto the screen with an extravagantly outrageous routine that is half vamp, half hyperactive child. This appearance required little more of her than to dance, but as her fame expanded, so too did her ambition. Besides her regular appearances in cabaret, she opened her own nightclub, inevitably called *Chez Josephine*. By the time talkies brought the silent era to a sudden end, she was prepared to add acting and singing to her repertoire.

Ironically, her voice revealed little of her "jazz age" heritage and could sometimes sound more operatic. But her dancing was altogether more modern and her film roles demanded that she just be herself. *Zouzou* (1934), Baker's first sound film, cast her as a laundress who becomes a music hall star, alongside the French romantic lead Jean Gabin. One of the film's highlights features an inventive sequence in which she dances in silhouette with her own shadow.

The following year, she starred in *Princesse Tam-Tam*, a rags-to-riches Pygmalion-style fantasy in which she played an African beauty passed off in Paris society as a native princess. The script was written by Pepito Abatino, her long-time manager and confidant. One of the most beautiful songs in the film—and one of Baker's biggest hits in the 1930s in both France and the United States—was "Le Chemin du Bonheur," which was translated and rearranged for Baker to sing in English as "Dream Ship" by the famous composer/arranger Spencer Williams (no relation to the actor), who had previously helped to assemble all the music for Baker's performances in *La Revue Nègre*. There were also lavish, Hollywood-inspired dance routines, performed to exotic rhythms. Baker's character watches the extravaganza transfixed, and is unable to keep still. Finally, she throws herself into the middle of the action to the horror of the aristocratic audience in the theater.

Through the next few decades, Baker made regular visits home to the United States, but she found it difficult to deal with the racism that was still an overt feature of American society. She was an early and outspoken advocate for equal rights. Having experienced racial discrimination firsthand both as a child in St. Louis and as an adult on tour, she often criticized the US for its racial policies. Racism severely marred her many visits to America during the 1950s and 60s, and the outspoken Baker refused to perform in cities that treated blacks as second-class citizens. She appeared proudly alongside Martin Luther King Jr. at the March on Washington for Jobs and Freedom in 1963, but turned down the offer to take on a full-time leadership role in the crusade for civil rights because of her responsibilities towards her twelve adopted children.

Gradually, her financial situation worsened during the 1960s, and she was forced to give up her family chateau, *Les Milandes*, in the Dordogne. Her close friend, Princess Grace of Monaco, arranged for Baker and her family to move to a villa in the South of France. Josephine continued to perform occasionally at prestigious events, although increasingly health problems made it difficult for her to maintain a regular schedule. On April 8, 1975, however, she opened what was intended to be a long season in a Paris revue designed to celebrate her fifty years in show business. The first night audience was filled with celebrities and the reviewers greeted her comeback as a triumph. But four days later, after slipping into a coma while she slept, she died at the age of sixty-eight.

Opposite: **LA REVUE DES REVUES (1927), Austrian**

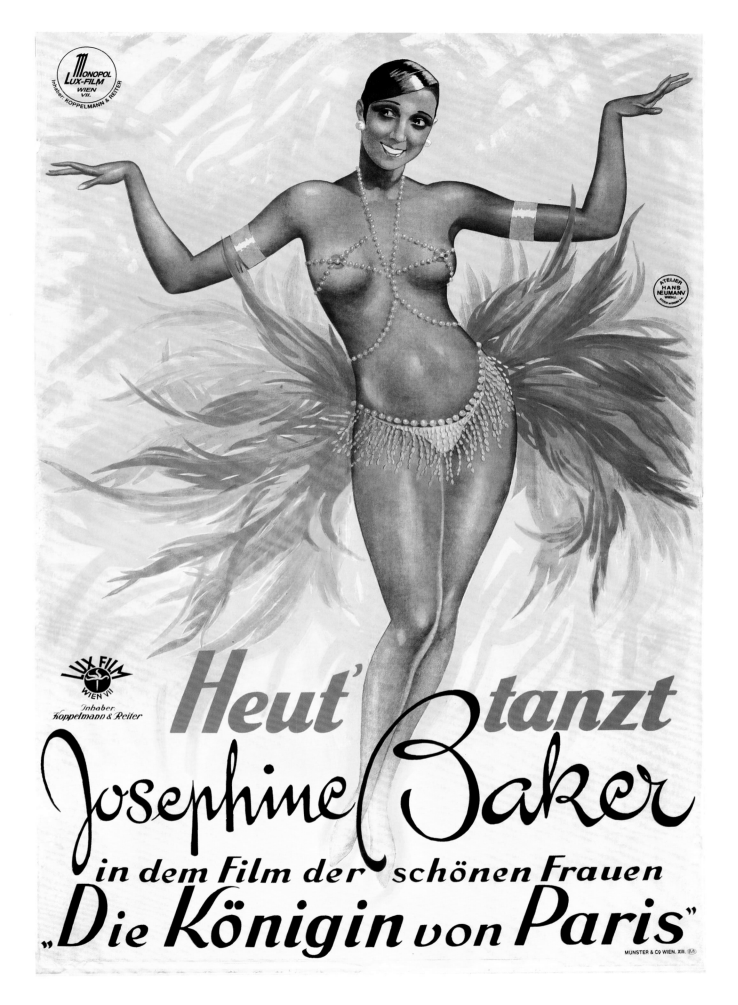

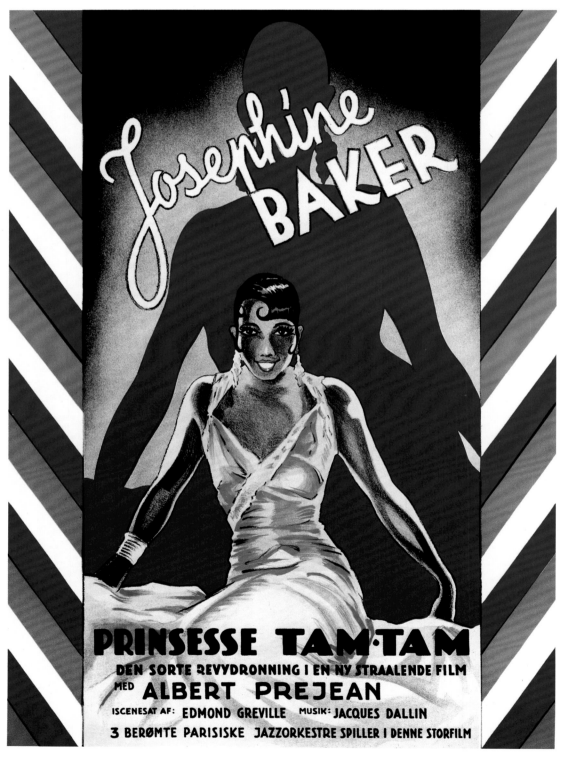

Left: PRINCESSE TAM-TAM (1935), Danish
Opposite: LA SIRÈNE DES TROPIQUES (1927), Swedish
Overleaf left: ZOUZOU (1934), Swedish
Overleaf right: LA REVUE DES REVUES (1927), Swedish

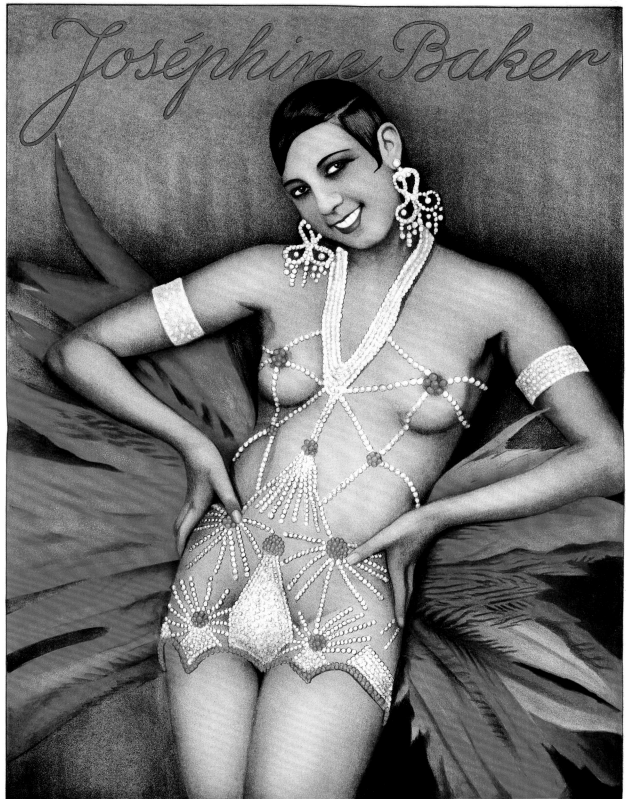

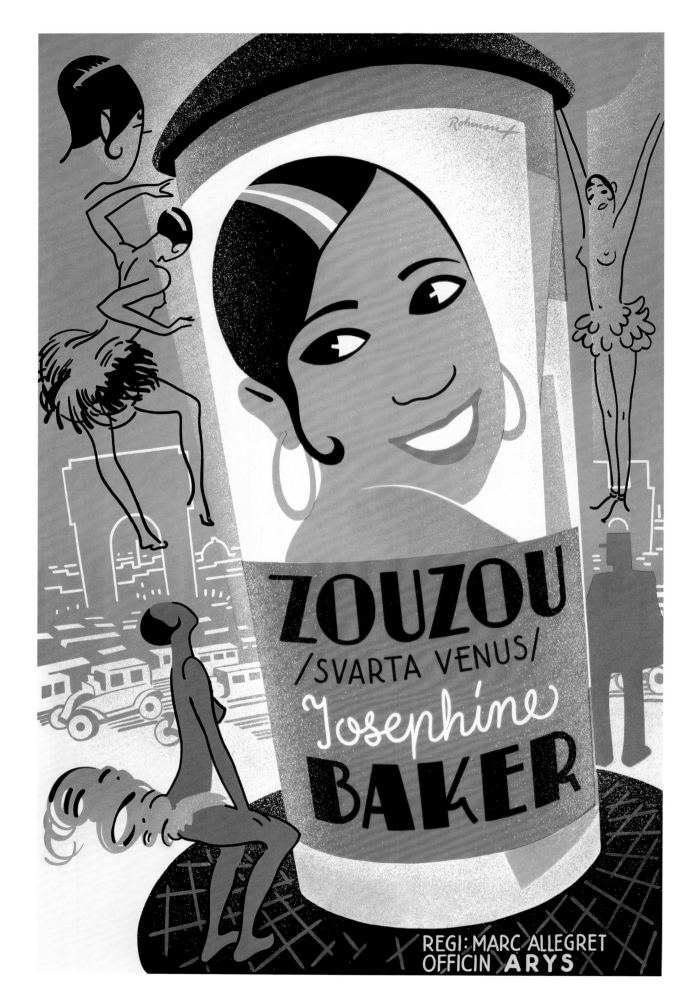

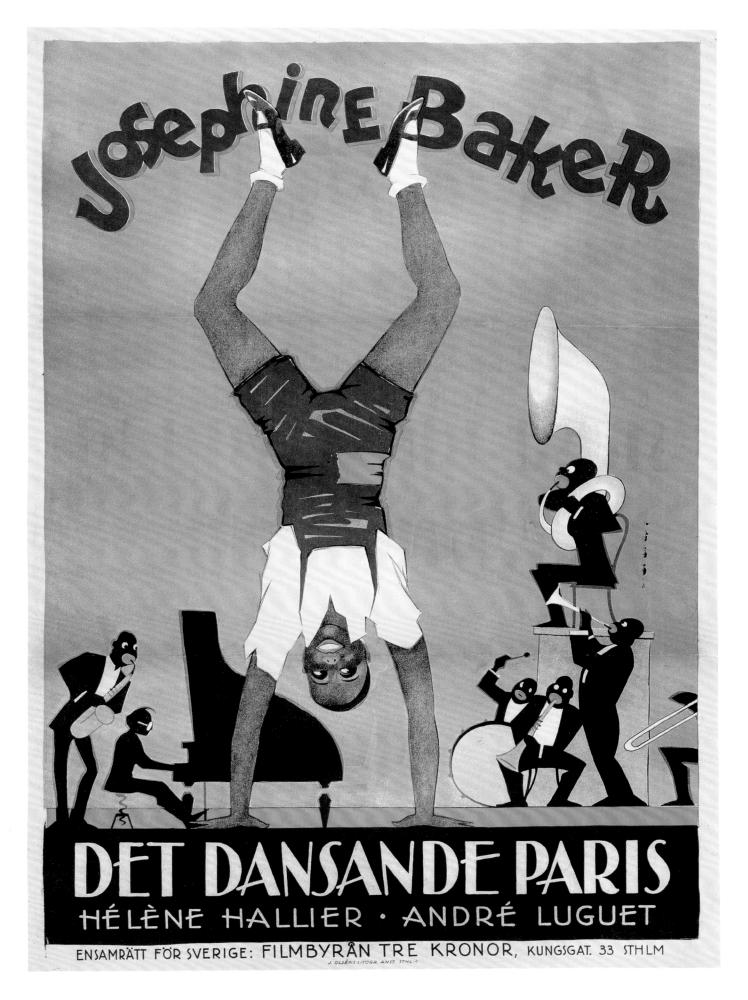

Freedom in Paris

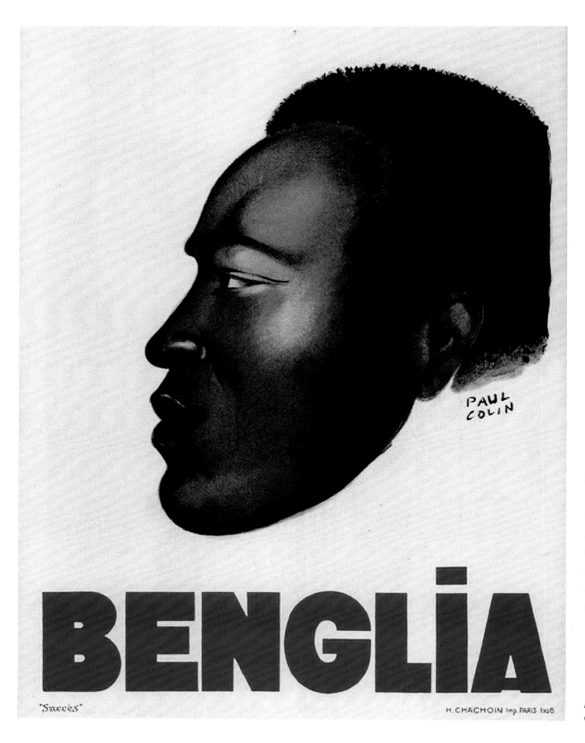

PAUL COLIN

"Succès" H. CHACHOIN Imp PARIS 1928

BENGLIA

At a time when they were regarded in their homeland as second-class citizens who must be segregated from their white compatriots, many African Americans found a more enticing climate on the other side of the Atlantic in Paris. As many as two hundred thousand black American soldiers served in France during World War I or its immediate aftermath, and they could not help but notice the stark difference between the hero's welcome they received there and the treatment to which they had become accustomed in the United States.

Several hundred of these soldiers remained in France after the war, establishing a community in Montmartre that would soon become the heart of a vibrant artistic and social culture. It was consolidated by the arrival in 1925 of *La Revue Nègre*, the African-American ensemble featuring singer/dancer Josephine Baker and jazzman Sidney Bechet. *La Revue* was both celebrated and caricatured in graphic artist Paul Colin's famous theater poster, which epitomized the French attitude towards these romantic, exotic outsiders. In return, the black American expats enjoyed the opportunity to express themselves, on stage, or in the streets of Montmartre, without fear of persecution or ridicule.

This sense of freedom extended to Habib Benglia, the first African actor in French cinema history. He starred in Jean Gremillon's 1931 film, *Daïnah la métisse*. Only fifty of its ninety minutes were ever shown in public, and Gremillon asked for his name to be removed from the credits in disgust. But even in its butchered form, this rarely-screened film has been hailed as a masterpiece, which casts an enigmatic light on the nature of racial identity.

Left: **BENGLIA (1928), French**
Opposite: **DAÏNAH LA MÉTISSE (1931), French**

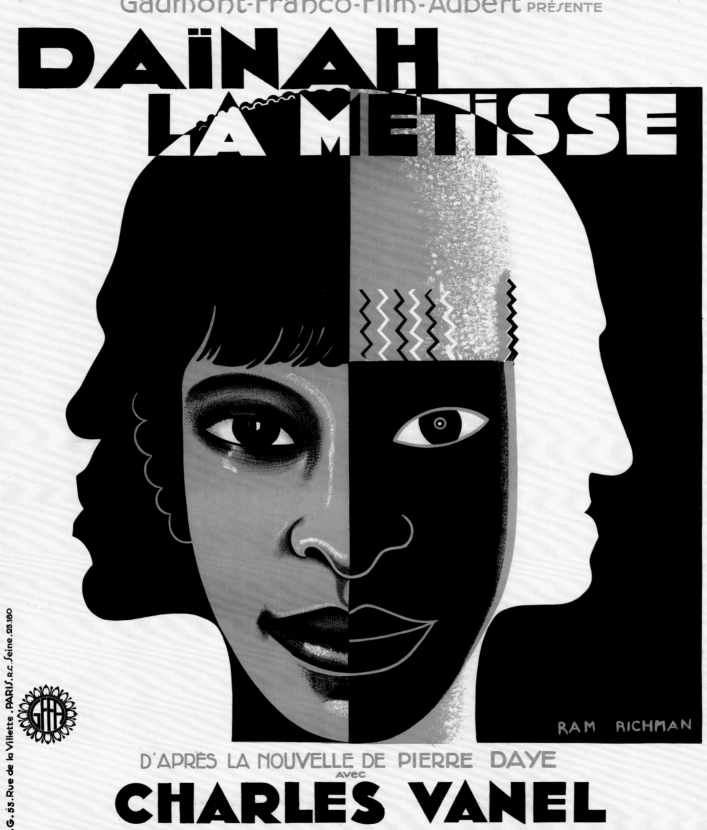

Blackface

In their 1931 feature, *Pardon Us*, Laurel and Hardy fall afoul of America's strict prohibition legislation and are sent to prison. Amidst the usual comic capers, they escape, and hide themselves amongst a community of African Americans picking cotton in the fields. One day, as the prison warden drives past the laborers, his car breaks down, so he requests help from our heroes. Initially, he fails to recognize them: it's only a distinctive whistle in one of Stan Laurel's teeth that alerts him to the convicts' real identities.

There's one crucial plot development missing in this account, which explains how two very obviously Caucasian men could hide amongst a group of African Americans without being noticed. To disguise themselves in their new milieu, Laurel and Hardy resort to one of the oldest tricks in American theater: adopting blackface, or "blacking up." None of their new black friends recognizes that they are not actually black; there is a scene where a dog licks Oliver Hardy's makeup off his cheek, and Stanley has to make hasty and amateurish repairs.

What was clearly meant, and received, as acceptable humor in 1931 is offensive and outlandish today. Yet it has been argued that the practice of blackface—using burnt cork, shoe polish, or greasepaint to color white skin black—was not intended to be racist or insulting. It was meant, its defenders say, as a tribute to the musical and comedic heritage of African Americans. It allowed white entertainers to "borrow" the songs and routines of the nation's black community and convey them to a much wider audience. Songwriters such as the legendary Stephen Foster even created "traditional" tunes like "Camptown Races" and "My Old Kentucky Home," designed to sound as if they were authentically African American.

Yet this account of blackface's origins ignores how "blacking up" affected the people whose culture was being stolen and whose features were being mimicked and exaggerated. African Americans weren't the only minority to suffer at the hands of white entertainers: theaters and music halls resounded to Irish songs, Jewish songs, German songs, all of them poking fun at immigrant communities, their culture, and their language. But the insult of blackface was reinforced by the official racial prejudice enshrined in America's legal system until well into the twentieth century: the segregation and discrimination that was the inescapable destiny of the black community.

From blackface came minstrel shows and "coon songs," popular ragtime songs that satirized African-American language and speech patterns while encouraging whites to believe that every prejudice they already held against their fellow black citizens was accurate. So widespread was blackface that even some black performers—including the renowned comic minstrel team of Bert Williams and George Walker—were forced to don the same exaggerated burnt cork and costumes, in case white audiences didn't think they looked "authentic" enough. They were also encouraged to perform coon songs and cakewalks, prompting the grotesque sight of black men slathered in greasepaint, garish lip coloring, and playing into the stereotype—while singing songs such as "Happy Are We Darkies So Gay," "Who's Dat Nigga Dar A Peepin?," and the most popular of them all, "All Coons Look Alike to Me," written by African-American composer Ernest Hogan.

The white stage performer Thomas D. "Daddy" Rice was among the first to popularize blackface with his "Jim Crow" routines in the 1830s. Nearly a century later, film director D. W. Griffith employed blackface to create the most evil of his "black" characters, Silas Lynch (George Seigmann), in *The Birth of a Nation*. One of the most popular entertainers of the century, white vaudevillian Al Jolson, regularly donned blackface as the climax of his stage act as well as in many of his films; while two pairs of comedians, Amos 'n' Andy and Moran and Mack, traded on the same gimmick. It is interesting to note that even some of America's most iconic child stars—Shirley Temple, Judy Garland—appeared on film in blackface, too.

After the 1930s, most American performers came to realize that blackface had no role in a modern society, although elements of the tradition limped on for another two or three decades. Then in 2000, the satire was turned on its head by Spike Lee's film *Bamboozled*, which confronted all the demons aroused by blackface and forced all of America, black and white, to face up to its ambiguous cultural heritage.

Opposite: **PARDON US (1931), Stan Laurel and Oliver Hardy**

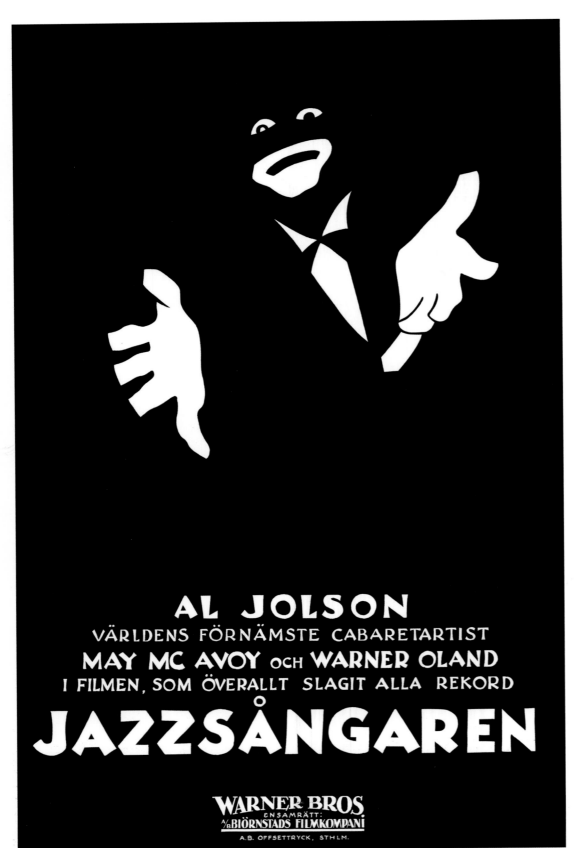

AL JOLSON
VÄRLDENS FÖRNÄMSTE CABARETARTIST
MAY MC AVOY OCH WARNER OLAND
I FILMEN, SOM ÖVERALLT SLAGIT ALLA REKORD

JAZZSÅNGAREN

WARNER BROS
ENSAMRÄTT:
A/b BIÖRNSTADS FILMKOMPANI
A.B. OFFSETTRYCK, STHLM.

For its first synchronous sound and spoken film, or "talkie," Hollywood looked not to black actors or entertainers but to an enduring, if antiquated, aspect of black American popular culture. *The Jazz Singer* (1927), based on *The Day of Atonement* (1922), a short story by Samson Raphaelson, starred white singer Al Jolson as Jakie Rabinowitz, a cantor's son who chooses assimilation over his family's faith. Though his dying father wishes him to reserve his talent for his religious rituals, Jakie takes on the identity of Jack Robin and wears blackface as he performs sentimental ballads in front of a secular audience.

His family is horrified. "He talks like Jakie," one of them says, "but he looks like his shadow." Jolson's character isn't without qualms about his decision: "the songs of Israel are tearing at my heart," he cries, while acknowledging "the call of the ages, the cry of my race." But it's another race entirely that we see him caricature, in a lengthy sequence that sees Jakie becoming "Jack," painting his face black, adding a grotesque white "smile," and disguising his own thinning hair beneath a curly wig. Jolson's charisma as a stage performer was undeniable: he was one of the major American entertainers of the century. But his blackface routines ensured that his legacy has dated and soured much more decisively than that of his peers, such as Bing Crosby.

Jolson went on to reprise his burnt cork minstrelsy role in another hit film, *The Singing Fool* (1928); and he was still returning to the same routines in his autobiographical 1936 picture, *The Singing Kid*, where he once again "blacked up" for the finale, alongside a team of female minstrel dancers.

Left: **THE JAZZ SINGER (1927), Swedish**
Opposite: **THE SINGING KID (1936)**

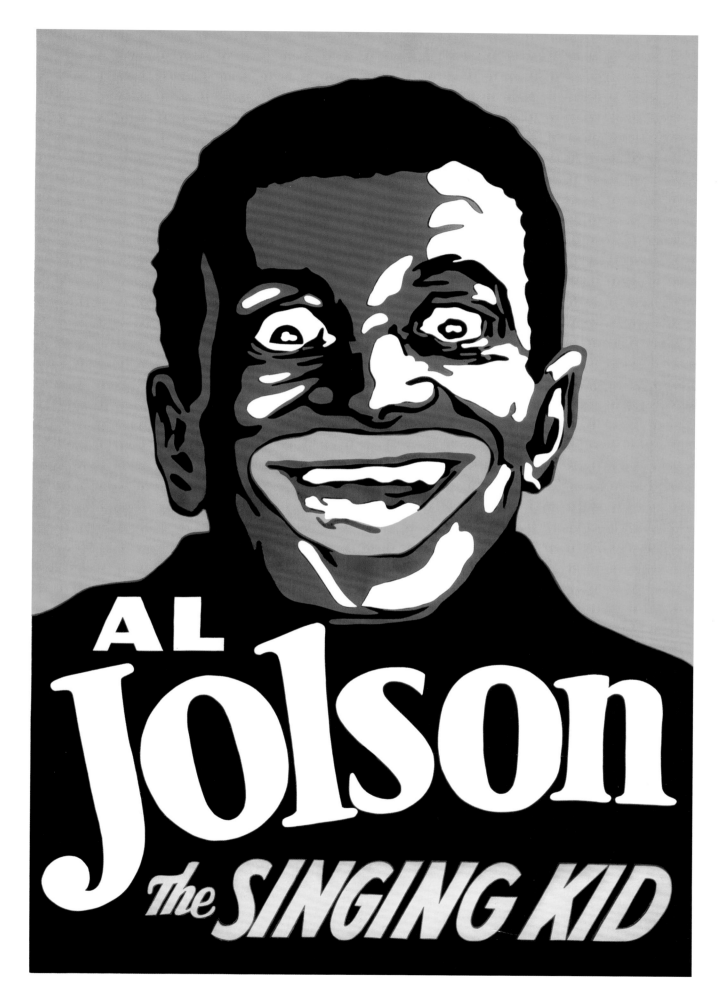

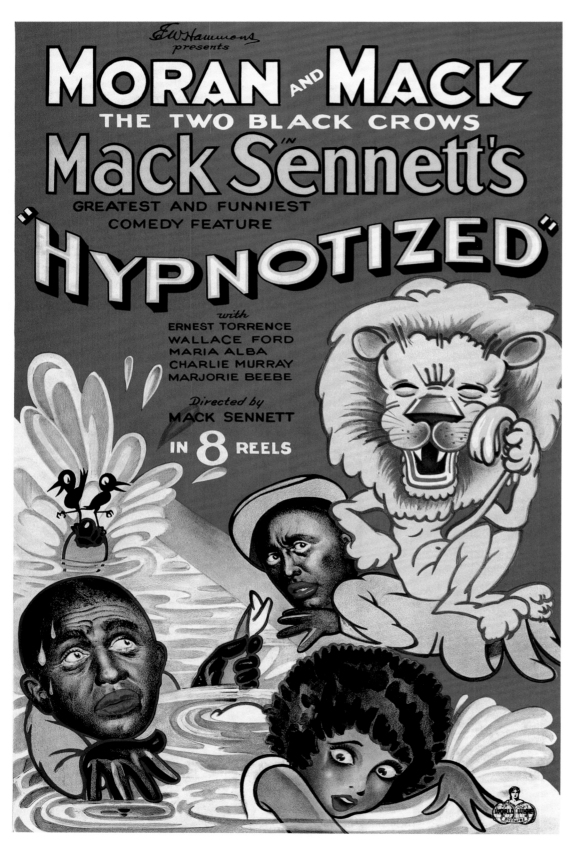

Two white comedians, George Moran and Charles Mack, adopted blackface as their stage gimmick, and achieved national fame in 1927 when their trademark "Two Black Crows" routines were released on records in a succession of hit singles featuring the same stereotyped characters. The act originated in vaudeville, won vast audiences in stage revues such as the *Ziegfeld Follies* and *George White's Scandals*, and was transferred onto radio in 1928. So it was inevitable that they would also receive offers to appear together—in blackface, of course—in movies such as *Why Bring That Up?* (1929), and *Anybody's War* (1930). By the time the latter was released, the pair had parted company for financial reasons. But producer Mack Sennett, Hollywood's "King of Silent Comedy Films," offered them a new contract to star in *Hypnotized* (1932). Just two years later, Mack was killed in a car accident, leaving Moran to search in vain for a new partner to replicate the pair's original success.

Their main blackface rivals on radio were Amos 'n' Andy, characters created in 1928 by two white comedians, Freeman Gosden and Charles Correll. They play a pair of African-American bumpkins who experience culture shock once they move from Atlanta to the South Side of Chicago. Drenched in stereotypical dialect, they attracted a diverse mass audience on a nightly basis. At the peak of their popularity, they made the movie *Check and Double Check* (1930), in which they appear in blackface. Virtually the only African Americans in the film are the members of Duke Ellington's Cotton Club orchestra, whose appearance at a high society ball is the device that brings Amos and Andy into the plot. Ellington performs "East St. Louis Toodle-Oo," "Three Little Words," and "Old Man Blues," among other numbers. Gosden and Correll ended their radio series in 1960 after more than twenty-five years on the air. In 1951, CBS TV launched *The Amos 'n' Andy Show*, a half hour comedy series that featured an all-black cast including Spencer Williams, Alvin Childress, and Tim Moore in the lead roles. It lasted two years before the NAACP forced it into syndication and ultimately off the air entirely.

Left: **HYPNOTIZED (1932)**
Opposite: **CHECK AND DOUBLE CHECK (1930), British**

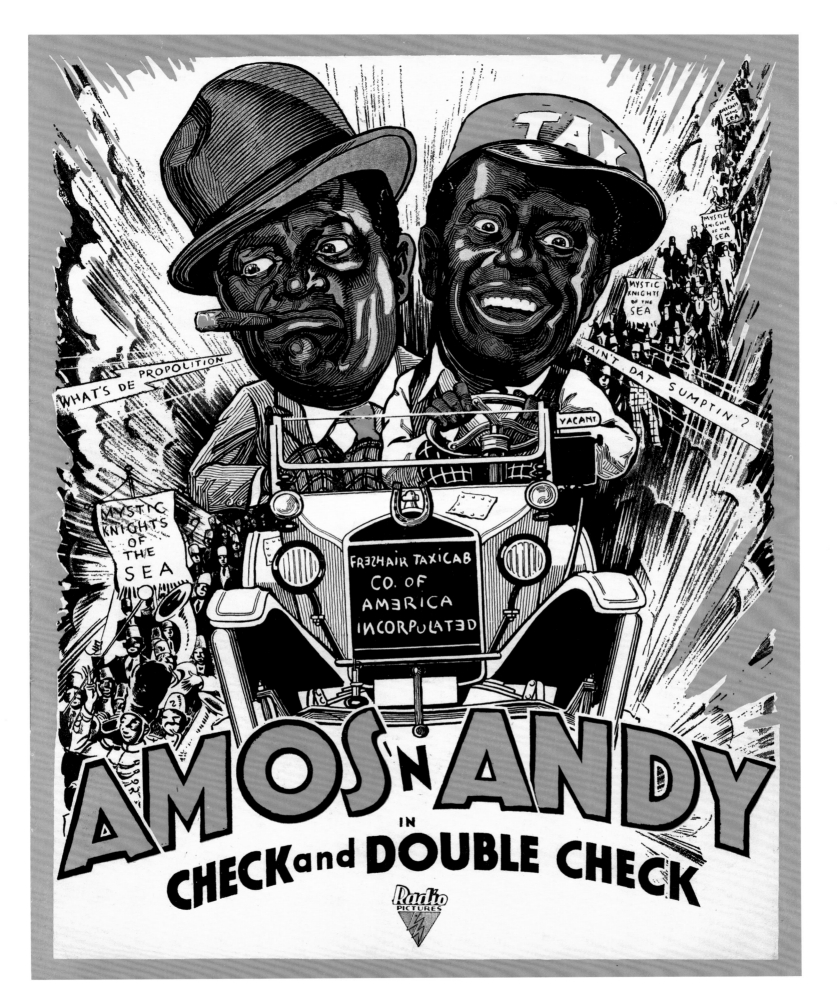

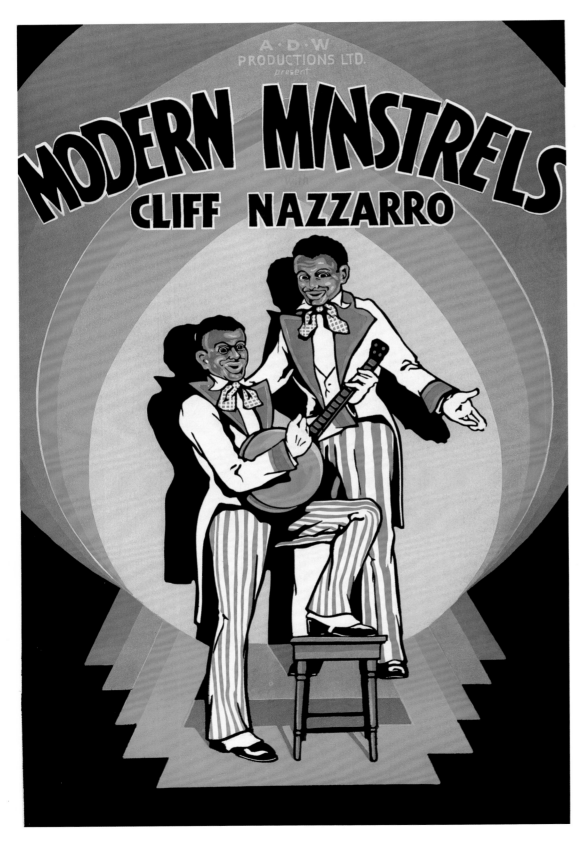

The title of the 1930 film *Modern Minstrels* turned the spotlight firmly on the blackface tradition that had been providing work for white entertainers over the previous century. This minstrel comedy starred Cliff Nazarro, a vaudeville master of ceremonies in all of the leading theaters in the late 1920s and early 1930s. Dubbed the "Master of Nonsense," Nazarro originated a perplexing lingo known as "double-talk," perfecting his act so well that he was cast as "Swivel Tongue" in the 1941 Fred Astaire picture *You'll Never Get Rich*.

Modern Minstrels promised "A thousand laughs! A thousand thrills!" but was soon forgotten, and Nazarro subsequently enjoyed more consistent work as a voiceover artist for Warner Bros.' *Merrie Melodies* animations.

A Pair o' Dice (1930) starred Lee "Bud" Harrison: its title was intended to suggest a pun on the word "paradise." Its poster displays a typically offensive "Negro" stereotype: two Pullman porters on a break, kneeling in full uniform and shooting craps. Letting one's wages "ride" on a gamble was a consistent scenario for this kind of blackface comedy.

Left: **MODERN MINSTRELS (1930)**
Opposite: **A PAIR O' DICE (1930)**

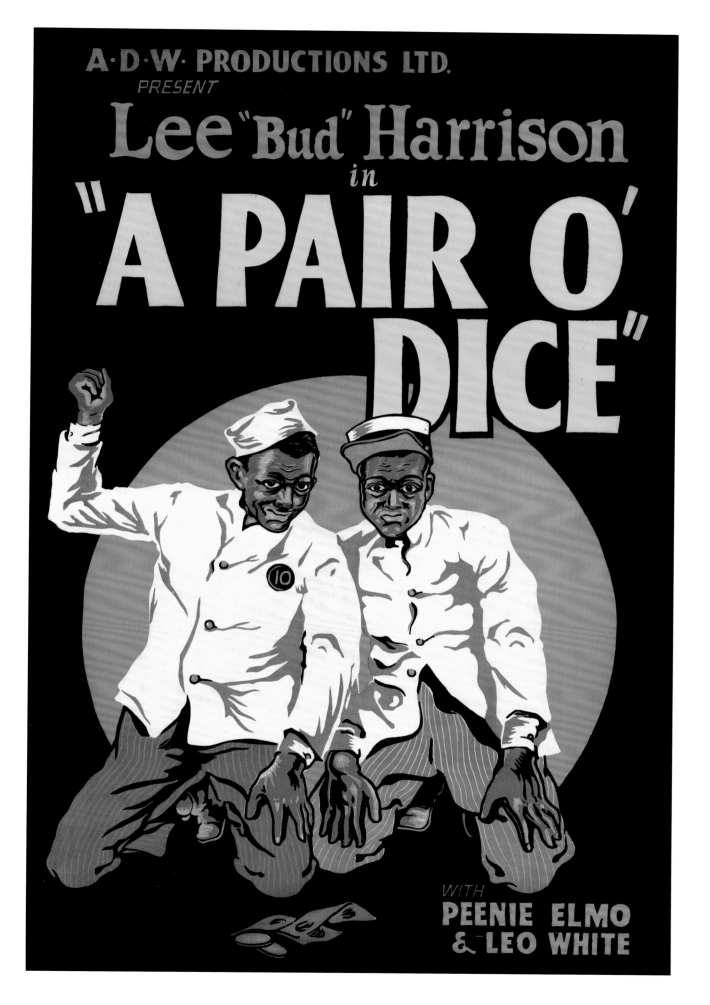

Stepin Fetchit

Few film actors have ever aroused as much controversy—much of it retrospective—as Lincoln Theodore Monroe Andrew Perry (1902-1985). Under the assumed name of Stepin Fetchit, he gained fame as the first African-American actor to open doors in Hollywood and he became the industry's first black millionaire. The price of his fame, however, was the virtually unchanging character that he enacted in over fifty films: the lazy, shiftless, black manservant.

He took his stage name from a racehorse and made his reputation during an era in which stereotypical roles were the inevitable fate of African-American entertainers. In 1927, he landed a role in the film *In Old Kentucky*, where his undoubted comic rhythm immediately made an impact. In his breakthrough appearance in *Hearts in Dixie* two years later, his buffoonish mannerisms and shuffling demeanor managed to further excite and delight white audiences and quickly became his screen trademark routine.

Much to the dismay of African-American audiences, Perry's controversial antics, and legendary behavior off-screen, lasted for decades, until audiences finally tired of his belittling and racist clowning. As Hollywood became more enlightened in the post-war years, and without wanting to risk further offense, the studios announced that they would sharply curtail the casting of demeaning roles in the Stepin Fetchit tradition in forthcoming films.

Left: **STEPIN FETCHIT (1929)**
Opposite: **IN OLD KENTUCKY (1927), French**

Hearts in Dixie

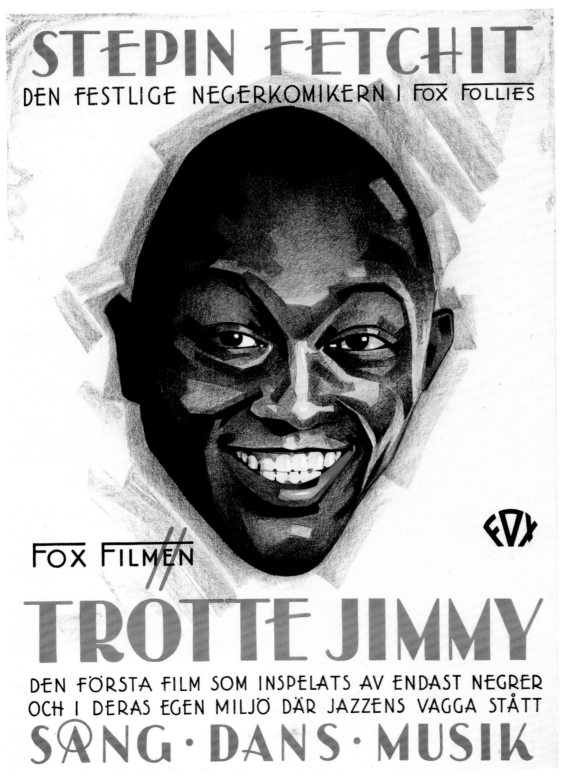

The Jazz Singer introduced the talking motion picture to American movie audiences in 1927. Two years later, continuing the transition to sound—and raking in huge profits with the new technology—Hollywood studios began to look at the rural lives of blacks as the subject of some of their feature films.

The Fox Film Corporation originally conceived *Hearts in Dixie* as a two-reel musical showcase of spirituals and minstrel comedy but the rough cuts, which featured a rich and distinct fidelity to the black vocals, so impressed the producers that the writers expanded it into a feature-length production. The first all-black-cast, all-talking musical to reach the screen, the film portrayed plantation life in the "idyllic" black South following the Civil War. The level of fantasy that surrounded the project can be glimpsed in the publicity slogans used to promote it. Fox promised that *Hearts in Dixie* would evoke "all the happiness and pathos of native workers," and demonstrate "the Soul of Dixieland, Talking and Singing," with "200 Negro entertainers from the levees and cotton fields." Prominent among the cast were Clarence Muse, in his feature film debut, Mildred Washington, Gertrude Howard, Zack Williams, and the ever-controversial Stepin Fetchit.

Left: **HEARTS IN DIXIE (1929), Swedish**
Opposite: **HEARTS IN DIXIE (1929)**

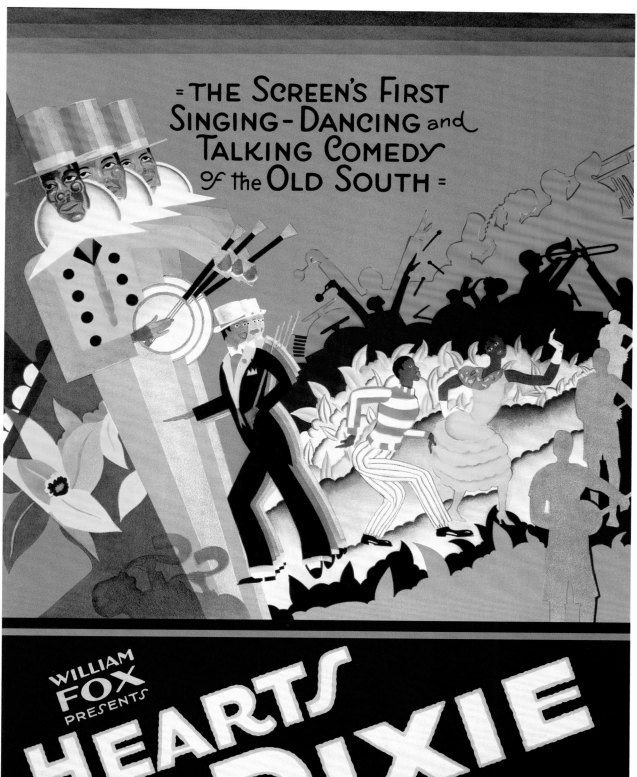

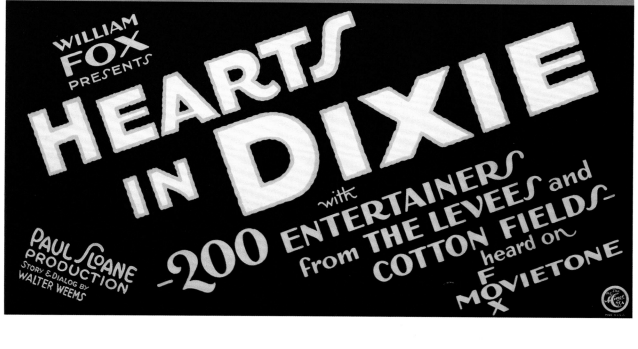

Hallelujah

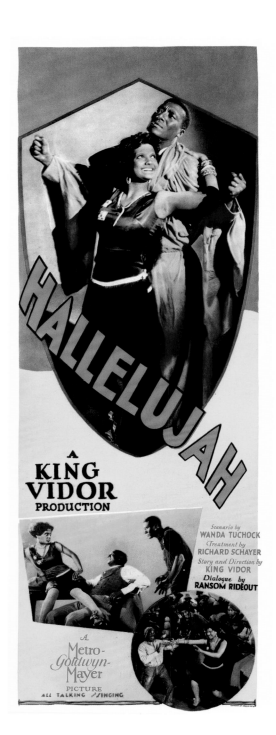

Hallelujah (1929) marked a turning point for African Americans in film. It was the second all-black-cast movie produced by a major Hollywood studio and the first sound film by the white director and writer, King Vidor. Although Fox had released *Hearts in Dixie* earlier that year, MGM's *Hallelujah* proved to be much more commercially successful.

The film is effectively a modern-day morality play about a decent young man who is seduced by the various pleasures of the flesh. Daniel L. Haynes played the leading role of Zeke, a sharecropper who falls into a trap set by Chick (Nina Mae McKinney) and her boyfriend, Hot Shot (William Fountaine). When Zeke's gullibility brings about his brother's death, he repents and becomes a preacher—so righteous, in fact, that even Chick is moved to convert after she hears him speak. But he falls victim to her wiles for a second time, with much dramatic intensity, before the conclusion of the film returns him to his family and his farming life with the expectation that he will marry the simple and pious Missy Rose (played by the soon-to-be-legendary blues singer, Victoria Spivey).

King Vidor was so intent on filming a story about the "real Negro" that he took the unusual step of employing black consultants to advise him. Vidor succeeded in incorporating both traditional aspects of black folk culture, such as gospel music, and more innovative styles, such as the dance forms popularized on the vaudeville stage. Some critics of the film decried what they saw as a reversion to old stereotypes, such as the faithful Mammy, the zoot-suited gambler, and the loose-moraled temptress; others found the depiction of an almost hysterical black religious fervor to be condescending. But most viewers, black and white, appreciated the film's portrait of an earnest, close-knit family, and hailed the way that the religious celebrations reinforced the more secular and social aspects of black culture.

Despite the rich picture of family life that it brought to the screen, *Hallelujah* was not as successful at the box office as the studio had hoped. It did, however, demonstrate the talents of black performers and showed the artistic possibilities of stories focused on black life. Still, Hollywood was many years away from casting its next studio film with African-American lead actors; Warner Bros.' *The Green Pastures* in 1936. And MGM's *Cabin in the Sky* and Twentieth Century Fox's *Stormy Weather* would not be released until 1943.

Left: **HALLELUJAH (1929)**
Opposite: **HALLELUJAH (1929), Swedish**

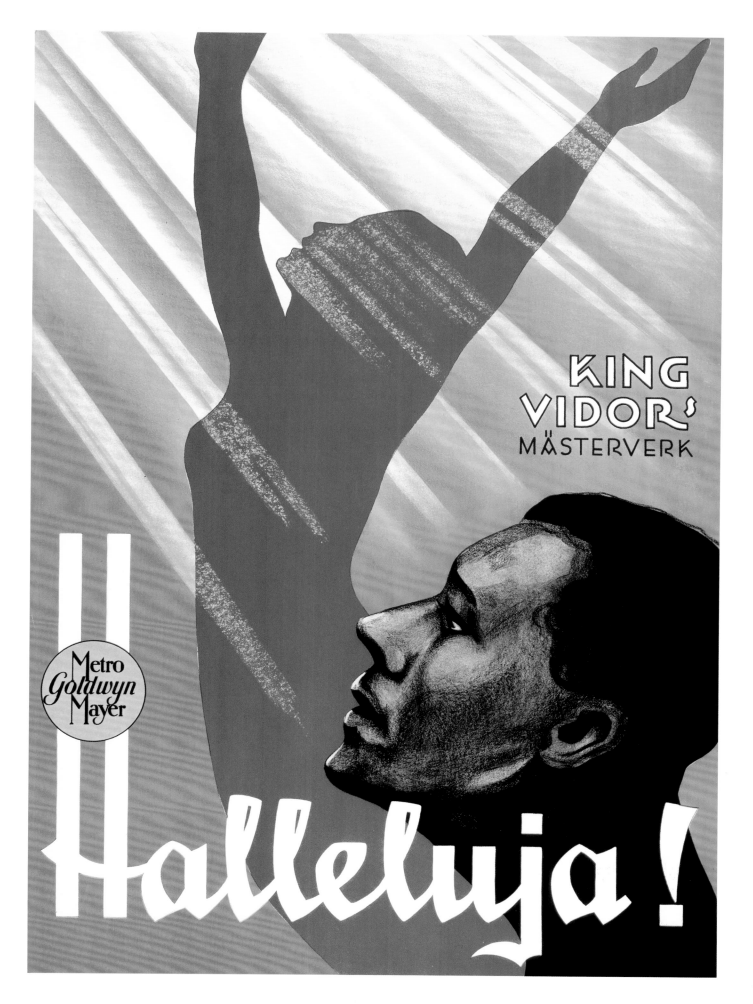

Ethel Waters

Simply having been responsible for introducing a song as memorable as "Stormy Weather" to the jazz and blues repertoire would be reason enough for posterity to remember Ethel Waters. But her performances at the Cotton Club, where that timeless tune was first heard in public, were merely one aspect of a career that stretched over sixty years and into the 1970s.

She was born in 1896, and exhibited a striking talent as a singer and dancer in her early teens. After debuting in the black vaudeville circuit in 1917, she signed her first recording contract to the tiny Cardinal Records label in 1920, the better established Black Swan Records in 1921, and then to Columbia Records in 1925, where she would achieve one of her biggest hits, "Dinah." She enjoyed later success with one of the classic jazz ballads, "Am I Blue?," and pushed at the walls of racial stereotyping with her forthright rendition of Fats Waller's "(What Did I Do To Be So) Black And Blue." She also worked with many of the most notable jazz musicians of the era, including pianist Fletcher Henderson, the Dorsey Brothers Band, and Benny Goodman's Orchestra.

Fortunately, much of her charisma was also captured for posterity on film. She made her screen debut in *On with the Show!* (1929), performing "Am I Blue?" as a cotton picker, and "Birmingham Bertha" with dancer John Bubbles. Arguably, though, her most potent cinematic vehicle was a twenty-one-minute short film, *Rufus Jones for President* (1933). In this fantasy satire on politics, a little boy (played by eight-year-old Sammy Davis Jr.) dreams that he becomes President of the United States while his "Mammy" (played by Waters) is Vice President. The satire is both pointed ("Two pork chops every time you vote," the electorate is promised) and humorous (W. C. Handy's "Memphis Blues" is adopted as the new national anthem). But seen today, what shines most brightly in the film is the compelling musical content by the two stars. The slim and slinky Waters, clad in a glamorous long white gown as she performs "Am I Blue?" and "Underneath the Harlem Moon," looks very different from the heavier figure she displayed in *Pinky* (1949) and *Member of the Wedding* (1952). Meanwhile, Davis delivers a precocious version of Louis Armstrong's "(I'll Be Glad When You're Dead) You Rascal You," already displaying the flair as a song and dance man that would be the fulcrum of his remarkable career.

Left: ON WITH THE SHOW! (1929), Ethel Waters
Opposite: RUFUS JONES FOR PRESIDENT (1933)

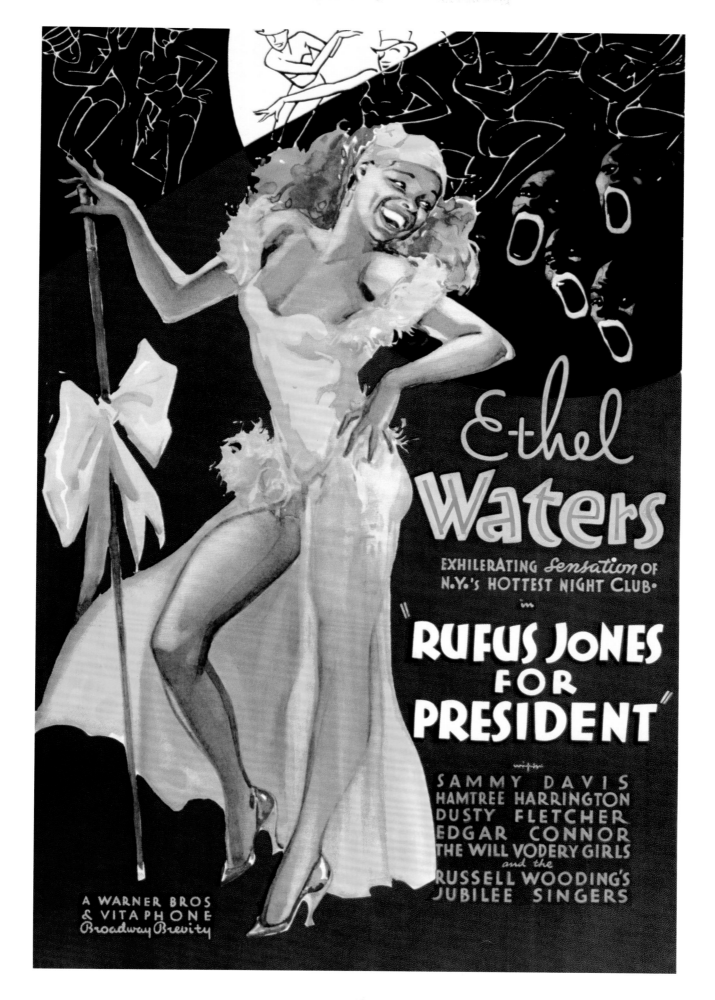

Paul Robeson

Paul Robeson was the epitome of the twentieth century renaissance man: an exceptional athlete, actor, singer, cultural scholar, author, and political activist whose talents caused him to be revered in his own lifetime. But his progressive political beliefs, which were at the core of everything he did, proved to be so unpopular with the establishment that for many years he was all but erased from popular history.

Born in 1898, Robeson grew up in Princeton, New Jersey. At the age of seventeen, he was given a scholarship to Rutgers University, where he excelled in the classroom and on the sports field, winning selection to the All-American football team of 1918. After graduating, he received a second degree in law from Columbia University. Instead of practicing in his chosen field, however, Robeson made the decision to embark on a stage and concert hall career, trading on his powerful singing voice and dramatic flair, and entering a profession where blacks had already achieved a level of acceptance during the Harlem Renaissance.

Robeson became one of the first African-American men to perform serious roles in the primarily white theater of the 1920s and 30s. He took the lead role in Eugene O'Neill's *All God's Chillun Got Wings* (1924) and *The Emperor Jones* (1925), while his *Othello* became the longest-running Shakespearian production in the history of Broadway. With a baritone voice as deep as a well, songs such as his trademark "Ol' Man River" helped to make him one of the most popular concert singers of his era. He also performed in a dozen films, including Oscar Micheaux's *Body and Soul* (1925), *The Emperor Jones* (1933), *Song of Freedom* (1936), *Show Boat* (1936), and *The Proud Valley* (1940).

His renown increased and spread around the world, thanks to his habit of performing charitable and political benefit concerts for causes relating to social justice. In a time of deeply entrenched racism, he continually stressed racial brotherhood and cultural understanding. At the height of his popularity, Robeson was both a national symbol and a leader in the struggles against fascism abroad and racism at home. This brought him admiration from many, but it also made him enemies among conservatives trying to maintain the status quo.

During the 1940s, Robeson's activities and pro-Soviet stance came to the attention of political demagogue Senator Joseph McCarthy, who singled him out as a major threat to American democracy. Attempts to silence and discredit him reached a climax in 1950, when the US State Department revoked his passport. No longer able to travel abroad to perform, Robeson's career was stifled.

It is one of the many ironies of this era that in 1956, the year when Robeson was subpoenaed to appear before the House Un-American Activities Committee, another African-American hero emerged to pick up his reins. The US ruling class who hoped to suppress Robeson and his ideals were now forced to deal with another fearless voice for freedom, as Martin Luther King Jr. deeply involved himself in the boycott of the Montgomery, Alabama, bus system.

It would be eight years before Robeson was free to travel again. With his wife, Essie, he left for Europe to revitalize his career, starting with a British concert tour, followed by further trips to the Soviet Union and Australia, where he was showered with awards and played to packed houses. After five years abroad, and in declining health, Robeson returned to New York in December 1963. Essie died five years later, and Robeson retired to Philadelphia, where he lived with his older sister Marian in virtual seclusion until his own death in 1976.

Even to this day, Paul Robeson's many accomplishments are often obscured by the propaganda of those who tirelessly pursued him throughout his life. He should be remembered for his role in the history of civil rights, his courage, and the dignity with which he struggled for his voice to be heard and the freedom of all peoples to be recognized.

Opposite: **PAUL ROBESON (1936)**

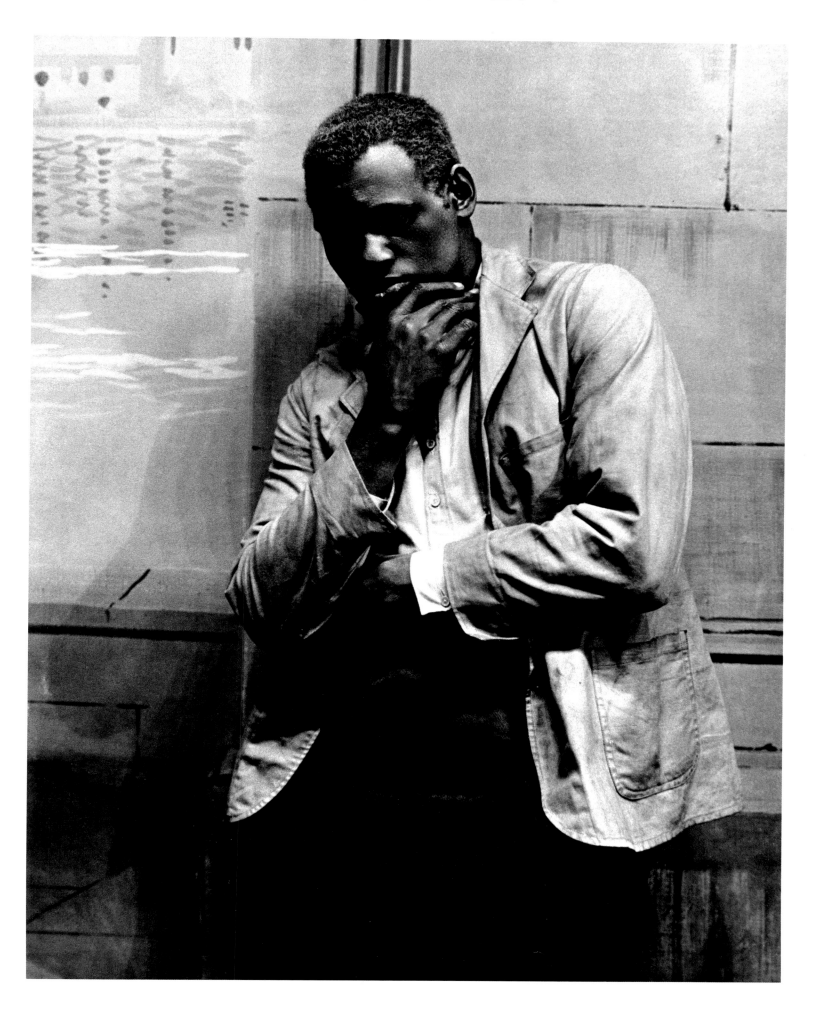

Paul Robeson

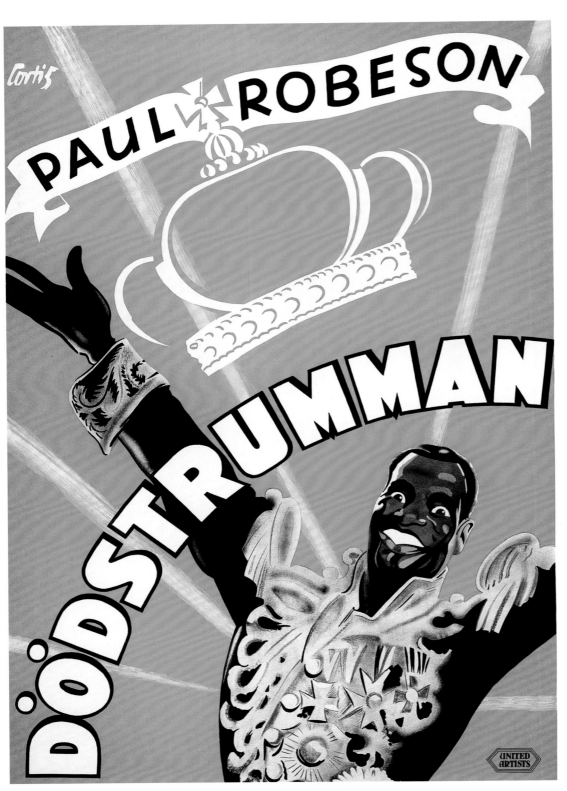

The Emperor Jones (1933) was a critically acclaimed film based on Eugene O'Neill's play, which was one of the first important attempts by a white writer to deal with black characters in a serious drama. Robeson successfully recreated his stage role as anti-hero Brutus Jones, an American ex-Pullman porter, who by sheer nerve manages to become the emperor of a tropical island, where he installs a dictatorship, and is finally killed by the natives. A commanding black character who is the intellectual and social equal of whites, Jones did not fall into the traditional stereotypes of the comic servant or the naive buffoon. Robeson's nuanced portrayal of the character remains among his most memorable screen performances. According to black film historian Donald Bogle, actress Fredi Washington had to wear heavy makeup to darken her naturally fair complexion, as the producers were concerned that otherwise Robeson might seem to be playing a romantic scene opposite a white actress.

Sadly, the success of Robeson's performance in The Emperor Jones did not guarantee him other parts with the same substance or sense of majesty. Later films such as Sanders of the River (1935), Jericho (1937), Song of Freedom (1936), and King Solomon's Mines (1937) returned him to similarly exotic locales, but effectively found him typecast in productions that were at best limited and at worst blatantly racist.

Robeson accepted some of these roles in the hope that they might foster awareness of racial folk motifs, including native songs and dances, but the films were disappointingly formulaic and even imperialistic. Like other actors and activists, his hopes of engendering major changes in the industry were, for the most part, frustrated.

Left: **THE EMPEROR JONES (1933), Swedish**
Opposite: **THE EMPEROR JONES (1933)**

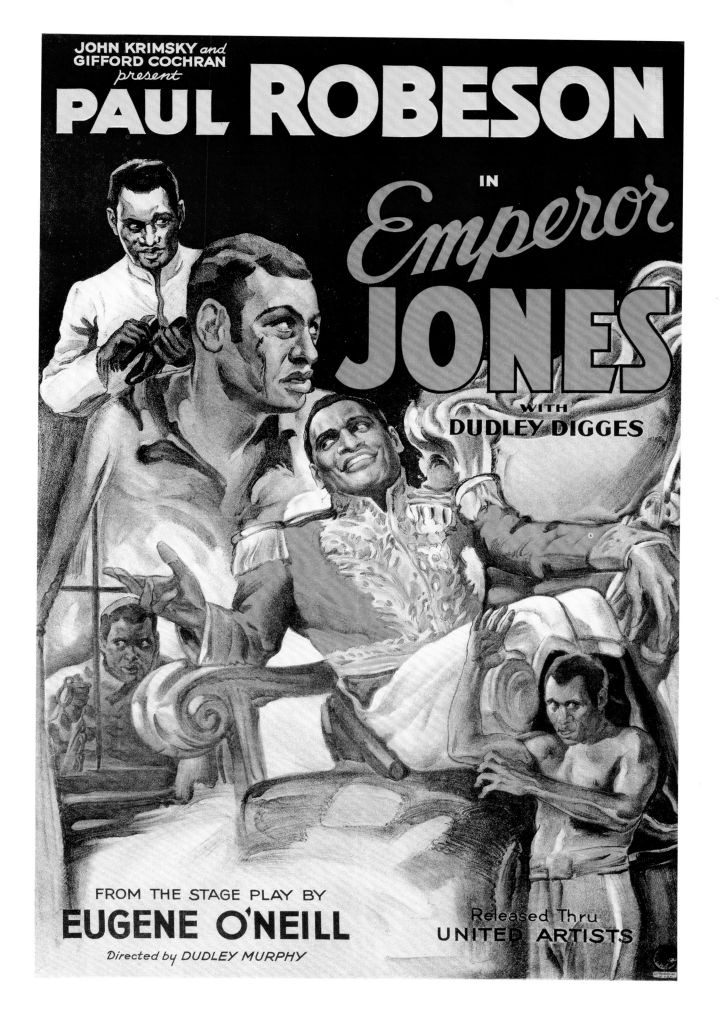

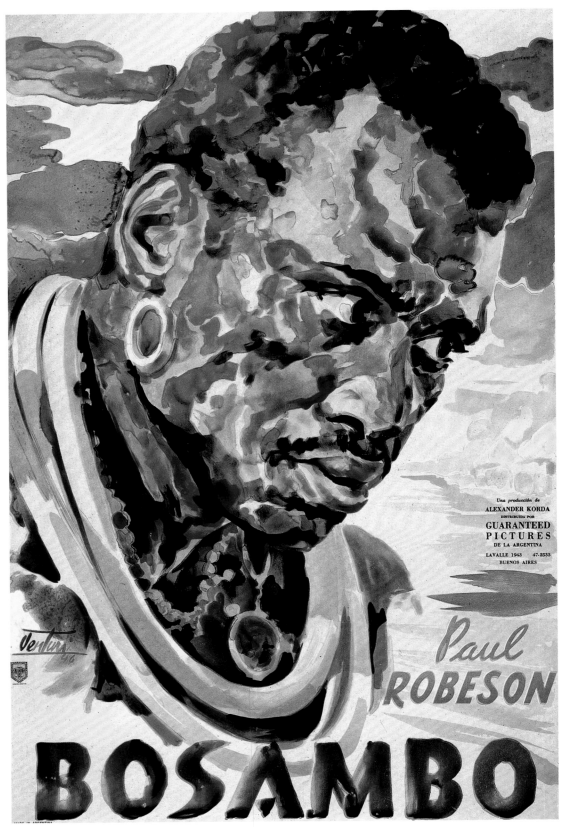

Una producción de
ALEXANDER KORDA
DISTRIBUIDA POR
**GUARANTEED
PICTURES**
DE LA ARGENTINA
LAVALLE 1943 47-2533
BUENOS AIRES

Paul
ROBESON

BOSAMBO

As a concert singer, Paul Robeson achieved extraordinary popularity in Britain, and the same may be said of the films he made there between 1935 and 1939. Each portrayed Robeson as the dignified, intelligent central character and as an accepted member of the British community.

The main exception was the unfortunate role of Bosambo in *Sanders of the River* (1935). In other territories, the film was retitled in honor of Robeson's character, the posters suggesting that he was the hero of the story. But there were no such intentions on the part of the filmmakers Zoltan and Alexander Korda, who seem to have set out to make a paean to the British civil servant.

Bosambo is a black chief employed as a tool by Sanders, the white District Commissioner in N'Gombi, Nigeria, to keep the native African tribes under British dominance. From the start, the stature of the two leading roles is made obvious: Bosambo addresses Sanders throughout as "Lord," as if to confirm the white man's eternal supremacy. Much of the film was shot on location in Africa, and the opening scenes show authentic native drumming and chanting, in which Paul Robeson's voice can gradually be distinguished above the others. But the narrative shows the black men of Africa as unruly and untrustworthy, and it takes the intervention of Sanders and a few of his white officers to quell a violent uprising with a few pistol shots and an upper-class British accent.

Robeson was bitterly disillusioned by the final edit of the film, which presented Bosambo as nothing more than a loyal servant of the white man. He protested about its paternalistic racism and unflinching support of colonialism. But despite the fact that he had disowned it, he was still criticized by the outspoken Jamaican nationalist leader Marcus Garvey for "pleasing England by the gross slander and libel of the Negro." Robeson continued to believe that the British film industry had something to offer him, however, and acted there for several more years.

Left: **SANDERS OF THE RIVER (1935), Argentinian**
Opposite: **SANDERS OF THE RIVER (1935), Swedish**

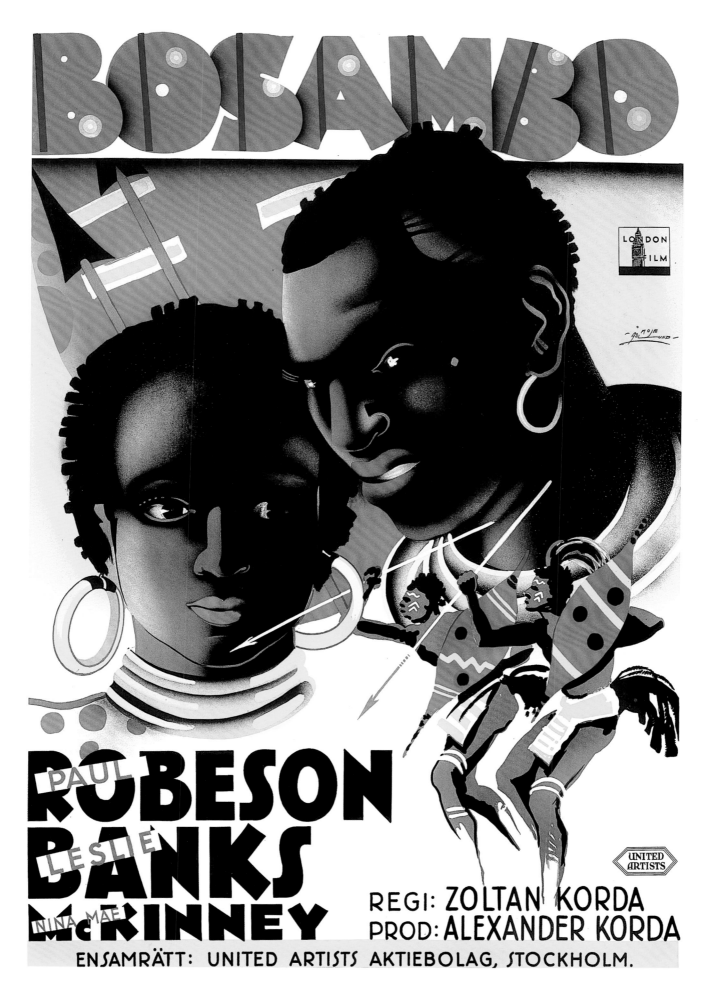

Big Fella (1937) certainly didn't resort to the crude racial stereotyping of *Sanders of the River*. But despite the fact that it was constructed around elements of *Banjo*, a novel by Claude McKay, one of the leading writers of the Harlem Renaissance, the film's narrative has very little to recommend it. It's a simple tale of a Marseille dockhand who is enlisted by the police to help solve the kidnapping of a young English boy. The entire movie was filmed at a studio near London, and then filled out with stock footage of the French city in a vain attempt to provide the requisite atmosphere. It is not surprising that it was given only the most limited release in the United States.

What saves the film for the viewer is the consistent use of music to break up the rather formulaic plot. Both Robeson and his co-star Elisabeth Welch are featured, with Robeson's wonderfully laid-back rendition of "Lazin'" opening the proceedings. His other songs include "River Steals My Folks from Me," "You Didn't Ought to Do Such Things," and "Roll Up Sailorman."

Big Fella also included a rare screen performance by Robeson's wife, Eslanda, quelling media speculation that he was actually married to a fellow black star, such as Elisabeth Welch or Nina Mae McKinney. Mrs. Robeson played the role of a café proprietor, and was also seen briefly in two other Robeson vehicles, *Borderline* (1930) and *Jericho* (1937).

The Proud Valley (1940) became the last of the seven films Robeson made in Britain. He plays the endearing and heroic David Goliath, an American sailor who hops a train and finds work as a coal miner in South Wales. Owing much to Robeson's commanding baritone voice, one of the film's highlights involves a national chorus competition in which the town choir of miners performs "Deep River" with Robeson as the lead soloist. In a tragic and untimely ending, Goliath puts his life on the line to save workers trapped in a mine tunnel. Because the film reflected Robeson's own political beliefs and interest in working-class solidarity, he found the project his most rewarding experience, "It was the one film I could be proud of having played in," he later said.

Hoping to participate in more socially progressive films and stage productions, Robeson returned to America. However, after appearing in *Tales of Manhattan* in 1942, Robeson decided to quit making movies, disgusted by the stereotypes imposed by Hollywood—in this instance, with the portrayal of rural blacks. He denounced the film, and never acted onscreen again.

Left: **THE PROUD VALLEY (1940), Russian**
Opposite: **BIG FELLA (1937), British**

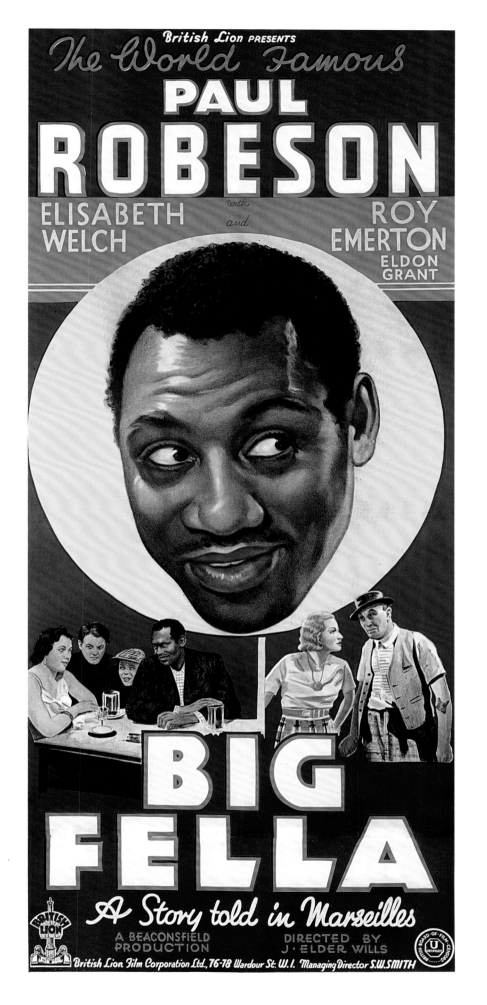

Louise Beavers

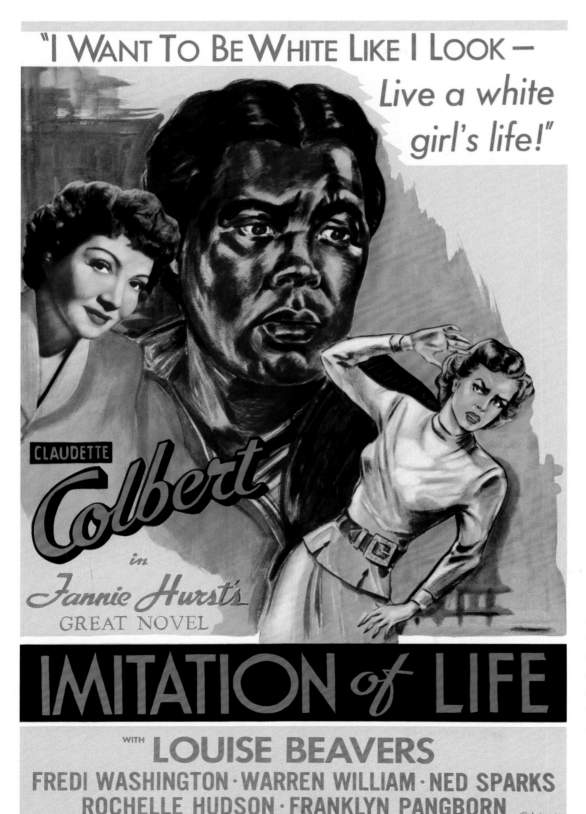

"I WANT TO BE WHITE LIKE I LOOK — Live a white girl's life!"

CLAUDETTE **Colbert**

in

Fannie Hurst's GREAT NOVEL

IMITATION *of* LIFE

WITH **LOUISE BEAVERS**
FREDI WASHINGTON · WARREN WILLIAM · NED SPARKS
ROCHELLE HUDSON · FRANKLYN PANGBORN

A JOHN M. STAHL production

Typecast throughout her entire career in film and on television as a good-natured domestic, Louise Beavers symbolized black advancement in the cinema world and racial pride off-screen. As film historian Donald Bogle explains, Beavers came to epitomize the lovable, loyal, overweight "Mammy" figure seemingly capable of taking on all the troubles of the world.

Of her more than 150 movie appearances, she is probably best remembered for her co-starring role as Delilah in the first important black-oriented film made by a Hollywood studio in the 1930s, *Imitation of Life* (1934). This was a decade when a new social consciousness infiltrated the motion picture industry, and many of the clichés of the past were being discarded. The film prided itself on its portrait of the modern black woman, still a servant, but now treated with dignity and respect. It was the only studio film of its time to address, or even suggest, that there was a race problem in America. No other Hollywood picture so poignantly affected or unknowingly hit a nerve within the African-American community.

For her role, Beavers should have received an Oscar nod from the Academy. That precedent was still five years away from being set, however, with Hattie McDaniel's Best Supporting Actress win for the 1939 film *Gone with the Wind*. Despite her unparalleled performance, Beavers was omitted from the original advertising campaign to promote *Imitation of Life*. It wasn't until the early 1940s—after McDaniel's historic Oscar win—that Beavers appeared prominently on a Realart Pictures poster for the film's re-release in theaters.

Though Beavers was the most prominent African-American actress during the first decade of sound films, she did not receive top billing in the films in which she appeared—at least not until *Life Goes On* (1938) and *Reform School* (1939), two all-black-cast race films—a stark reminder of the difficulties African-American actors faced in the early days of Hollywood when the only roles available to them were supporting rather than starring.

Left: **IMITATION OF LIFE (1934), Re-release 1949**
Opposite: **LIFE GOES ON (1938)**

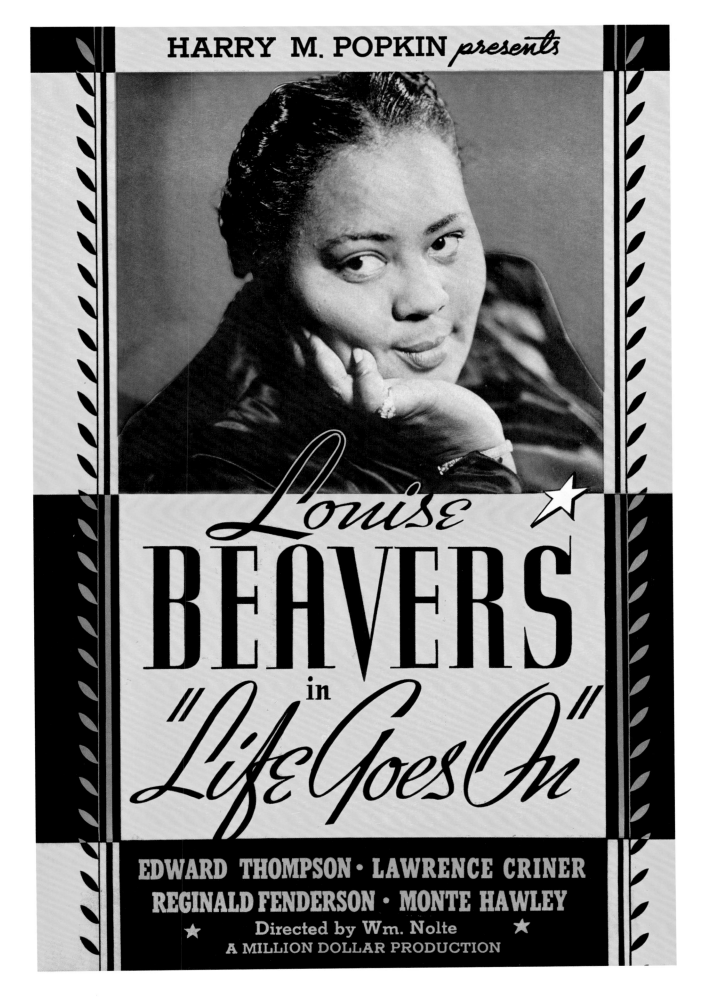

Bill Robinson

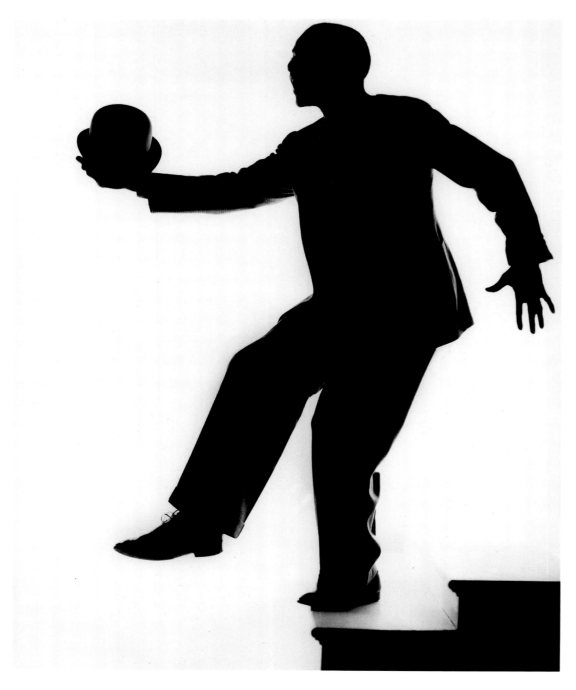

Bill Robinson was the premier African-American tap dancer of the twentieth century, who influenced generations of dancers by presenting his skills as an art form.

Born in 1878 in Richmond, Virginia, Luther Robinson learned to dance in the streets as a child and it was there that he adopted the nickname "Bojangles." By the turn of the century he had danced his way up through the ranks of white vaudeville and won a coveted spot at Broadway's legendary Palace Theatre, where he was billed as the "World's Greatest Tap Dancer," a title he would defend in formal stage competitions dozens of times. His famous "Stair Dance" was developed and first performed in 1918: an improvisational jazz-like composition of sounds with percussive syncopation emanating from his shoes as he effortlessly tapped over a five-step set of stairs.

His fame in Hollywood didn't come until the 1930s, when he was already in his fifties. His cinematic career saw him perform in several Hollywood films, including four paired with child star Shirley Temple. Although he was usually required to do nothing more than dance, Robinson occasionally found a meatier role, as in *One Mile from Heaven* (1937) or *Stormy Weather* (1943), where he played alongside two other legends of the era, Lena Horne and Cab Calloway.

Robinson only appeared in one independently produced race film, *Harlem Is Heaven* (1932); a story loosely woven around his own true-life experiences and that allowed him to showcase his "Stair Dance" to the tune of "Swanee River," accompanied by the piano of prominent ragtime performer Eubie Blake.

Left: HARLEM IS HEAVEN (1932), Bill Robinson
Opposite: HARLEM IS HEAVEN (1932)

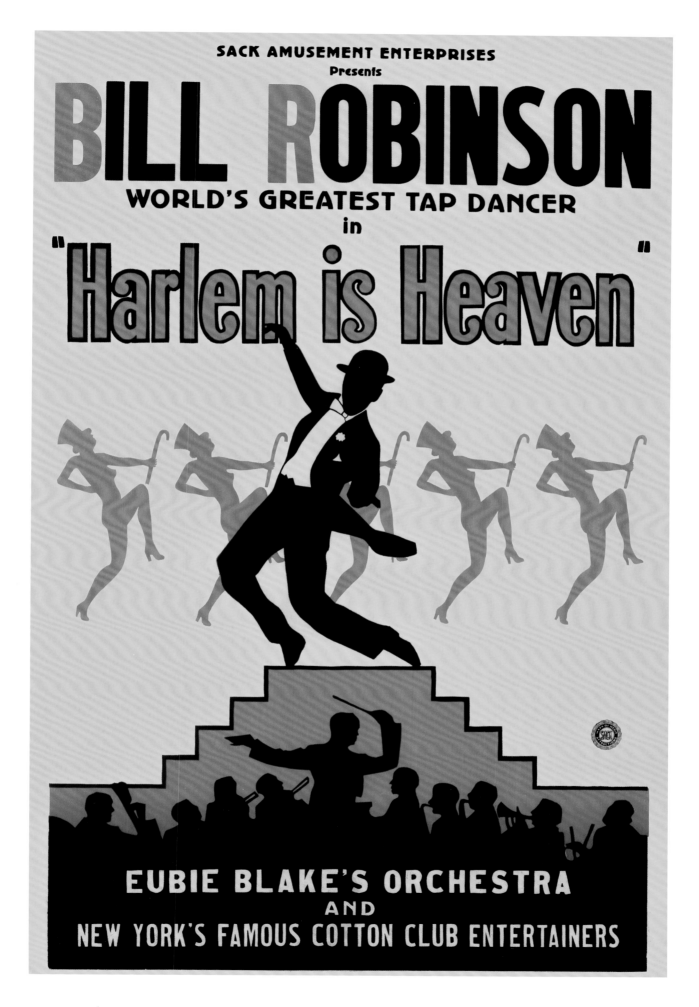

Rex Ingram

There were two major figures by the name of Rex Ingram who were active in the Hollywood community in the first half of the twentieth century: an Irish writer/director, and an African-American actor. The latter was the son of a fireman on the Mississippi River steamboat *Robert E. Lee*. He fought his way to a university education but chose to abandon an academic career after literally being discovered on a Hollywood street and offered a screen test, purely on the basis of his commanding looks and remarkable physique.

It was inevitable, perhaps, in the Hollywood of the 1920s, that he would be offered a strictly limited range of roles: an uncredited native in *Tarzan of the Apes* (1918) and *Salome* (1918); an Israelite slave in Cecil B. DeMille's 1923 epic, *The Ten Commandments*; then as an African "Fuzzy Wuzzy" fighter in *The Four Feathers* (1929).

His career took an unexpected turn for the better when he was offered the (unsurprisingly) huge role of "De Lawd" (and several other parts in the same picture) in *The Green Pastures* (1936).

Thereafter he was under consideration for any movie role that required a non-white actor with a larger-than-life presence. He played the escaped slave, Jim, who accompanies the young hero on his Mississippi escapades in *The Adventures of Huckleberry Finn* (1939); and was then seen, blown up to gargantuan size in a loincloth, as the genie Djinn in *The Thief of Bagdad* (1940). He enjoyed another "giant" role in *A Thousand and One Nights* (1945) but was allowed to appear life-size

in *Cabin in the Sky* and *Sahara* (both made in 1943).

Much in demand as a narrator and voiceover artist in the 1940s, he was well cast in *Moonrise* (1948) as Mose, who sings a deep-voiced blues tune to the hero, a man who has accidentally committed a murder. But Rex Ingram's career was about to meet its greatest challenge. The following year, he was tried and convicted under the Mann Act for having accompanied an under-age girl (fifteen years old) across state borders— exactly the same crime for which rock 'n' roll pioneer Chuck Berry served time more than a decade later. Ingram was sentenced to eighteen months' imprisonment, though he was released after ten.

The resulting scandal effectively torpedoed his screen career. Hollywood ignored him, and for several years he was only able to gain bit parts in television dramas, for which his name was omitted from the credits. By the late 1950s, however, he had undergone some form of rehabilitation in the industry's eyes, and from then until his death in 1969 he picked up more notable roles on TV and on the big screen. Comedian Bill Cosby championed Ingram's cause in his final months, and despite being seriously ill, the actor roused himself from his sick bed for one last appearance on Cosby's networked television show.

Opposite: **REX INGRAM (1936)**

The Green Pastures

WARNER BROS. Pictures, Inc. Present

THE GREEN PASTURES

A FABLE BY MARC CONNELLY

DIRECTED · BY
MARC CONNELLY WILLIAM KEIGHLEY A WARNER BROS. PICTURE

Despite the mediocre box-office showing of *Hearts in Dixie* and *Hallelujah*, Warner Bros. took a chance on Hollywood's third all-black-cast musical, *The Green Pastures*, in 1936. Based on Marc Connelly's long-running Pulitzer Prize-winning play, it tells the story of Mr. Deshee, a kindly old black Sunday school teacher in Louisiana who makes the Bible stories come alive by transforming the biblical characters into contemporary men and women. The film included some of the finest actors of the day: Rex Ingram as De Lawd, a patriarchal Jehovah who dresses like a Southern gentleman; Eddie Anderson as Noah, a good man who finds it hard to resist a taste of tobacco and alcohol; Oscar Polk as Archangel Gabriel; and Ernest Whitman as the sadistic Pharaoh.

By playing multiple roles, the actors created a clever continuity within the stories: Ingram, for example, appeared not only as De Lawd but also as Adam and Hezdrel, while the children in Mr. Deshee's class doubled as heavenly cherubs serenaded by the spirituals of the famous Hall Johnson Choir.

While the white press unanimously hailed the film as a sublime and heartbreaking masterpiece of American folk drama, black audiences rejected its demeaning and stereotypical racial portrayals. Nonetheless, *The Green Pastures* was enormously popular; on opening day at Radio City Music Hall in New York, tickets sold at the rate of six thousand per hour. Held over for an entire year's run at some theaters, the picture went on to become one of the most successful black-cast films of all time.

Above: THE GREEN PASTURES (1936)
Opposite: THE GREEN PASTURES (1936), Swedish

Left and opposite: **THE GREEN PASTURES (1936),**
Promotional Stills

Stereotypes

Where you have prejudice, you will also find caricature—a way of reducing the people you dislike to stereotypes, which can be kindly but still patronizing (like the endless portraits in Hollywood films of buxom "Negro mammas") or violently crude (like the equation of Jews and rats in the Nazi propaganda films of the 1930s).

Outside the work of overtly racist right wing organizations such as the Ku Klux Klan, and after the rampant racial bias of D. W. Griffith in *The Birth of a Nation*, the American film industry would undoubtedly have claimed that their racial stereotypes of blacks were intended to be comic, at worst, and endearing. Yet that didn't make them any easier to stomach by those who found themselves at the wrong end of the caricaturing process.

One generation's stereotype often becomes the next generation's racial attack—a prime example being the decorative lawn jockey in the US, or the children's toy the golliwog, which was a normal part of British family life all the way into the 1970s. It's quite probable that most white filmgoers in the 1930s, 40s and 50s didn't notice that any stereotypes were being employed. But what once passed as acceptable strikes us today as outrageously offensive.

As an art form that already depends on caricature, animation lends itself to depictions of people that pass beyond the humorous and slip into the gratuitously cruel. The *Tom and Jerry* cartoons created mid-century by William Hanna and Joseph Barbera for MGM have delighted generations of children. But many of them feature the stereotypical figure of an African-American maid, usually only seen as a mountain of flesh with a screeching voice. You can find the archetype of that portrayal in the 1935 animation *Little Black Sambo*, based on an 1899 story by Helen Bannerman, which became so popular that the name of its boy hero was transformed into a nickname regularly applied to anyone of African or Caribbean origin. Even in cartoon terms, the "mamma" in this film is drawn in such extreme fashion that she is barely recognizable as human. "That tiger sure do like dark meat," she warns her son Sambo, shortly before he goes out to confront the big cat—and turns into a white boy through sheer fright.

Fifteen years later, the "mamma" character was absent when Tom the cat and Jerry the mouse were shipwrecked on a desert island in *His Mouse Friday* (1951). Yet the stereotypes were still close at hand, in the shape of cannibals with bones in their hair. To frighten his archenemy, Jerry dons blackface and mimics the exaggeratedly "Negro" voice of the cannibals. More recent releases of this film on DVD have snipped out some of the most outlandish sequences, and also removed all the film's caricatured dialogue.

Bosco was a young black boy—drawn more to resemble a monkey than a human—who was the star of more than three dozen short cartoons in Warner Bros.' *Looney Tunes* series. Did children recognize Bosco and his chums as racial stereotypes? Probably not in the 1930s, but that message appears screamingly obvious today, with fatal results to the series' reputation.

The pioneering novel *Uncle Tom's Cabin*, by Harriet Beecher Stowe, inevitably found itself being used as the basis of stereotype-heavy animations. After a 1930 cartoon in the *Jungle Jinks* series that portrayed most of the characters in the guise of blacked-up minstrels, there was a 1947 adaptation by animator Tex Avery, called *Uncle Tom's Cabana*. This is deemed by many to be among Avery's finest work, and it was clearly not intended to be racist in content. Liberties taken with the original story permitted Uncle Tom to be run over with a steamroller and cut in half with a sawmill blade. Finally, in a moment of uncharacteristic militancy, Tom hurled Simon Legree (a vicious slave-owner in the original book) into outer space tied to the Empire State Building. The message may have been progressive, but as the poster illustrates, the drawing of Tom betrayed a century of prejudice.

The easy dissemination of racial stereotypes was not limited to animated cartoons. *Shoe Shine Boy* (1943) was a fifteen-minute MGM short starring Melvin Bryant, in a tale of a young man desperately trying to earn enough money shining shoes to purchase a trumpet for his first day in the US Army. The film may have been tame enough in the day, but the poster slipped over the borderline between caricature and stereotype.

On the surface, the *Our Gang* series of comedies, starring the kids known as The Little Rascals, were a beacon of American liberalism. A staple of movie houses and TV screens for more than fifty years, they featured a racially mixed group of neighborhood children who found themselves in humorous predicaments as they played mischievous pranks with their pals. The series was launched by Hollywood producer Hal Roach in 1922, and featured the children simply acting as children, regardless of their racial background. Their humor was merely a by-product of the everyday situations that they confronted.

That didn't save The Little Rascals from racist set-ups, however. The most notorious offender was *The Kid from Borneo* (1933)—made worse by the identity of the man playing the ultra-stereotypical role of Bumbo, "The Wild Man From Borneo," complete with a nose-bone and a sweet tooth for candy. He was none other than John Lester Johnson, a boxer who famously beat the legendary Jack Dempsey, breaking three of the future champion's ribs. This 1916 contest is believed to have been part of the first integrated professional boxing event, at the Harlem Sporting Club. Johnson was denied a shot at the championship because of his color, however, and after he retired he helped to support himself by taking bit parts in motion pictures. *The Kid from Borneo* was his solitary leading role, and it required him to dress up as the stereotypical jungle native, half animal, half man. The humor of the film depended on Bumbo and his addiction to candy: as soon as he saw some, he would mutter the only English phrase he knew, in a low, growling voice: "Yum yum! Eat 'em up!" So the children predictably assumed he was a cannibal, and much period humor ensued. From this distance, Johnson's role seems painfully demeaning: scant reward for a career of courage in the ring. Yet *The Kid from Borneo* also offers some consolation: we, and Hollywood, have come a long way from the time when it was considered utterly normal for black actors to have to lower themselves in that way. Stereotypes are far from dead, but the era when one race would nakedly impose these caricatures on another has gone.

Opposite: **SHOE SHINE BOY (1943)**

Left: **LITTLE BLACK SAMBO (1935); HIS MOUSE FRIDAY (1951); BOSCO (1933); UNCLE TOM'S CABANA (1947)**
Opposite: **THE KID FROM BORNEO (1933)**

Mantan Moreland

Mantan Moreland's prolific career spanned over 150 films during the 1930s and 40s. He came to Hollywood in 1935, as many black actors did, via the minstrel show and vaudeville "chitlin' circuit," where he performed and perfected his "indefinite talk" routine with his partner Ben Carter, which required each comic to finish the sentence of the other without allowing the conversation to actually end. The act required quick delivery and perfect timing between the two. Moreland's extreme popularity earned him offers to appear in a number of independent all-black-cast race films such as *Harlem on the Prairie* (1937), *One Dark Night* (1939), *Four Shall Die* (1941), and in dozens of other grade-B productions in Poverty Row studios like Monogram.

Audiences remember Moreland best as Birmingham Brown, the eye-popping, superstitious, and easily frightened chauffeur to the Chinese detective Charlie Chan in fifteen of the film series' installments between 1944 and 1949. His signature line,

"Feets, don't fail me now!" highlighted every picture as he fled from even the slightest sign of danger.

By 1950, however, many African Americans felt embarrassed by Moreland's buffoonish clowning on screen. It was, after all, a post-war era, as Hollywood had begun to earnestly present a new and more positive image of blacks in film. Ultimately, Moreland denounced his stereotypical roles, and in 1956 tried to revive his struggling career in an all-black-cast Broadway production of *Waiting for Godot*. But by the mid 1960s, ill health began to plague him. He made a few cameo appearances in film and TV, including a small role in Melvin Van Peebles' *Watermelon Man*, before passing away in 1973.

Above: BLACK MAGIC (1944), British
Opposite: MANTAN MORELAND (1944)

Herb Jeffrey

It would be easy to read the small print on film posters and record labels and imagine that the singing cowboy of the late 1930s and the star vocalist on some of the Duke Ellington Orchestra's biggest hits were, by coincidence, near namesakes. But the actor Herb Jeffrey and the singer Herb Jeffries were, in fact, one and the same man. He performed with Earl Hines, Erskine Tate, and Blanche Calloway in the early 1930s, then concentrated for several years on his acting career, before joining Ellington's band at the height of its powers in 1940. He appeared on two best-selling singles, "You You Darlin'" and "Flamingo," then left to concentrate on a solo career. He remained an active club singer, making occasional recordings of ballads, standards, and western tunes, into the mid 1990s.

He was also the star of four late-1930s all-black-cast westerns. Before the "talkie" era began in the late 1920s, there had already been several all-black westerns made by the Norman studio. Recognizing the growing popularity of westerns featuring white singing cowboys such as Gene Autry with white and black audiences alike, Hollywood producer/director Jed Buell cast Herb Jeffrey in *Harlem on the Prairie* (1937) and in the role of Bob Blake in *The Bronze Buckaroo* (1938), *Two-Gun Man from Harlem* (1938), and *Harlem Rides the Range* (1939). Jeffrey was promoted as "The Sepia Singing Cowboy," although his background was more varied than that: born Umberto Alexander Valentino, he was half Irish, half mixed-race.

Left: **HERB JEFFREY (1941), with Jimmy Blanton**
Opposite: **THE BRONZE BUCKAROO (1938)**

Clarence Muse

GOLDPORT PICTURES

Presents

THE OUTSTANDING DRAMATIC STAR

CLARENCE MUSE

in

BROKEN STRINGS

WITH A 100 PER CENT ALL-STAR COLORED CAST

AN INTERNATIONAL ROAD SHOWS RELEASE

DIRECTED BY
BERNARD B. RAY

AN L.C. BORDEN PRODUCTION

Though Clarence Muse played demeaning subservient roles in most of his Hollywood films, he managed to avoid the animated "Uncle Tom" manner by maintaining a sense of dignity and self respect in his characters that other black actors at the time lacked. He was unafraid to criticize the barefaced stereotyping on behalf of the major studios, openly objecting to *Gone with the Wind* (1939), for example.

His stage training with the Lincoln Players and Lafayette Players Stock Company in Harlem led him to act in a more serious dramatic vein. Given the freedom, he had an uncanny ability to distinguish his characters by breathing realism and spirituality into the down-home family man persona he had been playing since *Hearts in Dixie* (1929). Other notable films in which Muse appeared during his fifty years in Hollywood were: *Huckleberry Finn* (1931); *So Red the Rose* (1935); *Spirit of Youth* (1938), with boxer Joe Louis; *Way Down South* (1939), for which he co-wrote the screenplay and songs with Harlem Renaissance poet Langston Hughes; *Invisible Ghost* (1941); *Porgy and Bess* (1959); *Buck and the Preacher* (1972); and *The Black Stallion* (1979), his final film.

Muse himself co-wrote the script for *Broken Strings* (1940)—an independently produced all-black-cast drama in which he stars as a dignified concert violinist—with the specific intention of refuting Hollywood's offensive stereotypes. The *Pittsburgh Courier* quoted him as saying, "I simply wish to tell the truth about our race during the early days." It was arguably his finest role.

Muse's respect for African-American history was also apparent in his starring role in *The Peanut Man* (1947), a biographical drama on the life of George Washington Carver, whose experiments with peanuts led him to develop hundreds of uses for the crop, while increasing the efficiency of farming techniques.

Left: **BROKEN STRINGS (1940)**
Opposite: **THE PEANUT MAN (1947)**

TONY PATON Presents **CLARENCE MUSE** as DR. GEORGE WASHINGTON CARVER in THE PEANUT MAN

WITH ERNEST ANDERSON AND AN ALL STAR CAST

FIRST COLORED FEATURE FILM IN GLORIOUS NATURAL COLORS

Lena Horne

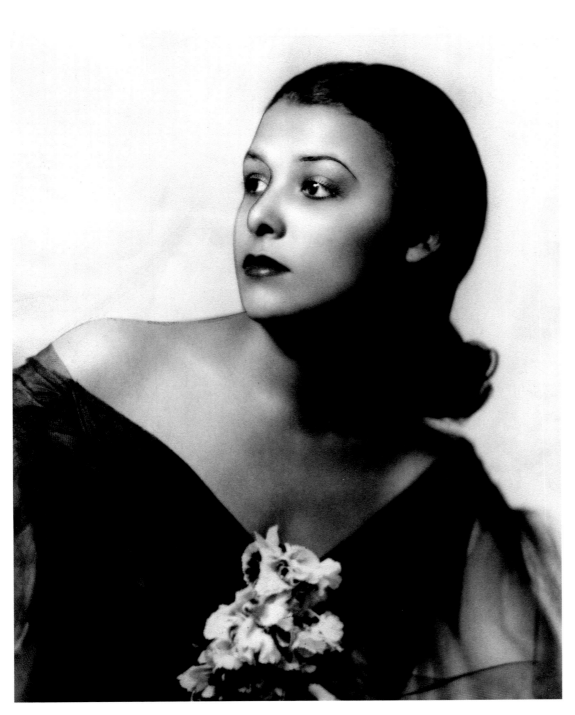

In the fall of 1933, Lena Mary Calhoun Horne began her show business career in the chorus line at the Cotton Club. By the mid 1930s, her singing career had blossomed and she toured with Noble Sissle's Society Orchestra under the more refined name Helena Horne. After years of working clubs, fronting bands, minor film and stage work, her big break came in 1942, when she became the first black female performer to earn a long-term movie contract with a major studio (MGM). Though she became the first black woman to be fully glamorized and publicized by her studio, she didn't always receive star treatment, as her screen appearances were often marginalized with an isolated song or two having nothing to do with the plotline. When the studio felt that her scenes might offend Southern audiences unable to accept a beautiful black woman in romantic, non-menial roles, her sequences were simply cut.

In 1943, Horne was brought to national attention for her lead roles in two all-black-cast Hollywood musicals, *Cabin in the Sky* and *Stormy Weather*. Her success inspired distributor Ted Toddy to dust off the reels of his 1938 low-budget film, *The Duke is Tops*, an independently produced race film for segregated audiences that gave a (then) twenty-one-year-old Horne her first opportunity to appear on the big screen. Toddy elected to re-release the film in the wake of Horne's new exposure to a much wider audience, retitleing it *The Bronze Venus* and, as the poster confirms, emphasizing her role above all of her fellow cast members.

Horne's small list of movie credits certainly doesn't reflect her stature as an entertainer, which brought her several Grammy awards, and a stellar career on record, television, and in live performance.

Left: LENA HORNE (1936)
Opposite: THE BRONZE VENUS (aka THE DUKE IS TOPS, 1938), Re-release 1943

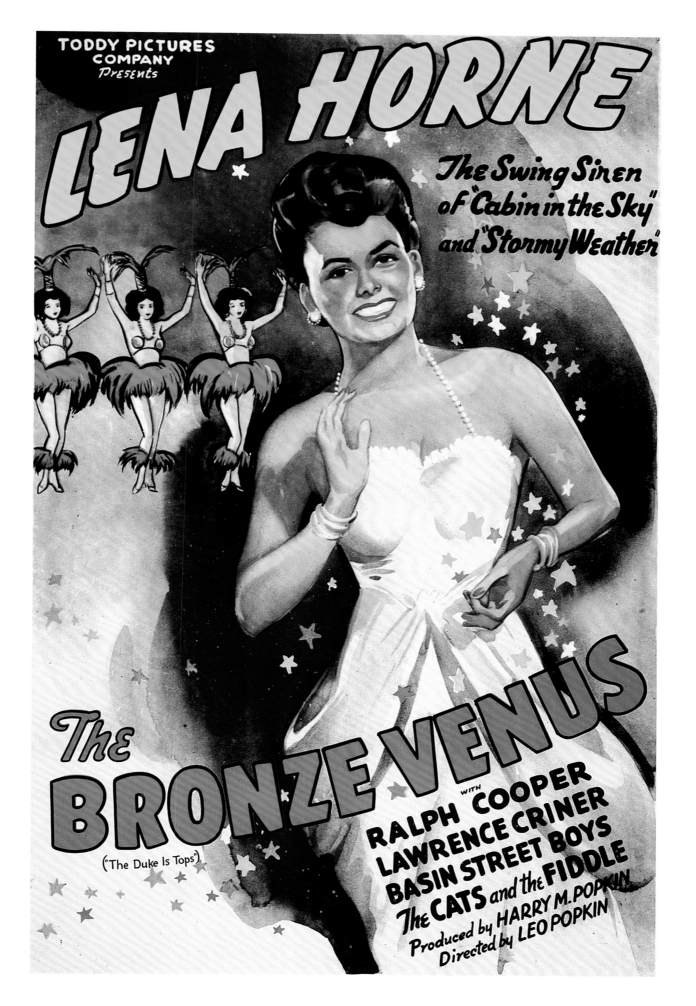

Cabin in the Sky

Providing a much-needed escape for African-American movie audiences during World War II, this Vincente Minnelli film (his first directorial role for MGM) was an exceptional all-star musical fantasy and morality tale about the eternal struggle of a man caught in a tug of war between heaven and hell. Based on a show that had already proved its commercial appeal on Broadway, it won the heart of *New York Times*' critic Brooks Atkinson, who declared that it was impossible to imagine how the play could have been improved, and called it "original and joyous … [It is] the peer of any musical in recent years." This convinced MGM to finance their first all-black production in nearly fourteen years.

The action was played out in a *Wizard of Oz*-style dream that comes to Little Joe Jackson (Eddie "Rochester" Anderson) while he lies unconscious from a wound he suffered while gambling at Jim Henry's Paradise Café. Good and evil take on human form and compete for Little Joe's favor. He is torn between the loyalty of his good Christian wife Petunia (Ethel Waters), and the temptations of the adulterous hussy Georgia Brown (Lena Horne). Added to the cast are a treasure trove of talent, including Rex Ingram, Mantan Moreland, John "Bubbles" Sublett, Willie Best, Kenneth Spencer, Oscar Polk, Ford Washington Lee, Butterfly McQueen, Ernest Whitman, Nick Stewart, and Ruby Dandridge; with featured musical numbers by the Hall Johnson Choir, Louis Armstrong, and the Duke Ellington Orchestra.

The grand struggle for Little Joe's soul takes place between the forces of Satan, represented by Lucifer Jr. (Rex Ingram), and God's General (Kenneth Spencer). Joe is given six months to redeem himself and ensure entrance to the "Cabin in the Sky"; and, with Petunia's help and prayers, he succeeds.

The film included lively musical sequences with choral arrangements by Hall Johnson, as in the opening sequence. Unlike the makers of the earlier *Hallelujah* and *The Green Pastures*, *Cabin in the Sky* did not claim to be presenting a peculiarly African-American religious perspective. Instead, Vincente Minnelli and the screenwriters relied on the structure of fables and fantasies to point to universal human issues. As the film's "foreword" noted, "The folklore of America has origins in all lands, all races, all colors."

In general, the response from both black and white critics was favorable, while black audiences recognized Minnelli's lighthearted and sympathetic portrait of a small African-American community. At the same time, the fact that the film was released in a period of heightened concern about screen images of African Americans dampened enthusiasm for the production slightly. *Cabin in the Sky* hit theaters one year after the NAACP's Walter White's call for more varied and realistic representations of African Americans in Hollywood movies. In many people's eyes, the film's use of the commonplace black religious setting failed to lift it beyond the concerns of previous movies in a similar vein.

There was another issue for the film to overcome. It undoubtedly provided welcome entertainment for American audiences during World War II. But some African Americans worried that the concentration on fantasy would overshadow their real contribution to the war effort overseas, and also subtly undermine their struggle for victory against racism at home.

The poster used to promote the film in the US was designed by one of the most important and influential caricaturists of the twentieth century: Al Hirschfeld (1903-2003). His skill in creating the most incisive satirical portraits using the simplest of lines remains unparalleled, and he was a true genius of his art.

An artist of considerable prestige was also responsible for the posters for the Italian release of *Cabin in the Sky*: Ercole Brini (1913-1989). He was predominantly known for his distinctive watercolor style, which often revealed the delicate emotions that lay beneath the surface of characters' faces. This film aside, he is most renowned for his poster for the 1948 release *Ladri di biciclette* (better known to English-speaking audiences as *Bicycle Thieves*), and five Paramount movies starring Audrey Hepburn.

Top composers from Tin Pan Alley contributed to the film's soundtrack, notably Harold Arlen and Yip Harburg. Their "Happiness Is A Thing Called Joe," performed in the movie by Ethel Waters, was nominated for an Academy Award. Meanwhile, jazz fans still treasure the performances by Armstrong, Ellington, and their orchestras—including Mercer Ellington's memorable composition, "Things Ain't What They Used To Be." On every artistic level, *Cabin in the Sky* was a landmark in American motion picture history.

Opposite: **CABIN IN THE SKY (1943)**

ETHEL WATERS · EDDIE "ROCHESTER" ANDERSON · LENA HORNE

DUE CUORI IN CIELO

(CABIN IN THE SKY)

con LOUIS ARMSTRONG · REX INGRAM · DUKE ELLINGTON E LA SUA ORCHESTRA · IL CORO DI HALL JOHNSON
SCENEGGIATURA DI JOSEPH SCHRANK · DIRETTO DA VINCENTE MINNELLI · PRODOTTO DA ARTHUR FREED

RIPALTA Industrie Grafiche - Milano - Via Antossi, 17 - 1959

AVVERTENZA

Left: CABIN IN THE SKY (1943), Italian
Opposite: CABIN IN THE SKY (1943), Swedish

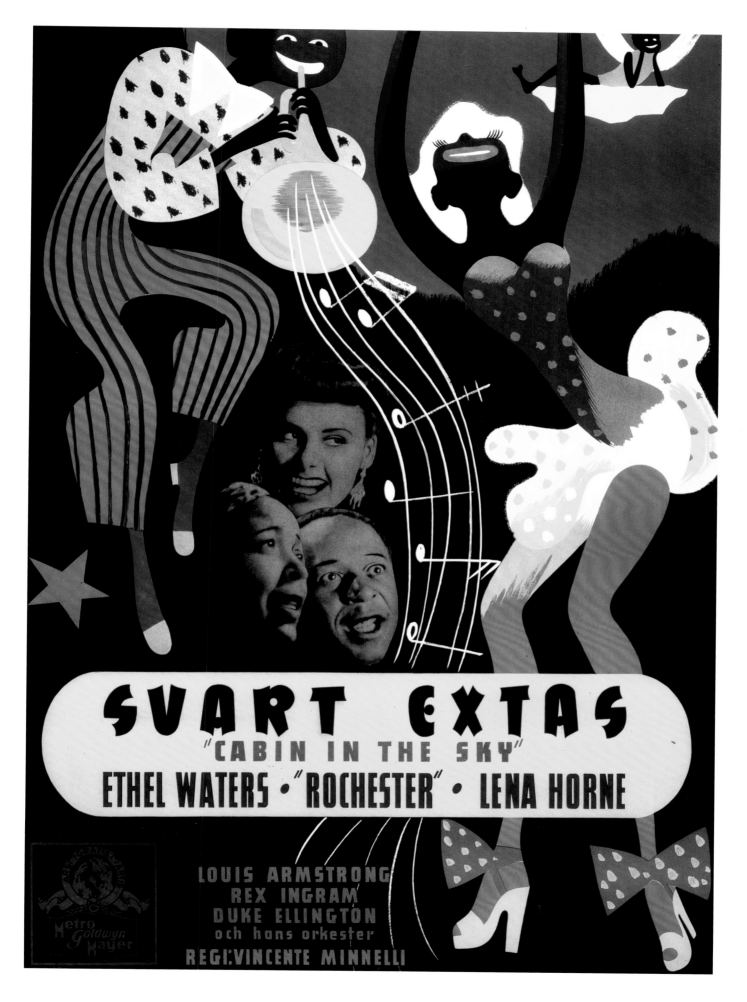

Stormy Weather

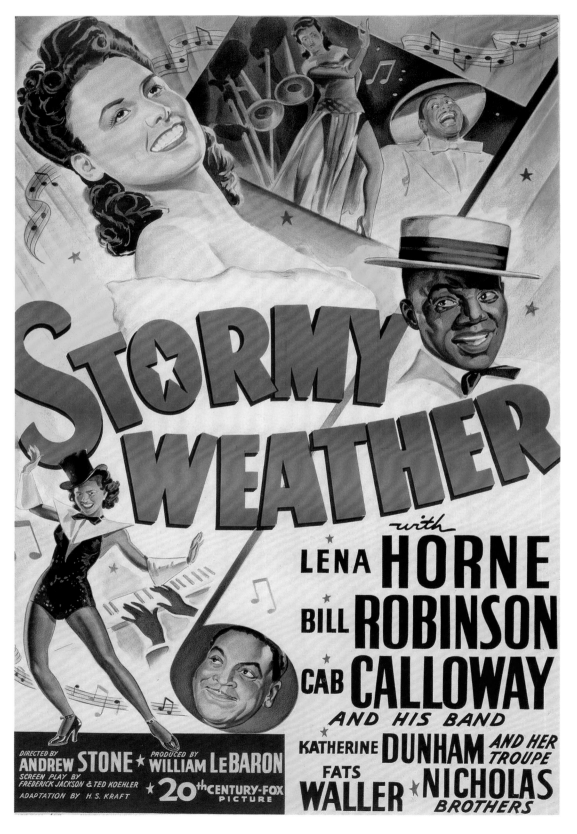

On July 21, 1943, only three months after MGM released the groundbreaking *Cabin in the Sky*, Twentieth Century Fox premiered another all-black, all-star musical that again celebrated the best of African-American entertainment. *Stormy Weather* was a lavish revue based on the memories of dancer Bill Williamson (played by tap dancing icon Bill "Bojangles" Robinson) who, using flashbacks, relates to a group of admiring neighborhood children the story of his climb up the show business ladder, and his on-off romance with Selina Rogers (Lena Horne). The film's thin plot, disguised as a love story, strings together the singing and dancing numbers that provided a showcase for such luminaries of the entertainment world as Cab Calloway, Fats Waller, Ada Brown, the Nicholas Brothers, Dooley Wilson, and Katherine Dunham, among many others.

The title song provided a professional signature for Lena Horne's entire career, while the film also gave Robinson a welcome opportunity to display his extraordinary terpsichorean skills without the help of his regular sidekick, child star Shirley Temple. Another dancing spotlight focused upon brothers and partners Fayard and Harold Nicholas, whose staircase splits still elicit screams of delight from audiences, more than seventy years after *Stormy Weather* was first released.

Stormy Weather and *Cabin in the Sky* undoubtedly marked the high point of Hollywood's all-black-cast musicals.

Left: **STORMY WEATHER** (1943)
Opposite: **STORMY WEATHER** (1943), Swedish

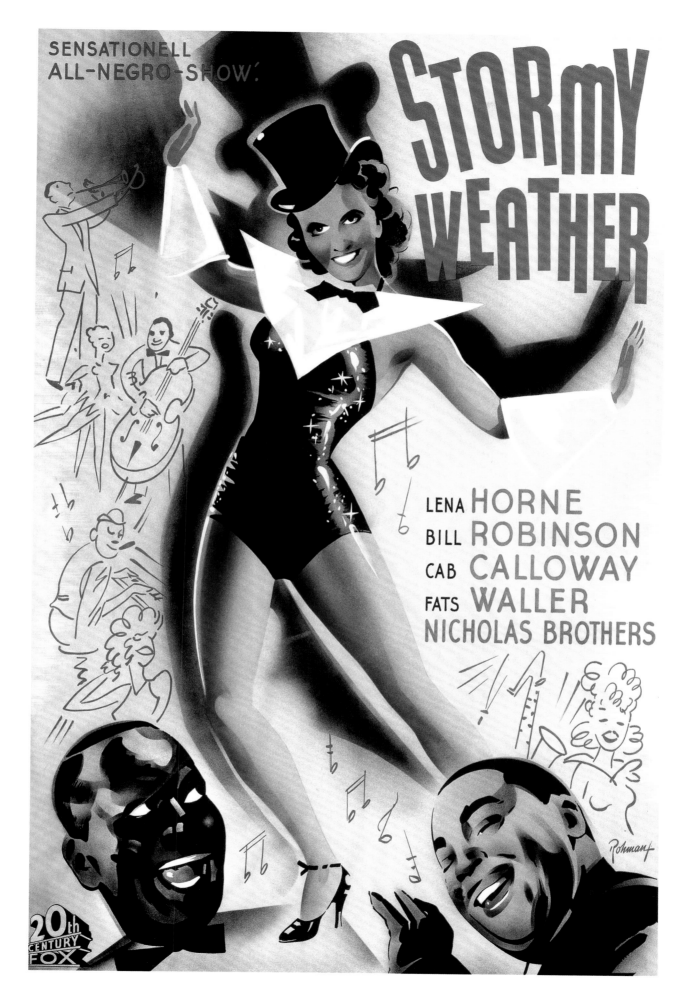

The Nicholas Brothers

Fred Astaire called it the greatest dance routine in cinema history. But the Nicholas Brothers' beyond-belief splits and synchronized athleticism in *Stormy Weather* was merely one brief episode in a double-lifetime of physical brilliance.

Their movie career began with a 1932 musical short entitled *Pie, Pie Blackbird*, when Fayard Nicholas was eighteen years old and his younger sibling and protégé, Harold, just eleven. That was also the year when they made their debut at the legendary Cotton Club. Because of their youth, they were allowed to mingle with the white audience members, which their fellow performers were barred from doing. Harold appeared alone in *The Emperor Jones* (1933), but usually they were booked as a duo, both in films such as *Kid Millions* (1934) and *The Big Broadcast of 1936* (1935), and on Broadway in Rodgers & Hart's *Babes in Arms* in 1937.

One of their most spectacular appearances was in *The Great American Broadcast* (1941), made by Twentieth Century Fox to mark the twentieth anniversary of commercial radio. Their sequence found the brothers dressed as porters on a railroad station, before embarking on a series of dance moves as flamboyant as anything in the movies—climaxing in a dramatic dive through a pair of carriage windows.

Though their film scenes were usually isolated (like Lena Horne's) so that they could be cut to avoid upsetting white audiences in the South, their reputation as Hollywood's finest pair of dancing siblings survives. Fayard Nicholas kept the family tradition alive by continuing to dance and teach until shortly before his death in 2006, at the age of ninety-one.

Left: **THE NICHOLAS BROTHERS (c.1938)**
Opposite: **THE GREAT AMERICAN BROADCAST (1941), Italian**

Jazz on Film

Jazz and the motion picture industry reached maturity early in the twentieth century. Both art forms were children of the creative and technological advances of the late 1880s, made tentative commercial debuts in the 1890s and early 1900s, and achieved an early form of perfection in the "Roaring Twenties." So it is not surprising that jazz and cinema have collided and collaborated so often, and so successfully, throughout their history.

In 1927, the success of the first so-called "all-talkie feature," Warner Bros.' *The Jazz Singer* (a "jazz" film in name, if not actually in musical style), initiated a three-decades-long era during which some of the greatest names in jazz music were immortalized on film. Jazz bands and singers were frequently spotlighted in early movie shorts. They were also used as major drawing cards for feature films that were being aimed at the youth audience of that period. Some jazz figures were featured time and time again on screen, such as Cab Calloway, Louis Armstrong, Duke Ellington, and Benny Goodman. But other important performers made solitary, often uncredited, film appearances.

It is important to note at this point that the definition of "jazz" that was prevalent in the 1920s, and our current description of the genre, are very different. The novelist F. Scott Fitzgerald coined the phrase "The Jazz Age" for the explosion of dancing and dance bands that echoed across America, and then around much of the world, through the 1920s and beyond. But that didn't mean that every musician who contributed to that cultural hysteria was a jazz performer. It was customary at the time for every dance band, whether they were playing a fox trot, a waltz, or a one-step, to be called a "jazz band," even though most of the popular music of that era would now be dismissed by the jazz purists. Perhaps the most popular dance band of the 1920s, in person and on record, was that led by Paul Whiteman, who was given the nickname "King of Jazz." That became the title of a 1930 film that showcased his well-trained and inventive orchestra. But the music they were playing was only a pale facsimile—and a far, far cry—of that produced by the black bands of the period.

Many other films were more "authentic" in jazz terms. The music was often included as little more than a novelty in some of the mainstream big studio productions of the 1930s and 40s. But at the same time as that exploitation was taking place, many independent film producers—black and white—began to produce "black cast" films; or, as they were described in both the black and white newspapers of the time, "race films." These were intended for distribution to theaters that catered exclusively to black audiences. The popularity of jazz music, and the fact that it could be captured on film at comparatively low cost, led to the inclusion of jazz performers in countless black cast films.

For the sake of posterity, it is fortunate that so much film footage was shot of one of the greatest bands in jazz history: Duke Ellington and his Orchestra. In 1927, when Joe "King" Oliver's short-sighted business sense turned down a gig at the Cotton Club in Harlem, Duke's musicians were brought in instead as the house band. Very soon the Cotton Club was the most famous jazz venue in the world. So Hollywood was quick to capture them on film in *Black and Tan* (1929).

The fifteen-minute short begins with Duke teaching his cornet player (Arthur Whetsol) the melody to his hit, "Black and Tan Fantasy." But then a simple narrative intrudes, as Fredi Washington—playing Duke's leading lady—declares her intention to defy the doctors who have ordered her to rest her damaged heart, by dancing as part of Duke's floorshow that night. The result is inevitable to anyone who knows the funereal melody of "Black and Tan Fantasy": she collapses on stage, and finally dies while the strains of Ellington's tune play over the soundtrack.

A happier fate awaited Fredi Washington, who went on to receive recognition as a dramatic actress in *Imitation of Life* (1934). The director of *Black and Tan*, Dudley Murphy, had previously made *St. Louis Blues* (1929) with Bessie Smith, and later shot *The Emperor Jones* (1933) with Paul Robeson.

Opposite: **BLACK AND TAN (1929)**

One figure who stands supreme above all his peers in the history of twentieth century jazz is Louis Armstrong. From the time he joined King Oliver's band in 1922 onwards, he was at the center of every debate about jazz; a figurehead who established the template of the music for more than one generation.

Yet Louis was always a controversial figure, and not just because of his music. He saw his primary function as being to entertain a diverse audience, but his on-stage antics—"mugging," eye-rolling, mopping his brow with the ever-ready white handkerchief—were viewed by some African Americans as demeaning to his race. To others, they were nothing more than visual trademarks that accompanied the brilliance of his musical performance.

From the 1930s onwards, he appeared in around thirty films—sometimes as a performer, less often as an actor (albeit usually playing himself). Among them was *New Orleans* (1947), a drama about Storyville, New Orleans, in 1917, starring Armstrong and the legendary vocalist Billie Holiday (as his sweetheart) in her only dramatic film role. *New Orleans* ostensibly told the early history of jazz, but the real African-American innovators were relegated to the sidelines of the plot, in favor of the white characters taking the leading roles. The film comes alive, however, when Armstrong and Holiday are on screen performing songs such as "Do You Know What It Means to Miss New Orleans" and "The Blues Are Brewing."

Though Holiday's acting career began and ended with the same movie, Armstrong went on to become the most successful jazz musician in the history of film, thanks to his roles in projects such as *A Song Is Born* (1948), *The Glenn Miller Story* (1954), *High Society* (1956), *Paris Blues* (1961), and *A Man Called Adam* (1966).

Above: **NEW ORLEANS (1947): Louis Armstrong (cornet), Meade Lux Lewis (piano), Bud Scott (guitar), Barney Bigard (clarinet), Kid Ory (trombone), Red Callender (bass), Zutty Singleton (drums)**
Opposite: **NEW ORLEANS (1947), Swedish**

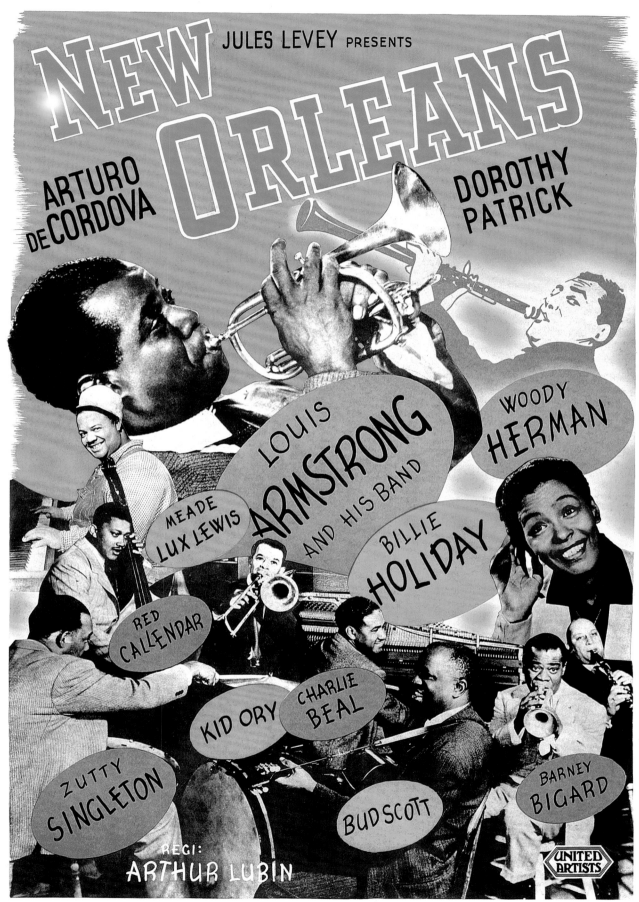

One of the most enduringly popular jazz performers was Cab Calloway. In the 1930s and early 1940s, his band contained some of the finest up-and-coming musicians of the age, including Dizzy Gillespie, Illinois Jacquet, and Jonah Jones. Known as the "King of Hi-De-Ho," Calloway created his own lingo and exploited the novelty appeal of his scat singing and jive vocals with tunes such as "Minnie The Moocher," "Reefer Man," "St. James Infirmary," and "(Hep Hep) The Jumpin' Jive." To help listeners understand the slang, he published a Hepster's Dictionary in the 1940s, explaining that "Gimme some skin" was a reference to shaking hands, or "Frisking the whiskers" was what the cats (musicians) do when they are warming up for a swing session.

The catchphrase that became Calloway's trademark, "Hi-De-Ho," provided a fitting title for a full-length musical feature in 1947 (it was also used earlier for an eleven-minute short for Vitaphone in 1937). *Hi-De-Ho* was a lightweight love story, with Ida James and Jeni LeGon as Cab's main interests, intertwined with club performances by his band, the Peters Sisters, the Miller Brothers, and comedian Dusty Fletcher. Veteran musicians Doc Cheatham, Ben Webster, and Milt Hinton, among others, provided the music for Cab's tunes such as "Don't Falter At The Altar," "Hi De Ho Man," and "I Got A Gal Named Nettie."

Sadly cameras were not on hand to immortalize a later incident in Cab's career. In 1971, going down a reception line at the White House during the Nixon Administration, the President shook hands with Cab and said "Mr. Ellington, it's so good that you're here. Pat and I just love your music."

Left: **STORMY WEATHER (1943), Cab Calloway**
Opposite: **HI-DE-HO (1947)**

It has gone into history as the first blues song of all time: an anthem so popular, and widely covered, that it made a legend out of its creator, William Christopher Handy. Better known as W. C. Handy, he was immortalized in a statue near Beale Street, the home of the blues, in Memphis, Tennessee; as well as in a 1958 biographical drama starring Nat "King" Cole.

Only the minimum of research is required to discover that St. Louis Blues was predated by several songs in Handy's catalog, notably his 1912 composition "Memphis Blues." What's more, musicologists have more recently cast doubt on the idea that Handy was the sole originator of these songs—suggesting, instead, that he was merely the first to structure traditional tunes into a regular set of music and lyrics, and (more importantly, in the long run) to copyright them as his own work.

Whatever the truth, there is no argument about Handy's importance as a popularizer of the blues; or about the appeal of the song with which his name will forever be linked. So it's probably fitting that St. Louis Blues gave its title not just to that movie portrait of Handy himself, but also to a 1929 short film that provides us with our only "moving" footage of the woman who became known as the "Empress of the Blues": Bessie Smith.

Born in 1894, she was not the first of the so-called "classic blues" singers to make a record: among her African-American friends and rivals, Mamie Smith (no relation) arrived there first, by more than two years. Powerful and strident as Mamie's early records were, however, they were not in the same league as Bessie's. Beginning with the coupling of "Down Hearted Blues" and "Gulf Coast Blues" in 1923, and ending a decade later with four recordings in November 1933, Bessie created a remarkable series of vocal performances that can stand proudly against any similar catalog in the history of popular music. She never performed in a "white" club, but by the end of the 1920s, she was earning $800 a week for live appearances, with an additional $1,000 per recording.

Like many blues singers, however, her career was halted in its commercial tracks by the Great Depression. Combined with the insurgence of a new popular music style called "Swing," which presented bands like Count Basie, Glenn Miller and Tommy Dorsey to a younger audience, the spotlight on the blues had been stolen and by 1931, Bessie Smith was simply out of style. Then in 1933, music impresario John Hammond recorded her for the Okeh label, updated her repertoire and put her back on the road to tour in the South, where her popularity still drew large crowds. On the verge of a comeback, Smith was en route to a performance in Memphis, Tennessee, when her

life was tragically cut short by an automobile accident on September 26, 1937. She was forty-three.

Smith's appearance in the 1929 St. Louis Blues short was her only film appearance. She had originally recorded W. C. Handy's trademark song four years earlier for Columbia Records, accompanied by the cornet playing of Louis Armstrong. Critics regard this as the acme of 1920s blues recordings. In the film, directed by Dudley Murphy (Black and Tan, The Emperor Jones) and shot in Astoria, New York, Smith plays the long-suffering and wronged wife of an uncaring gambler; first singing a solo version of "My Man Blues," followed by the title song accompanied by members of Fletcher Henderson's orchestra, the Hall Johnson Choir, and pianist James P. Johnson. The overwhelming pathos of Smith's vocals help to make this dramatized interpretation of the blues a true film classic.

The second film to go by the title of St. Louis Blues was very different from Bessie Smith's original. The 1958 movie told a fictionalized biography of "the father of the blues," W. C. Handy, and highlighted one of the issues that had confronted African-American music since the turn of the century—the pull between the sacred and the secular.

Dozens of black performers were forced to decide whether to devote their talent to the Lord, or whether to pursue the more commercial option of singing what was usually dubbed "the devil's music," a term applied equally to jazz, rock 'n' roll, rhythm and blues, and soul. In an early scene in the film—in a variation of the Jazz Singer paradigm—Handy's father, a devout Baptist preacher, rails against the "evil" music that his young son wants to play on his cornet. "He listens to Satan!" Handy Sr. concludes. Exactly the same debate could be heard in the homes of artists such as Sam Cooke, Aretha Franklin, and Marvin Gaye, among many others.

St. Louis Blues features a line-up of some of the greatest blues, jazz, and gospel performers, including Nat "King" Cole (as Handy), Cab Calloway, Mahalia Jackson (who never strayed from the path of gospel), Ella Fitzgerald, Eartha Kitt, and Billy Preston (who portrays Handy as a child).

During a Hollywood dinner given in his honor in November 1957, Handy proclaimed Nat Cole's depiction of him "forever a monument to my race." Sadly, he died of pneumonia in New York on March 28, 1958, a few days before the film was due to premiere in the same city.

Opposite: ST. LOUIS BLUES (1929)

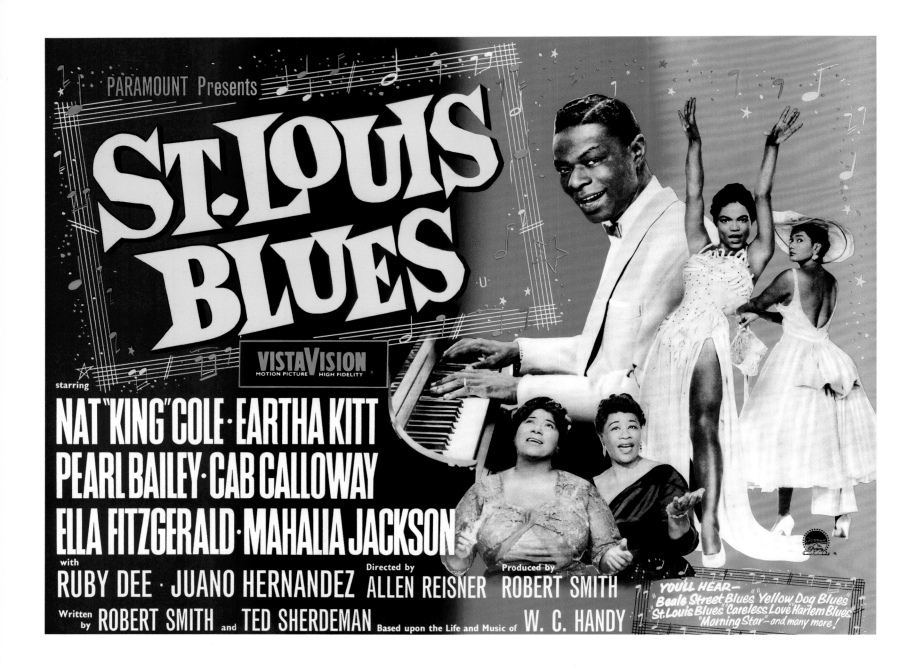

Above: ST. LOUIS BLUES (1958), British
Opposite: ST. LOUIS BLUES (1958), Italian

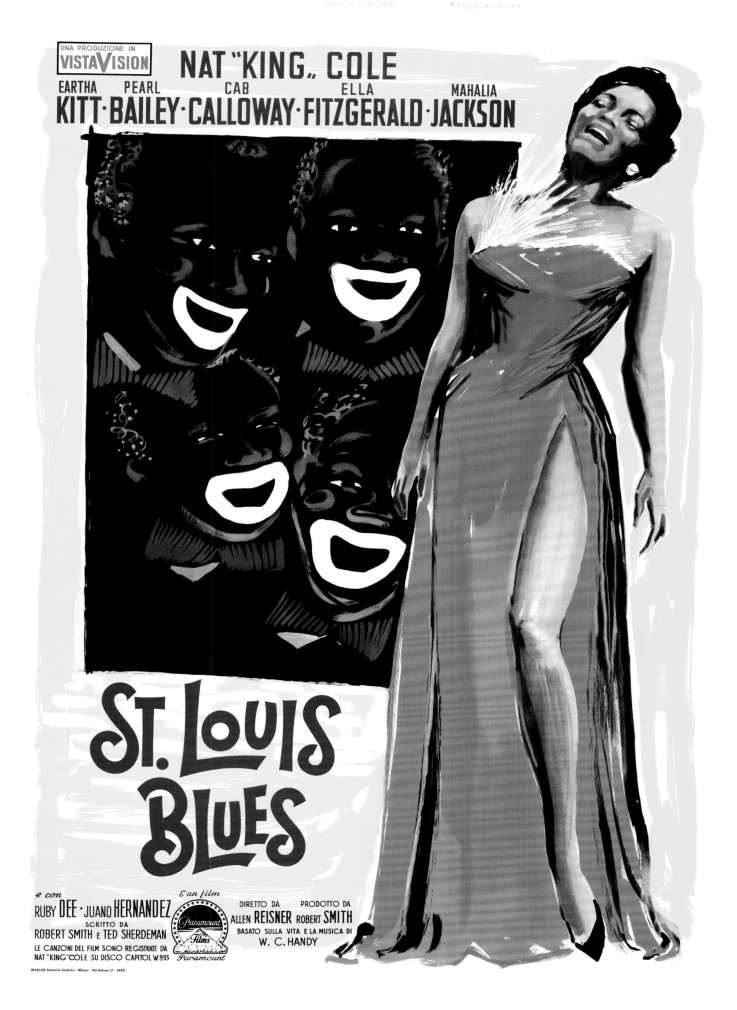

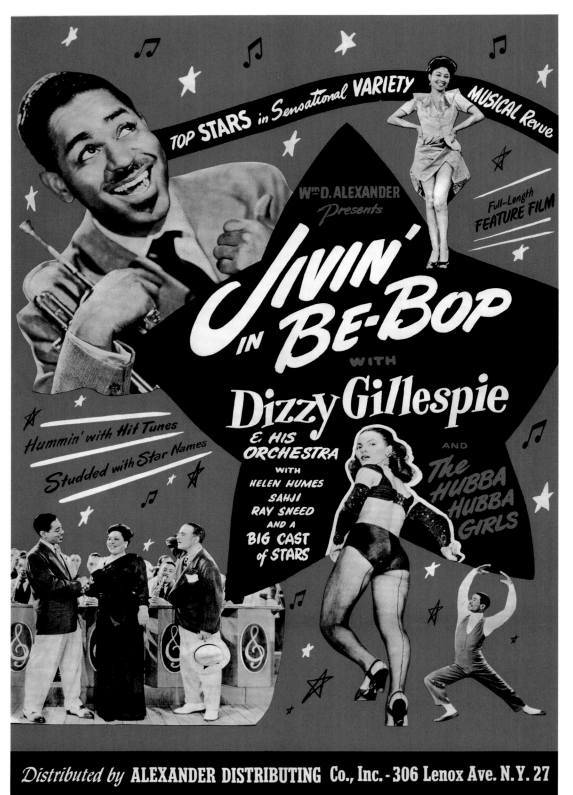

Many jazz films were nothing more than live performances captured by the camera—although the limited budget available to independent producers in the 1940s meant that they lacked the visual impact of the multi-camera shoots of subsequent decades.

The short film *International Sweethearts of Rhythm* (1946) focused on the greatest all-female band of the swing era, at the height of their success. Modeled after Ina Ray Hutton and Her Melodears (an all-white female band), the Sweethearts were formed in 1937 at the Piney Woods Country Life School, a Mississippi establishment for black children. The sixteen-piece band was actually a multi-racial affair, which included Chinese saxophonist Willie Mae Wong and Mexican clarinetist Alma Cortez.

Although from 1940 onwards they were headlining at theaters and clubs, the Sweethearts had to eat and sleep in their tour bus when they travelled the South, because segregation laws prevented them from visiting most restaurants and hotels. The white and lighter-skinned band members were sometimes forced to wear dark makeup, to avoid the additional layer of prejudice that would be directed at an interracial group.

While the Sweethearts struggled commercially when many of their male counterparts were back on the bandstand after serving in World War II, trumpet icon Dizzy Gillespie was about to reach his pinnacle of success. *Jivin' in Be-Bop* (1947) gave him the chance to show movie audiences his new be-bop jazz style, which he had developed in long, experimental, after-hours jam sessions in New York with the likes of Charlie Parker, Thelonious Monk, and Kenny Clarke. Besides including such modern jazz standards as "Salt Peanuts," "Ornithology," and "A Night In Tunisia," the film portrayed many of the elements of a black variety show, with the help of a variety of musicians, singers, and dancers including Helen Humes, Sahji, and the Hubba Hubba Girls. Although the filming conditions robbed the show of much of the visceral excitement that would have been experienced in a club, *Jivin' in Be-Bop* is still a vital time capsule of a crucial period in jazz history.

Left: **JIVIN' IN BE-BOP (1947)**
Opposite: **INTERNATIONAL SWEETHEARTS OF RHYTHM (1946)**

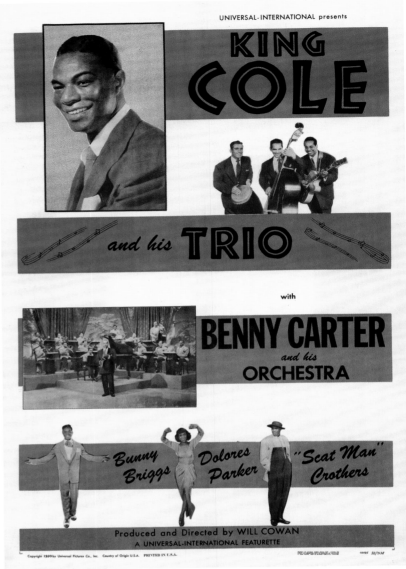

The short films made around the turn of the 1950s provided later generations with some of their most vivid portrayals of jazz' most important artists. Universal International produced many such pictures—visually conservative, but musically superb. Their posters were clearly designed to highlight the exciting live performances they contained.

The legendary jazz band of Count Basie provided support not only for their leader but also for Billie Holiday in this 1951 musical short. Their talents would be attraction enough, then and now, but the picture also featured "Sugar Chile" Robinson, a pre-teen piano virtuoso who contributes storming renditions of "Numbers Boogie" and "After School Boogie." Sadly his career ended in controversy after he was caught smoking a cigar in his dressing room at the age of seventeen when (because of his diminutive height) he was still being marketed as a child star. The scandal encouraged him to quit the entertainment business and concentrate on his education.

Jazz pianist and crooner Nat "King" Cole was also a star in his teens, and his popularity kept on growing until his tragically early death from lung cancer at the age of forty-five. This 1950 Universal International short caught Cole when he was still concentrating almost entirely on jazz, before the lure of pop fame dragged him away from his piano.

Salute to Duke Ellington (1950) was a fifteen-minute short featuring "Things Ain't What They Used to Be," "Take the A Train," "Violet Blue," "A History of Jazz in Three Minutes," and "She Wouldn't Be Moved." Ellington held his orchestra together continuously for almost fifty years, using it as a musical laboratory for his new compositions. He shaped his writing specifically to showcase the talents of his band members, many of whom remained with him for long periods. He also scored for stage and film soundtracks (notably for *Anatomy of a Murder* in 1959), while several of his instrumental works were adapted into songs that became musical standards. In addition to constant touring, he recorded extensively, leaving behind a gigantic body of work that is still being uncovered and assessed many years after his death.

Above (left to right): 'SUGAR CHILE' ROBINSON, BILLIE HOLIDAY, COUNT BASIE AND HIS SEXTET (1951); KING COLE AND HIS TRIO WITH BENNY CARTER AND HIS ORCHESTRA (1950)
Opposite: SALUTE TO DUKE ELLINGTON (1950)

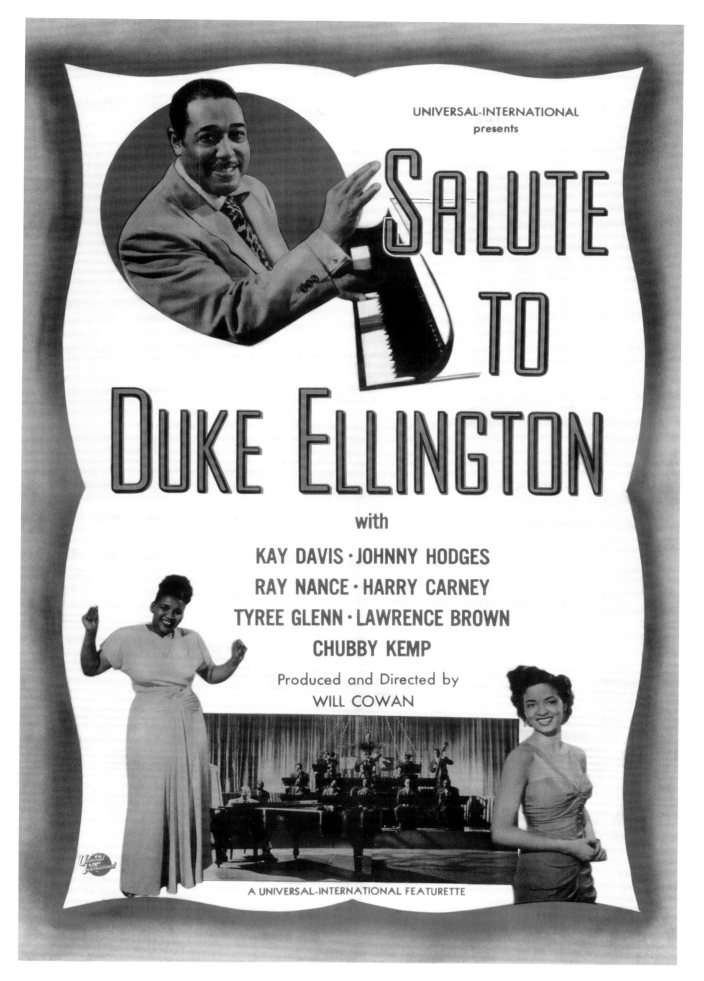

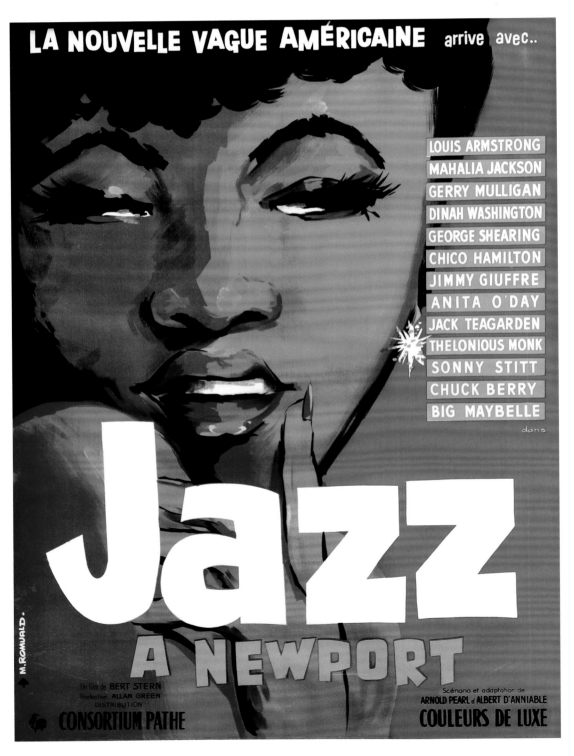

One of the most important concert films ever made, *Jazz on a Summer's Day* captured performances by some of the icons of jazz with unprecedented intimacy. By training his cameras on the 1958 Newport Jazz Festival, noted fashion and commercial photographer Bert Stern created a beautiful documentary about the ability of jazz to infiltrate the least likely of places: the genteel seaside community of Newport, Rhode Island. He merged images of landscapes, water, and sky with performing musicians and audience members, and in doing so, intimately created an alluring incongruity—jazz in bright open spaces, as opposed to the dark bars and smoky clubs typically associated with it.

What was revolutionary for the period was both the synchronization of picture and stereo sound; and the way in which Stern's camera team seemed to be able to effortlessly mingle with the musicians, focusing in (sometimes extreme) close-up. The results were revelatory, appearing to unlock the secrets of each performer's creative processes.

What is perhaps most interesting from the vantage point of more than half a century is that Stern was able to capture performances by such a wide array of artists, in such a comparatively brief film (the released cut was seventy-eight minutes long). The finished product was therefore bound to feature something for almost every taste. The roster of legendary jazz giants included Thelonious Monk, Big Maybelle, Dinah Washington, Gerry Mulligan, Chico Hamilton, Jimmy Giuffre, Sonny Stitt, Anita O'Day, and Eric Dolphy. Among the highlights are Louis Armstrong and Jack Teagarden's celebrated "Rocking Chair" duet and Mahalia Jackson's almighty gospel climax of "The Lord's Prayer."

Left: **JAZZ ON A SUMMER'S DAY (1959), French**
Opposite: **JAZZ ON A SUMMER'S DAY (1959)**

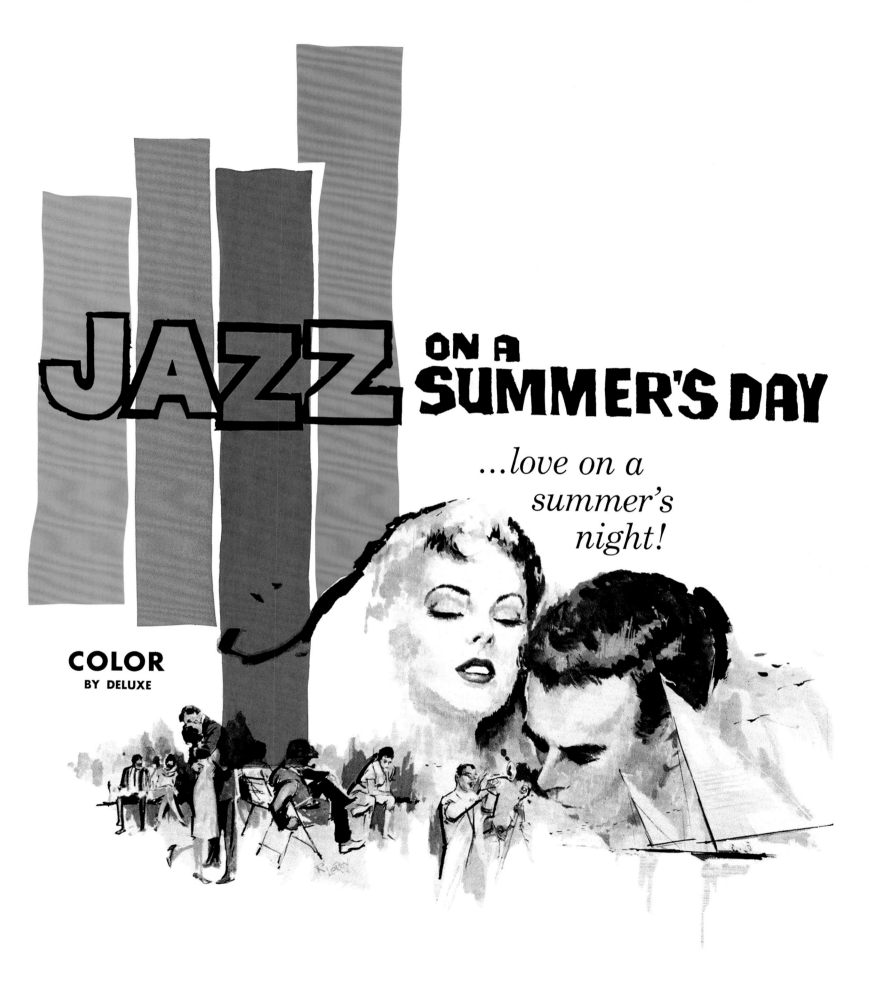

Joe Louis

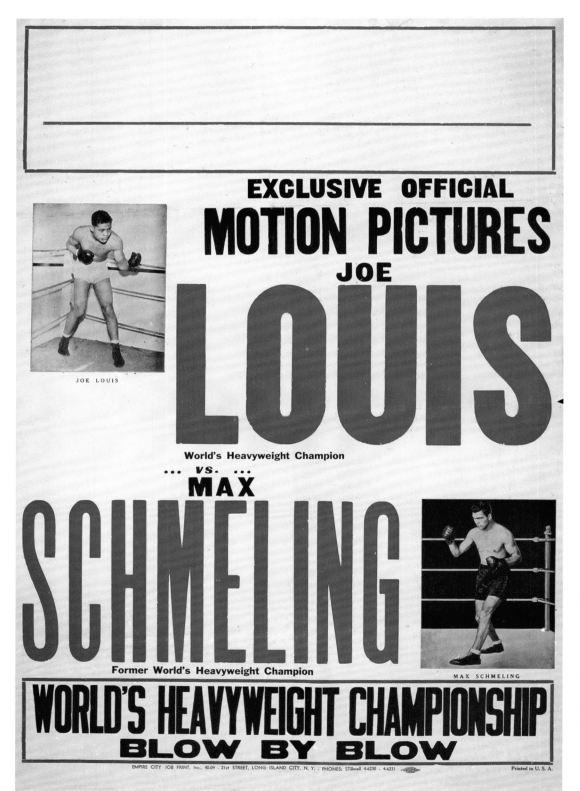

EXCLUSIVE OFFICIAL
MOTION PICTURES
JOE
LOUIS

JOE LOUIS

World's Heavyweight Champion
... VS. ...
MAX
SCHMELING

Former World's Heavyweight Champion

MAX SCHMELING

WORLD'S HEAVYWEIGHT CHAMPIONSHIP
BLOW BY BLOW

EMPIRE CITY JOB PRINT, Inc., 40-09 · 21st STREET, LONG ISLAND CITY, N. Y., · PHONES: STillwell 4-6230 · 4-6231

Printed in U.S.A.

Many consider Joe Louis, the "Brown Bomber," to be the greatest boxer of all time. His success in the most prestigious of boxing's divisions was a source of enormous pride and accomplishment for black America, a symbol of opportunity for his race at a time when segregation was still a part of their everyday lives.

Louis held the world heavyweight boxing title from 1937 to 1949, longer than any fighter in history. From the time that he began his professional career in 1934 until his retirement as champion, he lost only one bout—a defeat by the German boxer Max Schmeling in 1936, which he avenged two years later in one of the most memorable contests in American sports history. The Nazi regime in Germany had greeted Schmeling's victory as proof of the superiority of the white race, so Louis was under incredible pressure to win the rematch—which he did by knockout in the first round. He later wrote: "I knew I had to get Schmeling good … the whole damned country was depending on me." Both bouts were filmed, and distributed for exhibition around the country in the days before live telecasts transformed the boxing game.

Joe Louis made his acting debut in 1938, in the almost entirely autobiographical *Spirit of Youth*. Ten years later, following his service in the military, he took on another movie project—this time playing himself in *The Fight Never Ends* (1948). In the film he becomes a role model to a group of Harlem youths who are tempted to "go bad." Ruby Dee, fresh from the Broadway hit *Anna Lucasta*, co-stars, and a brief appearance by the Mills Brothers adds some musical flavor.

Joe's example lingered in real life too, inspiring a new generation of African-American athletes. But on a personal level, he was dogged by the IRS over non-payment of back taxes, a succession of broken marriages, and a failed attempt at professional wrestling. He spent the last three decades of his life in financial difficulty, ultimately taking a job as a "greeter" at Caesar's Palace casino in Las Vegas. He died in 1981, four years after a stroke had confined boxing's greatest champion to a wheelchair.

Left: **JOE LOUIS VS. MAX SCHMELING (1938)**
Opposite: **THE FIGHT NEVER ENDS (1948)**

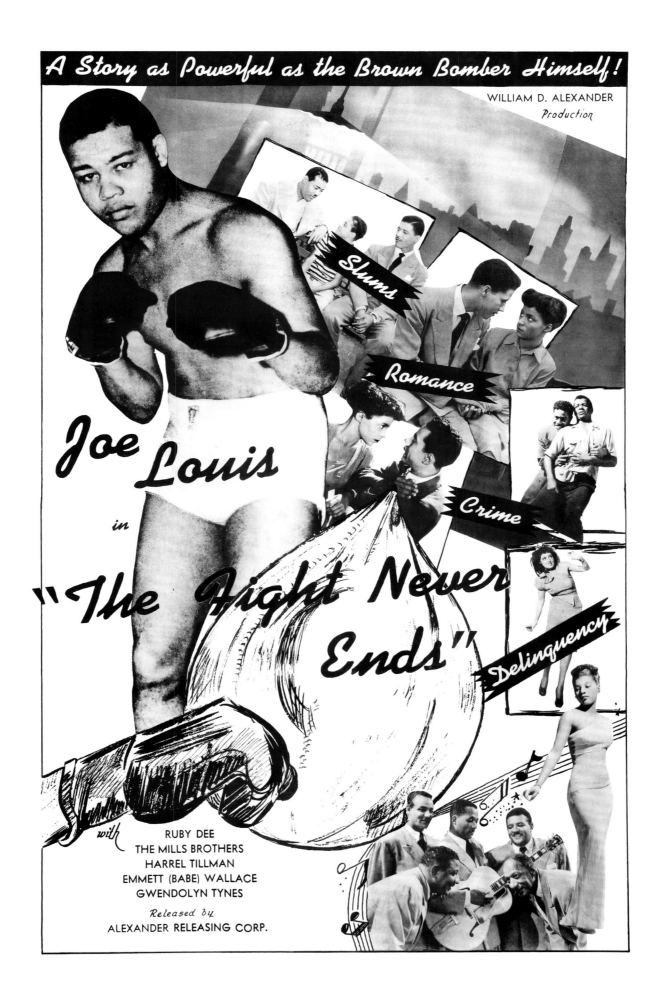

Military

The truism that "war is hell" did not begin with Vietnam. That was the first war in which the gruesome details came streaming into American living rooms, but it was not the first to be a nightmarish affair. During the Revolutionary War, the Continental Army's most mortal threats came not from British troops, but from starvation, disease, and exposure to the unforgiving elements. Throughout American history, warfare has proved a painful and ugly business.

Yet military life has always played a central role in Americans' understanding of themselves, from the epic travails of George Washington's troops to the twentieth century battles to export freedom and democracy. African Americans, however, have long been blotted out of the histories from which this identity is drawn; an omission that has been reinforced by both art and popular culture. Despite the remarkable integration of the Continental Army, the absence of African Americans in art depicting the Revolutionary Era is shocking. Only those individuals who served alongside celebrated leaders such as Washington and French General Lafayette were visible, and then only as servants. The reality of their contribution was very different. Black soldiers have been at the center of every military saga since Crispus Attucks drew the unfortunate distinction of being the American Revolution's first casualty.

The film posters in this chapter represent a century's worth of efforts to reintroduce the black soldier in the popular mind. None stands out more in that vein than 1989's Academy Award-winning *Glory*, the story of the Civil War's all-black Massachusetts 54th Regiment. Formed after President Lincoln finally responded to abolitionist leader Frederick Douglass' relentless lobbying for the North to marshal black fighters, it would be the first black unit recruited from among Northerners and the first composed almost entirely of free men. The 54th's tragically heroic charge on Fort Wagner—marching over a thousand yards under fire from five Southern installations and suffering massive loss of life, but still successfully planting the American flag inside Wagner's gates—produced the Civil War's first black Medal of Honor winner (in William Carney).

These soldiers, however, have served not merely in defense of the nation. From the Revolution through the Civil War, blacks fought primarily in an effort to secure their collective freedom. Each conflict brought a renewed debate within the African-American community about whether and how they should participate. This is not to say that the African-American soldier's patriotism is less profound than his or her white colleague's, but rather that it is more complex. Black soldiers throughout history have faced a paradoxical struggle: the simultaneous fight on behalf of, and in opposition to, America.

On April 2, 1917, President Woodrow Wilson proclaimed that "the world must be made safe for democracy," and with great reluctance, he declared war against the Imperial German government. African Americans held differing opinions regarding the European conflict, but some quickly "closed ranks" to help defend liberty and democracy in Europe. After obtaining promises by government officials for improved racial conditions after the war, black leaders rallied young African Americans to enlist.

One of the most influential black spokesmen in favor of participation in the war was W. E. B. Du Bois, editor of the African-American newspaper *The Crisis*. Du Bois editorialized: "We of the colored race have no ordinary interest in the outcome. That which the German power represents today spells death to the aspirations of Negroes and all the darker races for equality, freedom and democracy. Let us not hesitate. Let us, while this war lasts, forget our special grievances and close our ranks shoulder to shoulder with our white fellow citizens and the allied nations that are fighting for democracy."

Moved by such patriotic discourse, many African Americans eagerly joined the war effort. An even greater influence in their decision was the feeling that black patriotism and loyalty was on trial, thereby viewing the conflict as an opportunity to prove their worthiness and discard their second-class citizenship at home.

The War Department decided to send the 369th Regiment (formerly the 15th New York Infantry) of the US Army to France. They were the first contingent of African-American combat troops to go to war, and they were nicknamed the "Harlem Hellfighters" by the Germans, who were afraid of their deadly tactics.

To encourage recruitment in 1918, the US government commissioned a twenty-four-minute film entitled *Our Colored Fighters*, which showcased the training and combat participation of African-American troops. The film appeared in theaters throughout the United States, having been premiered at the Manhattan Casino, one of the primary entertainment destinations in Harlem. Built in 1902, the Casino was renowned for being the "proving ground" for black basketball teams, concerts by the 125-piece orchestra of James Reese Europe, activist rallies by Marcus Garvey, and parties thrown by socialite Madame C. J. Walker. James Reese Europe himself joined the 369th Regiment as a lieutenant, and led the famous Harlem Hellfighters Band, whose performances for troops did much to establish a passion for African-American rhythms and melodies.

Our Colored Fighters followed in the footsteps of similar recruiting films made by the US Army, such as *Labor's Part in Democracy's War* and *Women's Part in the War* (both released in 1917), and *America's Answer* and *Pershing's Crusaders* (both 1918). All of these pictures were made at President Wilson's request by the Committee on Public Information (CPI), headed by journalist George Creel. The CPI's Division of Films established the template for the official films that would be made by the Office of War Information in World War II.

Opposite: **OUR COLORED FIGHTERS (1918)**

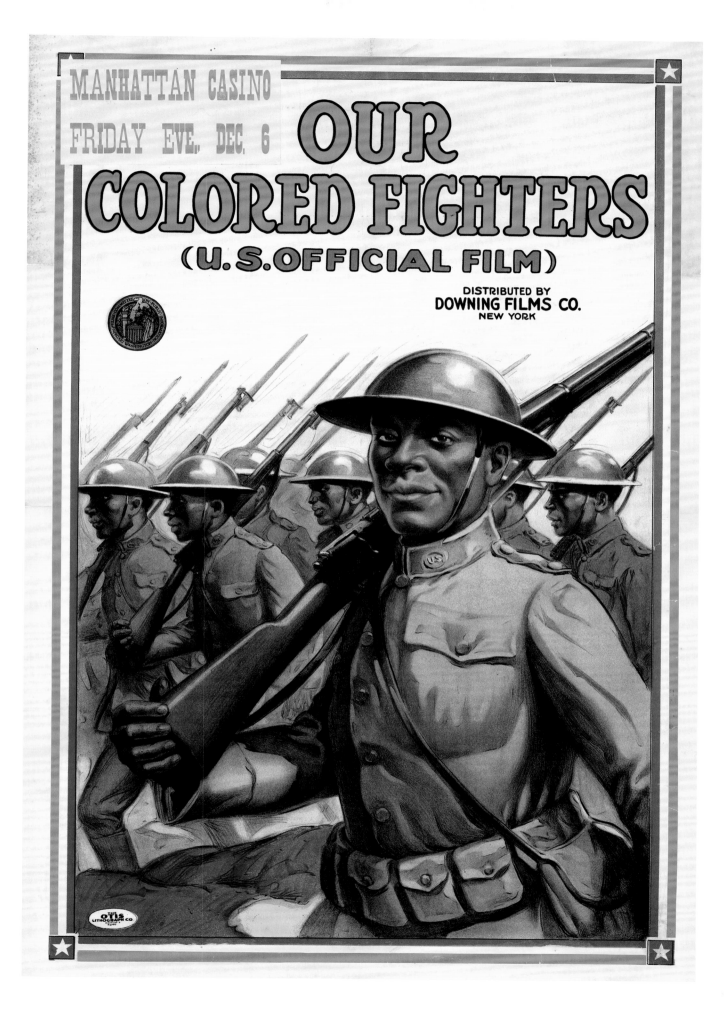

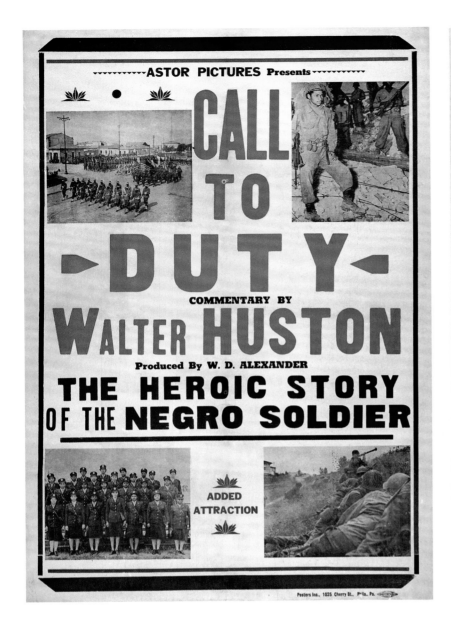

Because of the heightened demand for manpower during World War II, the US military increased opportunities for African Americans in the Armed Forces. The black soldier received prominence in three documentaries made by the War Department: *Teamwork*, produced by the United States Signal Corps; *The Highest Tradition*; and *Call to Arms*. Each portrayed the dignity and courage of the many thousands of African-American troops who had fought in previous wars, while helping to dispel the hatred and prejudice rampant in America. *Call to Duty* (1946), narrated by award-winning Hollywood actor Walter Huston, focused on the Navy and Coast Guard's first-time recruiting of black women into their reserve units.

The Negro Soldier (1944) was made by the War Department on the assumption that it would only be screened to black troops, but its impact was such that it was distributed to mainstream cinema audiences. World Heavyweight Champion boxer Joe Louis was made the centerpiece of the film, which was intended to demonstrate that there was no racial prejudice at work in the Army. *The Negro Soldier* was produced by famous director Frank Capra, and was written by Carlton Moss, an African-American screenwriter, actor, and independent film director.

A companion film, *The Negro Sailor* (1945), was a docudrama filmed by Navy camera crews and then completed in Hollywood. It featured Joel Fluellen, in his first starring role, as a Navy recruit in training for war duty. The story chronicled an African-American newspaperman's induction into service, and the process whereby a recruit learns the teamwork expected of him, and the training necessary to support the nation's war effort. Essentially a work of pure propaganda, *The Negro Sailor* emphasized the need for racial harmony in a segregated society. Interestingly, the film was intended to follow *The Negro Soldier* into commercial picture houses, but the Department of Public Relations Office of the Navy postponed distribution until 1946. Only after representatives of twenty-five civic organizations in New York had given their approval was the film allowed to be shown beyond military audiences.

Above (left to right): **CALL TO DUTY** (1946); **THE NEGRO SAILOR** (1945)
Opposite: **THE NEGRO SOLDIER** (1944)

WARNER BROS.

EL SARGENTO NEGRO

JEFFREY HUNTER

CONSTANCE TOWERS

WOODY STRODE

DIRECTOR JOHN FORD

Like any nation at war, the United States produced dozens of extremely partisan movies about World War II. While the conflict still raged, Hollywood's films were intended as overt propaganda, designed to bolster public confidence and pride; emotions that would continue to shape the movies made in the decade after the war. Only in later years could a more ambivalent story be told.

In 1943, Humphrey Bogart led the cast of Columbia Pictures' *Sahara*. This was a conventional tale of Allied bravery and decency; Bogie scolds a German for racial prejudice and stops his armored tank to pick up an Italian POW who might otherwise have perished in the desert heat. After the war, most European distributors publicized the film—as in the American campaign—by using poster artwork showing Bogart in a heroic motif. The Italian distributors instead chose to design the poster art around the solitary black member of the cast, Rex Ingram, in the role of the noble Sudanese Sergeant Major who savagely confronts the racism of a Nazi officer, with grave results.

The Spanish distributors of John Ford's 1960 Civil War drama, *Sergeant Rutledge*, retitled it to emphasize the racial origins of Woody Strode's lead actor, as well as to portray Strode on the poster as a stoic, determined hero; an African-American soldier who is falsely accused of a double murder and of raping a white woman. This was fully in keeping with Ford's efforts to treat minority cast members with more respect than in his earlier westerns, and to present the black man as dignified and honorable. Although some of his 1960 audience might not have been receptive to the anti-racist theme, Ford tried to change popular attitudes about prejudice by presenting a man who was neither black nor white, but simply a soldier.

Left: **SERGEANT RUTLEDGE** (1960), Spanish
Opposite: **SAHARA** (1943), Italian

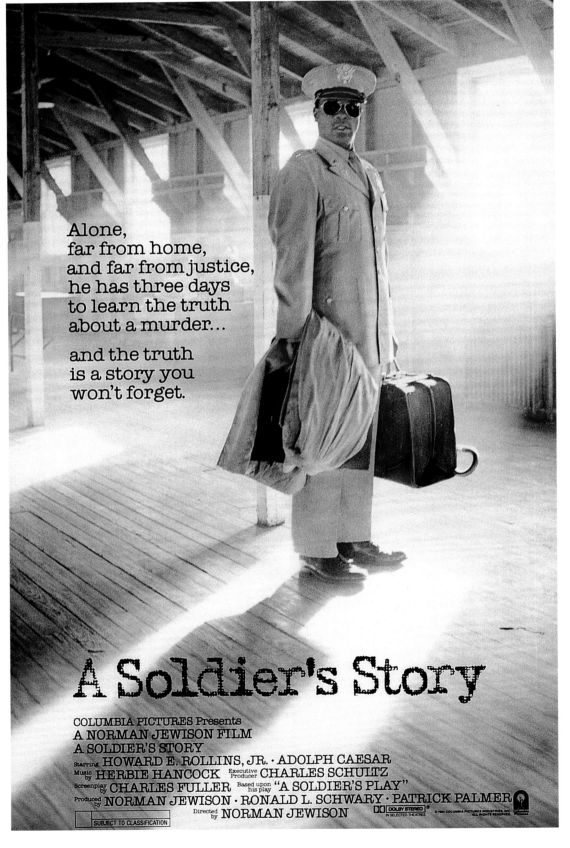

Alone,
far from home,
and far from justice,
he has three days
to learn the truth
about a murder...

and the truth
is a story you
won't forget.

A Soldier's Story

COLUMBIA PICTURES Presents
A NORMAN JEWISON FILM
A SOLDIER'S STORY
Starring HOWARD E. ROLLINS, JR. · ADOLPH CAESAR
Music by HERBIE HANCOCK Executive Producer CHARLES SCHULTZ
Screenplay by CHARLES FULLER Based upon his play "A SOLDIER'S PLAY"
Produced by NORMAN JEWISON · RONALD L. SCHWARY · PATRICK PALMER
Directed by NORMAN JEWISON

DOLBY STEREO
IN SELECTED THEATRES © 1984 COLUMBIA PICTURES INDUSTRIES, INC.
ALL RIGHTS RESERVED

SUBJECT TO CLASSIFICATION

In 1984, award-winning producer/director Norman Jewison brought Charles Fuller's Pulitzer Prize-winning drama, *A Soldier's Play,* to the screen. The film version was largely performed by members of the Negro Ensemble Company, the premier American black theater troupe, who had first staged the play off-Broadway in 1981.

The film takes place in 1944 at an army base deep in Louisiana, where the sergeant of an all-black platoon (played by Adolph Caesar) is shot to death. Washington sends Captain Davenport (Howard Rollins Jr.), a military attorney, to investigate. He is the first black commissioned officer anyone at the segregated base has ever seen, and his appearance is met with resentment among the whites and pride among the blacks. Davenport eventually solves the case, but not before revealing the hidden insecurities and fears that breed racial hatred among suspects, black and white.

Another view of the African-American contribution to the US military was provided by *Glory* (1989). One day when screenwriter Kevin Jarre was walking on Boston Common, he realized that some of the soldiers on a Civil War monument were black. Until then, it had never occurred to him that African Americans actually fought in that conflict. In that moment, the inspiration for *Glory* came to him.

President Lincoln's Emancipation Proclamation of 1862 cleared the way for many African Americans to join the military. Motivated by a call to arms from abolitionist Frederick Douglass, more than one thousand recruits, including his own sons Charles and Lewis, joined the Massachusetts 54th Infantry Regiment, the first black unit to march into battle.

The fictionalized *Glory*—with an ensemble cast including Denzel Washington, who won an Academy Award for Best Actor in a Supporting Role—chronicles the enlistees' struggle to prove themselves worthy soldiers and Americans. It follows the men from the training grounds, where they are denied uniforms, rifles, respect, and equal pay, to the battlefields of South Carolina, where they become a coordinated fighting unit; and it culminates in the bloody assault on Fort Wagner in Charleston.

Left: **A SOLDIER'S STORY (1984)**
Opposite: **GLORY (1989)**

COMING THIS CHRISTMAS

昭和36年度芸術祭参加

大島 渚 監督作品　パレスフイルムプロダクション製作

飼育

どす黒い狂気の時代の惨烈な残像── 戦争を断罪する白熱と異色の衝撃

三国連太郎
（東映）

小山明子

三原葉子

中村雅子

岸 輝子
（映像）

沢村貞子

山茶花 究

浜村 純

戸浦六宏

竹田法一

島田 屯

加藤 嘉

ヒュー・ハード

製作　田島三郎
　　　中島正幸
原作　大江健三郎
脚本　田村 孟
脚本協力　松本俊夫
　　　　　石堂淑朗
　　　　　東松照明
撮影　舎川芳次
音楽　真鍋理一郎

⓪ 大宝株式会社配給

The poster for Nagisa Ôshima's *The Catch* (1961; also known as *Shiiku*) portrayed Hugh Hurd in the role of an African-American airman in World War II, who has been shot down and is then kept prisoner in a rural Japanese village. Unaware that the war has ended, the locals keep Hurd imprisoned in the basement of a storehouse, waiting for instruction from a higher authority that never arrives. They increasingly demonize their captive because of his race, with tragic results. Although the soldier's racial identity is crucial to the narrative, *The Catch* was ultimately a film about Japan's own cultural self-awareness, and how the nation's view of itself had led it to military destruction.

Racial tension of another kind—less direct, and intermingled with the collective fear of combat—stalked Robert Altman's screen adaptation of David Rabe's ensemble stage play, *Streamers* (1983). It is set in a basic-training barracks during the Vietnam War, where the recruits, including David Alan Grier (in his screen debut), Michael Wright, Matthew Modine, and Mitchell Lichtenstein are waiting for the moment when they are sent to the front line. As if the strain of their situation were not enough, there is internal conflict in the barracks between those of different temperaments, exacerbated by the perennial chasm of race and homophobia. The global disputes that have triggered the war are mirrored by the personal squabbles of the young soldiers who are hostages to the international tension.

Left: **THE CATCH (aka SHIIKU, 1961), Japanese**
Opposite: **STREAMERS (1983)**

Race Films

At the turn of the twentieth century, a cultural revolution took place. Almost overnight, every neighborhood and town had a nickelodeon, a small makeshift theater where anyone could gaze in awe at the new process of "moving pictures," which showcased exotic locales and offered a wide array of stories and subjects from famous books and popular plays, cut to the length of a modern-day music video. Minorities were usually represented as stereotypes: the drunken Irishman, the greedy Jew, the watermelon-eating Negro. Following the tradition of minstrel shows, white actors in blackface portrayed black roles on film. Typical films of the period included *Uncle Tom's Cabin* (1903), *A Nigger in the Woodpile* (1904), *The Wooing and Wedding of a Coon* (1905), *The Masher* (1907), and the two series, *Rastus* (1908-1910) and *Sambo* (1909-1911), which pictured their characters as humorous, lazy, shiftless, and stupid. These stereotypical exaggerations were consistent with the impression that many Americans had of blacks, and they became the basis for the racial tension that persisted in Hollywood for decades, until well after World War II.

On the relatively rare occasions that actual black actors were allowed to appear on screen, their roles were so restricted that the richness of African-American culture and the talent of black performers were all but obscured.

Blacks were, in the words of African-American author Ralph Ellison, "invisible." In later years, when Southern viewers who were used to (and who accepted) the stereotypical depictions, perceived some of the films as "too positive" or that they challenged Southern racist attitudes, film censors simply edited black characters out of versions shown in those theaters. In fact, many films that featured blacks in prominent roles never even played in the South.

Beyond this mainstream white cinema, however, another kind of filmmaking emerged in the early 1910s and prospered into the late 1940s. It spawned the production of so-called "race" films with all-black casts, that were created by both black and white producers and directors specifically for African-American audiences. The Foster Photoplay Company, the Lincoln Motion Picture Company, the Ebony Film Corporation, the Norman Film Manufacturing Company, the Micheaux Pictures Corporation, and at least thirty other independent production companies created what was, in effect, a "separate cinema," a parallel universe of black films, with its own stars and traditions, which played in segregated theaters in both the North and the South. With these race movies, made away from the Hollywood studios on the most restrictive of budgets, independent filmmakers sought to provide mass entertainment for a black audience by creating stories with distinct cultural references and by dramatizing worlds in which African-American heroes and heroines were depicted as vital, ambitious, and assertive. The stories, which ranged from comedies, westerns, and horror films to gangster dramas and detective thrillers, allowed black actors and actresses to display their acting talents in serious dramatic roles—as caring doctors, educated business owners, courtroom lawyers, even romantic cowboys—all roles that reflected the African-American experience, which was conspicuously absent from Hollywood films.

By the late 1940s, race films began to decline in numbers and in popularity, due to the increasingly progressive outlook in Hollywood and in the country as a whole. That outlook had been fostered by the shared national endeavors of World War II. As technical standards in Hollywood improved, the low-budget race films seemed even more outdated by comparison. But at the same time, the big studios realized that America was changing, and they began to show an interest in tackling social issues that would have been utterly taboo a decade earlier. By using the black cause as a metaphor of American justice, they produced films that promoted the theme of racial integration (and sometimes cultural assimilation) and that also touched on the conflicts between blacks and whites. Race films didn't often enter this territory, preferring to create their own, non-white world for obvious reasons. When Hollywood began to allow African Americans to be seen on screen as legitimate citizens with their own valid concerns, the need for race films diminished, and with them the movies themselves.

The Black King (1932) was a satirical portrait of black separatist Marcus Garvey. Made by an independent, white-owned New York company, Southland Pictures, the film starred A. B. DeComathiere, a veteran of the famous Lafayette Players Stock Company and a favorite of African-American director Oscar Micheaux. DeComathiere played "Charcoal Johnson," a con man who takes money from uneducated African Americans for a fake "Back to Africa Movement." As far as truth and history are concerned, the film has little value except as an example of the types of acting opportunities afforded to African-American actors, even if the roles were only distorted stereotypes. The "Back to Africa" theme occurs (and is used much more effectively) in later films, such as *Cotton Comes to Harlem* (1970).

Opposite: **THE BLACK KING (1932)**

White-owned Sack Amusements of Dallas, Texas, was a combination theater chain, distribution, and production company for feature films and short subjects catering to African-American audiences. Founded by Alfred N. Sack and his brother Lester in 1920, the business became a major distributor to many independent filmmakers, including Oscar Micheaux and Spencer Williams in the late 1930s, and was responsible for a large series of successful race films through the 1940s.

Sack produced films on minuscule budgets and with very short shooting schedules. The final product invariably suffered from poor production, continuity issues, and worse, stilted acting. Yet black audiences easily overlooked the production problems in favor of seeing positive images of themselves on screen as compared to their Hollywood counterpart.

Sack's early poster designs displayed the same uncomplicated and inexpensive approach that it followed in making its films: typically a simple two or three bright color silkscreen in a stylized folk art motif, as seen in two of its earliest, most notable distribution projects, the Bessie Smith short, *St. Louis Blues* (1929, see page 111), and Duke Ellington's *Black and Tan* (1929, see page 105).

Deep South (1937), *Old Man Samson* (1936), *Camp Meetin'* (1936), and *Mississippi Moods* (1937) celebrated the atmosphere of Southern life from the black perspective. Central to all four of these shorts was the Hall Johnson Choir, a popular ensemble of African-American spiritual singers, who contributed to many films of this period. Offering musical entertainment, comedy and drama, this quartet of short films remained sufficiently popular for them to be re-released in 1944, at a time when wartime restrictions made the production of new movies very difficult.

Left: **MISSISSIPPI MOODS** (1937)
Opposite: **DEEP SOUTH** (1937)

SACK AMUSEMENT ENTERPRISES
Presents

DEEP SOUTH

WITH

WILLIE BEST
DAISY BUFORD
CLARENCE MUSE

AND THE

HALL JOHNSON CHOIR

During the difficult years of the Depression, and then World War II, movie theaters offered a rare moment of respite and escapism to audiences black and white. The circuit for race films required just as much variety as its mainstream Hollywood counterpart, with musicals, comedies, thrillers, and family dramas, among others.

Gang Smashers, made by producer Harry Popkin's optimistically titled Million Dollar Pictures in 1938, was written by Ralph Cooper, who was more normally seen in front of the camera in films such as *Gangsters on the Loose* (1937) and *Dark Manhattan* (1937). Nina Mae McKinney starred as a dame running Harlem's underworld rackets.

McKinney, often described as "The Black Garbo," was considered Hollywood's first African-American love goddess. She skyrocketed to fame in MGM's *Hallelujah* (1929), and appeared opposite Paul Robeson in *Sanders of the River* (1935). Yet she quickly discovered that there were virtually no significant follow-up roles for her as a black leading lady other than those offered by all-black independent productions, such as *The Devil's Daughter* (1939), *Straight to Heaven* (1939), and *Mantan Messes Up* (1946). Her work in Hollywood during the 1940s was reduced to minor supporting roles in dramas such as *Dark Waters* (1944), *Danger Street* (1947), and *Pinky* (1949).

Murder on Lenox Ave (1941) was adapted from a story by the African-American actor Frank Wilson, and was a modern version of Othello, according to the pressbook. One of the last black-cast gangster films, it followed the tangled lives of the various tenants of a Harlem brownstone in a neighborhood known as the Negro's "International Boulevard." Chorus girls, musicians, criminals, and decent families were seen living side-by-side, and becoming involved in the heartbreak of a tragedy. Musical distraction was offered in the score by Donald Heywood, and featuring vocalist Mamie Smith.

Left: **MURDER ON LENOX AVE** (1941)
Opposite: **GANG SMASHERS** (1938)

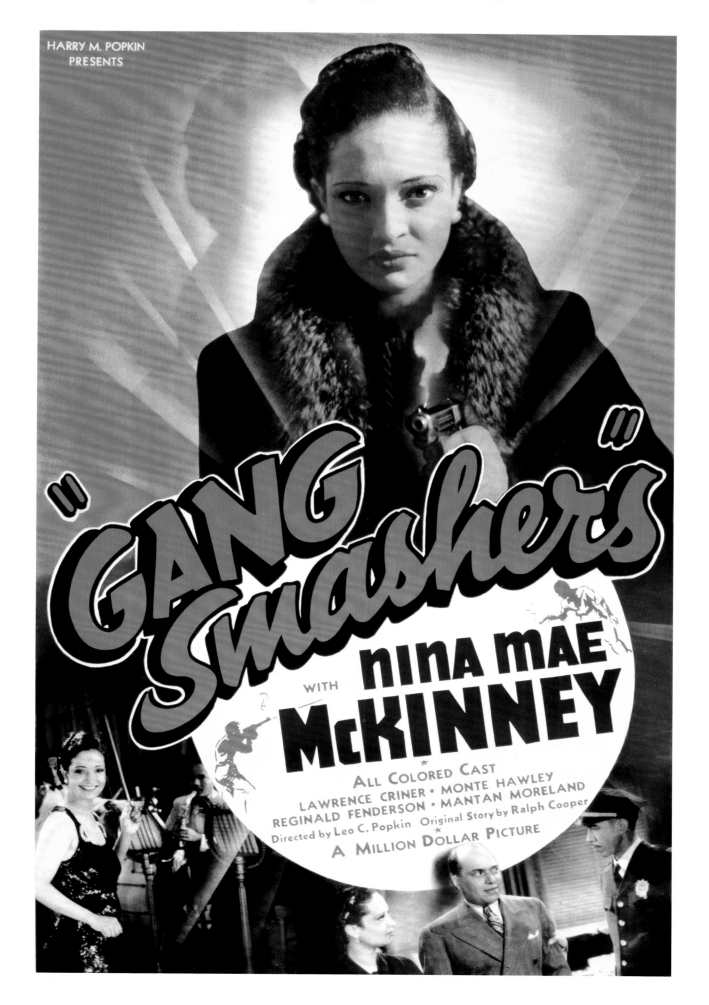

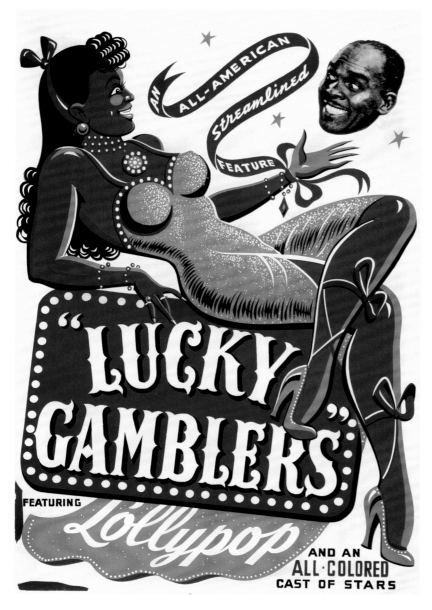

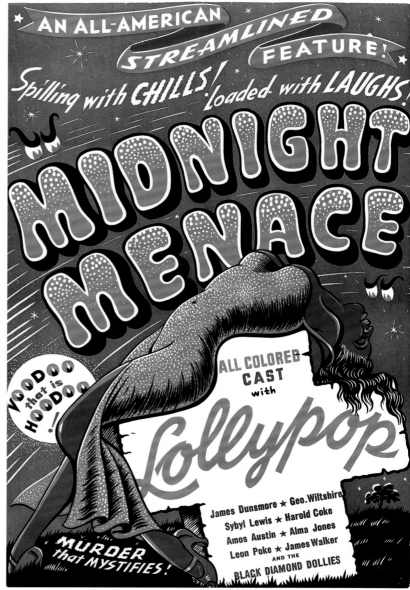

In 1942, the Chicago company All-American News began releasing newsreels that followed the war activities of African-American men and women in the armed services throughout the world. They were shown in black theaters, with little distribution elsewhere. Other subjects included black college sports and women's fashions. By 1945, All-American had ceased making newsreels, and began concentrating instead on "quickie," feature-length musical comedies.

Lucky Gamblers (1946) starred ladies' man Lollypop Jones, a hugely popular singer and dancer among black audiences who was virtually unknown to the rest of the country. Shot in All-American News' New Jersey studio, the film featured a virtually unknown cast, with the exception of J. Augustus Smith. Smith had been working in theater and on the race movie circuit for many years, having appeared in films such as *Louisiana* (1938; aka *Drums o' Voodoo*) and *Murder on Lenox Ave*. He and Jones

teamed up again in 1948 for *Boarding House Blues*.

Jones also starred in two other 1946 pictures, *Midnight Menace* and *Chicago After Dark*, where he was able to show off his popular "hoodoo-voodoo" antics. The pressbook for *Chicago After Dark* summed up its appeal: "Take a very doleful-looking cab driver, add an escaped lunatic who is, nevertheless, a very attractive girl, add some show girls and musicians who are caught in a police raid on a burlesque show, then throw in some loony guards and irate cops. Mix them up and you have *Chicago After Dark*, the merry, mad, loony tuney feature."

Above (left to right): **LUCKY GAMBLERS (1946); MIDNIGHT MENACE (1946)**
Opposite: **CHICAGO AFTER DARK (1946)**

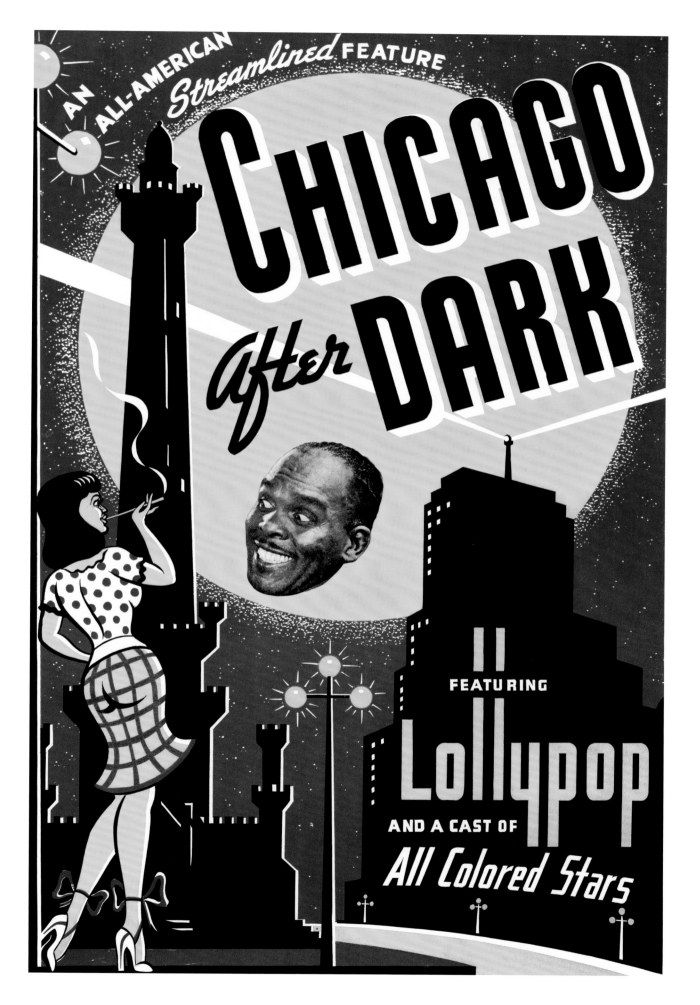

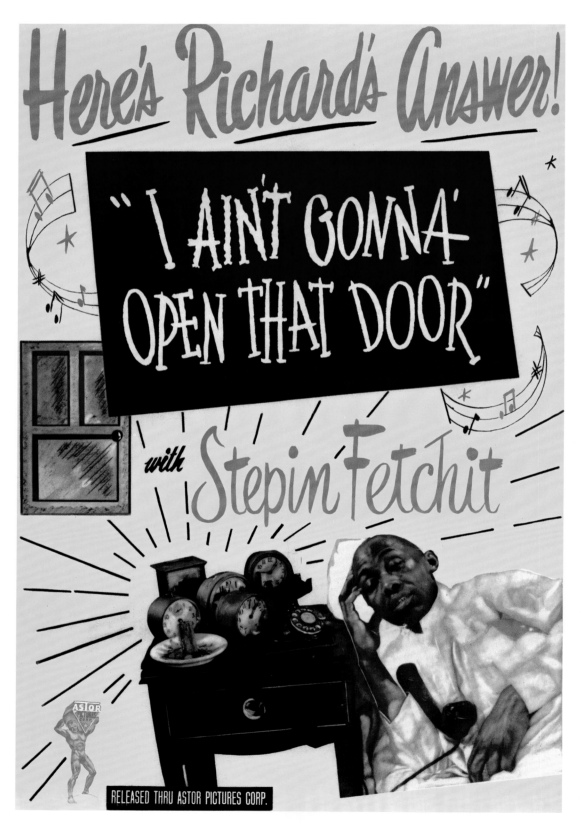

Here's Richard's Answer!

"I AIN'T GONNA' OPEN THAT DOOR"

with Stepin Fetchit

RELEASED THRU ASTOR PICTURES CORP.

Comedian and singer Clinton "Dusty" Fletcher was best known for his "Open the Door, Richard" comedy routine. Wearing a suit of ill-fitting clothes, he would drunkenly try to climb a ladder, while complaining in a comic monologue that his fictitious friend has locked him out. The routine inspired a hit song, also titled "Open the Door, Richard," by rhythm and blues sax player Jack McVea; which in turn led Stepin Fetchit to take on the role of Richard in a short film, *I Ain't Gonna Open That Door* (1947)—singing his reply to the absent Fletcher, to the accompaniment of Earl Bostic's band.

Meanwhile, Dusty Fletcher was seen in *Boarding House Blues* (1948), showing off his comic talents alongside the likes of Jackie "Moms" Mabley in what was essentially a series of vaudeville routines linked by a far-fetched narrative. Mabley was dressed, as always, in an old-time cotton housedress, floppy shoes, and a toothless smile while calling her audience "my children." She became successful during the Harlem Renaissance of the 1920s, appearing in venues like Connie's Inn and the Cotton Club. A pioneer of black humor, her career lasted over fifty years. *Boarding House Blues* also featured Lucky Millinder, leading his swinging orchestra with infectious verve and supporting Bull Moose Jackson as he sang "I Love You, Yes I Do." Millinder's band closed with a hot number, "(Do) The Hucklebuck," which gave viewers a taste of the rockin' sound that was just about to transform the rhythm and blues market, and then the whole pop business.

Left: **I AIN'T GONNA OPEN THAT DOOR (1947)**
Opposite: **BOARDING HOUSE BLUES (1948)**

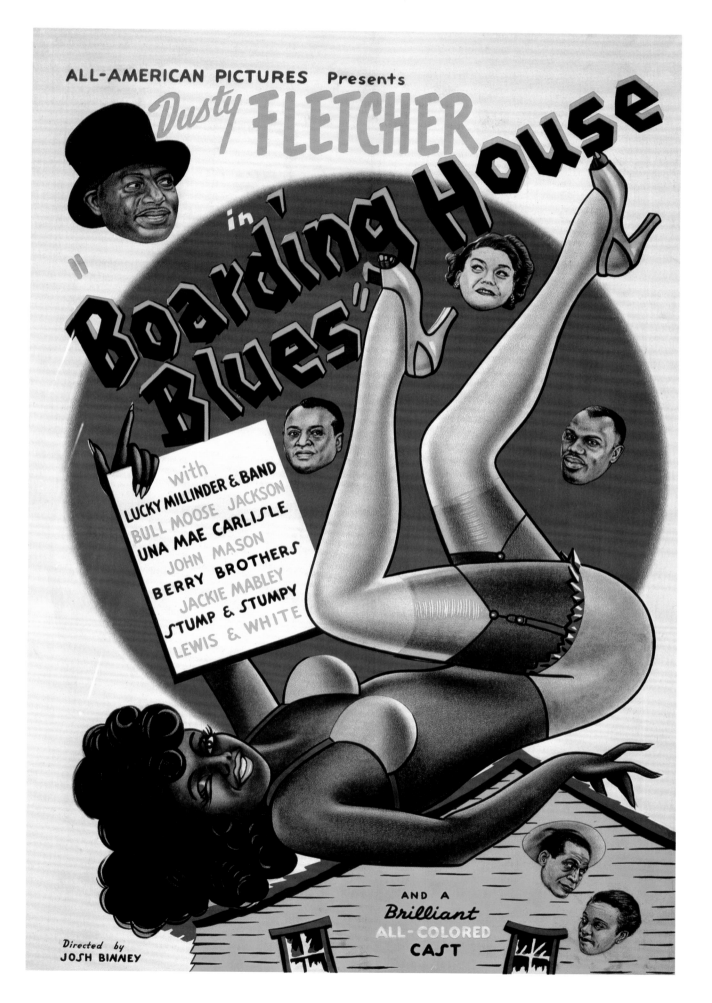

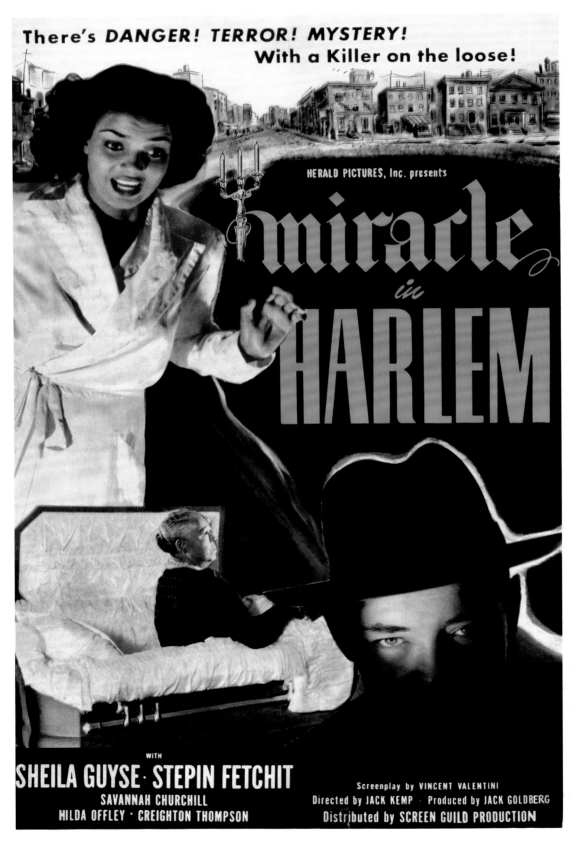

There's DANGER! TERROR! MYSTERY!
With a Killer on the loose!

HERALD PICTURES, Inc. presents

miracle in HARLEM

WITH
SHEILA GUYSE · STEPIN FETCHIT
SAVANNAH CHURCHILL
HILDA OFFLEY · CREIGHTON THOMPSON

Screenplay by VINCENT VALENTINI
Directed by JACK KEMP · Produced by JACK GOLDBERG
Distributed by SCREEN GUILD PRODUCTION

By the late 1940s, the independent film movement and the market for race films had nearly been wiped out by the changing face of mainstream Hollywood cinema, with its new genre of "problem" films tackling issues that were close to the heart of the African-American community. Suitably, perhaps, the redoubtable Stepin Fetchit appeared one more time in *Miracle in Harlem* (1948), one of the last race films to be completed. A murder mystery that centered around a family-owned candy business, it took a surprisingly serious look at post-World War II black America and its hopes of new promise and prosperity. Like so many films aimed at the African-American community, *Miracle in Harlem* opened with the sound of a black choir, delivering a soulful rendition of the spiritual "Swing Low, Sweet Chariot." Sheila Guyse added a powerful version of "Look Down That Lonesome Road," while Broadway singer Juanita Hall belted out "Chocolate Candy Blues."

The following year, *Souls of Sin* (1949) marked the end of the road for race films. It focused on the social environment that bred criminality in the black community, and dramatized the lives of three men in a Harlem rooming-house: a writer, a gambler, and a musician, each with a specific dream of success. Glamour girl singer Savannah Churchill played the siren who led the film's male star, played by Jimmy Wright, to his inevitable decline.

Although race films suffered from low production values, uneven acting, and often simplistic storylines, they did serve a cultural purpose. But with the integration of black actors into serious roles in mainstream movies, audiences began to denounce race films, leaving no hope for the genre's revival. *Souls of Sin* was the last.

Left: **MIRACLE IN HARLEM (1948)**
Opposite: **SOULS OF SIN (1949)**

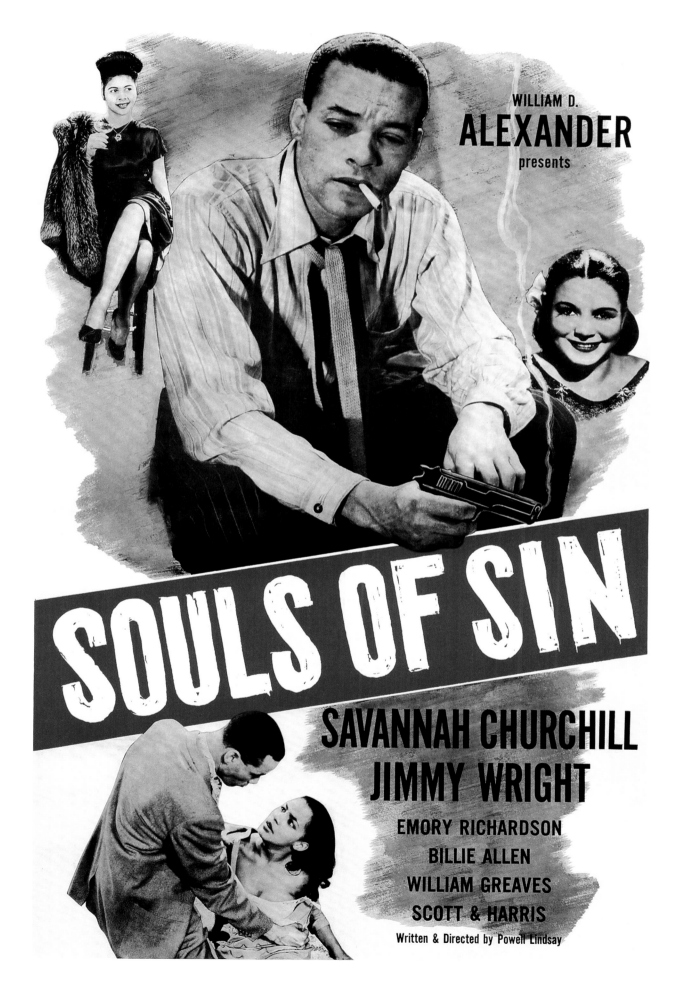

WILLIAM D.
ALEXANDER
presents

SOULS OF SIN

SAVANNAH CHURCHILL
JIMMY WRIGHT

EMORY RICHARDSON
BILLIE ALLEN
WILLIAM GREAVES
SCOTT & HARRIS

Written & Directed by Powell Lindsay

Spencer Williams

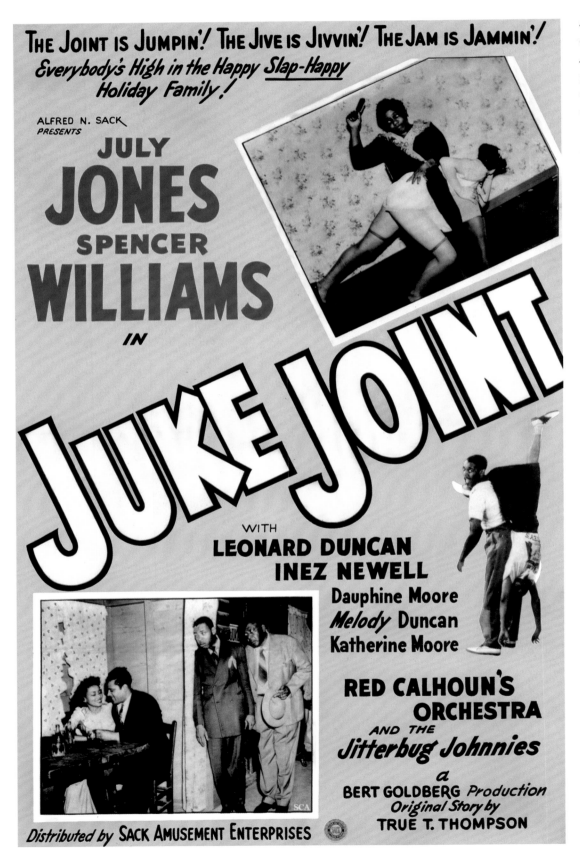

THE JOINT IS JUMPIN'! THE JIVE IS JIVVIN'! THE JAM IS JAMMIN'!
Everybody's High in the Happy Slap-Happy Holiday Family!

ALFRED N. SACK
PRESENTS

JULY
JONES
SPENCER
WILLIAMS
IN

JUKE JOINT

WITH
LEONARD DUNCAN
INEZ NEWELL
Dauphine Moore
Melody Duncan
Katherine Moore

RED CALHOUN'S
ORCHESTRA
AND THE
Jitterbug Johnnies
a
BERT GOLDBERG *Production*
Original Story by
TRUE T. THOMPSON

Distributed by SACK AMUSEMENT ENTERPRISES

Although many Americans remember Spencer Williams only as Andy Brown in the CBS-TV version of *Amos 'n' Andy* (1951-53), his most significant achievement was probably his film work in Texas in the 1940s, when he was active as a screen actor, writer, and director. He was born in Vidalia, Louisiana, in 1893. As a teenager he moved to New York, where he became a "call-boy," alerting actors that they were needed on stage, and a comedy student under vaudeville star Bert Williams.

In 1929, during the early days of sound, Christie Studios in Hollywood hired Williams as a writer for a series of black-cast shorts adapted from the magazine stories of Jewish writer Octavus Roy Cohen, including *Melancholy Dame*, *Oft in the Silly Night*, *The Lady Fare*, *Music Hath Charms*, and *The Framing of the Shrew*. He also acted in many a popular series of all-black-cast westerns with Herb Jeffrey, including *Harlem on the Prairie* (1937), *The Bronze Buckaroo* (1939), *Harlem Rides the Range* (1939), and *Two-Gun Man From Harlem* (1938). Williams also wrote and appeared in the first horror film with an all-black cast, *Son of Ingagi* (1940).

In the early 1940s Williams met Al Sack, a Dallas-based film distributor whose company, Sack Amusement Enterprises, provided "ethnic" films for many theaters in the Southwest. When Sack offered to back Williams financially in a run of feature films for black audiences, Williams eagerly agreed to write, direct, and act in what became a series of films, most of which were shot in and around Dallas. The content of the films varied from religious: *The Blood of Jesus* (1941), *Brother Martin* (1942), *Go Down, Death!* (1944); to comedy: *Dirty Gertie From Harlem U.S.A.* (1946), *Beale Street Mama* (1946), *Juke Joint* (1947); to drama: *Marchin' On* (1943), *Of One Blood* (1944), *The Girl in Room 20* (1945). Unlike most of the genre, Williams' films are generally faithful to reality and unmarred by stereotypes. Sack's "hands-off" support gave Williams an artistic freedom that few other artists, except for pioneer Oscar Micheaux, ever enjoyed.

Left: **JUKE JOINT (1947)**
Opposite: **THE BLOOD OF JESUS (1941)**

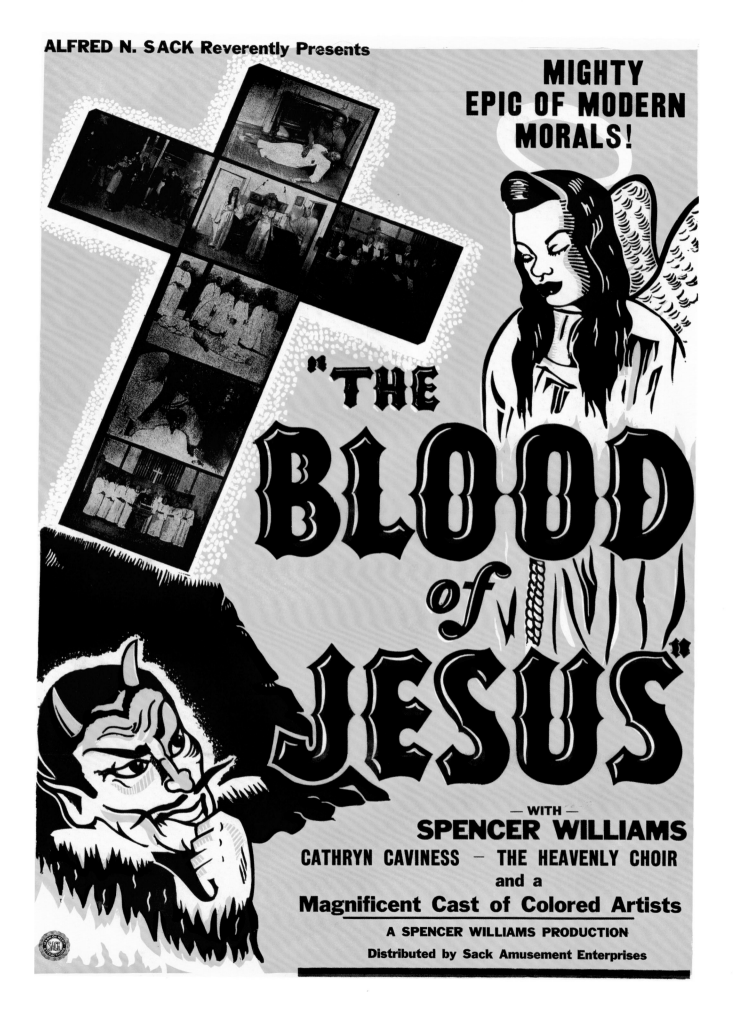

Problem Films

World War II helped to heighten racial consciousness as pressure developed within America to rectify social inequalities. The government and the movie industry collaborated on films that paid tribute to the black contribution to the military effort (*Sahara*, *Bataan*, and *Crash Dive*); the "New Negro" began making his (and her) way to the screen in Hollywood productions like the movie adaptation of Ellen Glasgow's *In This Our Life* (1942); and post-war agreements between the studios and the NAACP forced Hollywood to address its image and reconsider some of its more blatant stereotyping.

The result of all of these social changes was a new genre of Hollywood movie production: the so-called "problem" films, a cycle of motion pictures that investigated the race problem in America. Rather than treating African Americans as sub-human (in the style of D. W. Griffith) or as stereotypes (as encouraged by the likes of Stepin Fetchit), these films choose to focus on the way in which blacks were being treated. It was no longer African Americans who constituted the problem; but rather the prejudice and segregation that were forced upon them by the rest of the nation.

Problem films were therefore essentially liberal in intention, meant to open the eyes of their mainstream audience to the issues that confronted African Americans on a daily basis. Starting with the films *Home of the Brave*, *Lost Boundaries*, *Pinky*, and *Intruder in the Dust* in 1949, they helped to implant a new kind of black racial imagery into the discourse of Hollywood. They also paved the way for a previously unseen black character: the integrationist hero, played by the likes of Sidney Poitier, who would become increasingly familiar to Hollywood audiences over the next two decades.

Independently produced by Stanley Kramer, *Home of the Brave* launched Hollywood's quartet of problem pictures. Shot on a shoestring budget, absent of big-name stars, and with the unusual theme of racism as its subject matter, the film was based on the successful 1946 Broadway play by Arthur Laurents, in which the hero was a young Jewish soldier, the victim of anti-Semitism within the military. In the film, however, Kramer substituted a black character for the Jewish protagonist. Through a series of flashbacks, *Home of the Brave* describes the emotional breakdown of a young African-American army private, Peter Moss, played by James Edwards. As he undergoes examination by a sympathetic medical captain, Moss unravels his tale, revealing a number of racial incidents he endured while on a special five-man mission to a Japanese-held island during World War II. Repeatedly harassed by his fellow soldiers, Moss cracks up under the pressure. The viewer learns, however, that it is not the island experience alone that has led to the black soldier's breakdown. It is the crippling frustration built up by a lifetime of racial discrimination.

Home of the Brave was the first post-war film to focus directly on racial discrimination, and also the first in which such caustic words and phrases as "nigger" and "nigger lover" were uttered on screen. Its forthrightness and honesty was historic and cathartic, and it marked a genuine turning point for African Americans and for Hollywood.

Kramer—who would become film's most liberal producer/director of the time for his commitment to social relevance—continued, as he put it, "communicating a message to the conscience of humanity" in such fine features as *The Defiant Ones* (1958), *On the Beach* (1959), *Inherit the Wind* (1960), *Judgment at Nuremburg* (1961), and *Guess Who's Coming to Dinner* (1967), which he directed and produced; and *The Men* (1950), *High Noon* (1952), and *The Wild One* (1953), which he produced. His contribution to the tone and strength of American cinema, and to the importance of racial understanding, particularly during an era when liberalism came to be seen by many as increasingly suspect, is an important one.

Opposite: **HOME OF THE BRAVE (1949)**

THE FIRST MOTION PICTURE OF ITS KIND!

Here is the picture Hollywood said could never be made. Without pulling punches, it tells the suspense-packed story of a top-secret mission on a danger-infested island in the Pacific.

It is a picture that the entire country will acclaim for the exalting, exciting entertainment it is!

Mossy
He carried more than his own weight...and the burden of a black skin!

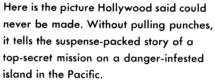

Screen Plays Corp.
presents

"HOME OF THE BRAVE"

with
Douglas Dick · Frank Lovejoy · James Edwards · Steve Brodie · Jeff Corey · Lloyd Bridges
Produced by Stanley Kramer
Based on an original play by Arthur Laurents · Screenplay by Carl Foreman
Associate Producer Robert Stillman · Directed by Mark Robson
Musical Score by Dimitri Tiomkin · Released thru United Artists

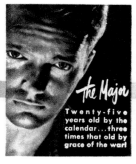

The Major
Twenty-five years old by the calendar...three times that old by grace of the war!

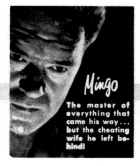

Mingo
The master of everything that came his way... but the cheating wife he left behind!

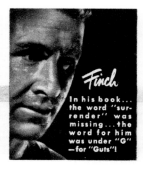

Finch
In his book... the word "surrender" was missing...the word for him was under "G" —for "Guts"!

"T.J."
The Corporal with two stripes on his sleeve... and one down his back!

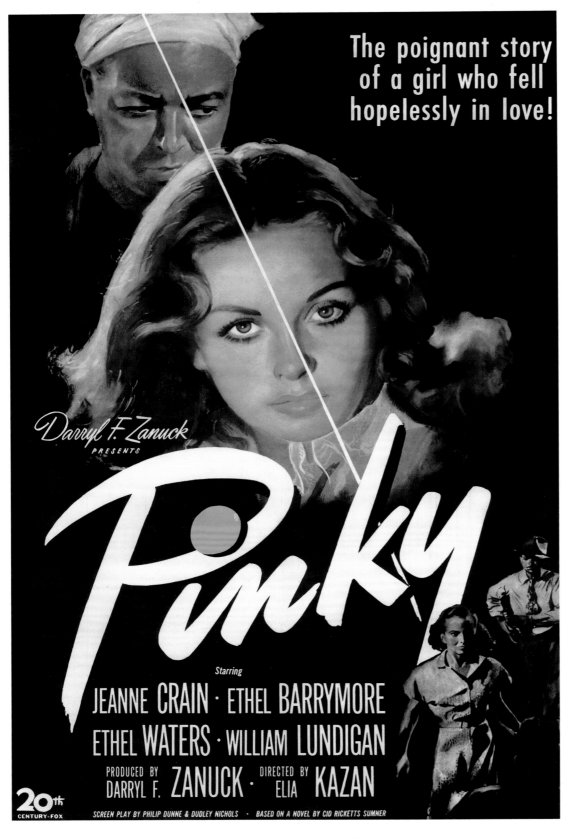

The poignant story of a girl who fell hopelessly in love!

Darryl F. Zanuck
PRESENTS

Pinky

Starring

JEANNE CRAIN · ETHEL BARRYMORE
ETHEL WATERS · WILLIAM LUNDIGAN

PRODUCED BY DARRYL F. ZANUCK · DIRECTED BY ELIA KAZAN

20th CENTURY-FOX

SCREEN PLAY BY PHILIP DUNNE & DUDLEY NICHOLS · BASED ON A NOVEL BY CID RICKETTS SUMNER

The second of the problem films was *Lost Boundaries* (1949). It was based on a *Reader's Digest* true story—taken from William L. White's book—of a black family who lived in a New England town, and "passed for white" for twenty years.

In the film, a young black doctor (played by white actor Mel Ferrer) decides to compromise his racial identity in order to get a decent job. He has already been robbed of a post at a black hospital because his skin did not appear to be black enough for him to fit in. So he takes his family from their African-American community in the South to the countryside of New Hampshire. After many years without incident, the truth surfaces, and the family must confront the racism prevalent within small-town America. Eventually a white minister gives a sermon on tolerance, and in true Hollywood fashion, harmony is restored. An immediate critical hit, *Lost Boundaries* was even hailed by the black press, initially critical of producer Louis De Rochemont for casting white actors in the black roles.

Another 1949 film, *Pinky*, tells the story of a light-skinned black girl from Southern Mississippi (played by white actress Jeanne Crain) who, while studying nursing in the North, passes for white. Fearing the consequences of her engagement to a white doctor, she returns home to the South to live with her strong and moral grandmother, played by veteran African-American actress Ethel Waters. Her grandmother chastises Pinky for "passing," because it is dishonest and reveals a lack of pride in her heritage. Facing the grim reality of being black in the old South, Pinky eventually comes to a new racial awareness.

Actress Lena Horne often reminisced about the Hollywood of the late 1940s and early 1950s. Interestingly, in one of her stories, she told how white actress Jeanne Crain beat her out of the role as the light-skinned young black woman in *Pinky*. At that time, film studios—and audiences—found it unthinkable to use an African-American actress for an interracial romantic role.

Left: **PINKY (1949)**
Opposite: **LOST BOUNDARIES (1949)**

THE TRUE STORY OF A FAMILY WHO LIVED A LIE FOR TWENTY YEARS!

FILM CLASSICS, INC.
presents the **LOUIS DE ROCHEMONT** production of
"LOST BOUNDARIES"
with **BEATRICE PEARSON**
MEL FERRER
Susan Douglas · CANADA LEE and introducing RICHARD HYLTON
Under the direction of **ALFRED L. WERKER**
Based on **WILLIAM L. WHITE'S** document of a New England family
Screen adaptation by Charles Palmer · Screenplay by Virginia Shaler and Eugene Ling
An **RD-DR** production

A DRAMA OF REAL LIFE FROM "THE READER'S DIGEST"

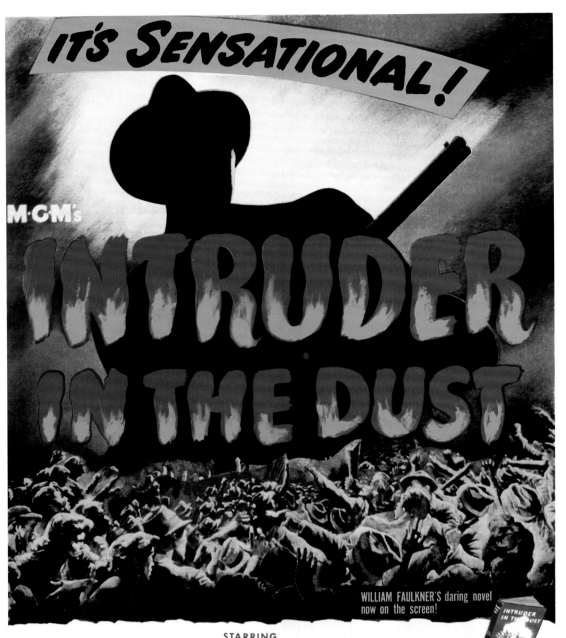

The last in the cycle of problem films was director Clarence Brown's faithful screen adaptation of William Faulkner's novel *Intruder in the Dust* (1949). It is a study of a fearless and proud black man living in the racist climate of Mississippi. When Lucas Beauchamp, played by Juano Hernandez in his Hollywood film debut, is arrested for killing a white man, lynching fever takes over the town.

Beauchamp is on trial for more than murder, however. He is a noble, yet self-righteous man, whose "uppity" arrogance and independence alienates him from the white community, who want him cut down to size. He would rather be lynched for a crime he didn't commit than give up his dignity or conform to the conventional, subservient role expected of a black man in the South of the 1940s.

Intruder in the Dust stands out among the other films of the period because of its refusal to stoop to any form of condescension towards its black characters, or to rationalize the behavior of bigots. America's racial problems, it proved, could no longer be kept in the background; while African-American characters could never be exploited as they had been in the past.

As proof of the film's realism, starring actor Hernandez did not have an easy time during the production of the film. It was shot on location in Faulkner's segregated hometown of Oxford, Mississippi, where Hernandez had to live apart from the rest of the cast and crew at the home of a local African-American undertaker.

Left: **INTRUDER IN THE DUST (1949)**
Opposite: **INTRUDER IN THE DUST (1949), Swedish**

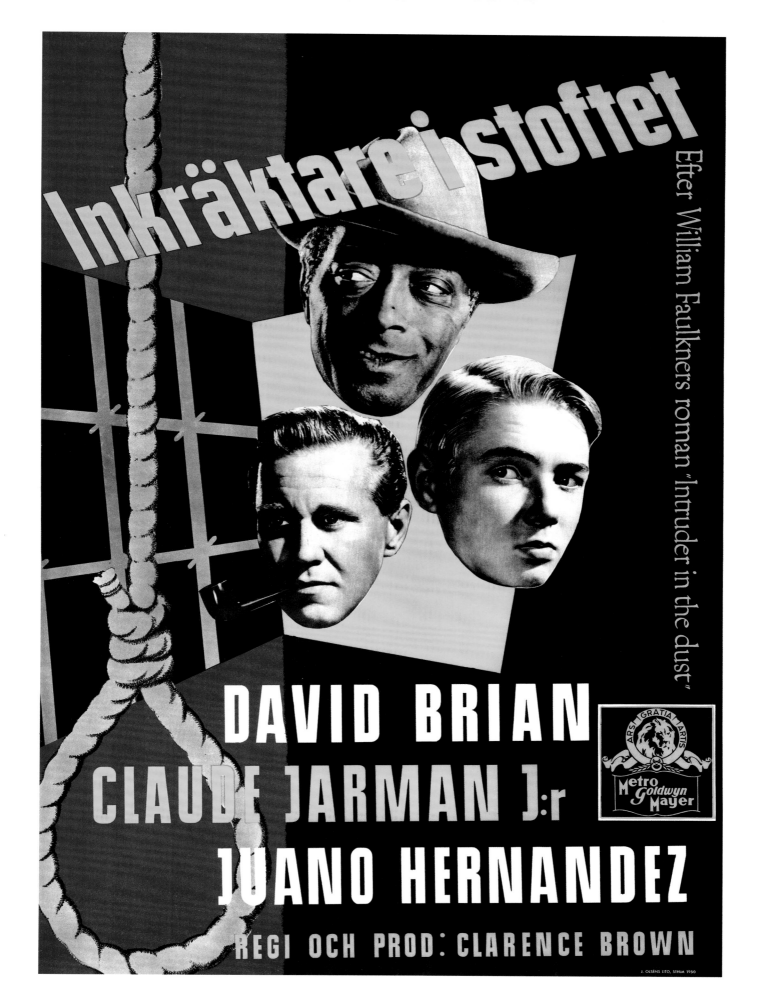

Jackie Robinson

Sports have always symbolized the American ideals of sportsmanship and fair play. Yet until more recent years, the role played by African Americans in those sports has been denied, omitted, or overlooked. Black athletes have never lacked the ability, grace, or strength to excel in sports, but they have historically been handicapped and prevented from the opportunity to compete on equal terms with white athletes. Only after decades of sacrifice and struggle was this basic human right granted.

The unfairness of discrimination is obvious today, but this was not always the case. From 1888 to 1946, no profession in America enforced the color line more stubbornly than organized baseball. The game was lily-white, forcing a segregation that relegated black players to minor league baseball teams. In 1880, there were twenty black players there. By 1887, however, there were still no black players in the major leagues, and those twenty in the minors all lost their jobs. "Jim Crow" racism would rule baseball, as it did America as a whole, for many years to come.

It was only in World War II that the issues of social equality and integration sounded the need for change in America, and with it, the position of the black athlete. What happened over the next few years represented a milestone in the history of African Americans in sports, as the white men who operated professional sports were finally forced to acknowledge the principle of equality, both on and off the field.

Nobody represented that struggle for recognition more fully or more courageously than the legendary Jackie Robinson. Recent detailed research by scholars of baseball history suggests that Robinson was not the first African American to play in the major leagues. Moses Fleetwood Walker played one season with the Toledo Blue Stockings in the 1880s, before the color bar was fully introduced; while before him, William Edward White is believed to have played one game for the Providence Grays in 1879. But it is undeniable that it was Robinson who first smashed through the color line and made a national impact on the struggle for civil rights being waged by the African-American community.

To immortalize his achievement, Robinson took time off from his career, after the Brooklyn Dodgers won the pennant in 1949, to star in the movie *The Jackie Robinson Story* (1950). His co-stars included Ruby Dee, Louise Beavers, Joel Fluellen, Bernie Hamilton, and football great Kenny Washington.

The film looked back over a sporting career that began at UCLA in 1939, where Robinson excelled at baseball, basketball, football, and track. Less than two years later, he was playing professional football with the Los Angeles Bulldogs; and after wartime service as a lieutenant, the Montreal Royals signed him to a minor-league farm club of the Brooklyn Dodgers. He won the league's batting title in 1946, and the Dodgers then invited him to join the team as first baseman. He made his debut for them at Ebbets Field on April 15, 1947. Hostile opponents and racist spectators publicly provoked him with bean-ball pitches and death threats.

Conscious of his unique position as a role model, however, Robinson managed to ignore all the epithets hurled at him—even his own teammates' petition to eject him from the team. In 1947, he led the National League in stolen bases and was named Rookie of the Year. Two years later, he won the National League batting title and the Most Valuable Player Award. By now, he was recognized and respected as a symbol of African-American accomplishment and pride.

Robinson played his entire major league career for the Brooklyn Dodgers (1947-56). His success in demolishing racial barriers helped to pave the way for other black athletes to participate in professional sports. Having endured years of openly expressed racial prejudice, in 1962, Robinson became the first African-American to be included in the National Baseball Hall of Fame. In 1997, major league baseball retired Robinson's jersey number 42, as a tribute to his unique contribution to the game.

Opposite: **THE JACKIE ROBINSON STORY (1950)**

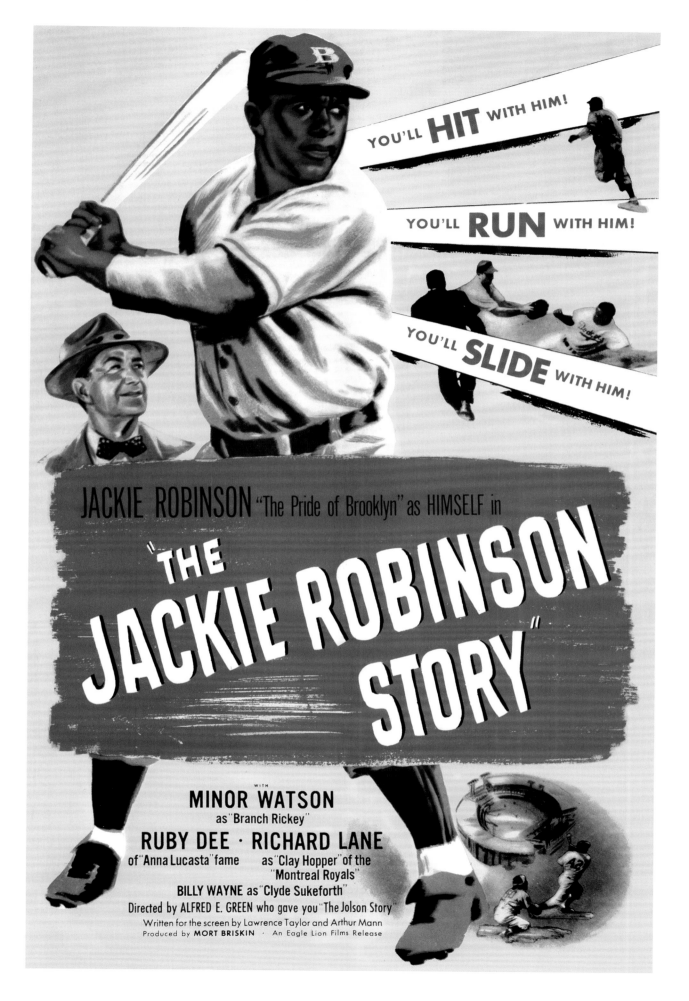

Sidney Poitier

Few figures have had as vital and decisive an impact on the depiction of African Americans on screen as Sidney Poitier. Between 1950 and the late 1960s, he came to epitomize the troubled, persecuted, yet still conciliatory, black man who was determined to assert his independence in a white world. Most of the characters that Poitier played were decent, intelligent, almost saintly men who white audiences found attractive and unthreatening. He was invariably polite on screen, clean-cut, soft-spoken, and imbued with Christian tolerance and compassion. Yet for those same reasons, he was often viewed with disdain by those who, from the mid 1960s onwards, wanted to see African Americans taking an overtly militant and revolutionary stance against the Establishment. Nonetheless, it could be argued that no man did more in his time to alter the popular perception of what was then called "the New Negro" than Poitier. His on-screen turmoil and struggle to assert his civil rights reflected the wider crusades that were beginning to register on the American national imagination and that ultimately led to the legal and social breakthroughs of the 1960s.

Sidney Poitier was born in Miami, Florida, in 1927, prematurely, to parents who had come from the Bahamas to sell their tomato crop at the city's produce market. He spent his youth in Nassau. As a teenager, he made his way to New York, where he struggled to make a living washing dishes. In 1943 he joined the army and, after serving two years in a medical unit, returned to Harlem. After noticing in the *Amsterdam News* a classified ad for "Actors Wanted" for the American Negro Theater, he began studying acting and soon started performing as part of a group of post-World War II black actors that included Harry Belafonte, Ossie Davis, Ruby Dee, and Lloyd Richards (who years later directed Poitier in the stage version of *A Raisin in the Sun*).

Poitier first arrived in Hollywood in late 1949, to make his big screen debut with striking impact in *No Way Out* (1950), writer/director Joseph Mankiewicz's lesson on tolerance—an unflinching look at the struggle against racism. Poitier's name quickly became synonymous not only with roles of courage and dignity but also with strong box office receipts. With such films as *Blackboard Jungle* (1955), *Edge of the City* (1957), *The Defiant Ones* (1958), *Porgy and Bess* (1959), and *A Raisin in the Sun* (1961), he pushed Hollywood's boundaries of racial integration even further.

In 1963 Poitier became the first African American to win an Academy Award for Best Actor for his role in *Lilies of the Field*. In that film, he played Homer Smith, an easy-going ex-GI who meets a group of German nuns trying to build a chapel in the Arizona desert. After agreeing to work for them for just one day, Homer stays on, so inspired by their faith that he takes on extra jobs to help pay for the building materials, and musters the resources of the neighboring citizens to complete the project. The church, he realizes, is an important symbol to the community and raising it will in turn raise the hopes of the impoverished and oppressed townspeople. The day the church is to be consecrated, however, Homer leaves, knowing that he has already fulfilled the sisters' ambitions and his own. Ralph Nelson, the film's director, managed to wrap the entire shoot in just fourteen days—extraordinary for an Academy Award-winning film.

In his interracial love stories, *A Patch of Blue* (1965) and *Guess Who's Coming to Dinner* (1967); his coming-of-age drama, *To Sir, with Love* (1967); and the racially provocative *In the Heat of the Night* (1967), Poitier continued to redefine the long overdue presence of African-American actors in Hollywood. For a time during the late 1960s, though, it became fashionable to denigrate his "integrationist" role in American film history. As 1970s black audiences became more tuned into the new era of blaxploitation films like *Sweet Sweetback's Baadasssss Song* (1971), *Shaft* (1971), and *Super Fly* (1972), Poitier switched course and began directing films. With the post-Civil War drama *Buck and the Preacher* (1972) and the trio of comedies *Uptown Saturday Night* (1974), *Let's Do it Again* (1975), and *A Piece of the Action* (1977), Poitier re-invented his popularity in the black community.

For much of the 1980s, Poitier all but abandoned his acting in favor of directing a few unremarkable features. As film historian Donald Bogle explains, "Oddly, these features lacked the dramatic intensity that had distinguished Poitier as an actor. Sadly, too, the 1980s generation seemed unaware of what a great dramatic talent he had been in the past." Since then, he has made occasional appearances on the big screen and on television, while also serving (in honor of his parents' origins) as Ambassador to The Bahamas, both to Japan and to UNESCO. Poitier occupies a singular and well-deserved place in film history and is recognized globally as a true industry pioneer.

Opposite: **NO WAY OUT (1950), Sidney Poitier**

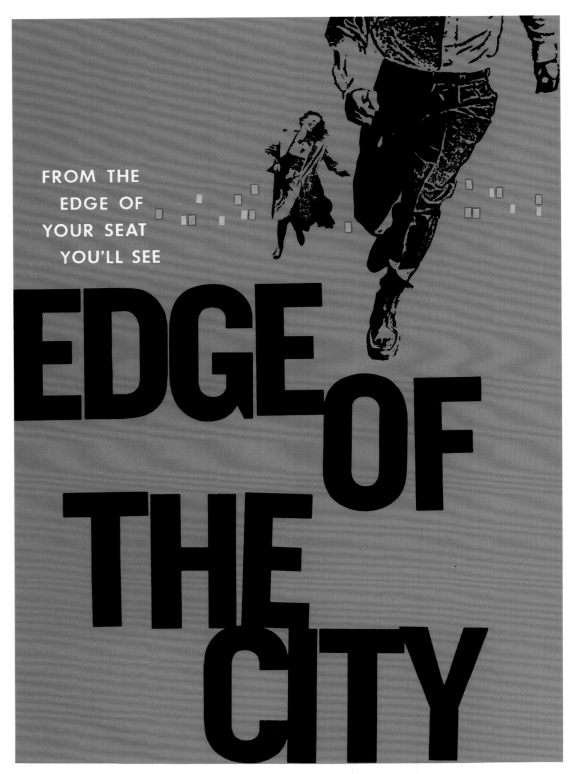

FROM THE
EDGE OF
YOUR SEAT
YOU'LL SEE

EDGE
OF
THE
CITY

No Way Out (1950) marked the debut of a twenty-three-year-old Poitier, as well as the extraordinary husband and wife team, Ossie Davis and Ruby Dee. As the distinctive design of Paul Rand's poster for the film confirms, credits for Poitier list him merely as one of the supporting cast members, yet his role as Luther Brooks, an educated, bright, African-American medical intern at a metropolitan hospital, was clearly central to the plot.

When a pair of white racist brothers are shot by police during a foiled gas station robbery, Brooks tends to them in the hospital's prison ward. When one dies, the other—a snarling repellent racist (played by Richard Widmark) vilely obsessed with vengeance—accuses Brooks of murder and retaliates by instigating a race riot in the neighboring white shantytown. Brooks, who must fight to prove his innocence, seeks an autopsy that will exonerate him.

The film dared to deal directly with racism in a way that earlier films had mostly hinted at. Fearing that the film's release in the South could incite a riot, Twentieth Century Fox completely avoided the subject matter in all of their advertising campaigns: the posters, film trailers, and newspaper ads chose to promote the film as a "noir melodrama" instead.

At a time when segregation was still rife in the American mindset, *Edge of the City* (1957) became a milestone in cinematic history; the first film to show a black man as a fully-integrated, first-class citizen, rather than a "problem," as in the cycle of liberal dramas several years earlier. Based on writer Robert Alan Aurthur and producer David Susskind's television drama starring Poitier, *A Man Is Ten Feet Tall*, the film—which saw Poitier reprise his role—focused on the notion that friendship can defy race. Poitier and co-star John Cassavetes are dock workers in the New York railroad yards who develop an unlikely interracial friendship. When their racist boss objects, a severe price is paid. As instructed by studio brass, Saul Bass's artwork for the poster, while a striking and compelling design, again avoids any indication of a racial element to the film.

Left: **EDGE OF THE CITY (1957)**
Opposite: **NO WAY OUT (1950)**

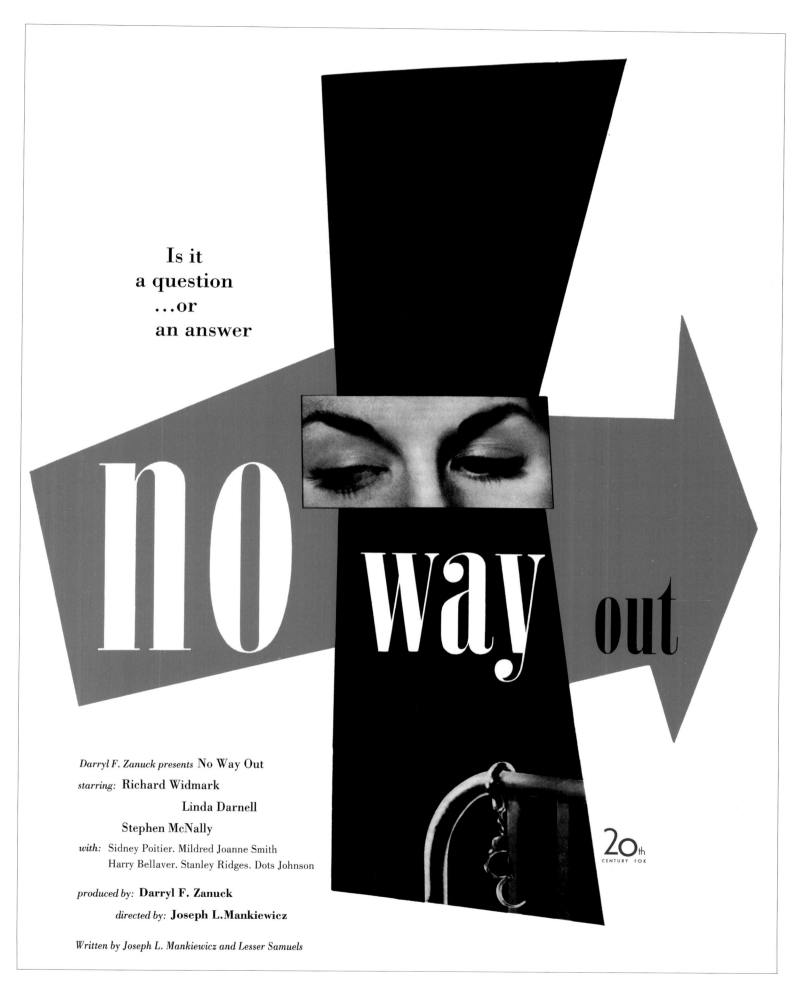

Is it
a question
…or
an answer

no way out

Darryl F. Zanuck presents No Way Out
starring: Richard Widmark
Linda Darnell
Stephen McNally
with: Sidney Poitier. Mildred Joanne Smith
Harry Bellaver. Stanley Ridges. Dots Johnson

produced by: **Darryl F. Zanuck**
directed by: **Joseph L.Mankiewicz**

Written by Joseph L. Mankiewicz and Lesser Samuels

20th
CENTURY FOX

Sidney Poitier, Rod Steiger in
**IN DER HITZE
DER NACHT**
**Mit Warren Oates, Lee Grant
DREHBUCH:
STIRLING SILLIPHANT
REGIE: NORMAN JEWISON
Musik:Quincy Jones.Das Lied
„In der Hitze der Nacht" wird
gesungen von Ray Charles
Produktion:Norman Jewison
–Walter Mirisch
Ein amerikanischer Farbfilm**

ERHARD GRÜTTNER.

The gritty tone of *In the Heat of the Night* (1967) was set from the start: the first sound the audience hears is Ray Charles' guttural voice delivering the title song, which is the highlight of Quincy Jones' jazz and blues-inspired soundtrack. Norman Jewison's direction drew remarkable performances from both of his stars: Sidney Poitier and Rod Steiger.

This was a detective thriller, set in the small town of Sparta, Mississippi (but filmed in Sparta, Illinois, presumably to avoid the same racial problems that the film dramatized). Based on the novel by John Ball, it featured Steiger as a bigoted white sheriff, and Poitier as Virgil Tibbs, a well-dressed black stranger who is picked up at the local train station on suspicion of the murder of a wealthy industrialist. "On your feet, boy," the arresting officer addresses him, instantly establishing the racial attitude of Sparta, and the movie.

Tibbs, it transpires, is a homicide detective from Philadelphia who soon embarrasses Sheriff Gillespie with his shrewd investigative skills. Yet as the unlikely pair work together to solve the crime, their initial dislike for each other develops into a mutual, though grudging, respect.

The film portrays that ambivalent relationship with great technical skill—much of the credit due to Director of Photography, Haskell Wexler. It is unsurprising that *In the Heat of the Night* was nominated for seven Academy Awards. The film won Best Picture, and Steiger won the Oscar for Best Actor. Poitier, in what was one of his finest roles, surprisingly walked away with nothing other than an offer to reprise his role as Detective Tibbs in two other films, *They Call Me Mister Tibbs!* (1970) and *The Organization* (1971).

Left: **IN THE HEAT OF THE NIGHT** (1967), East German
Opposite: **IN THE HEAT OF THE NIGHT** (1967)

"THEY GOT A MURDER ON THEIR HANDS. THEY DON'T KNOW WHAT TO DO WITH IT."

THE MIRISCH CORPORATION Presents

SIDNEY POITIER ROD STEIGER

in THE NORMAN JEWISON- WALTER MIRISCH PRODUCTION

"IN THE HEAT OF THE NIGHT"

co-starring
WARREN OATES
LEE GRANT

Screenplay by
STIRLING SILLIPHANT

Produced by
WALTER MIRISCH

Directed by
NORMAN JEWISON

COLOR by DeLuxe MUSIC – QUINCY JONES "IN THE HEAT OF THE NIGHT" sung by RAY CHARLES

RELEASED THRU
UNITED ARTISTS
A Transamerica COMPANY

Suggested For Mature Audiences ORIGINAL MOTION PICTURE SOUNDTRACK AVAILABLE ON UNITED ARTISTS RECORDS

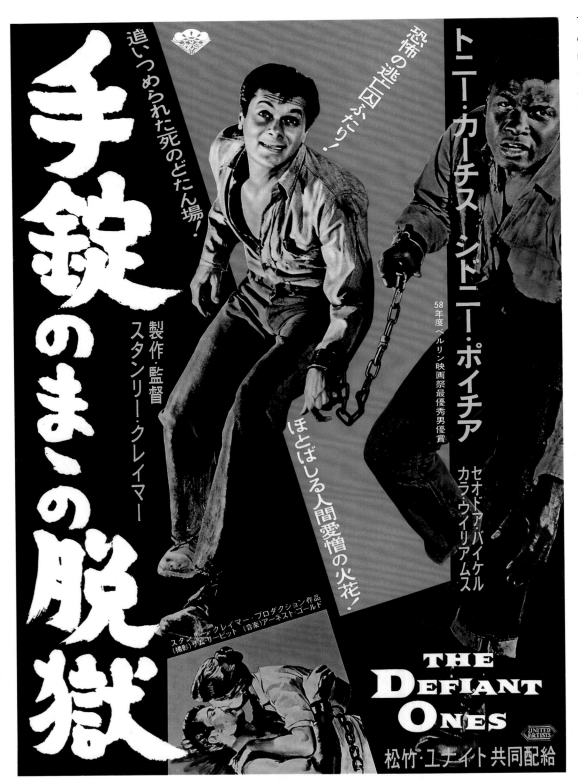

The theme of racial conflict that runs through much of Sidney Poitier's work was examined in two of his most popular films, both projects by Hollywood's most unabashedly liberal director, Stanley Kramer. In *The Defiant Ones* (1958), two convicts—one black (Poitier), one white (Tony Curtis)—escape from an overturned prison van. As they flee through woods and swamps, they stay together, shackled by a two-foot chain. They are a portrait in contrasts: Curtis, loud, bigoted and threatening; Poitier, quietly simmering with anger from a lifetime of racism. They taunt one another, argue and fight. But by the time their chains are finally severed and they are free to go their separate ways, an unseen bond unites them.

Today, the symbolism of *The Defiant Ones* is obvious. But in 1958, its message was still powerful and controversial. United Artists released the film only four years after the Supreme Court ruling against segregation in the Brown v. Board of Education case; the Montgomery bus boycott was still fresh in American minds and the civil rights laws of the 1960s were a far-off dream.

Almost a decade later, Kramer's *Guess Who's Coming to Dinner* (1967) picked up on the implications of the civil rights movement, at a time when an interracial kiss on screen could still be profoundly shocking. The film marked the final reunion of veteran actors Katharine Hepburn and Spencer Tracy (who died shortly after shooting ended), and would have had resonance with its audience for that reason alone. But the fun lies in watching two self-satisfied white liberals being forced to confront their own hypocrisy, when their daughter brings home an African-American boyfriend (Poitier), whom she intends to marry. Kramer's footage of an interracial love scene ended up on the cutting-room floor, and the audience glimpsed only one fleeting kiss in a taxi's rearview mirror during the opening credits. Still, Kramer succeeded in prompting viewers to examine their own attitudes on race relations. The film was a box-office hit, and Poitier was voted the most popular male star by the Theater Owners of America.

Left: **THE DEFIANT ONES** (1958), Japanese
Opposite: **GUESS WHO'S COMING TO DINNER** (1967), Japanese

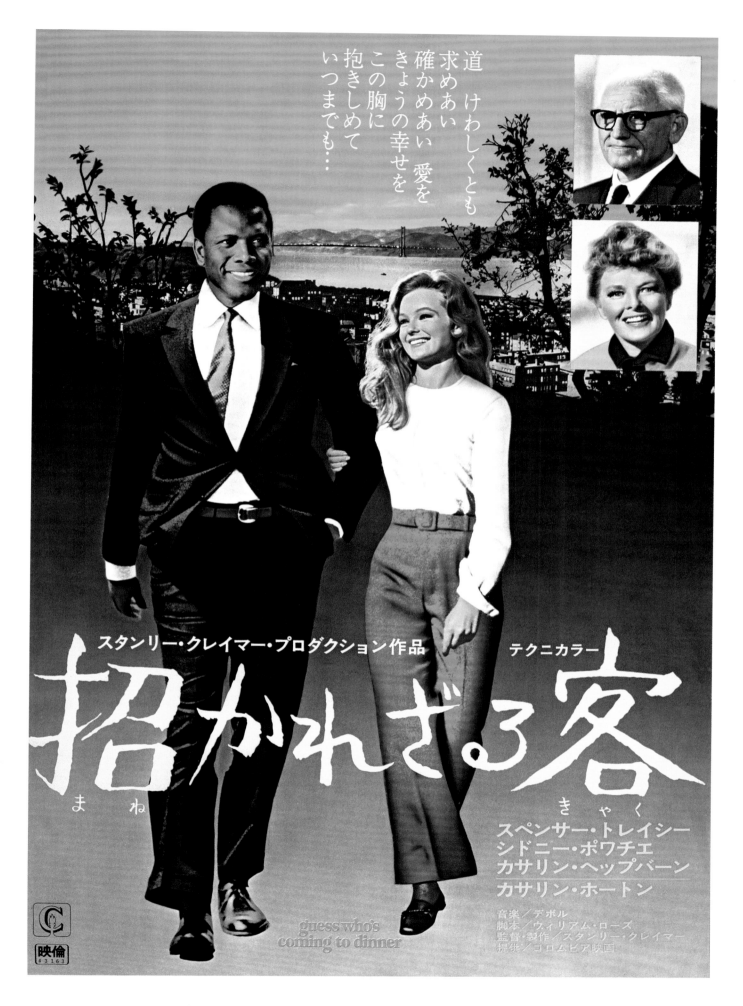

guess who's
coming to dinner

Amerykański melodramat filmowy

W CIENIU DOBREGO DRZEWA

REŻYSERIA: GUY GREEN

W rolach głównych: SIDNEY POITIER,
SHELLEY WINTERS, ELISABETH HARTMAN,
WALLACE FORD,

A Patch of Blue (1965) treated the issues of interracial romance with less detail, and not as openly, as its groundbreaking successor in the genre, Guess Who's Coming to Dinner (1967). However, the film tells a sensitive story about the beauty of friendship and the cruel reality of prejudice. Elizabeth Hartman (in her screen debut) starred as an eighteen-year-old white blind girl who meets a professional businessman (played by Sidney Poitier) in the park where she sells beads. They befriend each other and as he tends to her welfare, helping her overcome the barriers of disability, a romance blossoms. She is unaware, however, that he is black. Their relationship is sweet, heartbreaking, and under the circumstances of the era, also taboo.

Racism plays a more subtle role in To Sir, with Love (1967) because the film takes place in Britain, where discrimination paled in comparison to America. Poitier played a teacher at a school in London's tough East End. In order to reach his rebellious and unruly students, he rejects the textbooks and teaches them life lessons instead. Writer/director James Clavell's adaptation of E. R. Braithwaite's 1959 semi-autobiographical novel of the same name, allowed Poitier to come full circle: from being a disruptive student himself in Blackboard Jungle (1955) to the respected "Sir," as he becomes affectionately known. His pupils include three of the most iconic young British actors of the era; Judy Geeson, Suzy Kendall, and singer Lulu, who contributed the hit title song.

The ability of international graphic designers to transcend the barriers of a different culture, via art, is reflected in the advertising campaigns in Poland of both Maria Ihnatowicz's stark, chalk-like, black and white illustration for To Sir, with Love (1967) and the deliberately childlike simplicity of Marian Stachurski's painting for A Patch of Blue (1965).

Left: **A PATCH OF BLUE (1965), Polish**
Opposite: **TO SIR, WITH LOVE (1967), Polish**

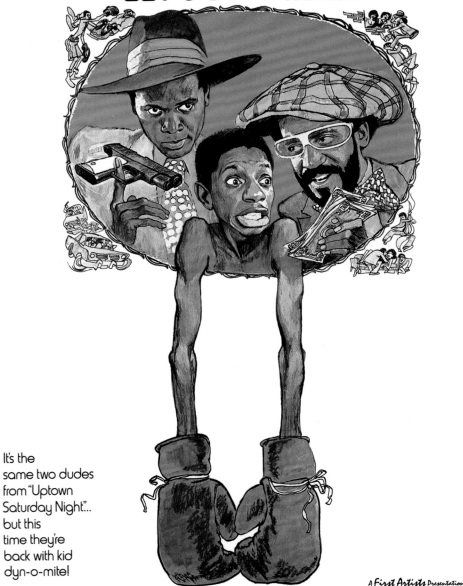

It's the
same two dudes
from "Uptown
Saturday Night"...
but this
time they're
back with kid
dyn-o-mite!

After more than a decade of playing men of integrity in a string of "socially responsible" dramatic films, Sidney Poitier was keen to expand his range and explore his talents as a film director. His first such project was a successful western, *Buck and the Preacher* (1972), followed by the more romantic *A Warm December* (1973). The black community loved them both; signaling a solid hit for Poitier's efforts.

In a complete, and courageous, change of direction, he next tried his hand at comedy. *Uptown Saturday Night* (1974) became the first of an unofficial trilogy of hit films which paired him as the straight man to Bill Cosby's more outrageous characters. As the trailer for the film explained, they were "a couple of regular guys, trying to hit the big time … before the big time hits them." They get involved in some crazy situations with some equally crazy criminals, in a plot populated with a high-powered ensemble cast of well-known black actors. Richard Pryor, Calvin Lockhart, Flip Wilson, and a virtually unrecognizable Harry Belafonte were among those who provide the comedy with its richest caricatures.

Uptown Saturday Night proved to be so successful that Hollywood demanded two more vehicles for the Poitier and Cosby coupling: the boxing comedy drama *Let's Do It Again* (1975), and the urban crime comedy *A Piece of the Action* (1977). All three films featured posters and publicity material designed by Bill Gold with art by Jack Rickard; while soul star Curtis Mayfield specially composed the soundtrack music for the latter two. Poitier's knack for directing comedy movies reached its zenith in 1980 with *Stir Crazy*, which starred Richard Pryor and Gene Wilder, and grossed more than $100 million at the box office.

Left: **LET'S DO IT AGAIN (1975)**
Opposite: **LET'S DO IT AGAIN (1975), Alternative artwork**

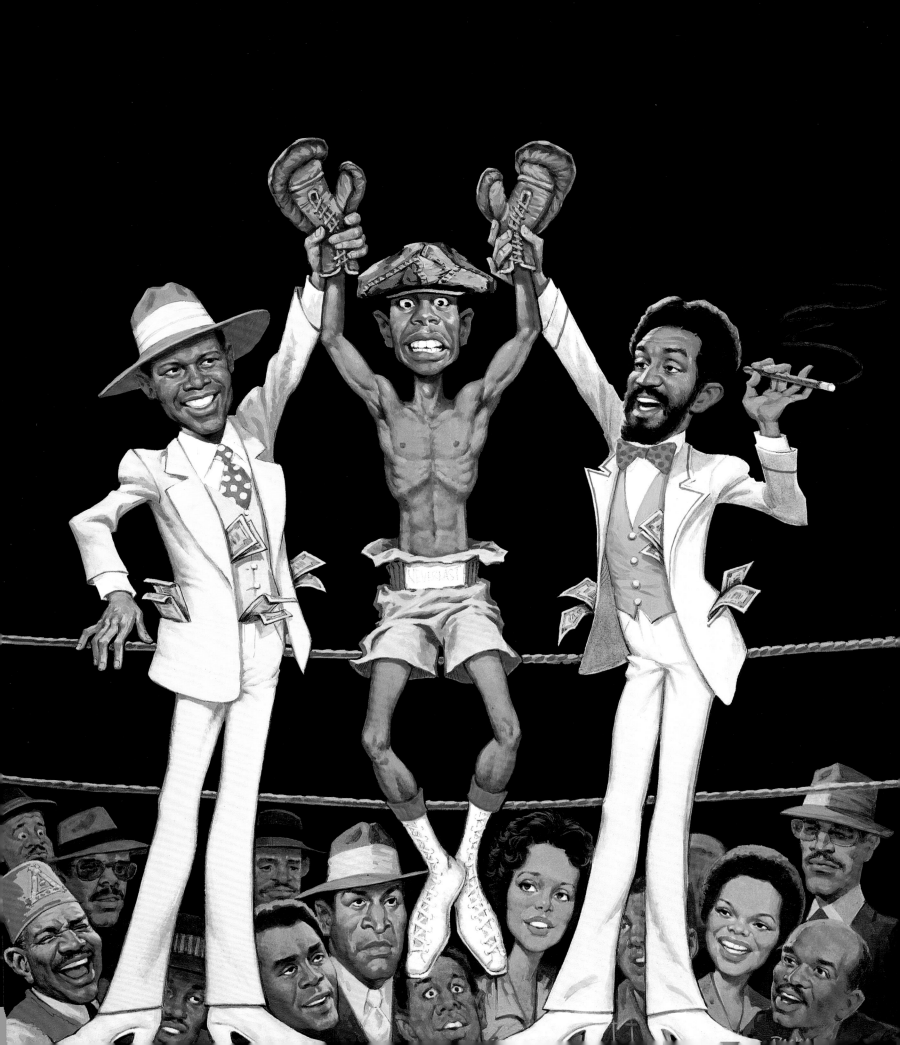

Dorothy Dandridge

Born in Cleveland, Ohio, in 1922, Dorothy Dandridge was encouraged into show business by her mother Ruby, herself a performer and aspiring actress. From an early age, Dorothy sang and danced with her older sister Vivian under the name of "The Wonder Children." They earned a spot on the National Baptist Convention touring churches for three years throughout the South. In the 1930s, fortune came in the form of a cameo for the girls in the Marx Brothers' comedy, *A Day at the Races* (1937). As teenagers, Dorothy and Vivian teamed up with a friend, Etta Jones, formed the Dandridge Sisters, and began singing on tour with the famous swing band, the Jimmie Lunceford Orchestra, and later with Cab Calloway's band at the Cotton Club in New York. In 1935, the trio began performing as a "specialty act" in films such as *The Big Broadcast of 1936* (1935), *Easy to Take* (1936), *It Can't Last Forever* (1937), *Going Places* (1938), *Snow Gets in Your Eyes* (1938), and *Irene* (1940), before Dorothy finally began to be offered solo roles.

It was in the race film *Four Shall Die* (1940) that Dandridge made her feature film debut. Her first major break came a year later in 1941 in *Sun Valley Serenade*, a big budget Hollywood film in which she joined the dancing Nicholas Brothers for their famous song and dance number, "Chattanooga Choo Choo." Dandridge also starred in a series of "soundies"—musical shorts viewed on a visual jukebox that were a forerunner to modern music videos—including *Cow Cow Boogie* (1941), *Swing for your Supper* (1941), *A Jig in the Jungle* (1941), *Paper Doll* (1942), and *Zoot Suit* (1942).

Just shy of her twentieth birthday, Dandridge embarked on what proved to be a troubled marriage with fellow teenage star Harold Nicholas of the Nicholas Brothers. They had a daughter who was born handicapped, and this strain undoubtedly contributed to the collapse of the marriage, and their subsequent divorce in 1951. Dandridge was a very private woman in a very public profession. On screen, there were no hints that anything was wrong when, for example, she performed a duet with the legendary Louis Armstrong in 1944's *Pillow to Post*. The financing of her daughter's full-time health care, however, became expensive and Dandridge had to concentrate on advancing her career by returning to the nightclub circuit both in America and abroad.

In 1948, she joined the Actors' Lab in Los Angeles where she flourished in the creative atmosphere that also allowed her to hone her craft. She returned to the screen for a role as an African Queen opposite Lex Barker in *Tarzan's Peril* (1951). When the Hollywood censorship bureau voiced objections to the film's blatant sexuality, Dandridge suddenly gained "crossover" appeal to black and white audiences alike. By the time she turned thirty, she was reaching new heights in her career on stage, film, and television. In 1953, her celebrated club act led to her first starring role in a major Hollywood film, *Bright Road*. A year later, she starred as a tempestuous femme fatale in the famous Hollywood musical *Carmen Jones*, securing her the kind of recognition that ensured her popularity as a bona fide movie star. Her unforgettable performance earned her the distinction of being the first African-American woman to receive a nomination for an Academy Award for Best Actress. *Life* magazine even featured her on its cover, in recognition of her triumph and new level of celebrity.

Despite the publicity and attention, however, there were no great follow up roles for Dandridge and she returned to television and nightclub work. Her off-screen life was also unraveling. After a four-year affair with a married man—*Carmen Jones'* director Otto Preminger—she became disenchanted and abruptly ended the relationship. Three years passed before she made another movie. Desperate, she accepted a supporting role in three interracial love stories that did little for her career: *Island in the Sun* (1957), *Tamango* (1958), and *The Decks Ran Red* (1958). In 1959, Samuel Goldwyn produced a big budget adaptation of the Gershwin musical *Porgy and Bess*. Dandridge signed on to play Bess (opposite Sidney Poitier's Porgy). When director Rouben Mamoulian stepped down and Otto Preminger replaced him, things became tense on set.

It was also in 1959 that Dandridge embarked on her second marriage, to white restaurateur Jack Denison. The union drained her emotionally and financially, ending in bankruptcy and divorce in 1962. At forty, Dandridge found herself alone, in debt, and in a downward emotional spiral. There were no movie jobs, few club offers, and only occasional television appearances. In September 1965, tragedy struck when a drug overdose of anti-depressant pills claimed her life at the age of forty-two, a bitter end to a career that had showed so much talent and unfulfilled promise.

Opposite: **CARMEN JONES (1954), Dorothy Dandridge**

Dorothy Dandridge

Carmen Jones

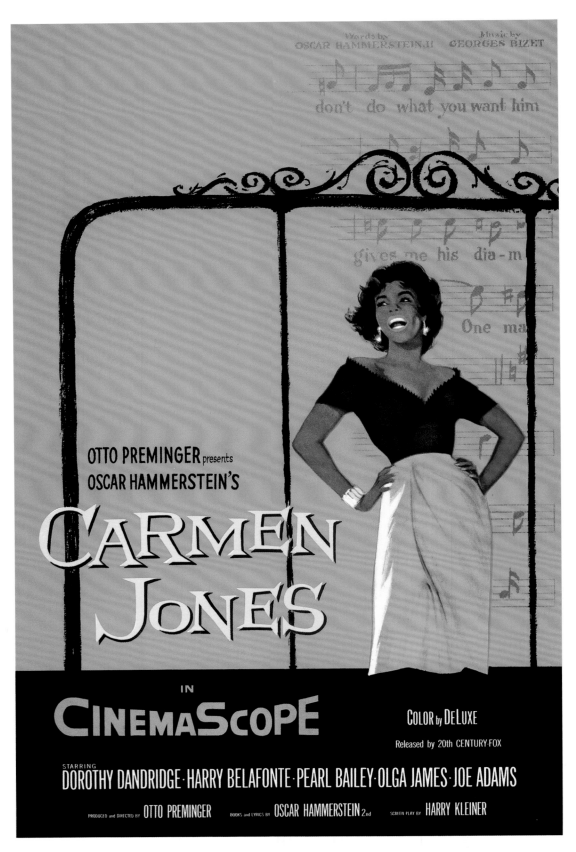

Twentieth Century Fox's *Carmen Jones* (1954) was the first all-black-cast musical released by a Hollywood studio since *Stormy Weather* (another Fox project) in 1943. With magnificent lyrics by Oscar Hammerstein II set to the music of Georges Bizet, *Carmen Jones* presented a lavish, Americanized, all-black version of Bizet's classic opera *Carmen* (based, in turn, on a novella by Prosper Mérimée).

Carmen Jones (Dorothy Dandridge)—a sexy "hot bundle" according to the script—lures Joe (Harry Belafonte), a handsome soldier headed for Officers' Flight School, away from his sweetheart, Cindy Lou (Olga James), and causes tensions with his sergeant (Brock Peters). Although Joe deserts his regiment and runs away with Carmen, she soon tires of him and takes up with a heavyweight prizefighter, Husky Miller (Joe Adams), in a betrayal that prompts Joe's tragic revenge.

Dandridge and Belafonte were accomplished singers, however, neither had the necessary operatic range, so Marilyn Horne (then a nineteen-year-old student) and LaVern Hutcherson dubbed their voices. Featured in the film as Carmen's gold-digging friends were Pearl Bailey, who performed "Beat Out Dat Rhythm on a Drum," and Diahann Carroll, making her Hollywood feature film debut. Directed by Otto Preminger, *Carmen Jones* received two Academy Award nominations, including Best Actress for Dandridge, the first black woman to be so honored.

Left: CARMEN JONES (1954)
Opposite: CARMEN JONES (1954), Italian

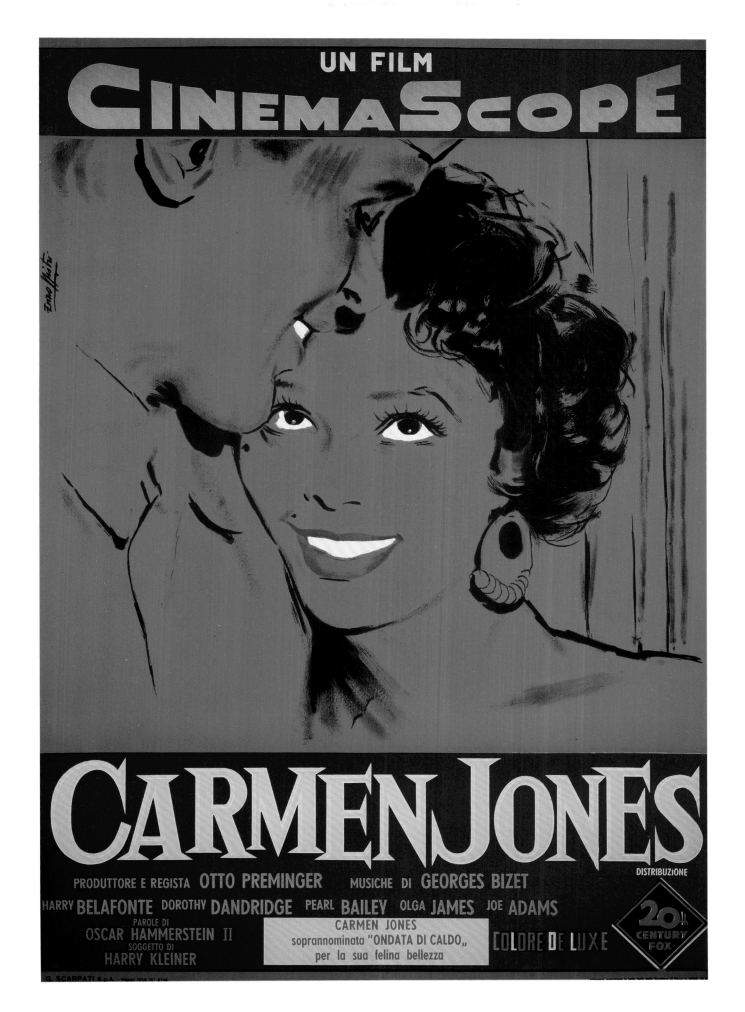

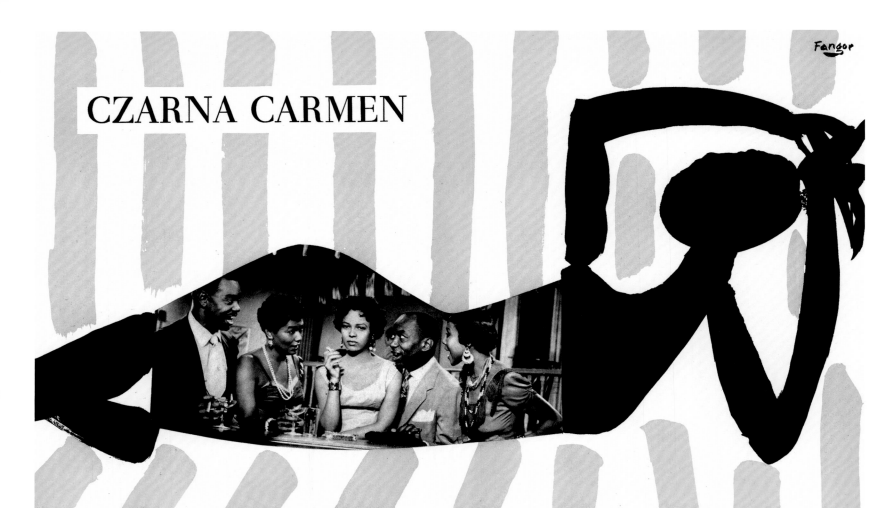

CZARNA CARMEN

Barwny film produkcji amerykańskiej Reżyseria: Otto Preminger W rolach głównych: Harry Belafonte, Dorothy Dandridge

Above: **CARMEN JONES (1954), Polish**
Opposite: **CARMEN JONES (1954), Polish**

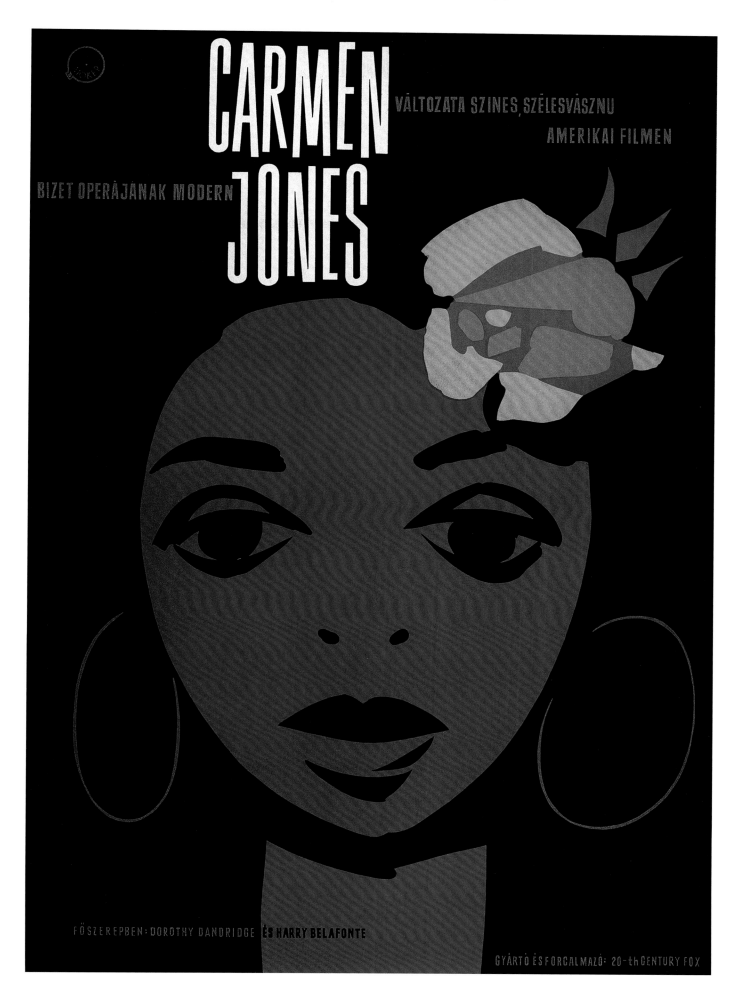

Porgy and Bess

SAMUEL **GOLDWYN** PRESENTA IL CAPOLAVORO DI **GEORGE GERSHWIN**

PORGY and BESS

SIDNEY **POITIER** · DOROTHY **DANDRIDGE** · SAMMY **DAVIS** Jr. · PEARL **BAILEY**

MUSICA DI **GEORGE GERSHWIN** LIBRETTO DI **DU BOSE HEYWARD**

LIRICHE DI **DU BOSE HEYWARD** E **IRA GERSHWIN**

(TRATTO DALL'OPERA DI "PORGY" DU BOSE E DOROTHY HEYWARD) ORIGINARIAMENTE REALIZZATA PER LA SCENA DA **THE THEATRE GUILD** SCENEGGIATURA DI **N. RICHARD NASH**

REGIA DI **OTTO PREMINGER** DISTRIBUZIONE **CEIAD COLUMBIA** · **CINEMASCOPE** · **TECHNICOLOR**®

The film version of the famous Gershwin opera *Porgy and Bess* (1959) brought to an end the thirty-year cycle of extravagant, all-black-cast Hollywood musicals that had begun with *Hearts in Dixie* in 1929.

The Negro folk tale set in a pre-World War I ghetto area of Charleston, South Carolina, known as "Catfish Row," had long fascinated American audiences. Based on DuBose Heyward's 1925 novel *Porgy*, a subsequent dramatized Broadway production, and its operatic adaptation by George and Ira Gershwin, the score contained such familiar and enduringly popular numbers as "Summertime," "It Ain't Necessarily So," "I Got Plenty O' Nuttin'," and "I Loves You, Porgy."

After Harry Belafonte had rejected the opportunity to play Porgy, Sidney Poitier was the studio's next choice. Samuel Goldwyn exerted pressure on him to agree, threatening politely that if he refused, he might lose the role he was about to play in *The Defiant Ones*, alongside Tony Curtis. Dorothy Dandridge also starred, along with several of her *Carmen Jones* alumnae, including director Otto Preminger, and actors Pearl Bailey, Brock Peters, and Diahann Carroll. Sammy Davis Jr. also appeared in a role originally intended for Cab Calloway.

Left: **PORGY AND BESS** (1959), Italian
Opposite: **PORGY AND BESS** (1959), German

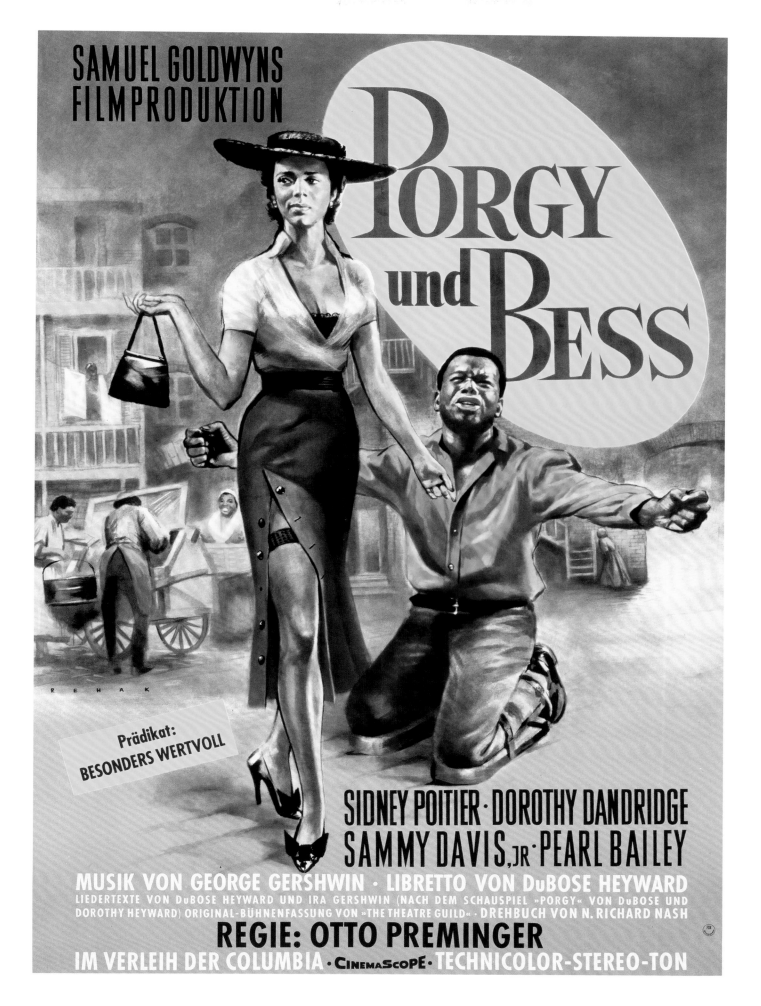

ЛЕНИНГРАДСКИЙ
ГОСУДАРСТВЕННЫЙ
ОРДЕНА ЛЕНИНА
АКАДЕМИЧЕСКИЙ
МАЛЫЙ ТЕАТР
ОПЕРЫ
И
БАЛЕТА

Дж. ГЕРШВИН

ПОРГИ
И
БЕСС

Музыкальный руководитель и дирижер — лауреат Государственной премии РСФСР им. М. Глинки. заслуженный артист РСФСР
Ю. ТЕМИРКАНОВ
Режиссер-постановщик народный артист РСФСР
Э. ПАСЫНКОВ
Художник
О. ЦЕЛКОВ

While critics were respectful of the actors and exceptionally kind in their reviews of *Porgy and Bess*, Columbia Pictures never recouped its original costs, a failure that persuaded producer Samuel Goldwyn to call it quits after forty-five years in the film business. The disappointing box-office receipts may well have been caused by the negative reaction to the project from the NAACP on the grounds that the story contributed to the denigration of African Americans. Such qualms about the negative portrayal of the black characters had been raised as early as 1935, when the opera was premiered. Some African-American performers considered Gershwin's piece a racial travesty; others regarded it as a masterpiece. And there were those, such as Duke Ellington, who disliked the implications of *Porgy and Bess*, but found the musical material irresistible.

Ironically, the film adaptation was criticized from another angle entirely: the guardians of the Gershwin estate. They protested that the movie had cut too much of the maestro's music, simplified his orchestral arrangements, and ruined the unity of the original opera. Indeed, they had the last word: fifteen years after the film was released, it was withdrawn permanently from circulation at the demand of the estate. It has never been given an official release on DVD.

Left: **PORGY AND BESS (1959), Russian**
Opposite: **PORGY AND BESS (1959), East German**

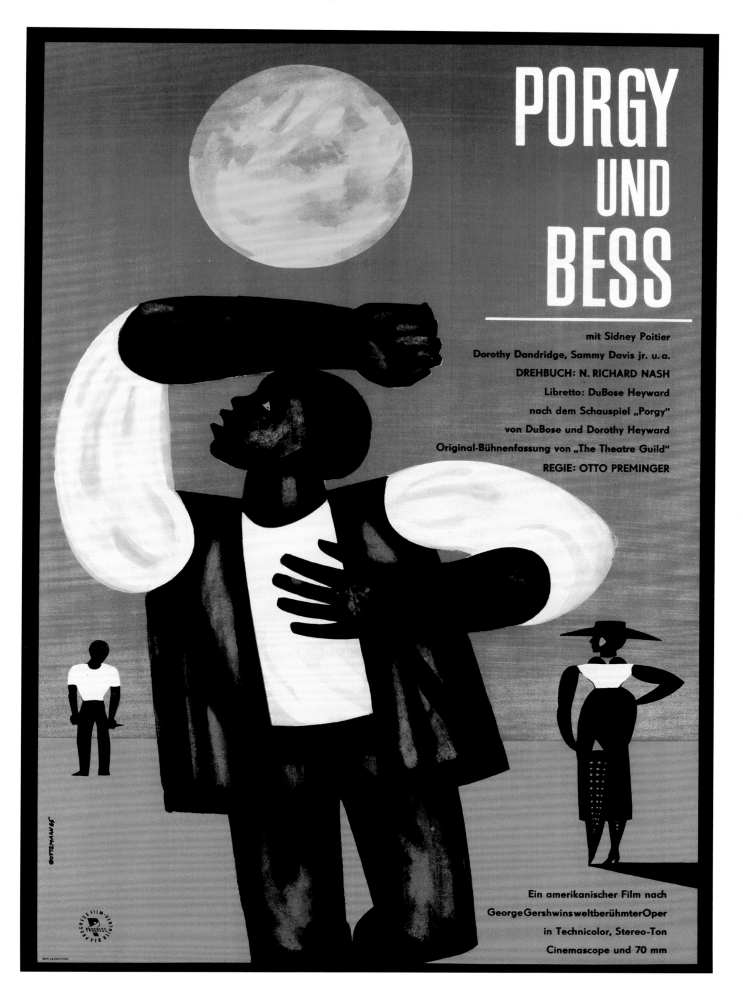

Harry Belafonte

Born in Harlem, New York, in 1927, Harry Belafonte spent part of his childhood in his mother's native Kingston, Jamaica. He finished high school back in New York before shipping off to the Navy during World War II. He began singing in clubs in the 1950s, in order to pay for acting classes at the American Negro Theater and the Dramatic Workshop of the New School, and ignited the calypso music boom that swept through the American music industry in the 1950s. His 1956 album, *Calypso*, sold over a million and a half copies, yielding such familiar hit songs as "Day-O (The Banana Boat Song)," "Jamaica Farewell," and "Man Smart (Woman Smarter)." A string of successful record releases established him as one of the top three male stars of the decade, alongside Frank Sinatra and Elvis Presley. Yet Belafonte's first love was acting. His good looks and distinctive voice made him a prime candidate for Hollywood's first African-American romantic hero. In 1953, Belafonte made his debut in the movie *Bright Road*, the first of three in which he appeared with Dorothy Dandridge. A year later, *Carmen Jones* shot Belafonte to stardom, and in 1957 he titillated audiences in the interracial potboiler *Island in the Sun*.

In 1959, *Odds Against Tomorrow* gave Belafonte the opportunity to tackle a grittier character, one filled with a steely, fierce determination. It was a film noir drama in which a disgraced former police officer (Ed Begley Sr.) in need of cash turns to crime by planning a bank heist in Hudson, New York, with two accomplices, a jazz musician (Belafonte) and a troubled war veteran (Robert Ryan), whose racial fears and prejudices threaten to jeopardize the job.

Abraham Polansky wrote the screenplay, but credited it to his friend, black novelist John O. Killens, because he was blacklisted. The evocative soundtrack featured John Lewis of The Modern Jazz Quartet. The film also marks the (uncredited) screen debut of Cicely Tyson.

Above: **ODDS AGAINST TOMORROW (1959)**, Mae Barnes and Harry Belafonte
Opposite: **ODDS AGAINST TOMORROW (1959)**

ALL THE ANGER IN THIS MAN ...ALL THE SUSPENSE THE SCREEN CAN HOLD...TOGETHER THEY MAKE THE GREATNESS OF **ODDS AGAINST TOMORROW**

After the atomic bombs fell on Japan in August 1945, Hollywood became fascinated with producing a film about the end of civilization and a post-apocalyptic world. One of the first "post-nuclear" films was *Five*, made by independent producer/director Arch Oboler for Columbia Pictures in 1951. Three years later, novelist Richard Matheson wrote *I Am Legend*, which filmmakers adapted to the screen multiple times over the next fifty years, most recently with the 2007 Will Smith remake.

In 1959, Harry Belafonte produced (and starred in) *The World, the Flesh and the Devil*, a doomsday scenario that takes place in New York City. Belafonte plays a mine inspector working underground in Pennsylvania when a nuclear bomb detonates. He emerges to find himself— or so he believes—the last human being alive. Making his way to New York in search of survivors, he wanders around Manhattan for days in despair, through deserted streets and canyon-like avenues that are littered with overturned buses and debris. When a white woman (Inger Stevens) appears, they develop a tight friendship. But when a third survivor (Mel Ferrer) shows up, the stage is set for a clash of romance and race as Stevens finds herself torn between the two men, one white, one black. *The World, the Flesh and the Devil* attempted to make a statement about race and humanity by presenting the controversial subject of interracial romance in the days before the Civil Rights Act of 1964.

Not long after the film's release, and at the height of his career, Belafonte sidelined acting to spend the 1960s supporting the civil rights movement. He became Hollywood's principle figurehead, serving as Martin Luther King Jr.'s chief fundraiser and liaison to Attorney General Robert Kennedy. His significant financial contributions greatly helped the success of the Freedom Riders in the South, the March on Washington in 1963, and the Freedom Summer voting drives in 1964. He continues his dedication to civil and humanitarian causes into the twenty-first century.

Left: **THE WORLD, THE FLESH AND THE DEVIL (1959),**
Harry Belafonte
Opposite: **THE WORLD, THE FLESH AND THE DEVIL (1959)**

The Most
Unusual Story
Ever Told!

M-G-M presents
A SOL C. SIEGEL
PRODUCTION
starring

HARRY
BELAFONTE

INGER
STEVENS

MEL
FERRER

the
WORLD,
the
FLESH
and the
DEVIL

Exploitation

While the major Hollywood studios competed to offer more spectacular productions, more dramatic technical innovations, and bigger stars than their rivals, a very different ethos held sway among some of the industry's smaller and less well-funded production companies in the 1950s and 60s. This was the era when theaters presented double bills: the main attraction supported by a cheaper "B-movie." These second-tier offerings were either major-studio releases deemed unlikely to succeed on their own; or else low-budget productions made by independent studios.

Free from any attempt to create cinematic art, and from the self-imposed "production code" that operated a form of censorship on major releases, these indie films explored themes and plots considered too risqué or too ridiculous for major studios like Warner Bros. or MGM to tackle. Instead, they exploited their audience's desire for cheap thrills—sex, violence, drug use, and other taboo subjects—and therefore came to be called "exploitation" films.

Inevitably, exploitation films offered fertile ground for titles concerning issues of racial conflict. In *I Passed for White* (1960), an apparently Caucasian mother desperately asks if her newborn baby is black, revealing her own shame and hidden African-American identity. *My Baby Is Black!* (1961) explores the implications of an interracial marriage, and *Free, White and 21* (1963) invites the audience to act as jury in a race-related rape trial. *I Crossed the Color Line* (1966; also released as *The Black Klansman*) portrays a light-skinned African American who masquerades as a white man so that he can infiltrate the Ku Klux Klan group who killed his young daughter.

In most cases, the posters for these films—usually designed with the same blatant appeal to the sensations as scandal magazines—have worn better than the movies themselves and have gained something of a cult following amongst collectors of film posters.

Left: **FREE, WHITE AND 21 (1963); THE BLACK KLANSMAN (1966); I CROSSED THE COLOR LINE (1966); MY BABY IS BLACK! (1961)**
Opposite: **I PASSED FOR WHITE (1960)**

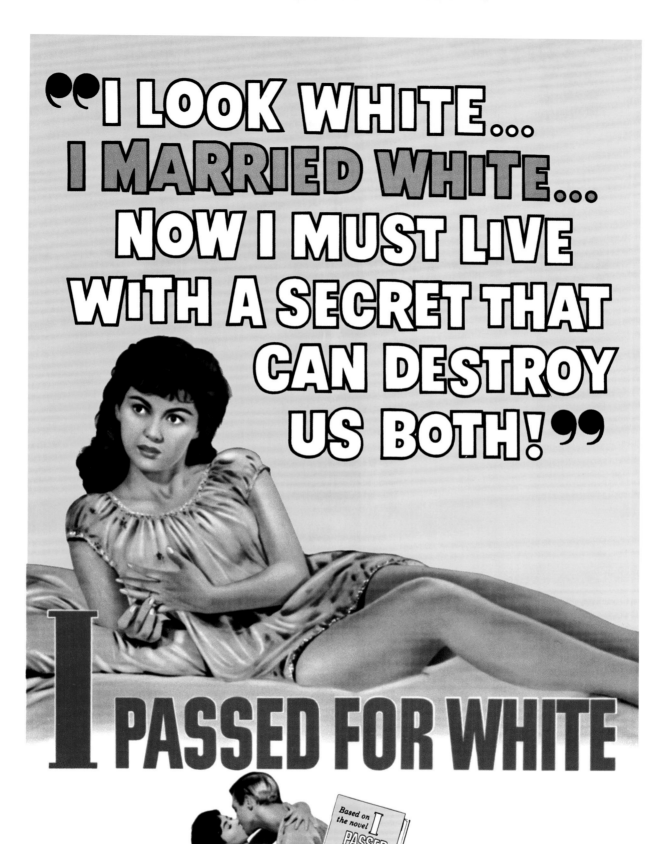

Produkcja: Dino De Laurentis

MANDINGO

Dramat włosko–amerykański

Reżyseria: **Richard Fleischer**

W rolach głównych: **James Mason, Susan George, Perry King**

When independent productions began to eat into the profits of the big studios in the late 1960s, it was inevitable that the majors would invade the "exploitation" field for themselves. The early 1970s success of such "blaxploitation" (black exploitation) films as *Sweet Sweetback's Baadassss Song*, *Shaft*, and *Super Fly*, with their emphasis on black confrontation of white oppression, forced Hollywood to change its perspective on America's heritage of slavery, and the "plantation myth" with which audiences had become so familiar. Gone now were the devoted slaves and demure Southern belles of sentimental films such as *The Birth of a Nation*, *Jezebel*, and *Gone with the Wind*.

Mandingo (1975), adapted from the 1957 bestseller by Kyle Onstott, reversed this myth of a harmonious old South, and exposed the barbaric nature of the slave system. Set on a crumbling, decadent, 1840s antebellum Louisiana plantation called Falconhurst, the film examines the declining years of the slave-breeding Maxwell family. The greedy and tyrannical patriarch of the plantation (James Mason) buys a superior athletic slave, Mede (heavyweight boxing champion Ken Norton), to pit him against other slaves for sport and profit. Ultimately, however, the wife of the owner's son (Susan George) uses Mede as a tool in her battle against her husband, placing her and the slave in an intimate, tragic relationship.

With its depiction of the more realistic sexual and violent aspects of slavery, and regular scenes of brutal punishment and erotic encounters, the film presents a compelling slice of American history in lurid terms. Though many people considered it tasteless, some critics defended *Mandingo* as the only Hollywood film that dared to offer an honest and thorough depiction of the direct connections between racism, slavery, and white fears about black male sexuality. Film director Quentin Tarantino has been particularly vocal in his admiration for the film, which has been suggested as one of the inspirations for his own project, *Django Unchained* (2012).

Left: **MANDINGO (1975), Polish**
Opposite: **MANDINGO (1975), German**

DINO DE LAURENTIIS präsentiert:

Mandingo

JAMES MASON, SUSAN GEORGE, PERRY KING, KEN NORTON

Mit RICHARD WARD ✳ BRENDA SYKES ✳ LILLIAN HAYMAN ✳ nach dem Roman von Kyle Onstott und dem
Theaterstück von Jack Kirkland ✳ Drehbuch: Norman Wexler ✳ Musik: MAURICE JARRE (Doktor Schiwago) ✳
Produktionsleitung: Ralph Serpe ✳ Produktion: DINO DE LAURENTIIS ✳ Regie: RICHARD FLEISCHER.

im Verleih der TOBIS Filmkunst

Sammy Davis Jr.

LA RAGAZZA CHE SCOTTA

ANNA LUCASTA

Alongside Frank Sinatra, Dean Martin, Peter Lawford, and Joey Bishop, Sammy Davis Jr. was one of the famous Rat Pack—its sole African-American member. He starred with Frank and Dino in a succession of buddy movies, shared their bills in concert halls, nightclubs, and Vegas casinos, and swapped guest appearances on television specials and chat shows. This fame solidified his position as one of the few black performers of his era to find favor with audiences on both sides of the color barrier.

His turbulent private life, which involved a controversial interracial marriage, and a car crash that robbed him of an eye, was matched by his mercurial career as a performer, and his shifting reputation with his black audience. At its worst, he was criticized as an "Uncle Tom" figure, who was prepared to put up with "humorous" racial jibes from his pals to ensure that he belonged in their company. Yet at the same time, the public widely admired his brilliant and diverse abilities as a song and dance man, comedian, and spectacular stage entertainer—qualities already on show when he appeared in *Rufus Jones for President* (1933) as a seven-year-old child.

Davis began his career tap dancing in vaudeville with his father and Will Mastin in The Will Mastin Trio, until his service in the Army during World War II. Upon his return, he re-emerged in a lead role on Broadway in *Mr. Wonderful* (1956) and co-starred with Sidney Poitier and Dorothy Dandridge in the film *Porgy and Bess* (1959). That same year, he delivered a sizzling performance opposite the silky nightclub singer Eartha Kitt in *Anna Lucasta*. The pair exhibited an unmistakable sexual chemistry in a tale of thwarted romance between a sailor and a San Diego temptress.

Davis's acting skills were in evidence again in the downbeat drama *A Man Called Adam* (1966), in which he starred as a successful jazz trumpeter, Adam Johnson, whose tormented past and inner anger threaten to destroy his career. Though noted jazzman Nat Adderley dubbed Davis's trumpet playing in the film, there is no hint of faking in the climactic scene in which Adam Johnson breaks down on stage. Some of the giants of jazz lend their support—among them, Louis Armstrong, Mel Tormé, Kai Winding, and Benny Carter (who composed the score).

Sadly, Sammy Davis Jr.'s undeniable thespian talent was given less chance to shine in most of the films he made after 1960. His ensemble vehicles with the other Rat Pack are still passably watchable and amusing, but as *Anna Lucasta* and *A Man Called Adam* revealed, Davis could call upon a sense of emotional commitment and dramatic flair that was rarely required in such lightweight movies as *Ocean's Eleven* (1960), *Sergeants 3* (1962), and *Robin and the 7 Hoods* (1964).

Left: **ANNA LUCASTA (1959), Italian**
Opposite: **A MAN CALLED ADAM (1966)**

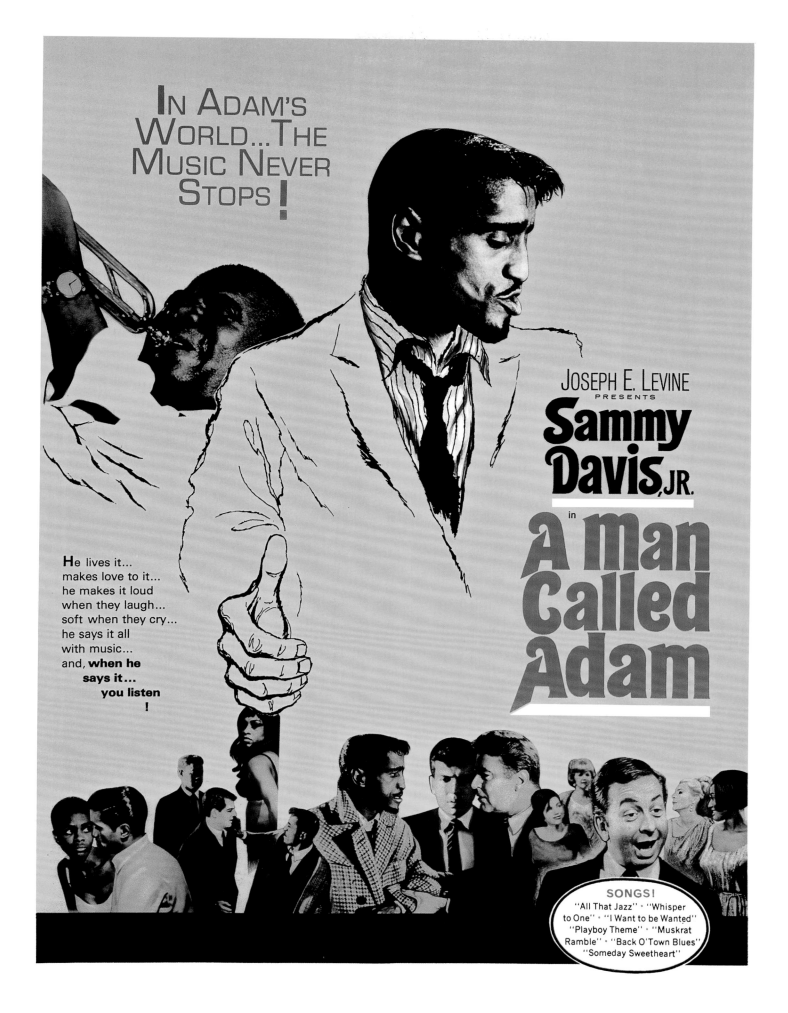

The Independents

The development of the portable movie camera during World War II signalled the start of a new wave of independent filmmaking that would forever change the business (and the history) of motion pictures both here and abroad. For the first time it was possible to make movies spontaneously with faster setups, lower budgets, and no dependency on a major film studio. Directors could afford to take risks and explore new artistic territory outside of the classical Hollywood narrative.

Beginning in the mid 1940s through the 1960s, a large group of iconoclastic filmmakers experimented with this new method of "guerilla filmmaking," its techniques and processes. Early works by Maya Deren, Kenneth Anger, Orkin and Ray Abrashkin, and Ken Jacobs impressed a global overseas audience into the next generation. It was the era of the French New Wave, when a group of young filmmakers—including François Truffaut, Éric Rohmer, Jean Rouch, Agnès Varda, and Jean-Luc Goddard—tore up the Hollywood rule book and created movies that were faster, younger, and more experimental than anything produced by the major studios.

But in 1957, John Cassavetes, a successful New York actor, directed what was perhaps the most influential groundbreaking forerunner for American alternative cinema in its tone, subject matter, and style. *Shadows* was a spontaneous work of cinema verité that explored human relationships and racial identity in the late 1950s beat atmosphere of New York City. Made with a skeletal script, borrowed equipment and a nonprofessional cast, critics hailed the film as a visionary masterpiece. Its success allowed a group of other independent filmmakers, including Stan Brakhage, Shirley Clarke, Robert Frank, and Jonas and Adolfas Mekas, to make even more intellectual, less technically polished, avant-garde options to the feature film. In turn, their work opened doors for other filmmakers of the 1960s such as Lionel Rogosin, William Greaves, Robert Downey Sr., Michael Roemer, Larry Peerce, Ivan Dixon, and Ossie Davis, who took on stories of the black experience both in America and abroad.

Above: **SHADOWS (1957), On set (Cassavetes on right)**
Opposite: **SHADOWS (1957)**

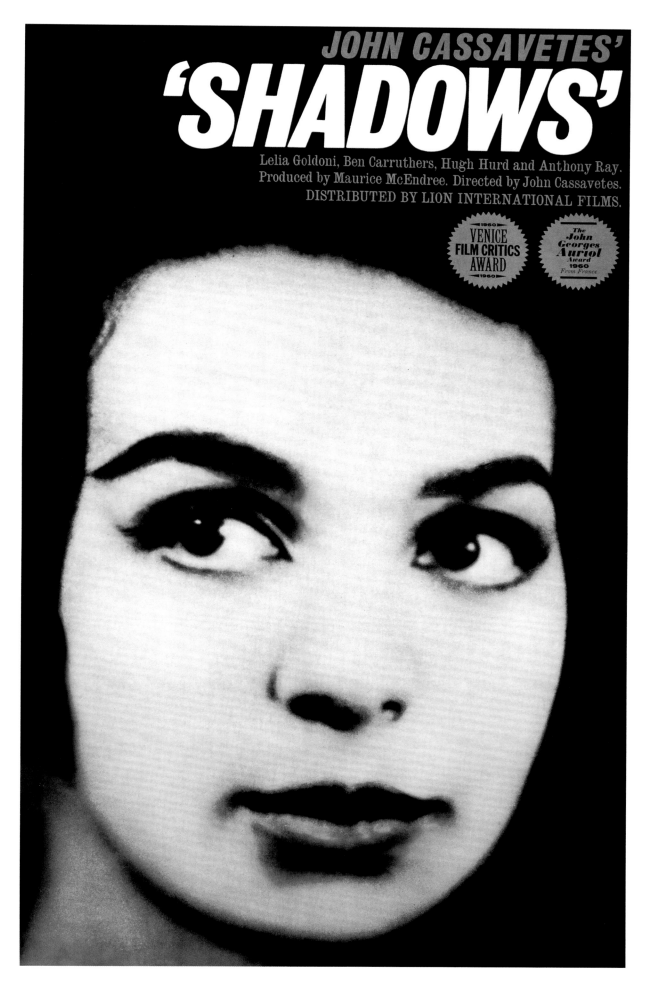

Several important independent films of the early 1960s focused in honest and uncompromising terms upon the reality of African-American life, at a time when the civil rights movement was gaining momentum. These films offered viewers black protagonists who, with militant spirit, demanded a chance to fulfill themselves without having to live up to white standards.

Nothing But a Man (1963), director Michael Roemer's portrait of black pride set in the South, told an uplifting story about a man and a woman whose love overcomes racial and class barriers. It starred Ivan Dixon (in a role turned down by Sidney Poitier) and jazz singer Abbey Lincoln. The film also helped to launch the careers of other notable black actors, including Esther Rolle, Yaphet Kotto, Julius Harris, Moses Gunn, Mel Stewart, and Gloria Foster.

Larry Peerce's *One Potato, Two Potato* (1964) presented the screen's first study of interracial marriage. The film centers on a custody battle between a divorced white couple over their young daughter. When the husband deserts his wife, she falls in love with a responsible and sensitive African-American co-worker (played by Bernie Hamilton). Against opposition from his family, the two marry, taking her daughter to live with them. Despite social pressures, their marriage works. The film's success led the way for Hollywood to further exploit the genre of interracial romance and marriage in *A Patch of Blue* (1965) and *Guess Who's Coming to Dinner* (1967).

The Cool World (1963), Shirley Clarke's stark semi-documentary portrait of life in a ghetto overrun with crime, drugs, and racism, is noted as the first fiction film to be shot entirely on location in Harlem. Against this backdrop, a baby-faced teenager dreams of buying a gun and someday earning neighborhood respect when he takes over the local Royal Pythons gang. Based on a novel by Warren Miller and produced by legendary documentarian Frederick Wiseman, the film highlights a soundtrack composed by Mal Waldron and performed by the Dizzy Gillespie Quintet, featuring Yusef Lateef, Art Taylor, and Aaron Bell.

Above (left to right): **NOTHING BUT A MAN (1963); ONE POTATO, TWO POTATO (1964)**
Opposite: **THE COOL WORLD (1963)**

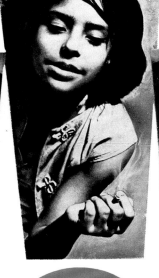

HOOKER!

FUZZ!

JUNK!

RUMBLE!

These are words that mean big trouble in

These
are the ones
who play it
cool, and find out
about life and love
before they're in high school!
This is the picture
that explodes like a
time bomb
In the face of a city!

The Cool World

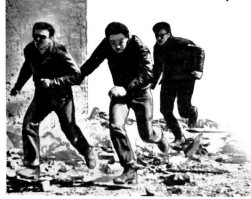

DIRECTED BY SHIRLEY CLARKE
PRODUCED BY FREDERICK WISEMAN
MUSIC BY MAL WALDRON
FEATURING DIZZY GILLESPIE
A CINEMA V PRESENTATION

The Connection (1961) was independent director Shirley Clarke's debut feature film adaptation of Jack Gelber's off-Broadway play about a group of heroin addicts waiting for their "connection." While the original Living Theatre production had used a play-within-a-play strategy for its narration, Clarke devised a more cinematic frame involving a documentary director at work on a cinéma vérité portrait of the drug scene. The music featured throughout was composed by the pianist/writer Freddie Redd and performed by his quartet, with alto saxophonist Jackie McLean, bassist Michael Mattos, and drummer Larry Ritchie. The film also stars Roscoe Lee Browne, in his feature film debut, and Carl Lee, one of the few aggressive black male leads seen on screen during the early 1960s.

Dutchman (1967) was British director Anthony Harvey's film adaptation of Amiri Baraka (LeRoi Jones)'s one-act play. After approaching a conservative black businessman, Clay (Al Freeman Jr.), on a subway train, an attractive young blonde, Lula (Shirley Knight), engages him in an intriguing dance of seduction. Symbolic of the historical mistreatment of blacks, the serial seductress entices, confronts, and betrays Clay, accusing him of being an Uncle Tom. But when Clay, who must stay "buttoned up" to contain his rage, finally explodes, lashing out at her pseudo-liberal intellectualism, she pulls out a knife and stabs him to death. Lula then boards another train and approaches a new black victim.

Radicalized by the injustice, the Clay character is transformed into a militant, and then persecuted by the white society that has forced his transformation in the first place. Like the legendary Flying Dutchman who is doomed to sail the seas forever, Baraka suggests that the black man cannot escape racist discrimination, and the play echoes the raw anger of his prose writings and poetry.

The British posters for both films were designed by the celebrated artist Peter Strausfeld for use at the Academy Cinema on London's Oxford Street. Strausfeld was renowned for his unusual woodcut artworks, which were pasted across the London Underground network. Because only around two hundred of each design were ever printed, and most pasted onto walls, very few copies have survived. *The Connection* and *Dutchman* are the only two designs Strausfeld produced for black-themed films.

Above: **DUTCHMAN** (1967), British
Opposite: **THE CONNECTION** (1961), British

SAINT - SEVERIN · STUDIO de L'ETOILE

12, RUE SAINT-SEVERIN - ODE.50.91 - Mo St.Michel 14, RUE TROYON - ETO.19.93 - Mo Etoile

"Putney Swope"

un film de ROBERT DOWNEY

Off-off playwright Robert Downey Sr. remembers avant-garde filmmaker Jonas Mekas trying to convince him to make an art house film in the early 1960s. Mekas ran the Film-Makers' Cooperative and monthly midnight screenings at the Charles Theater in New York's Lower East Side, where all of the new wave of independent filmmakers would congregate. As a writer, Downey was intrigued by the idea, although it took several years working the margins of the underground scene before he finally picked up a camera.

In 1969, Downey directed *Putney Swope*, a spoof on the advertising business and the corrupt white corporate power structure. At the heart of its biting satire was race in the person of the title role, played by Arnold Johnson. Swope is the token African American on the board of directors of an otherwise all-white Madison Avenue firm who, through a chain of accidents and intrigue, is elected the new head of the agency when the old chairman dies of a heart attack in the middle of a meeting. Swope immediately fires all but one of the company's white board, hires replacements from the ghetto, renames the agency Truth and Soul Inc. and declares that he will boycott all advertising for tobacco, alcohol, and war toys. Dedicated to truth in advertising, they produce outrageous commercials with shock-effect for products like Face-Off Acne Cream, Ethereal Cereal, and Lucky Airlines.

Many years later, Henry Louis Gates Jr. reminisces about his early days at Yale in 1969; "While Douglass, Du Bois, Garvey, Robeson, and Marshall were our role models, it's probably accurate to confess that we drew an enormous amount of secret inspiration from the cult figure Putney Swope … one of the first fantasies rendered on film of how things would be different once we were to take over."

Left: PUTNEY SWOPE (1969), French
Opposite: PUTNEY SWOPE (1969)

Up Madison Ave.

"PUTNEY SWOPE"

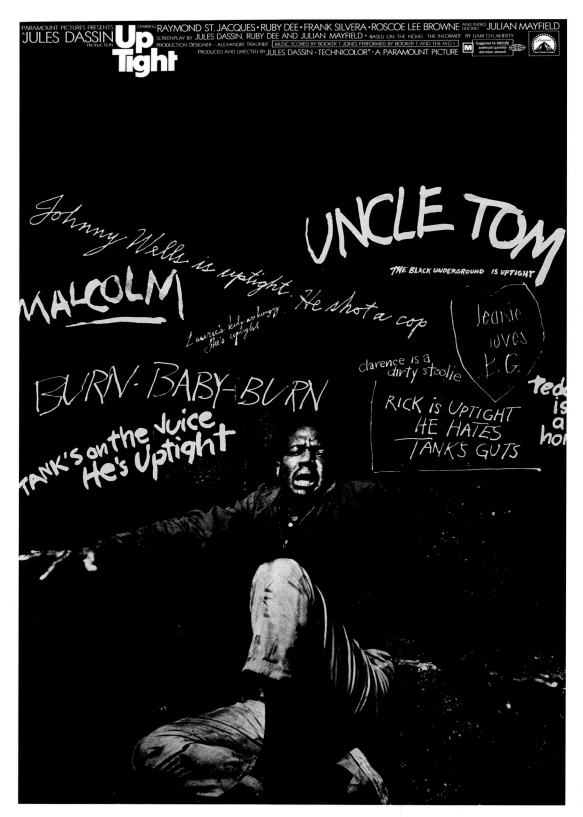

As the 1960s neared its political and social climax, a new radical tradition of black film was about to emerge—one that would become twisted into the garish shape of the "blaxploitation" movies. Two films around the turn of the decade captured in fictional form the way in which the slow progress of the civil rights crusade had prompted the formation of revolutionary political groups dedicated to overthrowing the white government of the United States. Neither film suggested that this would be a failsafe or easy solution; both reflected a new realism among the black community.

Jules Dassin's *Uptight* (1968) was effectively an update of *The Informer*, a 1935 film made by John Ford about the Irish Republican Army. The setting this time was Cleveland, and the opening scenes of Martin Luther King's funeral procession ensured that this could only be viewed as a very contemporary tale. Booker T. & the M.G.'s, themselves a mixed-race group, provided the memorable soundtrack for this tale of militant idealism, racial tension, and betrayed ideals.

Three years later, Wendell Franklin directed the grittier narrative of urban realism that was *The Bus Is Coming*. The "bus" was symbolic: not just an alternative to the civil rights image of the "freedom train," but also a barbed reference to the back-of-the-bus segregation that sparked Rosa Parks' famous act of defiance on a bus in Montgomery, Alabama, in 1955. The setting for Franklin's movie was a ghetto in Los Angeles, where a black nationalist group had emerged as a vehicle for the overflowing anger and disgust of young African Americans. The group provides a refuge for a veteran who returns from Vietnam after serving in the United States Army, to discover that his brother has been killed by racist cops. Realizing that everything he has been fighting for is a lie, he chooses to ride the bus of revolution and separatism.

Left: **UPTIGHT (1968)**
Opposite: **THE BUS IS COMING (1971)**

"the bus is coming"

THE **MAN** CAN'T STOP IT!
DON'T MISS IT!

Ossie Davis

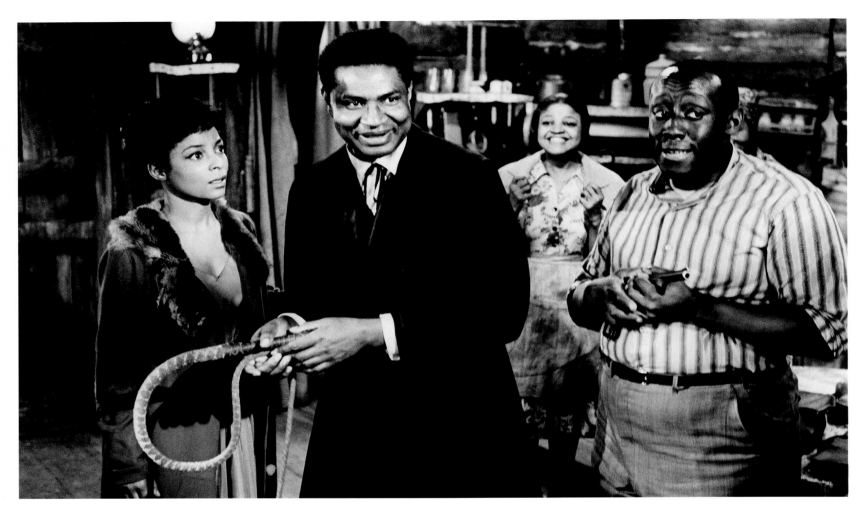

Actor and director Ossie Davis believed that the audiences of the early 1960s were sophisticated enough to enjoy, and laugh at, the old exaggerated stereotypes. *Gone Are the Days!* (1963) was a film adaptation of Davis's own 1961 stage play, *Purlie Victorious*, a far-fetched satire of racial attitudes in the old South. In an attempt to secure wider distribution for the film, he re-titled and re-released it as *The Man from C.O.T.T.O.N.* to ride on the coattails of the successful 1960s television series, *The Man from U.N.C.L.E.*

Davis stars as the Reverend Purlie—a fast-talking, conniving minister who returns home to a rural Georgian plantation to convert a battered barn, owned by a racist Southern aristocrat, into an integrated church. His aim is to educate the community about the evils of prejudice and bigotry. Davis's real-life wife, Ruby Dee, co-stars with future television icons Alan Alda (*M*A*S*H*) and Sorrell Booke (*The Dukes of Hazzard*).

During the post-war years, Davis was among a new breed of black actors who tried to find commercial success while avoiding stereotypical roles. In 1946, he made his Broadway debut in *Jeb Turner* as a wounded veteran coming home to the bigotry of the South. Also in the cast was Ruby Dee and the couple married two years later. In 1950, Davis made his screen debut (with Sidney Poitier), in Joseph Mankiewicz's racial drama, *No Way Out*.

Davis and Dee saw hard times in the 1950s when both were blacklisted for their political views during the McCarthy era. As long-standing political activists, they were prominent at the height of the civil rights movement, and served as masters of ceremony for Martin Luther King's March on Washington in 1963. Two years later, Davis delivered the eulogy at the funeral of Malcolm X.

Davis's movie career survived the blacklist that had threatened the livelihoods of dozens of artists, including his long-time friend Paul Robeson. He received a Tony Award nomination for his supporting role in *Jamaica* on Broadway, and in 1959 he replaced Poitier in Lorraine Hansberry's acclaimed drama, *A Raisin in the Sun*. He and his wife received numerous joint honors, including induction into the NAACP Hall of Fame in 1989, the National Medal of Arts in 1995, the Screen Actors Guild Lifetime Achievement Award in 2000, and the Kennedy Center Honors in 2004. Ossie Davis died on February 4, 2005, at the age of eighty-seven, leaving behind a legacy of courage, dedication, and inspiration.

Above: **THE MAN FROM C.O.T.T.O.N. (aka GONE ARE THE DAYS!, 1963), Ruby Dee, Ossie Davis and Godfrey Cambridge**
Opposite: **THE MAN FROM C.O.T.T.O.N. (aka GONE ARE THE DAYS!, 1963)**

Muhammad Ali

Arguably the most recognizable man of the twentieth century, Muhammad Ali has achieved the rare feat of becoming immortal in his own lifetime. Boxing pundits still argue about whether, pound for pound, he was the greatest prizefighter in history; whether he could have defeated such legendary champions as Jack Johnson, Joe Louis, or Rocky Marciano; and what he might have achieved in the ring had his career not been interrupted for three years at its peak.

What nobody can deny is that the man born Cassius Clay in Louisville, Kentucky, in 1942, had a greater impact on the world around him than any other figure in sporting history—indeed, some might say that his influence surpassed that of presidents and kings. Though he has been stricken by illness for three decades, exacerbated by punches received in the ring, he remains an international celebrity, a spokesman for world peace, a global hero, and a timeless icon for the world of sports.

In purely boxing terms, there had never been a heavyweight like the young Cassius Clay, who brought new levels of speed, charisma, and playful arrogance to the sport. He grew up at a time when being black and poor meant almost no prospects for economic advancement. At the age of twelve, however, he reported the theft of his bicycle to a policeman, who suggested that he should take boxing lessons so he could protect himself from bullies. Within six years, he had won six Kentucky Golden Gloves competitions and a gold medal for the United States at the 1960 Olympics in Rome.

Yet Cassius Clay was made acutely aware of his racial identity when he returned to America as a champion, and still faced prejudice and segregation. He was so disgusted that he tossed away his gold medal, and vowed to fight for the pride of his people. On February 25, 1964, Clay shook up the boxing world when he unexpectedly won the heavyweight championship title from Sonny Liston. After his victory, Clay joined the Nation of Islam and changed his name to Muhammad Ali, declaring that Cassius Clay was his "slave name." His close ties with Malcolm X, and with the Nation's leader, Elijah Muhammad, ensured that he came under close scrutiny from the American government, and gave his subsequent fights extra publicity and a political edge.

Ali defeated all his credible opponents in the heavyweight division over the next three years, but then faced his most difficult battle. In 1967, as the Vietnam War escalated, the US Army drafted Ali. Citing his Islamic faith, he refused to serve, and was stripped of his title, had his licenses to box revoked, and was sentenced to prison for draft evasion. His response was blunt: "I'm expected to go overseas to help free people in South Vietnam, and at the same time my people here are being brutalized and mistreated … I got nothing against no Viet Cong … No Vietnamese ever called me a nigger."

This was the man portrayed in William Klein's 1969 documentary, *Float Like a Butterfly, Sting Like a Bee*, which featured revealing footage of Clay/Ali at the time when he first won the heavyweight title. Bypassing conventional documentary techniques, Klein told Ali's story in a very loose, natural, and semi-chronological collage style. His title was taken from a phrase coined by Ali's corner-man, Drew Bundini Brown, which aptly described Muhammad's remarkable combination of speed and power during his sixty-one-fight career.

In 1971, the US Supreme Court overturned Ali's conviction and jail sentence on appeal. Granted a fresh license to pursue his trade, Ali staged a comeback. In 1974, he regained his world title against George Foreman in the famous "Rumble in the Jungle" in Kinshasa, Zaire. The full story of that fight was told in Leon Gast's Oscar-winning 1996 documentary, *When We Were Kings*.

The charismatic and outspoken Ali retired from the ring in 1981. He later remembered: "Some people thought I was a hero. Some people said that what I did was wrong. But everything I did was according to my conscience. I wasn't trying to be a leader. I just wanted to be free."

Opposite: **FLOAT LIKE A BUTTERFLY, STING LIKE A BEE (1969)**

MUHAMMAD ALI / CASSIUS CLAY

FLOAT LIKE A BUTTERFLY STING LIKE A BEE

A FILM BY WILLIAM KLEIN • A DELPIRE PRODUCTION

AN EVERGREEN FILM PRESENTED BY GROVE PRESS AND ALVIN FERLEGER

Blaxploitation

The term "blaxploitation" was coined in the early 1970s for a style of black action films aimed squarely at African-American audiences. With black actors in the lead roles, and often anti-establishment plots, the films were frequently condemned for stereotypical characterization and glorification of violence. Critics saw them as morally bankrupt, and as portraying black actors in the most negative way. But not everybody in the black community agreed, as blaxploitation also provided its audiences with cinematic heroes in a more honest portrayal of urban life previously unseen in most Hollywood pictures.

Blaxploitation arose at a critical juncture for the Hollywood film industry. By the late 1960s, the major Hollywood studios were still reeling from the profound effects of a two-decades-old Justice Department lawsuit that involved their profitable theater monopolies. Combined with the insurgence of television, and the drop in audience popularity for musicals, the film industry was losing millions of dollars, forcing many to face the distinct prospect of bankruptcy. At the same time, the 1960s were a turbulent time in American race relations, and the civil rights movement exploded into the national consciousness. As the decade wore on, cries of "Black Power!" were heard from the ghettos across America, and it became increasingly difficult for Hollywood studios to ignore black society. While African-American political activists battled in the courtrooms and the streets for an end to segregation, for voting rights, and for equal rights, black filmmakers and actors began to infiltrate Hollywood. The civil rights movement and some bad luck for Hollywood studios would come together at just the right moment.

Enter Melvin Van Peebles, the first modern-day folk hero of black cinema. As writer, producer, director, soundtrack composer, and star, he lit the fuse of blaxploitation in 1971 with his independently-financed film *Sweet Sweetback's Baadasssss Song*. Shot on a miniscule budget in little more than two weeks, the film and its provocative depiction of a black man fighting the system—and winning—understandably struck a chord with African-American audiences around the country. The fact that the film was "rated X by an all-white jury" only increased its popularity, and by the end of 1971, *Sweetback* had grossed $10 million, a huge success for the era.

Sweet Sweetback may have been credited with launching the genre, but MGM's release of *Shaft* a few months later probably established a more precise blueprint for the movies that would follow. Making *Shaft* was a real gamble for the once prestigious MGM studio, which had fallen on dire times. They hired Gordon Parks, who had been the first black mainstream Hollywood director with *The Learning Tree* (1969), to direct Richard Roundtree in the movie that would ultimately rescue MGM from financial ruin, and receive an Oscar for Isaac Hayes' enduring score. *Shaft* offered a sexy, practically omnipotent hero, in the style of a "Black James Bond," and audiences lapped up his precarious balancing act between the white world and the ghetto, to the extent of $12 million.

These two successes enabled Hollywood to appreciate the potential power of the black ticket-buying public, who accounted for more than thirty percent of the box office in major cities. The year 1972 brought a proliferation of blaxploitation films, most notably the independently produced *Super Fly*. Directed by Gordon Parks Jr., and featuring a best-selling soundtrack by Curtis Mayfield, *Super Fly* took living "the life"

(an urban existence which revolved around drugs, sex, pimps, gambling, and guns) to the extreme by making a cocaine drug dealer (Ron O'Neal) its protagonist and center of focus.

An estimated two hundred blaxploitation movies were produced by 1976, with the range of stories as varied as for mainstream action films. They shared, however, gratuitous violence and guns, and most used a black-versus-white dichotomy as their defining element. Every available genre was plundered in an attempt to rehash old movie plots and ideas. There were horror films (*Blacula* and *Abby*), gangster tales (*Black Caesar* and *Book of Numbers*), crime melodramas (*Cool Breeze* and *Hit Man*), kung-fu fests (*Black Belt Jones* and *Black Samurai*), excursions in a sci-fi/zombie vein (*Sugar Hill* and *J.D.'s Revenge*), even black westerns (*Boss Nigger* and *Thomasine & Bushrod*).

Although many of its movies were formulaic, low-budget and cliché-ridden, the blaxploitation era succeeded in creating its own stars. Ex-football players, such as Jim Brown and Fred "The Hammer" Williamson, fitted the bill perfectly. It wasn't all macho, misogynist posing, either. The Amazonian figures of Pam Grier and Tamara Dobson led the female charge as gun-totin', revenge-seeking, supermamas who flaunted their sexuality with hard-hitting films like *Coffy*, *Cleopatra Jones*, and *Foxy Brown*.

One consistent ingredient, which undoubtedly heightened and extended the appeal of the blaxploitation genre, was its music, often contributed and scored by some of the most creative R&B and soul musicians of the era. Whether James Brown, Marvin Gaye, Curtis Mayfield, or Isaac Hayes composed the soundtracks, they added an element of depth and sophistication, often outclassing the movies for which they were made.

Blaxploitation proved that black actors possessed a strong box-office appeal; and although many of the films were written, directed or produced by white Hollywood, they did finally provide African-American talent with the recognition that it had been seeking, and richly deserved, since the early days of silent film.

But by the mid 1970s, the backlash had begun. The studios received considerable criticism from black pressure groups, including the NAACP, for the negative stereotypes used in most of the genre's movies, which were eroding positive role models and reinforcing white prejudices about black culture. Audiences also tired of the industry's endless re-workings of the crime/action/ghetto formula. Within a year, production virtually stopped dead, ironically putting the black actors and technicians—who had fought so hard to get into the movie business—back out of work. The boom was over, and blaxploitation's popularity declined as quickly as it rose.

In retrospect, however, blaxploitation has been acknowledged as leaving a positive legacy to African-American film history. Without it, the emergence of young black actors like Eddie Murphy in the 1980s might not have been possible; or, in turn, the success of black actors and directors, from Denzel Washington and Spike Lee to Halle Berry and Mario Van Peebles, who have confirmed that the achievements of those before them like Fred Williamson, Richard Roundtree, and Pam Grier were not in vain.

Opposite: **SHAFT (1971)**

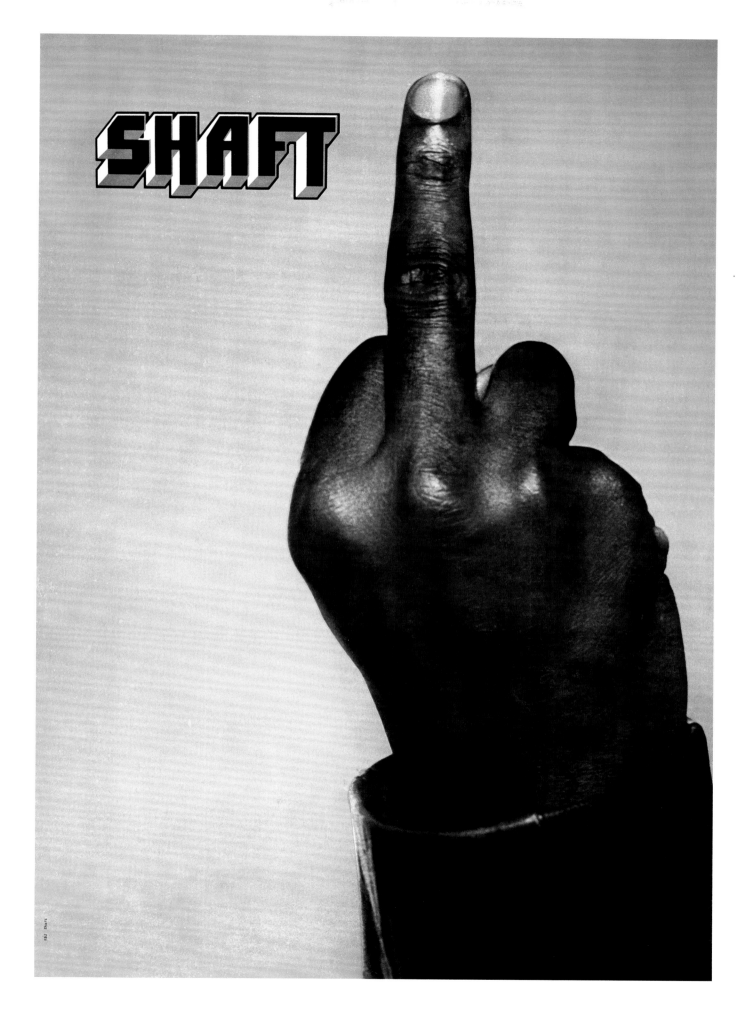

The Uppity Movie.

WATERMELON MAN

COLUMBIA PICTURES Presents
GODFREY CAMBRIDGE · ESTELLE PARSONS
A BENNETT—MIRELL—VAN PEEBLES Production
Written by HERMAN RAUCHER · Music by MELVIN VAN PEEBLES
Executive Producer LEON MIRELL · Produced by JOHN B. BENNETT
Directed by MELVIN VAN PEEBLES · COLOR

Born in Chicago in 1932, Melvin Van Peebles graduated from Ohio Wesleyan University with a BA degree in English. He spent three years in the US Air Force and, unable to find work in the airline industry, took a job as a cable car grip man in San Francisco. Disillusioned and frustrated by the lack of opportunities in America, Van Peebles moved to the Netherlands in the early 1960s to concentrate on his writing and to begin making short films. In 1968, he directed his first feature film, *The Story of a Three-Day Pass* (1968), in France.

Based on his book, *La Permission*, the film told the story of an interracial affair between an African-American soldier (Harry Baird) stationed overseas and a white French woman (Nicole Berger). The film's success prompted Columbia Pictures to convince Van Peebles to return to the United States and direct the outrageous comic satire *Watermelon Man* (1970). African-American comedian Godfrey Cambridge starred as a white middle-class racist (played by Cambridge in "whiteface" makeup), who wakes up one day to find that his skin has turned black. The original script called for Cambridge's character to wake up again at the end of the film and discover that it had all been a dream, and his skin was safely white again. Van Peebles refused to shoot something so insipid, and so the final cut of *Watermelon Man* was more uncompromising than Columbia had envisaged.

The following year, Van Peebles directed the independent feature film *Sweet Sweetback's Baadasssss Song*. With $500,000 from his *Watermelon Man* salary, a $50,000 loan from Bill Cosby, and a nineteen-day shooting schedule with a non-union cast and crew, Van Peebles emerged as a director with an emphatic style who captured the restless tempo of 1970s ghetto life and changed the whole conception of what a black film character could be. Hollywood was watching closely, and taking note.

Left: **WATERMELON MAN (1970)**
Opposite: **SWEET SWEETBACK'S BAADASSSSS SONG (1971)**

SWEET SWEETBACK'S BAADASSSSS SONG

A film of
MELVIN VAN PEEBLES

YOU BLED MY MOMMA — YOU BLED MY POPPA — BUT YOU WON'T BLEED ME

The mob wanted Harlem back. They got Shaft... up to here.

SHAFT

SHAFT's his name. SHAFT's his game.

METRO-GOLDWYN-MAYER Presents "SHAFT" Starring RICHARD ROUNDTREE · Co-Starring MOSES GUNN
Screenplay by ERNEST TIDYMAN and JOHN D. F. BLACK · Based upon the novel by ERNEST TIDYMAN
Music by ISAAC HAYES · Produced by JOEL FREEMAN · Directed by GORDON PARKS · METROCOLOR
R RESTRICTED · Under 17 Requires Accompanying Parent or Adult Guardian MGM

Shaft (1971) catapulted Hollywood into the blaxploitation era. The film's director, Gordon Parks Sr., cast newcomer Richard Roundtree as John Shaft, a black superhero and renegade detective whose savvy street smarts are equaled only by, as his name suggests, his sexual prowess. Made at a cost of $1.5 million, *Shaft* grossed more than eight times that amount and single-handedly saved a struggling MGM from financial ruin. Its Isaac Hayes soundtrack remained in the charts for well over a year, sparked a revolution of its own in the music business, inaugurating a new style of film scoring that was much emulated during the blaxploitation era. The appeal of *Shaft* to contemporary audiences resulted in two sequels, *Shaft's Big Score!* (1972) and *Shaft in Africa* (1973), though neither film was as popular as the original. In 2000, director John Singleton remade *Shaft* with Roundtree reprising his role and Samuel L. Jackson starring as his nephew and namesake.

In 1972, Gordon Parks Sr. channeled his salary for *Shaft* into the financing of *Super Fly* for his son's directorial debut, which proved notoriously more violent and raw than any of his father's work. At its root, the film had a classic film noir theme; the hood who must make one last score before he quits the business. Ron O'Neal plays Youngblood Priest, a black man with straight long hair, mutton chop sideburns, and slick threads who desperately tries to escape the cocaine business with his life intact. While Curtis Mayfield's soundtrack album (arguably the finest of its era) was compassionate and hopeful, the film was much more bleak. O'Neal turned director himself for the sequel, *Super Fly T.N.T.* (1973), while Mayfield returned for the soundtrack of *The Return of Superfly* (1990). Gordon Parks Jr. went on to helm three other blaxploitation films, most notably *Three the Hard Way* (1974), before a plane crash in Nairobi, Kenya, took his life in 1979.

Left: SHAFT (1971)
Opposite: SUPER FLY (1972)

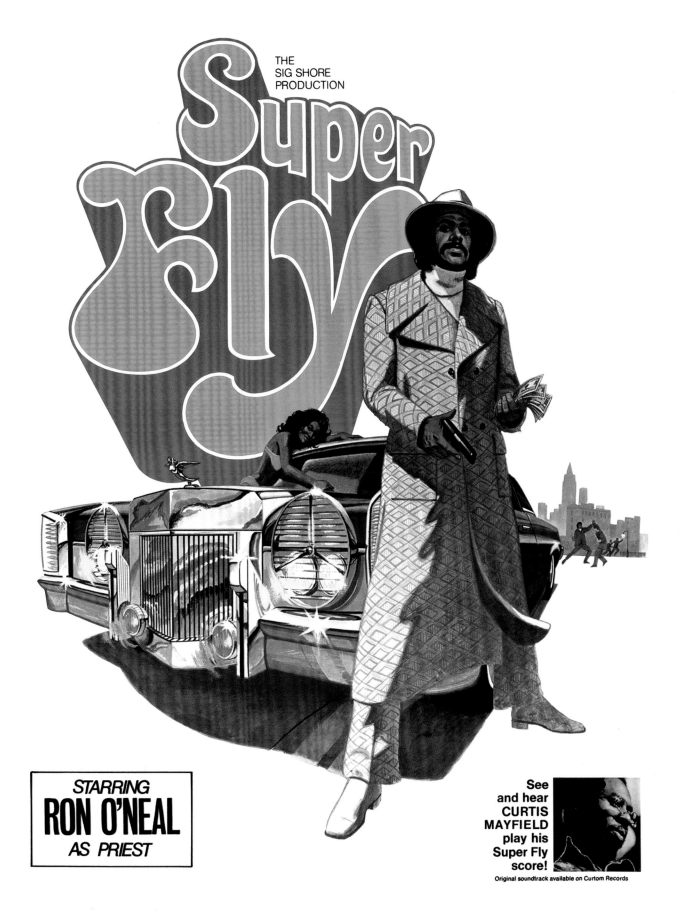

Never a dude like this one!
He's got a plan to stick it to The Man!

THE
SIG SHORE
PRODUCTION

Super Fly

Jim Brown is 'SLAUGHTER'

It's not only his **name**
it's his **business**
and sometimes--
his **pleasure!**

An AMERICAN INTERNATIONAL Picture
FILMED IN **TODD-AO 35 COLOR** by DE LUXE'

R RESTRICTED
Under 17 Requires Accompanying
Parent or Adult Guardian

SAMUEL Z. ARKOFF presents starring in
JIM BROWN·'Slaughter'·**STELLA STEVENS·RIP TORN**
co-starring
DON GORDON · MARLENE CLARK and **CAMERON MITCHELL** as A. W. Price
Produced by Directed by Written by
MONROE SACHSON · JACK STARRETT · MARK HANNA and DON WILLIAMS | Theme from 'Slaughter' Written and Performed by BILLY PRESTON |

Jim Brown, the legendary running-back with the Cleveland Browns football team, hung up his cleats and switched to a career in acting in the late 1960s. Featured in dozens of supporting roles in movies such as *The Dirty Dozen*, *Rio Conchos*, and *100 Rifles*, Brown developed a phenomenally confident and aggressive screen persona—an assertive master of machismo. However, his well-publicized bad temper, both on and off the film set, allowed Hollywood to all but blacklist him, and his promising career floundered.

But when *Shaft* made such an impression on audiences, American International Pictures figured Brown's bad-boy antics would work perfectly in the blaxploitation formula of fast-paced action, violence, and gratuitous nudity. In a successful attempt to revive his career, Brown accepted the lead role in *Slaughter* (1972) as a tough ex-Green Beret soldier in the mold of John Shaft/James Bond. A new black action hero had been created, and the following year a sequel, *Slaughter's Big Rip-Off*, appeared.

Fred "The Hammer" Williamson also hailed from the gridiron. After an eight-season career with the Pittsburgh Steelers, Oakland Raiders, and Kansas City Chiefs, he followed Jim Brown into acting, making film appearances in *M*A*S*H* and *Tell Me That You Love Me, Junie Moon*, and several television spots. In *Black Caesar* (1973), veteran writer/director/producer Larry Cohen loosely modeled his script on the 1930 gangster classic *Little Caesar* with Edward G. Robinson. Williamson starred as Tommy Gibbs, who works his way up from shoeshine boy to Godfather of Harlem. The film's gritty urban appeal is capped by a soul-music score from James Brown, and highlighted by the harrowing theme song "Down and Out in New York City." Williamson reprised his role as Tommy Gibbs in *Hell Up in Harlem* (1973), again with Cohen writing and directing. In total, Williamson appeared in over twenty blaxploitation feature films. By the mid 1970s, he also began to write, direct, and/or produce most of the low-budget features in which he starred, for his own Chicago-based production house, Po'Boy Productions.

Left: SLAUGHTER (1972)
Opposite: BLACK CAESAR (1973)

MR. T IS COLD HARD STEEL!

HE'LL GIVE YOU PEACE OF MIND... PIECE BY PIECE!

TROUBLE MAN

Trouble Man (1972) was a classic example of what white writers and producers perceived as the black lifestyle of the times: easy sex, fancy duds, and lots of "jive" language and obscenities for street realism.

If the scenario and stereotypes were strictly formulaic, much about the film lifted it from out of the ordinary, not least Marvin Gaye's breathtaking foray into the world of movie soundtracks. The cast also had a fine background: Robert Hooks was a member of the noted Negro Ensemble Company of New York, while Paul Winfield had given what would become an Oscar-nominated performance in *Sounder* earlier in the year. Veteran actor—and former *Hogan's Heroes* television star—Ivan Dixon directed.

His next project, *The Spook Who Sat by the Door* (1973), is remembered as his most controversial due to its black revolutionary theme. It is possibly the most radical and incendiary of any blaxploitation film of the 1970s; a story of aggressive reaction to white oppression in which a mild-mannered, unassuming social worker (Lawrence Cook) is recruited by the CIA as a token black and proceeds to learn, and later apply, the techniques of urban guerrilla warfare in Chicago. Corrosive and provocative, Dixon's adaptation of Sam Greenlee's novel of political unrest remains one of the great neglected chapters in black political filmmaking.

The film was a huge overnight success when released, but was abruptly taken out of distribution by the FBI claiming it would incite race riots.

Left: **TROUBLE MAN (1972)**
Opposite: **THE SPOOK WHO SAT BY THE DOOR (1973)**

"the spook who sat by the door"

The controversial best selling novel
now becomes a shocking screen reality.

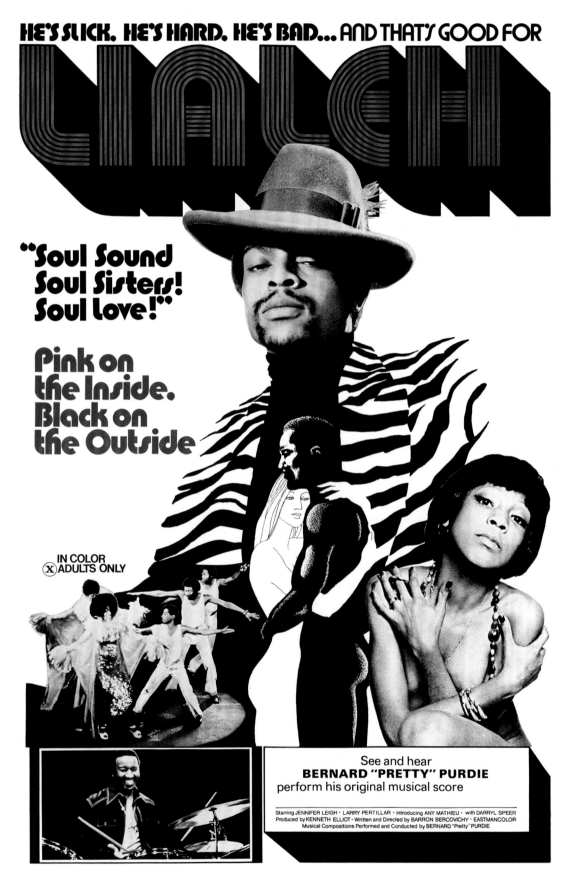

HE'S SLICK. HE'S HARD. HE'S BAD... AND THAT'S GOOD FOR

LIALEH

"Soul Sound
Soul Sisters!
Soul Love!"

Pink on
the Inside.
Black on
the Outside

IN COLOR
Ⓧ ADULTS ONLY

See and hear
BERNARD "PRETTY" PURDIE
perform his original musical score

Starring JENNIFER LEIGH · LARRY PERTILLAR · Introducing ANY MATHIEU · with DARRYL SPEER
Produced by KENNETH ELLIOT · Written and Directed by BARRON BERCOVICHY · EASTMANCOLOR
Musical Compositions Performed and Conducted by BERNARD "Pretty" PURDIE

While plenty of skin-flick veterans have parlayed their celebrity in the world of adult entertainment into record contracts, it's rare for a name musician to contribute the soundtrack to a pornographic film. The exception was Bernard "Pretty" Purdie, one of the most revered drummers of the 1960s and 70s, who had performed with such notable—and musically exacting—artists as Aretha Franklin, Steely Dan, James Brown, and Gil Scott-Heron.

Although he'd already recorded a number of solo albums by the time that *Lialeh* was released in 1974, Purdie clearly relished the opportunity of scoring an entire movie—and not just because his band were able to play on the set with naked women around them. The film may have been forgettable, but his soundtrack album has become something of a Holy Grail amongst collectors of prime 1970s funk.

Less rare, but none the less highly regarded, is Willie Hutch's soundtrack album for *The Mack* (1973)—considered one of the finest of the era. The film title—an American variation on the French slang word for pimp, *maquereau*—is one of the better "shot on the cheap" dramas, ranking alongside the genre's highest echelon like *Shaft*, *Super Fly*, *Foxy Brown*, and *Dolemite*. The film details the meteoric rise of an ex-con, Goldie (played by Max Julien), as he enters the pimp game. This slice of blaxploitation attempts to show us the "ins and outs" and fascination with the business, just as writers like Robert Beck—aka Iceberg Slim—and Donald Goines did by turning their pasts as pimps, pushers, and cons into popular books like *Trick Baby*, *Pimp*, and *Street Players*. *The Mack* taps into that vein of exploitation perhaps better than any other feature film, offering an authentic blend of reality and fiction. Most of the players in the movie are actual pimps playing themselves at the real Mack Ball in Oakland, California; a bizarre version of the Academy Awards with Macks and their girls, in feathers and furs, strolling down a red carpet from their limos.

Left: LIALEH (1974)
Opposite: THE MACK (1973)

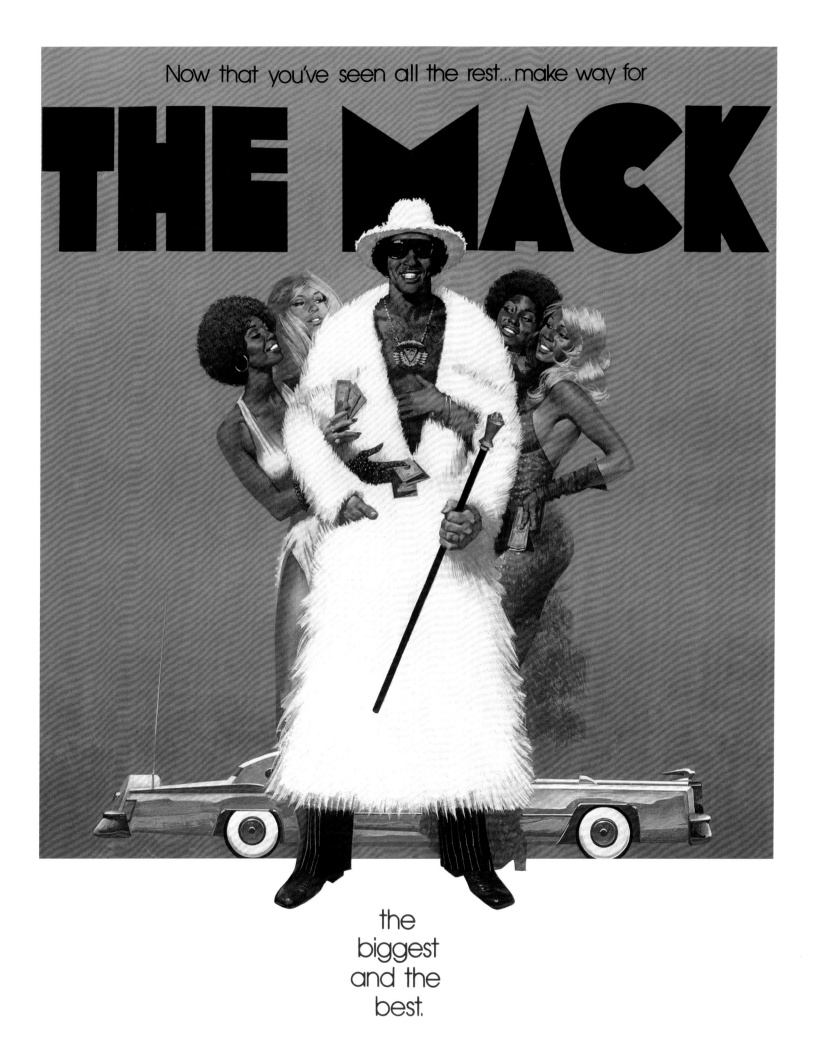

ENTER
JIM
V
"DRAGON"
KELLY

HE CLOBBERS THE MOB AS
BLACK BELT JONES

R RESTRICTED

A WEINTRAUB-HELLER Production "BLACK BELT JONES" starring JIM KELLY · GLORIA HENDRY · Screenplay by OSCAR WILLIAMS
Produced by FRED WEINTRAUB and PAUL HELLER · Directed by ROBERT CLOUSE From Warner Bros. Ⓦ A Warner Communications Company

Black Belt Jones (1974) provided an alternative take on the blaxploitation formula. Kung-fu master Jim Kelly, who had appeared alongside Bruce Lee the previous year in the very popular *Enter the Dragon*, reinforced his reputation as the first black martial arts movie star. Director Robert Clouse was another veteran from *Dragon*, while Gloria Hendry, who trained with Chuck Norris to get ready for the role, had the prior distinction of being the first black Bond girl in *Live and Let Die* (1973). She had also appeared in several blaxploitation films (*Black Caesar*, *Hell Up in Harlem*), typically cast as a tough woman; part of a wave of black-power feminists which included Tamara Dobson and Pam Grier.

The black action film genre commanded a great deal of interest for black audiences of the 1970s, often playing in urban theaters with a blaxploitation film as part of a double or triple feature. Kelly starred in a dozen such films, including a trio with the other icons of the genre, Jim Brown and Fred Williamson; *Three the Hard Way* (1974), *Take a Hard Ride* (1975), and *One Down, Two to Go* (1976).

Much more significant was another figure of violent mayhem: Pam Grier's title role in *Foxy Brown* (1974). Her most famous 1970s movies were rowdy and garish revenge dramas, with Grier usually portraying a sexy, aggressive Florence Nightingale of the ghetto, who administers to the needs of her oppressed brothers and sisters while delivering everything from castration to cremation to her male foes. She's a dream goddess of the slums, floating through a fantasy world of blood, guts, and gunfire. "I was strong," she recalled many years later, "but proved I could also be feminine." *Foxy Brown* was director Jack Hill's fourth and final film with Grier. The two had previously worked on the highly successful *Coffy,* and this picture was intended as a sequel, under the title *Burn, Coffy, Burn!* Grier's films revolutionized the way in which African-American women were portrayed on screen—independent, self-confident, and resourceful. Her larger-than-life persona established her as a reigning queen of the blaxploitation era.

Left: **BLACK BELT JONES (1974)**
Opposite: **FOXY BROWN (1974)**

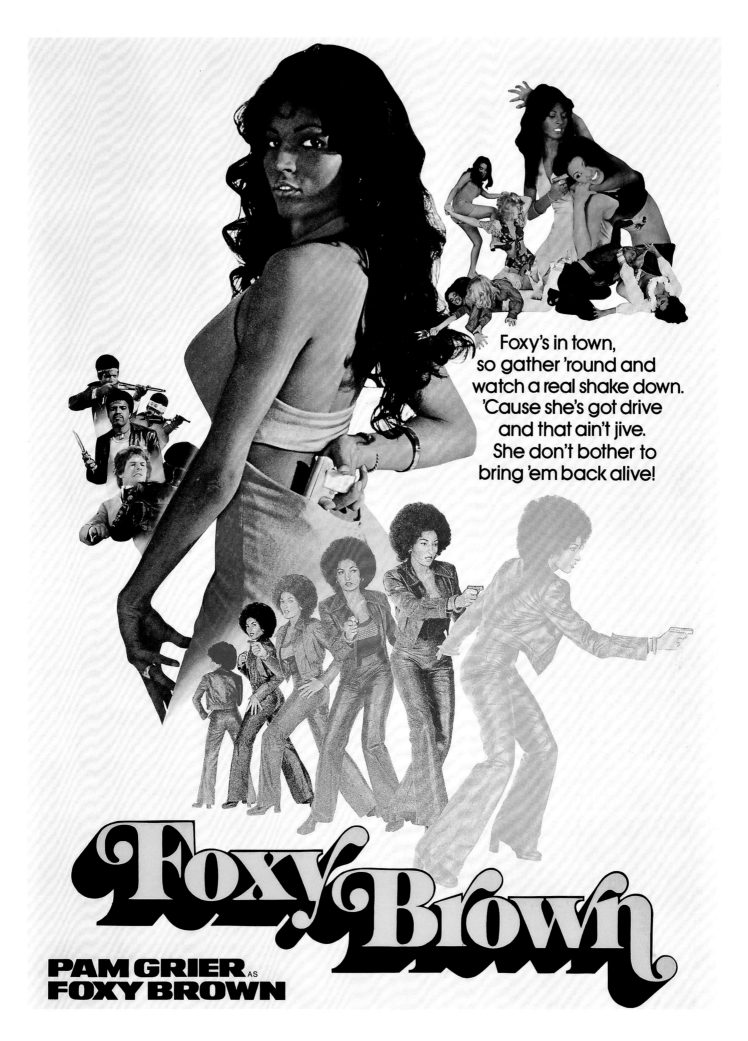

Foxy's in town,
so gather 'round and
watch a real shake down.
'Cause she's got drive
and that ain't jive.
She don't bother to
bring 'em back alive!

Foxy Brown

PAM GRIER AS
FOXY BROWN

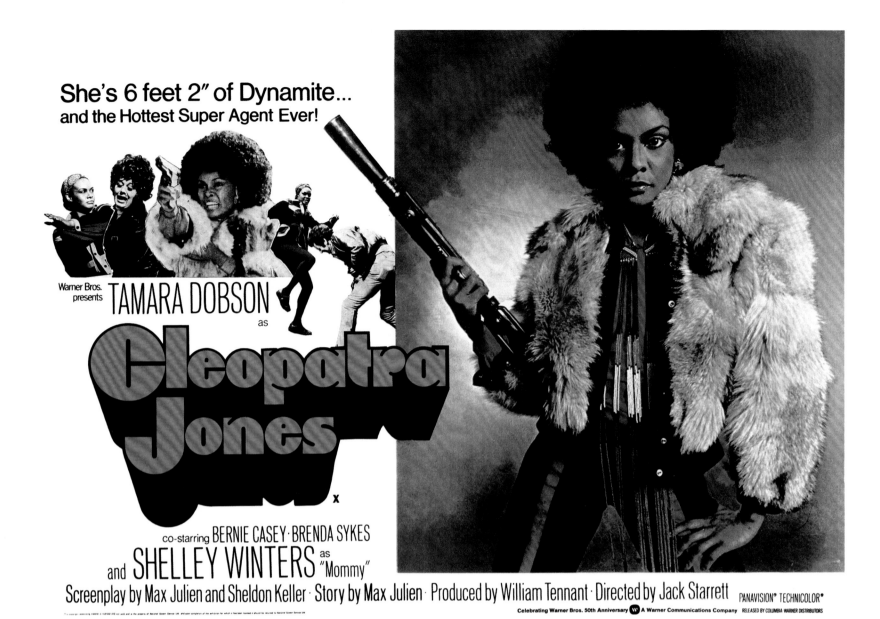

She's 6 feet 2" of Dynamite...
and the Hottest Super Agent Ever!

Warner Bros. presents TAMARA DOBSON as

Cleopatra Jones

X

co-starring BERNIE CASEY · BRENDA SYKES
and SHELLEY WINTERS as "Mommy"

Screenplay by Max Julien and Sheldon Keller · Story by Max Julien · Produced by William Tennant · Directed by Jack Starrett PANAVISION° TECHNICOLOR°

Celebrating Warner Bros. 50th Anniversary (W) A Warner Communications Company RELEASED BY COLUMBIA WARNER DISTRIBUTORS

The only real competition for Pam Grier's "supermama" status was Tamara Dobson. As the trailer for *Cleopatra Jones* (1973) declared, she was "the soul sister's answer to James Bond, and the most exciting new star in years, six feet two of dynamite." Dobson, a twenty-six-year-old former model with only minor experience in two 1972 movies, *Come Back, Charleston Blue* and *Fuzz*, was chosen for the lead role, originally intended for writer/producer Max Julien's then-girlfriend Vonetta McGee. Glamorous, sophisticated, and yet unassuming, Dobson was a delectable comic strip heroine come to life.

Special CIA narcotics agent Cleo Jones is committed to keeping the Los Angeles ghetto clean and safe. When she returns to the US from an operation in Turkey to destroy a massive $30 million field of opium poppies, a sadistic, leather-clad drug lord, "Mommy," is outraged and sets out to seek her revenge (the part was played by the double Oscar-winner Shelley Winters, indulging herself in a spectacularly over-the-top performance).

Like many blaxploitation thrillers, *Cleopatra Jones* centered around the vigilante efforts of the African-American community to fight off drug pushers and dealers.

The fast-moving action sequences, and theme of self-righteous black-do-goodism, proved popular with audiences, and led inevitably to a gaudy 1975 sequel, *Cleopatra Jones and the Casino of Gold*.

Besides Dobson, *Cleopatra Jones* is worth seeing for Shelley Winters' performance alone, without the added attraction of roles by Bernie Casey and Antonio "Huggy Bear" Fargas, and cameos from TV's *Soul Train* host Don Cornelius and top DJ Frankie Crocker.

The film also features a score by the legendary jazz trombone player and arranger J. J. Johnson, who blended conventional orchestrations with soul, jazz, and funk stylings, and vocal appearances by R&B stars Joe Simon and Millie Jackson.

Sepia magazine, a large format glossy publication founded in 1947 in the style of *Look* and *Ebony,* featured articles primarily on the achievements of African Americans. In May 1975 they featured a special tribute and publicity promotion for Dobson and her appearance in *Cleopatra Jones and the Casino of Gold.*

Above: **CLEOPATRA JONES (1973), British**
Opposite: **CLEOPATRA JONES AND THE CASINO OF GOLD (1975)**

The making of a movie star: Cleopatra Jones and the Casino of Gold

from Warner Bros.

The gnawing ambition to be a Hollywood movie star is without doubt the ultimate aspiration of more American girls than any other dream, but an infinitesimal few ever attain that "wish upon a star." Up until the 1970's, it was purely a Rinso White dream, for black beauties were virtually taboo as movie queens.

Inevitably the taboo had to fall, with black pulchritude persistently knocking at Hollywood's gates. To a once gangling, rail-thin, fence-jumping tomboy from Baltimore grown into a stunning, majestic 6-foot-2 beauty fell the distinction of becoming Hollywood's first black and female to merit star billing based on good looks alone. Tamara Dobson went from

New York model to top billing on movie marquees all over the world in her first movie, "Cleopatra Jones," and so successful was her debut as a black "sex symbol" that she will be back as No.1 again this coming month when her newest picture hits screens from Broadway to Hollywood. What is most significant about the Tamara Dobson story is that finally a black beauty made it to the top without singing or dancing . . . and even without any previous acting talent . . . but rather by the sheer visual impact of her alluring face.

Having survived intact the wolves of Broadway and Hollywood, Tamara still relishes the male animal and speaks frankly about the men in her life. She declares that she has only been truly in love once, to a "handsome, sophisticated, strong man . . .

much older than I." But now she plays the field, she admits.

Asked about her movie role as a "sex object," she laughs: "I like being a sexy lady. I certainly don't want to be thought of as dull and dried up: I'm not against Women's Lib — I'm quite a liberated woman myself — but it does seem to me that many ladies who say they don't want to be sex objects are really afraid of sex."

Warner's investment in Tamara is a straight dollars-and-cents proposition based on the high profits cleaned up in Tamara's debut. Filmed for $1,500,000, the picture reportedly grossed more than $8,000,000 . . . or about six times its cost. By comparison the highly-successful "Lady Sings The Blues" made on a $4,000,000 budget brought in $12,000,000 at the box office

world-wide . . . or three times its cost. In the Hollywood counting rooms where money is the name of the game, Tamara is thus twice as hot at the ticket wickets as Diana Ross, who won an Academy Award nomination and very nearly an Oscar for her maiden role. Like any chicken shack owner, the movie money moguls count profits on the basis of costs versus returns and by that criterion, Tamara is a big star.

With a second Cleo adventure now about to reinforce her stardom image, Tamara is ready for new worlds to conquer, new glamor roles to play, and she looks ahead to a Hollywood career that will stamp her as No. 1 among black movie beauties. And yet she knows that her facial allure and sexiness alone will not take her to the top or keep her there.

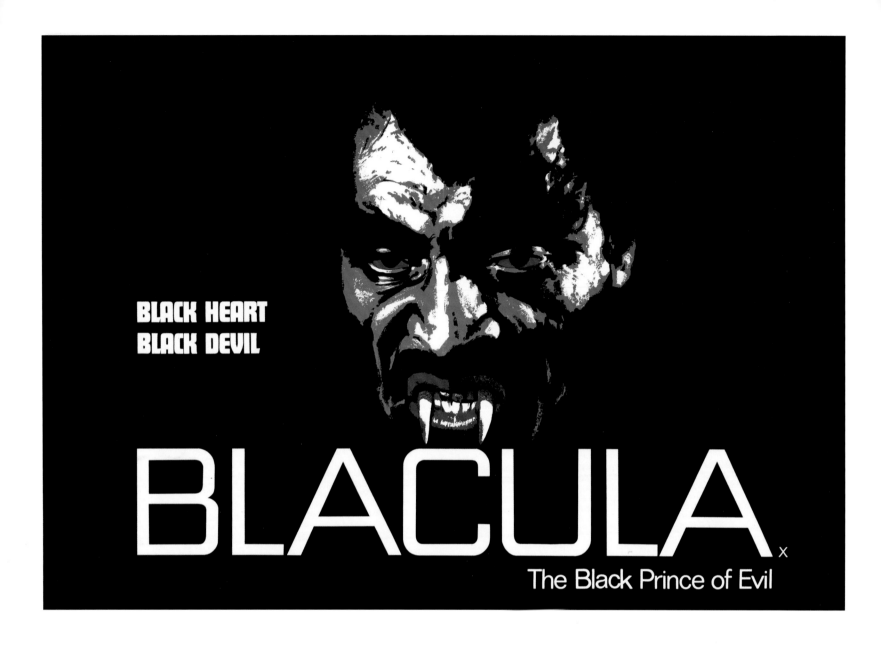

BLACK HEART
BLACK DEVIL

BLACULA x
The Black Prince of Evil

Blacula (1972) was the first and the best of the black horror film subgenre that would engulf blaxploitation for a brief period in the 1970s with *Blackenstein* (1973), *Ganja & Hess* (1973), *Abby* (1974), *Sugar Hill* (1974), and *Dr. Black and Mr. Hyde* (1976).

Shakespearean actor William Marshall put an eloquent and dignified spin on the age-old legend of the vampire, condemned to wander the streets of Los Angeles with an insatiable lust for blood, while pursuing his reincarnated wife. *Blacula*'s love interest, co-star Vonetta McGee, was described by the *New York Times* as "possibly the most beautiful woman currently acting in movies." Director William Crain—who also helmed *Dr. Black and Mr. Hyde*—attended the prestigious UCLA School of Theater, Film and Television. Along with alumnae Charles Burnett (*Killer of Sheep*), Julie Dash (*Daughters of the Dust*), Jamaa Fanaka (*Penitentiary*), and Haile Gerima (*Sankofa*), Crain was part of the LA Rebellion, who in the late 1960s drove a new black independent film movement contributing to a unique cinematic landscape. Crain mostly directed television shows such as *Starsky and Hutch* and *The Dukes of Hazzard*.

Having adapted Bram Stoker's *Dracula* with such success, American International Pictures (AIP) figured that a companion spin-off of another classic Gothic novel, Mary Shelley's *Frankenstein*, might be just as popular. Producers planned *Blackenstein: The Black Frankenstein* to be AIP's one hundredth film, and the first of a trilogy, to be followed by *The Fall of the House of Blackenstein* and *Blackenstein III*. Studio boss Samuel Arkoff was quoted as saying: "We plan to devote our full resources to making this hundredth picture particularly outstanding." Despite that, AIP soon cut itself loose from the project, selling it on to FRSCO Productions. However, even with the hiring of special effects maestro Kenneth Strickfaden, who had created the electric effects gadgets for the Boris Karloff classic *Frankenstein* (1931), the film flopped and the options for the sequels were never picked up.

Above: BLACULA (1972), British
Opposite: BLACKENSTEIN (aka BLACK FRANKENSTEIN, 1973)

FRSCO
PRESENTS...

NOT SINCE "FRANKENSTEIN" STALKED THE EARTH

HAS THE WORLD KNOWN SO TERRIFYING A DAY . . . OR NIGHT

BLACK FRANKENSTEIN

BLACKENSTEIN

A FRSCO PRODUCTIONS LIMITED FILM

WARNING !
TO PEOPLE WITH
WEAK HEARTS...
NO DOCTORS OR NURSES
· IN ATTENDANCE ·

STARRING **JOHN HART, IVORY STONE**. FEATURING **ANDREA KING, LIZ RENAY, ROOSEVELT JACKSON,
JOE DE SUE, NICK BOLIN, CARDELLA DI MILO, ANDY C.** AND INTRODUCING **JAMES COUSAR.**
ALSO INTRODUCING **MARVA FARMER**

WRITTEN AND PRODUCED BY **FRANK R. SALETRI** EXECUTIVE PRODUCER—**TED TETRICK** DIRECTED BY **WILLIAM A. LEVEY**

Blackenstein
Copyright ©1972 Frank R. Saletri.
All Rights Reserved.

NIGGERICH

A TRUE STORY!

PASHA WAS
A WINNER
WITH EVERYBODY

...EXCEPT
THE MOB!

Black Against White... Black Against Black!

Niggerich and *Baby Needs a New Pair of Shoes*; two different titles for the same, little-seen, shot-on-the-cheap, 1974 film that followed a tried and tested blaxploitation formula of cops, Italian mobsters, and hoods in the Harlem number's racket. As the trailer rhymed:

Play the numbers game, it can be good to you.
We take quarters, dimes, and nickels too.
Check your number, play it all,
Hit it big, you're walking tall.
The numbers game. You pick and choose.
Come on number, Baby Needs a New Pair of Shoes.

For a movie concerning illegal gambling, "Baby Needs a New Pair of Shoes" was an obvious title choice—an expression said for luck before tossing the dice. However, what defies belief is that the production company seriously intended to market the movie as *Niggerich*, this still being years away from the hip-hop community reclaiming and (arguably) reinterpreting the controversial word. Depending on your attitude, the film marked perhaps the most offensive offering from the bottom of the blaxploitation barrel.

One can only feel sorry for those caught up in this mess: including Paul Harris as Pasha, a soft-spoken, level headed, African-American crime lord who controls the numbers racket in Ohio; and veteran actor Frank DeKova as his Italian mobster rival, Big Tony.

Left: NIGGERICH (aka BABY NEEDS A NEW PAIR OF SHOES, 1974)
Opposite: BABY NEEDS A NEW PAIR OF SHOES (1974)

7 SEVEN, COME ELEVEN 11

FEELING GREAT...
WALKING TALL...
HIT MY NUMBER, THAT'S ALL!

BABY NEEDS A NEW PAIR OF SHOES

STARRING: **PAUL HARRIS, REGINALD FARMER,** AND **FRANCES WILLIAMS**
SPECIAL GUEST STAR **FRANK DE KOVA** ORIGINAL STORY BY **HOWARD** AND **ELIZABETH RANSOM**
DIRECTED BY **WILLIAM BRAME** EXECUTIVE PRODUCER **EDITH RANSOM** PRODUCED BY **HOWARD RANSOM**
ORIGINAL MUSIC BY PHIL MOORE III SONG BY ERNIE BANKS ORIGINAL SOUND TRACK ALBUM ON RANSOM RECORDS
ALERT FILM RELEASING, INC. COLOR R RESTRICTED

Black Music

It is one of the strange ironies of American history: the nation which imposed segregation on a percentage of its population, by virtue of the color of their skin, also took to its heart the music invented by the people against whom they were discriminating. However you divide up America's musical heritage over the last century, the majority of innovations and enduring styles have come from black performers and composers.

The story began with ragtime, the first African-American brand of popular music to find an international market; and also the first new genre to emerge in the age of recorded sound. Out of ragtime grew, among other things, the multi-headed beast known as jazz. This originated as a form of dance music, but as befitted a musical style hinged around collective improvisation, it quickly evolved in a dozen different directions. One of its hybrids was swing music, which swept across America in the mid 1930s and remained the dominant form of popular music until the early 1950s. Beneath the mainstream, meanwhile, some of the most adventurous jazz players pioneered a new tradition that came to be known as be-bop. The bop musicians cast off the strictures of the past and effectively plunged African-American music deep into the heart of a rhythmic avant-garde. By the end of the twentieth century, jazz had become nothing less than an alternative form of American classical music, with a repertoire of standard tunes as memorable and enduring as any canon of European "serious" music.

The jazz tradition was only one of the ways in which African Americans reworked the primal impulse of the blues. From this single source came a dazzling succession of musical genres: rhythm and blues, soul music, disco, hip-hop, house, and a bewildering number of sub-genres and cross-fertilizations from one style to another. Along the way, American music also took on board diverse influences from other continents, as Latin-American rhythms, reggae from the Caribbean, and African styles all left their mark.

The effects of all these different musical forms could be seen on the pop charts, on the dance floor, on the streets, and in the way that people—black and white—carried themselves through life, with a swing, a swagger, and a syncopated rhythm that hadn't existed in the pre-ragtime era. Unsurprisingly, the music also left an indelible mark on the movies, as jazz performers became a regular feature of dramas, comedies, and musicals in the 1930s. Jazz was heard regularly on movie soundtracks in the 1950s, and every Hollywood feature dripped with popular music of black origin from the 1970s onwards.

As early as 1929, when Bessie Smith starred in *St. Louis Blues*, blues and jazz became an integral part of the African-American movie experience. Producers soon discovered that allowing a jazz icon—like Duke Ellington, Louis Armstrong or Cab Calloway for example—a few minutes of exposure in a feature could expand the potential audience for their films. Meanwhile, early experiments in portraying African-American musicians in performance established the foundations for a film genre that is still vibrant today: the music documentary. Many of these captured the experience of a single performance or festival. Bert Stern's 1959 visual homage to the Newport Jazz Festival, *Jazz on a Summer's Day*, set up the template, which was then borrowed and adapted for such epochal rock movies as *Monterey Pop* (1968) and *Woodstock* (1970). Other non-fiction musical films concentrated on a particular performer or a movement, capturing footage of performers who might otherwise have been lost to succeeding generations.

Videotapes, videodiscs, and then DVDs helped to expand and maintain the market for such projects, besides encouraging the creation of multi-program documentary histories of jazz and the blues. Today, even musical figures who seem to have been almost forgotten by history, such as Big Bill Broonzy, Sixto Rodriguez, or Howard "Louie Bluie" Armstrong, can be treated to a reverent retrospective by PBS, the BBC, or an independent film company. These films undoubtedly help to enrich the viewer's understanding of the cultural diversity of American music. A case in point was the 1974 release of *Space Is the Place*, which focused on an artist with a rich musical heritage whose work never came close to touching the mainstream.

John Coney's independently-funded film is both a documentary study of a concert performance by the experimental jazz/R&B artist Sun Ra and his Myth Science Arkestra; and a science-fiction fantasy, filmed with an eye totally open to the potential of avant-garde techniques. It portrays Sun Ra as a space traveller—albeit a black nationalist one—who returns to earth to create music that can rescue the African-American community from cultural discrimination. But that summary is too formulaic for a film that, like Sun Ra's music, keeps changing shape and direction, as has the entire black music tradition of the past century.

Opposite: **SPACE IS THE PLACE (1974)**

THE HARDER THEY COME has more guts, wit, humor and sheer exuberance than most movies you'll see in any one year of movie-going."
— Vincent Canby. NEW YORK TIMES

"Fast, tough, sinuous...always exuberant, strong, surprising and effortlessly sinister as the blade sliding out of a knife."
— TIME

"A biting and harshly haunting film that goes off like dry gunpowder!"
— Rex Reed

Over the course of a decade, traditional music in Jamaica changed from being a peculiarly Caribbean interpretation of American jazz and rhythm and blues, through a series of dance rhythms (ska, rocksteady) into a definitive form that was ready to leave a lasting mark on the world. Following Jamaica's independence from Britain, national pride and creative energy was high when this new musical expression, "reggae," appeared in the late 1960s. Steeped in offbeat rhythms, staccato guitar chords, and with a unique sense of phrasing, the music infiltrated pop charts around the world. Its stars, Desmond Dekker, Jimmy Cliff, Toots and the Maytals, and Bob Marley, stoked a musical revolution and provided the subject of one of the most effective marriages of film and music ever achieved.

Perry Henzell's *The Harder They Come* (1972) was the movie that introduced both reggae music and Rastafarian culture to the United States, and was the first successful film to come out of Jamaica. Its score, featuring three songs by Jimmy Cliff, "The Harder They Come," "Many Rivers to Cross," and "You Can Get It If You Really Want," and tracks by other reggae artists like Desmond Dekker and Toots and the Maytals, spawned one of the great movie soundtrack albums of all time.

This hard-hitting social drama stars Cliff, a newcomer to acting, as a rural Jamaican country boy who comes to the city of Kingston to make a record. He finds that breaking into the music business is next to impossible. It is only after he has shot a cop and become a violent fugitive from the law that he wins the notoriety necessary for fame.

Rockers (1978) illustrated how much (and how little) Jamaica and the music business had changed in the years after Bob Marley became a global superstar. Though the film is a fictional narrative, the footage of Kingston is so graphic and encompassing that it can almost double as a documentary, with appearances and songs from such 1970s reggae icons as Burning Spear, Big Youth, Gregory Isaacs, Bunny Wailer, and Peter Tosh.

Left: THE HARDER THEY COME (1972)
Opposite: ROCKERS (1978)

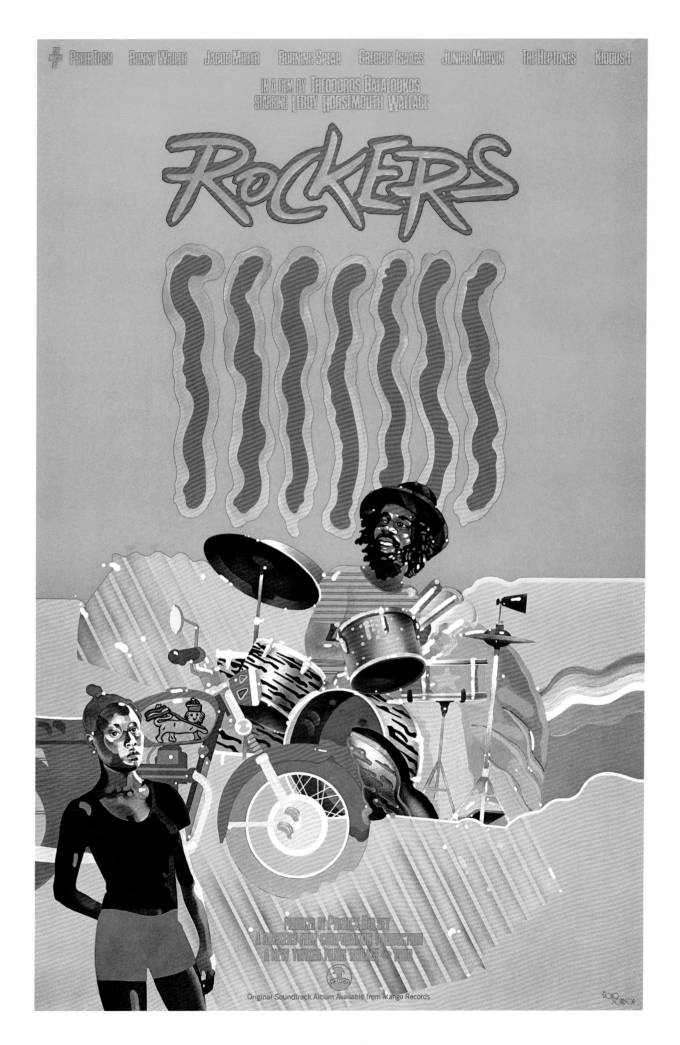

WATTSTAX

Laugh! Cry!
Sing! Hear!
Feel! Dance!
Shout!

A soulful
expression
of the
living word...

Wattstax was billed as the "Black Woodstock"; a day-long concert held in the Los Angeles Coliseum in 1972. Commemorating the seventh anniversary of the historic Watts Rebellion of 1965 that set fire to Los Angeles, it also celebrated the positive changes that the black community had pushed through after the devastation.

The event, MC'd by a dashiki-clad Jesse Jackson, brought together some of the Stax Record label's biggest artists in a combination of soul, gospel, and pop. The concert performances included Albert King, the Bar-Kays, The Staple Singers, Little Milton, Rufus Thomas, and a climactic performance by the iconic "Black Moses of Soul" Isaac Hayes. Comedian Richard Pryor linked the musical performances with acerbic stand-up routines.

In the *Wattstax* documentary film (1973), director Mel Stuart illustrated the broader context in which the event took place, interspersing footage from locations around Watts and interviews with residents about politics, culture, and their changing lives.

A Film About Jimi Hendrix (1973) chronicles the life of one of the most celebrated and influential African-American musicians of the 1960s. Jimi Hendrix forever changed the shape of pop music with profound lyrics, revolutionary guitar sounds, and wild musical expression on stage that included playing with his teeth, behind his head and burning his guitar. Produced three years after the legendary performer's untimely death, the documentary comprises intimate interviews with Jimi's friends, family, and colleagues interspersed with both classic and rare concert footage from Monterey Pop, Woodstock, the Fillmore East, the Isle of Wight, and even London's Marquee club. Musicians Eric Clapton, Pete Townshend, Mick Jagger, Buddy Miles, Little Richard, Billy Cox, Lou Reed, and engineer Eddie Kramer offer personal anecdotes that reflect a deep respect and admiration of Hendrix' artistry.

Left: **WATTSTAX (1973)**
Opposite: **A FILM ABOUT JIMI HENDRIX (1973)**

A Film about JIMI HENDRIX

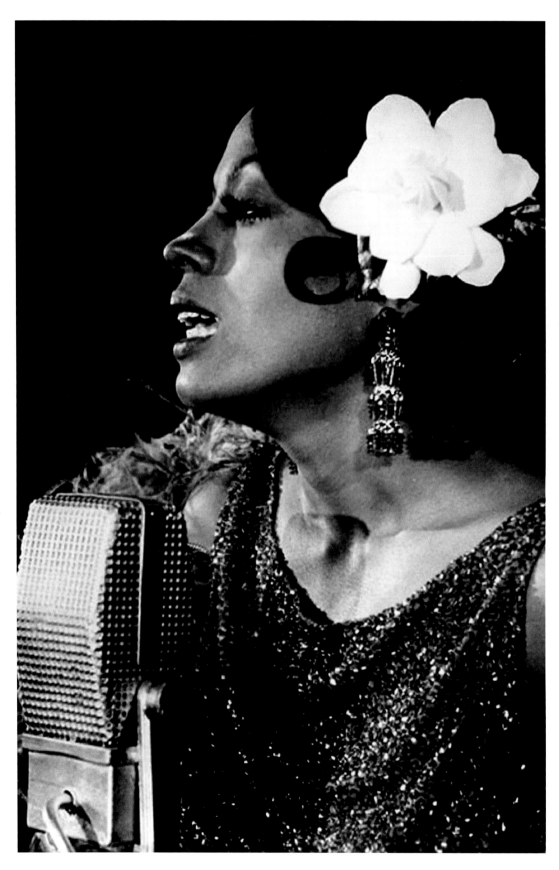

Billie Holiday was a giant of jazz: a virtuoso singer with a haunting voice, fueled by a tempestuous private life that ended in tragedy. She died in 1959 aged just forty-four, leaving behind more than three hundred recordings, and an indelible influence on everyone from Frank Sinatra to Cassandra Wilson and Macy Gray. Her rendition of "Strange Fruit" has been described as one of the key anthems of the struggle against racism in the United States, while her final recordings displayed in graphic and compelling detail the toll that her drug addiction took on her health.

In the early 1970s, having transferred its base from Detroit to Hollywood, Berry Gordy's Motown Records branched out into the movie business. Gordy secured the rights to Holiday's autobiography, entitled *Lady Sings the Blues*, prompting much speculation about who would take the leading role. To universal surprise, and enormous skepticism, Gordy offered the part of Holiday to his most intimate friend on the Motown roster: former Supremes' leader, Diana Ross. On the surface, the two women shared little in common. Ross was healthy, had a wholesome image, had no acting experience and had never sung jazz. Yet in her screen debut, she skillfully portrayed the complicated character of "Lady Day," from her childhood poverty and stint as a prostitute, to her marriages and decline from drug abuse. So convincing was her performance in *Lady Sings the Blues* (1972) that Ross was nominated for both an Oscar and a Golden Globe, being recognized at the latter awards ceremony as the year's most promising female newcomer.

Left: **LADY SINGS THE BLUES (1972), Diana Ross**
Opposite: **LADY SINGS THE BLUES (1972)**

She sang it... like she saw it.

LADY SINGS THE BLUES

A FILM BY CLINT EASTWOOD

BIRD

"There are no second acts in American lives." –F. Scott Fitzgerald

WARNER BROS. PRESENTS A MALPASO PRODUCTION
"BIRD" FOREST WHITAKER DIANE VENORA MUSIC SCORE BY LENNIE NIEHAUS
WRITTEN BY JOEL OLIANSKY EXECUTIVE PRODUCER DAVID VALDES
PRODUCED AND DIRECTED BY CLINT EASTWOOD [DOLBY STEREO]
IN SELECTED THEATRES

There was much to link *Bird* and *Thelonious Monk: Straight, No Chaser*: both were released by Warner Bros. in 1988, both had movie posters designed by Bill Gold, and both were directed by Clint Eastwood. Indeed, the two projects were linked even more closely than that. Eastwood, a lifelong jazz fan, had been delighted to secure the rights to film the life story of the groundbreaking be-bop saxophonist Charlie Parker (known to friends and fans alike as "Bird"). While researching Parker's career, Eastwood stumbled upon some remarkable footage featuring one of Parker's collaborators, the legendary pianist Thelonious Monk. Aware that Monk deserved to be better known by the public beyond jazz aficionados, Eastwood decided to assemble a documentary tribute, named after one of Monk's most famous tunes.

As the leading figures in the bop revolution, Parker, Monk, and trumpeter Dizzy Gillespie transformed the sound and style of jazz in the 1940s. Monk's musical vision was both ahead of its time and deeply rooted in tradition, spanning the entire history of the music from the stride piano of the early twentieth century to the tonal freedom of the avant-garde. *Straight, No Chaser* mixed stills, interviews, and priceless early 1950s TV footage with film of a recording session and a tour from 1968, shot by documentary filmmaker Christian Blackwood.

Meanwhile, Eastwood continued to work on *Bird*, which starred Forest Whitaker as Charlie Parker, Whitaker's brother Damon as the young Charlie, and Diane Venora as Parker's wife, Chan. In a bold move that probably did little to boost the project's commercial appeal, Eastwood decided to forego a traditional chronological approach, preferring a more spontaneous, jazz-like feel to the narrative. The finished movie aroused controversy among Parker's fans, some criticizing it, others finding it a suitable tribute to the musician whose uncompromising playing and boundless vision had remade jazz in his own image more than forty years earlier.

Left: **BIRD (1988)**
Opposite: **THELONIOUS MONK: STRAIGHT, NO CHASER (1988)**

Thelonious Monk

STRAIGHT NO CHASER

Michael Schultz

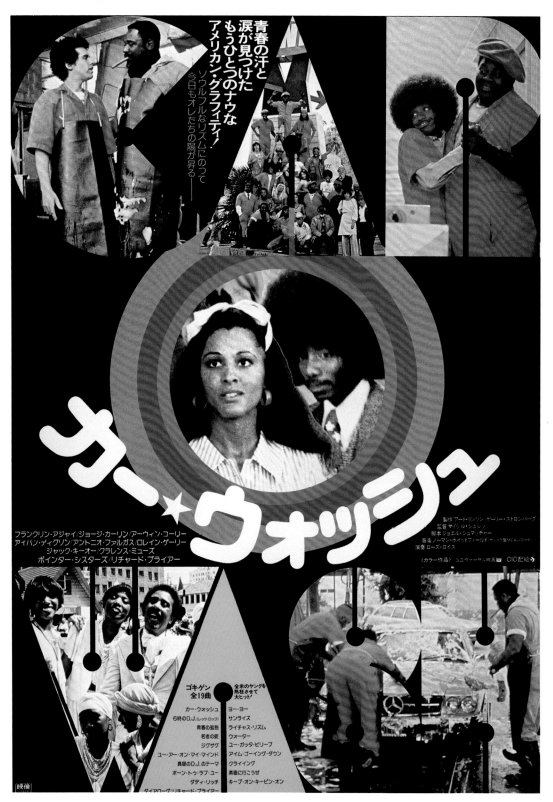

By the mid 1970s, the blaxploitation honeymoon was over and a retrenchment in Hollywood began. Rather than producing new or other types of black films, the industry did the reverse, producing less and less. Work for blacks—on either side of the camera—became scarce. Only two black directors worked consistently behind the camera in the mid 1970s: Sidney Poitier (*Uptown Saturday Night*, *Let's Do It Again*, *A Piece of the Action*), and Michael Schultz (*Cooley High*, *Car Wash*, *Which Way is Up?*).

Schultz came to film directing via the stage in 1968 with The Negro Ensemble Company in New York. On Broadway, he won an Obie and New York Drama Critics' Circle Award before making his television debut with the Lorraine Hansberry play *To Be Young, Gifted and Black*, for PBS in 1972.

But it is for his urban classic *Cooley High* (1975) that Michael Schultz is most widely remembered. It was pitched as the black equivalent to George Lucas's *American Graffiti* (1973): a film that staked its appeal on human drama and on its audience's nostalgia for its shared past. It was a coming-of-age comedy that followed the adventures and aspirations of two high school buddies (Glynn Turman and Lawrence Hilton-Jacobs) in the South Side of Chicago in the early 1960s. Void of the sex and violence requirements of the decade's earlier films, *Cooley High* was fondly embraced by audiences both black and white. The film's Motown soundtrack—featuring The Supremes, Stevie Wonder, the Four Tops, Martha Reeves, The Temptations, Junior Walker, and Smokey Robinson—helped boost its popularity and domestic box office gross.

Schultz then directed *Car Wash* (1976), a comedy about the day in the life of the Dee-Luxe Car Wash in Los Angeles. It featured an ensemble cast with Richard Pryor, George Carlin, Garrett Morris, Bill Duke, Ivan Dixon, Franklyn Ajaye, Antonio Fargas, Tracy Reed, and The Pointer Sisters. Norman Whitfield's group, Rose Royce, provided a chart-busting soundtrack highlighting the anthem to the disco era, "Car Wash."

Left: CAR WASH (1976), Japanese
Opposite: COOLEY HIGH (1975), German

Hey, Mama, cool it! Noch eine Nacht, dann bin ich achtzehn.

COOLEY HIGH

Wenn du mein Freund sein willst, mußt du dich mit mir prügeln . . .

FILMWELT zeigt einen Film von **MICHAEL SCHULTZ**

mit **LAWRENCE-HILTON JACOBS**
GLYNN TURMAN
GARRETT MORRIS
und **CYNTHIA DAVIS**
als Brenda

MOTOWN
SOUNDS of the SIXTIES

THE SUPREMES · STEVIE WONDER
MARTHA REEVES and THE VANDELLAS ·
THE TEMPTATIONS · THE MARVELETTES ·
SMOKEY ROBINSON and THE MIRACLES ·
BRENDA HOLLOWAY · BARRETT STRONG ·
THE FOUR TOPS · JR. WALKER ·
LUTHER ALLISON ·

Titelsong
»It's Hard To Say Good-Bye To Yesterday«
gesungen von G. C. CAMERON
OmU

An AMERICAN INTERNATIONAL PICTURE

Richard Pryor

The most daring comic talent since the heyday of Lenny Bruce, Richard Pryor was also the most controversial. Like Dick Gregory before him, he explored issues of racial inequality with great insight and depth, tackling taboo subjects that mainstream, white America would have preferred to be swept permanently under the rug. His emancipated style of African-American humor pushed every boundary and secured him legendary status.

Pryor was known as a "comedian," but that simple description enabled him to explore a wide range of media and styles. His irreverent record albums, including *Bicentennial Nigger* (1976) and *Wanted: Live in Concert* (1978), sold millions, and became the basis for the highly successful film documentary of his stage act: *Richard Pryor: Live in Concert* (1979). As an actor, he appeared in over forty feature films, from a series of popular comedies with Gene Wilder to serious roles in cult classics such as *Blue Collar* (1978). He even managed to tone down his act enough to front TV series for both adults and children.

Sadly, at the height of his popularity, his career began to take a disastrous turn when he suffered declining health and the effects of drug and alcohol abuse. He had a heart attack, attempted suicide, and fell ill with multiple sclerosis. Pryor retired from performing in the 1990s and was confined to a wheelchair until his death in 2005, at the age of sixty-five.

One of his film roles was supposed to have been in Mel Brooks' hallmark western comedy, *Blazing Saddles* (1974), for which he co-wrote the script. But Warner Bros. executives and studio producers considered him too controversial a figure to risk in the part. The role went instead to Cleavon Little, who, playing a black sheriff in a white town, lacked Pryor's uncompromising, highly-strung style on screen and didn't fully play into the absurd racial stereotypes. Still, Pryor's deliberately offensive parody of racism received three Academy Award nominations and won a Writers' Guild Award for Best Comedy Written for the Screen.

Left: **RICHARD PRYOR: LIVE IN CONCERT (1979)**
Opposite: **BLAZING SADDLES (1974)**

HI, I'M MEL. TRUST ME.

BLAZING SADDLES

MEL BROOKS WB FILM

Eddie Murphy

He's been chased, thrown through a window, and arrested.
Eddie Murphy is a Detroit cop on vacation in Beverly Hills.

BEVERLY HILLS
Cop

PARAMOUNT PICTURES PRESENTS A DON SIMPSON JERRY BRUCKHEIMER PRODUCTION IN ASSOCIATION WITH EDDIE MURPHY PRODUCTIONS·A MARTIN BREST FILM
EDDIE MURPHY·BEVERLY HILLS COP·MUSIC BY HAROLD FALTERMEYER·SCREENPLAY BY DANIEL PETRIE JR·STORY BY DANILO BACH AND DANIEL PETRIE JR
PRODUCED BY DON SIMPSON AND JERRY BRUCKHEIMER·DIRECTED BY MARTIN BREST·MOTION PICTURE SOUNDTRACK ALBUM ON MCA RECORDS AND TAPES
R RESTRICTED DOLBY STEREO A PARAMOUNT PICTURE

Opens Friday, December 7th At
LOEWS STATE **LOEWS ORPHEUM** **LOEWS 34TH ST. SHOWPLACE**
B'Way and 45th St. 575-5080 86th St. and 3rd Ave. 289-4607 Between 2nd and 3rd Aves. 532-5544
And At A Theatre Near You. Check Local Newspapers.

By the mid 1970s, the variety of opportunities open to African-Americans in Hollywood began to dissipate. The political backlash that surrounded blaxploitation films and their perpetuation of negative stereotypes—coupled with diminishing profits for the studios—sounded the death-knell to the genre.

Instead, when Hollywood wanted black actors, it chose to spotlight Richard Pryor and Eddie Murphy, two existing stars with bankable box-office appeal. Both could be cast in "buddy-buddy" sidekick roles alongside white stars. Such films as *Stir Crazy*, *48 Hrs.*, *Trading Places*, and *Superman III* did explore the theme of interracial male bonding, but didn't allow their black stars to portray rounded characters with their own goals and aspirations.

Born in 1961, Murphy began a stand-up comedy career in New York at the age of fifteen, and was only nineteen when producer Lorne Michaels signed him as a regular ensemble member on NBC's weekly hit television show, *Saturday Night Live*. This led to his film debut in 1982 in *48 Hrs.*, the first in a series of supporting roles. It was only in 1984 with his fourth movie, *Beverly Hills Cop*, that he was allowed a starring role as Axel Foley—a Detroit cop roaming through Beverly Hills, California, in pursuit of the killers of his best friend. The role established him as one of the most popular comic talents of the decade, though ironically it was originally written for an actor who was different in every imaginable way: Sylvester Stallone.

As his acting career soared, Murphy chose to remind his audience of his comedy roots in *Eddie Murphy's Raw*, a documentary of a live stand-up performance in New York, directed by Robert Townsend. Tipping its hat to Pryor's concert films and albums, Murphy's *Raw* was unashamedly aimed at an African-American audience, though his outrageous riffs on sex and race attracted a large white fan-base as well.

Left: **BEVERLY HILLS COP (1984)**
Opposite: **BEVERLY HILLS COP (1984), East German**

BEVERLY HILLS COP

ICH LÖS' DEN FALL AUF JEDEN FALL!

Eine Kriminalkomödie aus den USA · Es spielen: Eddie Murphy,
Lisa Eilbacher, Steven Berkoff u.a. Regie: Martin Brest

(204) Ag 500/73/87 4860

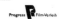

Spike Lee

As a director, writer, actor, producer, and activist, Spike Lee is one of the most influential figures in recent American cinema history. He changed the face of black film in the 1980s with his radical and perceptive dramas about racial identity. His pioneering breakout feature, *She's Gotta Have It*, along with *Do the Right Thing*, made it possible for the next generations of African-American filmmakers to follow in his footsteps. Yet he has never forgotten the African-American pioneers of the movie business, declaring: "Everything that we're doing, it's been because of the hell that they had to go through."

The title of Lee's production company, 40 Acres and a Mule Filmworks, is both a proud statement of African-American identity, and a harsh reminder of America's broken promises and racist policies. It refers back specifically to 1865, when General Sherman issued Special Field Order 15, which called for freed slaves in Georgia to be given parcels of land, 40 acres apiece, with which to start their lives of freedom. (The mule was essential to work the land, but not laid down in the Field Order.) Then, after the assassination of President Lincoln, his successor Andrew Jackson overturned the Order—one painful step backwards on the long march from slavery to civil rights.

Each of Lee's films is—in his own phrase—"A Spike Lee Joint." It is a unique way of identifying his work, and marking it out from the grandiosity of the Hollywood mainstream system. As he has proved, he is capable of working successfully as an independent, or within a major studio; and with black or white actors. His vision is not only individual, but cultural, from the standpoint of a politically aware and opinionated African American in a nation dealing with the legacy of centuries of prejudice and oppression.

"In order for there to be more human black characters, we have to start making the films ourselves," Lee said early in his career. "You cannot leave it up to the Alan Parkers, the Richard Attenboroughs, and the Steven Spielbergs of the world to tell our story. And *they* shouldn't have to do that, either." He set out on that quest at Morehouse College in Atlanta, where in his junior year he edited his first short documentary film, *Last Hustle in Brooklyn*. Using a Super 8mm camera he borrowed from a friend, the film comprised clips from in and around New York during the previous summer of 1977—including the electric blackout lootings and disco block parties in Brooklyn. He completed his master's degree thesis at Tisch School of the Arts at New York University with *Joe's Bed-Stuy Barbershop: We Cut Heads*. Made with student cinematographer Ernest Dickerson, the film won him an Academy of Motion Picture Arts and Sciences' Best Student Film Award in 1983.

Three years later, Lee had gathered together the miniscule budget required to make his debut professional feature, *She's Gotta Have It*. It was the first of more than forty films that have borne his directing credit over the past three decades: not just dramas and comedies based on his own scripts, but also jobs-for-hire in Hollywood, and a rich seam of documentaries that reflect his passionate interest in history and the arts.

Born in Atlanta and raised in Brooklyn, Spike was inspired by his parents' example: his mother Jacquelyn was an arts and black literature teacher, and his father was the bassist Bill Lee, who later scored several of his son's films. From the outset of his career, Spike's work has exhibited supreme craftsmanship, an uncompromising personal vision, and a refusal to be enclosed by any racial or artistic boundaries. Like Woody Allen, he is a quintessential New Yorker, who uses the city as both an inspiration and a vehicle for exploring multiple perspectives. Alongside Jim Jarmusch, he pioneered the American independent film movement of the 1980s, offering a unique and refreshing alternative to Hollywood orthodoxy. But Spike Lee's catalog is arguably more diverse and more courageous than that of any of his peers.

Working in a largely white environment, he has exhibited an ambition and range that is almost revolutionary in its impact. His movies vary widely in subject and style, although many of them explore the Brooklyn that he has known since his childhood—a vein that runs from *She's Gotta Have It* to *Red Hook Summer* (2012). Without compromising his position as an aggressively outspoken advocate of civil rights, Lee consistently touches the nerve of the American public.

His brand of storytelling extends from the fictional dramas for which he is best known to such notable documentaries as *4 Little Girls* (1997, which was nominated for an Academy Award), *Jim Brown: All American* (2002), and *When the Levees Broke: A Requiem in Four Acts* (2006). Throughout his prolific, and frequently controversial career, Spike Lee has remained a consummate filmmaker, whose guiding ethos was expressed in an early interview: "I really don't want any people to be in my films that look like they're acting. You want very natural people. I want them to feel free."

Opposite: **SPIKE LEE (1986)**

237 **Spike Lee**

Once the blaxploitation boom had subsided, African-American audiences had little to anticipate other than a Richard Pryor or Eddie Murphy comedy, or an occasional dramatic feature such as *A Soldier's Story* (1984) and *The Color Purple* (1985). The gloom lifted with the release of *She's Gotta Have It* (1986), an independently produced and directed film from newcomer Spike Lee.

The twenty-nine-year-old filmmaker shot the film in his Brooklyn neighborhood in less than two weeks on a budget of $175,000—dirt-cheap, by Hollywood standards. His style of "guerrilla filmmaking" was reminiscent of such groundbreaking African-American directors as Oscar Micheaux in the 1920s and Melvin Van Peebles in the 1970s.

The film starred Tracy Camilla Johns in the role of a contemporary black woman who exemplifies the female attitudes and concerns of the 1980s: she's independent, assertive, and has an equally realized personal and professional life. In the film, she has three lovers—Tommy Redmond Hicks, John Canada Terrell, and Spike Lee himself—each of whom she refuses to allow to control or restrict her. This scenario overturned the orthodox pattern of gender relationships in the movies, black and white, and established a feminist theme that remains one of Lee's characteristics as a writer and director.

She's Gotta Have It, both stylish and minimalist in its approach, won the coveted *Prix de Jeunesse* award at the Cannes Film Festival, and became a smash hit at the box office. While maintaining creative control of his work, Spike Lee single-handedly demonstrated to Hollywood that independent black film could make money, and that black audiences, as well as white, would support it.

Left: SHE'S GOTTA HAVE IT (1986), Japanese
Opposite: SHE'S GOTTA HAVE IT (1986)

A SERIOUSLY SEXY COMEDY

SHE'S GOTTA HAVE IT

BROOKLYN

ISLAND PICTURES PRESENTS
A SPIKE LEE JOINT
"SHE'S GOTTA HAVE IT" STARRING TRACY CAMILA JOHNS
REDMOND HICKS · JOHN CANADA TERRELL · SPIKE LEE · RAYE DOWELL · MUSIC BILL LEE
PHOTOGRAPHY ERNEST DICKERSON · PRODUCTION SUPERVISOR MONTY ROSS
PRODUCTION DESIGN WYNN THOMAS · ASSOCIATE PRODUCER PAMM JACKSON
PRODUCED BY SHELTON J. LEE · WRITTEN, EDITED, & DIRECTED BY SPIKE LEE

SOUNDTRACK AVAILABLE ON
ISLAND RECORDS & TAPES

©1986 FORTY ACRES AND A MULE FILMWORKS. ALL RIGHTS RESERVED

ISLAND
PICTURES

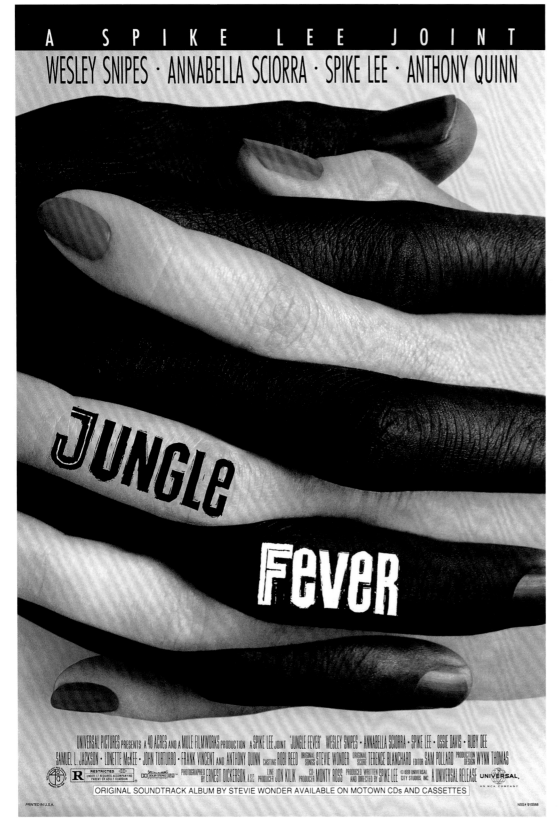

A SPIKE LEE JOINT

WESLEY SNIPES · ANNABELLA SCIORRA · SPIKE LEE · ANTHONY QUINN

JUNGLE FEVER

UNIVERSAL PICTURES PRESENTS A 40 ACRES AND A MULE FILMWORKS PRODUCTION A SPIKE LEE JOINT "JUNGLE FEVER" WESLEY SNIPES · ANNABELLA SCIORRA · SPIKE LEE · OSSIE DAVIS · RUBY DEE SAMUEL L. JACKSON · LONETTE McKEE · JOHN TURTURRO · FRANK VINCENT AND ANTHONY QUINN CASTING ROBI REED ORIGINAL SONGS STEVIE WONDER ORIGINAL SCORE TERENCE BLANCHARD EDITOR SAM POLLARD PRODUCTION DESIGN WYNN THOMAS
PHOTOGRAPHED BY ERNEST DICKERSON, A.S.C. LINE PRODUCER JON KILIK CO-PRODUCER MONTY ROSS PRODUCED WRITTEN AND DIRECTED BY SPIKE LEE ©1991 UNIVERSAL CITY STUDIOS, INC. A UNIVERSAL RELEASE UNIVERSAL AN MCA COMPANY

ORIGINAL SOUNDTRACK ALBUM BY STEVIE WONDER AVAILABLE ON MOTOWN CDs AND CASSETTES

PRINTED IN U.S.A. NSS# 910088

Spike Lee's provocative third feature film, *Do the Right Thing* (1989), was a landmark in American cinema. Set in the predominantly African-American Bedford-Stuyvesant section of Brooklyn, the film focuses on the racial polarities and strain that affect the staff, management, and clientele of Sal's Famous Pizzeria, a local Italian landmark. Before a new day comes, a young man is dead, a restaurant burned to the ground, and a racial divide has grown wider, suggesting that there may never be any resolution to the problems the film raises.

Do the Right Thing featured a stellar ensemble cast, including Ossie Davis and Ruby Dee, Samuel L. Jackson, Rosie Perez, and Lee himself. It won critical and popular praise as the most insightful view of race relations ever captured on film; but was also condemned by some as being inflammatory and even racist.

Lee's *Jungle Fever* (1991) appeared on the surface to explore the problems surrounding interracial relationships and their destructive ripple effect on the participants, their families, and friends. For Lee, however, the film had an even simpler and more universal theme: love, sex, and what happens when one of those things is explored without the other.

Wesley Snipes stars as an affluent African-American architect living in Harlem's elite Strivers' Row with his wife (Lonette McKee) and young daughter. He compromises his relationship by having an affair with his Italian-American secretary (Annabella Sciorra), who lives in the working-class neighborhood of Bensonhurst with her abusive father and two grown brothers. The fallout from their liaison is devastating. Thrown out of their homes, the outcast couple move in together, faced with the reality of a mixed-race relationship. Lee shows the viewer how race and class can cause conflict, but is more interested in examining the effect that this affair has on the people who surround the couple. It is through them that he probes the issues, albeit without resolving the conflicts, thereby forcing the audience to come up with its own solutions.

The film's cast included Spike Lee veterans Ossie Davis, Ruby Dee, Samuel L. Jackson, and debut screen appearances by Halle Berry and rapper Queen Latifah.

Left: **JUNGLE FEVER (1991)**
Opposite: **DO THE RIGHT THING (1989)**

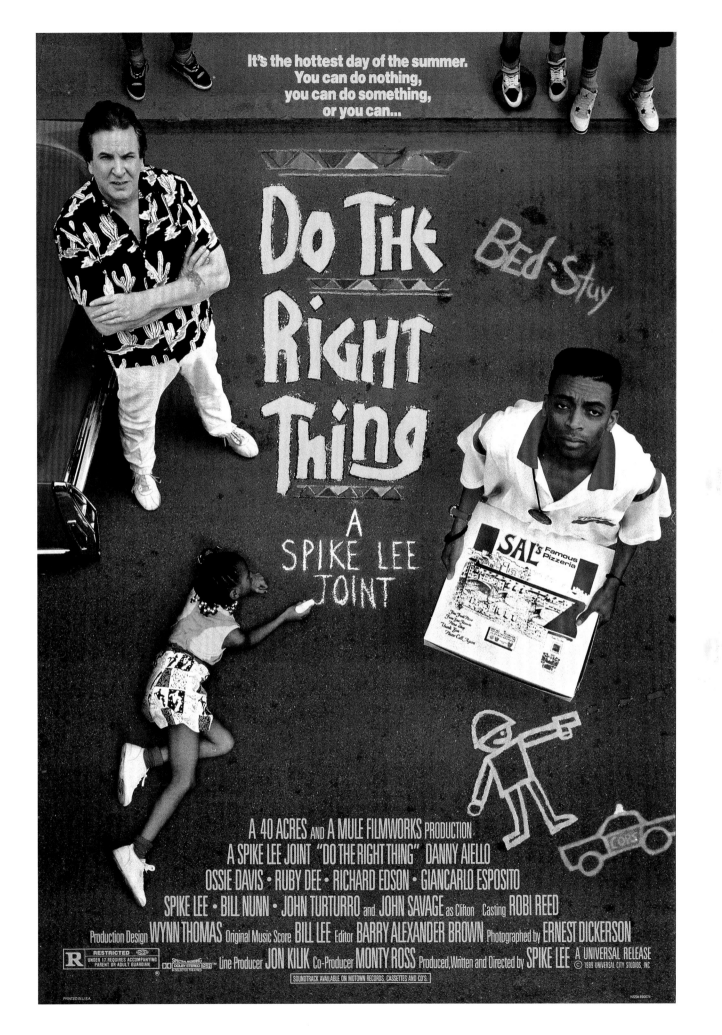

November 18

In *Malcolm X* (1992), Lee directed a provocative and compelling biopic of the charismatic African-American leader who had polarized opinion sharply in the years before his assassination in 1965. Denzel Washington portrayed the black nationalist preacher; Angela Bassett his wife, Betty Shabazz; and Al Freeman Jr. the leader of the Nation of Islam, Elijah Muhammad, who first saw Malcolm as his disciple, and later as his enemy— an opposition that sparked Malcolm's assassination as he addressed his weekly audience at the Audubon Ballroom in Harlem.

Early Hollywood portrayals of black actors in stereotypical roles are still the source of anger and embarrassment decades after those images disappeared from the screen. With typical courage and flair, Lee's provocative 2000 movie, *Bamboozled*, revisited all the implications of those offensive images.

By presenting a satire of a twenty-first century minstrel show, *Bamboozled* parodies the position of black performers in contemporary media, and questions just how much progress Hollywood has actually made since *The Birth of a Nation*. The film starred Damon Wayans as Harvard-educated Pierre Delacroix, who is the sole black writer for a struggling television network that specializes in clownish urban sitcoms. Under fire from his white, ghetto-wannabe boss to invent a hit show that will appeal specifically to black viewers, Delacroix vengefully creates a contemporary blackface minstrel show that, in the spirit of the Nazi frolics of *The Producers*, becomes a sensational smash and ratings winner. The title of the film was taken from a scene in *Malcolm X*, where the civil rights activist addresses African Americans thus: "You've been hoodwinked. You've been had. You've been took. You've been led astray, led amok. You've been bamboozled."

At the climax of *Bamboozled*, Lee fills the screen with a parade of the racist and culturally demeaning caricatures that the film sets out both to remind us of, and to destroy. They include images from *The Birth of a Nation*, *The Jazz Singer*, *Gone with the Wind*, and various mid-century cartoons: a visual catalog of Hollywood's sins against the black community.

Left: **MALCOLM X (1992)**
Opposite: **BAMBOOZLED (2000)**

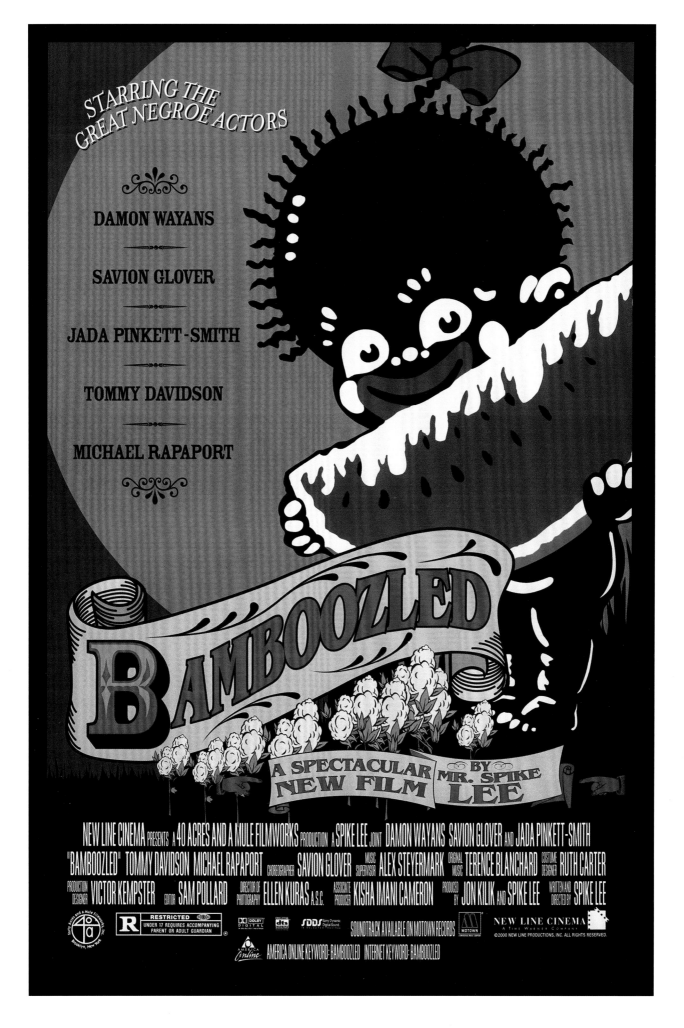

In his career as a director, Spike Lee has refused to be circumscribed by his race and by the scenarios of his early films. Although African-American characters dominate his work, he has proved himself more than capable of handling themes that are not directly governed by race. *Summer of Sam* (1999) was his first effort to feature an almost entirely white cast. As in all of his pictures, the interactions between the characters carry the weight of the film. It is set in New York during 1977, when the murderer David Berkowitz—who came to be dubbed "Son of Sam"—was on the loose, ultimately killing six women and injuring seven. Lee portrays a close-knit milieu of Italian characters in a Bronx neighborhood who are increasingly racked by paranoia, as the summer heat, fear of the killer, and mutual suspicion combine to explosive effect. This is no ordinary serial-killer tale: the subject here is the effect of the murders, not the crimes themselves.

25th Hour (2002) is another claustrophobic study of individuals under pressure; this time set in New York in the aftermath of the 9/11 catastrophe. The lead character is played by Edward Norton, who is about to begin a seven-year prison sentence for drug dealing; the narrative focuses on his final twenty-four hours of freedom, as he searches for someone to blame for his fate and ponders the effects that his imprisonment will have on himself, his closest friends, and family. As with *Summer of Sam*, the theme is not racial, but psychological, with Lee again demonstrating himself to be a master of exploring and exposing the detail and texture of human frailty, and the ambiguous nature of even the most intimate human relationships.

Left: **25TH HOUR (2002)**
Opposite: **SUMMER OF SAM (1999)**

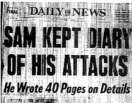

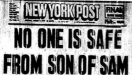

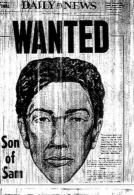

Apartheid

The word means "the state of being apart"—something that must have sounded very familiar to the ears of African Americans in the long decades before black citizens were afforded their full civil rights after a courageous and bitter struggle for freedom. Many nations around the world subjected elements of their population to discrimination and legally entrenched prejudice. But the word "apartheid" refers specifically to the harsh regime imposed in law by the South African government in 1948, and not relieved until 1994.

So central was apartheid to white South Africa's view of itself that the policy of segregation was enforced through every imaginable facet of everyday life—legalizing layers of oppression that had been obvious for decades to the black and colored inhabitants of the country. Every single South African was categorized into one of four groups, based on their racial origin and the color of their skin: white, colored, Indian, and, at the bottom of the heap, black. The apartheid legislation was refined and tightened down the years, with non-whites not only barred from voting in supposedly democratic elections, but also losing their citizenship. In 1970, South Africa disowned them; they belonged now to one of the artificial "homelands" established by the government, in order to ensure that all the members of particular ethnic groups lived together, far removed from the eyes of the white elite.

This process of segregation went far beyond anything witnessed in America, even during the worst excesses of racial discrimination and violence. The exclusion of blacks from South African society meant, first of all, that thousands of them were "resettled" (or expelled, more accurately) from the cities to the so-called "townships," where they endured the rigors of poverty and malnutrition. Barred from parks, restaurants, and stores frequented by white people, blacks were also required to carry identification documents with them at all times, and under the repressive "pass laws" their movements were highly restricted. All interracial marriage was banned; sex across the racial divide was illegal, and even casual conversation was likely to spark official investigation—unless between white master and black servant.

Not all white South Africans supported the apartheid regime. Many campaigned bravely against it, at risk to their own lives. But they were swamped by the all-seeing, all-controlling tools of the state, which became even more powerful when South Africa was expelled from the British Commonwealth and became an independent nation in 1961.

Black opposition to apartheid within South Africa revolved around the African National Congress and the Pan African Congress. But the events in Sharpeville in March 1960, when a peaceful "anti-pass law" demonstration resulted in police shooting dead sixty-nine black protestors, showed all too clearly what they were up against. The massacre was an important turning-point in the course of the anti-apartheid struggle. The ANC was proscribed as an illegal organization, and its leaders, including Nelson Mandela, given lengthy prison sentences. Yet echoes of the Sharpeville massacre were heard around the world, prompting the small British-based protest organization, the Boycott Movement, to spawn a global campaign under the auspices of the Anti-Apartheid Movement.

With segregation still very much a part of its own heritage, it is not surprising that America was slow to chronicle the anti-apartheid struggle in films. Before Sharpeville, in fact, in an age when international news often travelled slowly by road or by ship, knowledge of what was happening in South Africa was often surprisingly sparse elsewhere. When Henning Carlsen, a Danish filmmaker, visited South Africa in 1958, he was shocked to witness the effects of apartheid—a concept he knew nothing about before he arrived. He vowed to document the realities of South African life on film, and returned with a hidden camera to make *Dilemma* (1962; also known as *A World of Strangers*, after the Nadine Gordimer novel on which it was based).

The film's premiere inspired the creation of a Scandinavian branch of the Anti-Apartheid Movement. Viewers in Europe were shocked to see the restricted conditions under which blacks were forced to live in South Africa. One of the film's stars was Zakes Mokae, a black African who had formed a radical theater group with the white writer Athol Fugard. In 1963 he fled South Africa for Britain, training at the prestigious Royal Academy of Dramatic Art. By the end of the 1960s, he had moved to the United States, where he forged a successful career as a stage actor, while also making regular appearances in television series as varied as *Starsky and Hutch* and *The West Wing*.

Dilemma was a very different piece of filmmaking, filled with graphic documentary footage and music from Max Roach and Abbey Lincoln's pioneering 1960 jazz album, *Freedom Now Suite*. Shot on a tiny budget in severely limited circumstances, its message triumphed over its technical shortcomings.

These pioneering efforts inaugurated a tradition of filmmaking about apartheid that has continued to this day. The late Nelson Mandela lived to see his own life interpreted on screen in no fewer than twenty films, by actors such as Sidney Poitier (*Mandela and de Klerk*, 1997), Morgan Freeman (*Invictus*, 2009), and, most recently, Idris Elba (*Long Walk to Freedom*, 2013).

Hollywood established a pattern of black-white pairings in its film treatments of South Africa, such as *The Wilby Conspiracy* (1975, with Sidney Poitier and Michael Caine); *Cry Freedom* (1987, with Denzel Washington and Kevin Kline); and *A Dry White Season* (1989, with Zakes Mokae and Donald Sutherland). The last of these films was made by Euzhan Palcy from Martinique, one of the few black directors to tackle the troubled landscape of apartheid. Palcy is also the first black woman to direct a feature film for a major Hollywood studio.

Opposite: **DILEMMA (1962), Danish**

★★★★ ›DE SKAL SE DENNE FILM‹,
skrev B.T. begejstret om . . .

HENNING CARLSEN's
opsigtsvækkende
Sydafrika-film

bygget over
NADINE GORDIMER's
roman
A WORLD
OF STRANGERS
(I fremmed land)

DILEMMA

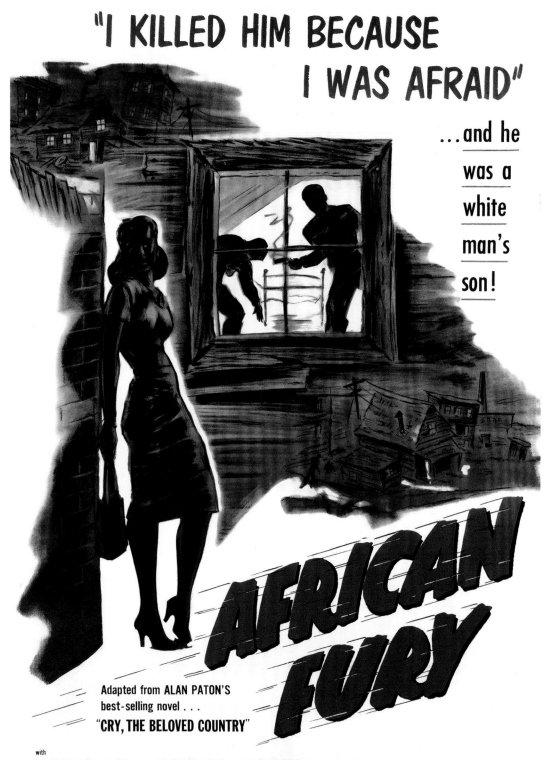

"I KILLED HIM BECAUSE I WAS AFRAID"

...and he was a white man's son!

AFRICAN FURY

Adapted from ALAN PATON'S best-selling novel . . .
"CRY, THE BELOVED COUNTRY"

with
CANADA LEE · CHARLES CARSON · SIDNEY POITIER · JOYCE CAREY
Screenplay by Alan Paton · Produced and Directed by Zoltan Korda
A Zoltan Korda-Alan Paton Production · A London Films Presentation
Released by Lopert Films Distributing Corp.

When the Hungarian director Zoltan Korda arrived in Johannesburg in 1950 to shoot the location footage for *Cry, the Beloved Country* (1951), he took with him the two stars of his movie: both of whom were black. In order to bypass the harsh apartheid laws that had been brought in two years earlier, Korda was forced to pretend that Sidney Poitier and Canada Lee were his servants—not the actors playing the two priests who were at the heart of his drama.

It was an irony, and an outrage, that might have brought a wry smile to the face of Alan Paton, whose novel of the same name provided the basis for Korda's film. He published his book early in 1948, just before the doctrine of apartheid was installed in law. The film reflected the new reality, although the legal switch made little practical difference to the lives of Paton's characters, struggling with racial prejudice and family strife—themes that collide with brutal consequences.

Much of the film was shot at Shepperton Studios in England, but the real-life location shots lent it an air of veracity that could not have been matched elsewhere. Sadly, the process of filming took its toll on Canada Lee, a civil rights activist, former boxer, and musician, whose most famous previous role had been in Alfred Hitchcock's *Lifeboat* (1944). He suffered a heart attack at the end of the shoot, and died in 1952, aged just forty-five.

Nor did the film itself survive unscathed: the print was taken out of Korda's hands by its American distributor, who cut it to reduce its political impact, and altered its title to *African Fury*.

Left: AFRICAN FURY (aka CRY, THE BELOVED COUNTRY, 1951)
Opposite: CRY, THE BELOVED COUNTRY (1951), British

The opening caption of Lionel Rogosin's film *Come Back, Africa* (1959) perfectly captured the director's intentions: "This film was made secretly in order to portray the true conditions of life in South Africa today. There are no professional actors in this drama of the fate of a man and his country. This is the story of Zachariah—one of the hundreds of thousands of Africans forced each year off the land by the regime and into the gold mines." As research, before beginning production of the film, Rogosin spent several months becoming accustomed to the way of life in South Africa and acquiring a sense of the cruelty and injustice of the apartheid government and its sensitivity to anti-government "conspiracies"—such as the very film he wished to create.

The secrecy surrounding the project extended to Rogosin's amateur performers. Figuring that too much knowledge might prove dangerous for them if they were picked up by the police, he merely gave them instructions for each scene, dubbing in much of the dialogue during post-production in London. As far as the South African authorities were concerned, Rogosin was simply shooting an apolitical documentary about life in

the country, and filming some of the musical performers he found in the townships— among them, the young Miriam Makeba, the singer who later became legendary as "Mama Africa" and a leading voice in the fight against apartheid.

What emerged was a movie that worked both as a documentary record of a time, a place, and a state of institutionalized racism; and a profound and shocking human drama. Taking its name from the title of an African National Congress slogan, *Come Back, Africa* premiered at the 1959 Venice Film Festival where it won the Pasinetti Critics' Prize. It remains an influential landmark in the troubled but diverse history of moviemaking in Africa.

Above: **COME BACK, AFRICA (1959), British**
Opposite: **COME BACK, AFRICA (1959), Re-release 2010**

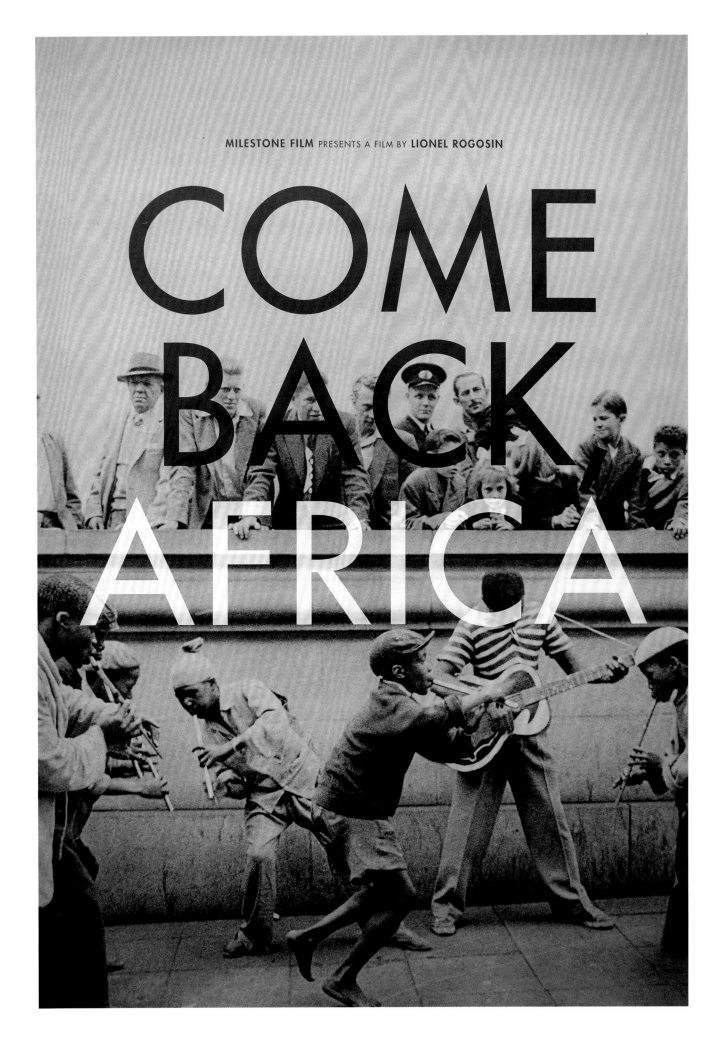

MILESTONE FILM PRESENTS A FILM BY LIONEL ROGOSIN

COME BACK AFRICA

It was only in the mid 1980s that the major Hollywood studios felt able to commit themselves to a big-budget movie that would address the struggle against apartheid. Television images of police brutality in South Africa had belatedly spread awareness of the repressive nature of the white minority regime. They also rekindled memories of the civil rights movement in the US, and finally led America to join the international trade, cultural, and sporting boycott of South Africa.

In 1987, director Richard Attenborough released *Cry Freedom*, his first film project since the Academy Award-winning epic, *Gandhi* (1982). Its ostensible subject is Steve Biko (Denzel Washington), the distinguished leader of the Black Consciousness Movement, who was tortured and killed in 1977 while in police custody. But the film's spotlight falls on Donald Woods (played by Kevin Kline), a liberal white South African newspaper editor. He flees the South African police with his family, having endured threats of imprisonment and death if he published the truth about Biko's murder.

Like *Cry Freedom*, *A World Apart* (1988) focused on those brave, non-black activists who risked their lives to support the struggle against apartheid. Writer Shawn Slovo based the screenplay on her formative years growing up with her siblings in an affluent neighborhood of Johannesburg in 1963. The drama fictionalizes the story of her parents—Joe Slovo, a lawyer, and Ruth First, a journalist—who, as subversive campaigners for the African National Congress, aggressively participated in the anti-apartheid movement. The story unfolds through the confused eyes of their young daughter and moves quickly to the alienation and frustrations she endures as a result of her father's exile and mother's arrest for politically revolutionary activities.

A World Apart marked the feature film directing debut of Chris Menges, the Oscar-winning cinematographer (*The Killing Fields*, *The Mission*). He won the Grand Prize of the Jury at the Cannes Film Festival for his efforts.

Left: **CRY FREEDOM (1987), Russian**
Opposite: **A WORLD APART (1988), Polish**

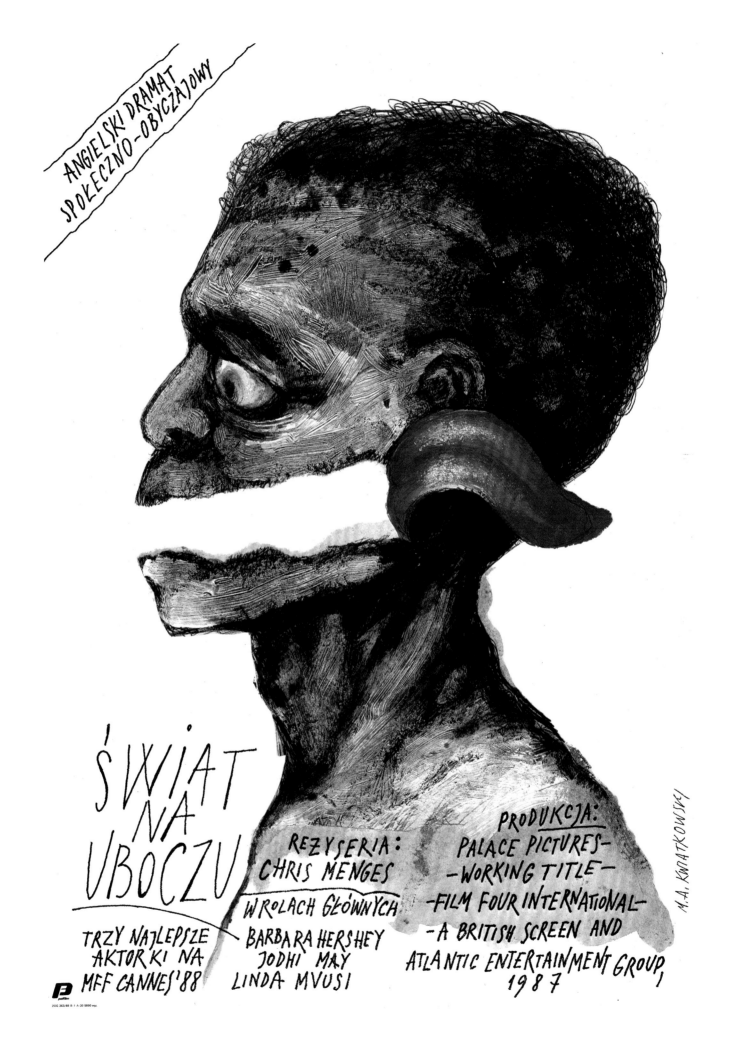

ŚWIAT
NA
UBOCZU

TRZY NAJLEPSZE
AKTORKI NA
MFF CANNES'88

REZYSERIA:
CHRIS MENGES

W ROLACH GŁÓWNYCH
BARBARA HERSHEY
JODHI MAY
LINDA MVUSI

PRODUKCJA:
PALACE PICTURES-
-WORKING TITLE-
-FILM FOUR INTERNATIONAL-
-A BRITISH SCREEN AND
ATLANTIC ENTERTAINMENT GROUP,
1987

M.A. KURATKOWSKI

The Polish School

As the victim of a brutal invasion by the Nazis, and then a takeover by the Soviet Communists, Poland has suffered more than its share of trauma and tragedy over the last century. In the 1930s, it was one of the most receptive territories in Europe to the enticing sounds of American jazz, boasting its own professional musicians, and a vast audience eager to hear the latest sounds from the US. That enthusiasm was squashed by the Nazis; and when the Soviets took cultural control over the whole of Eastern Europe after World War II, everything American was under suspicion.

Like the other nations of the Soviet Bloc, Poland was torn between its natural interest in black music, its sympathy for the plight of black Americans in a land still scarred by segregation and prejudice, and the official government disapproval of the US and all its products. In the Soviet Union, the official party line switched back and forth between treating African Americans as oppressed comrades, and disdaining them as capitalist enemies. In Poland, however, the national love of jazz was so strong that the government thought it best to allow the music to be heard. From the 1950s onwards, there were official festivals of jazz, and local musicians were allowed to perform songs that had been composed by Americans. With brief exceptions, African-American culture was seen by the authorities as being progressive and positive for the Polish people to enjoy. It is not surprising, therefore, that films showing blacks in a positive light were also approved for distribution in Poland.

The loosening of Stalinist restrictions didn't just allow Poland to experience jazz and African-American cinema: it also unleashed a golden era of film poster design. Government censors continued to pay close attention to the content of films, but they were far less concerned with the posters used to promote them. As a result, Polish artists and designers experienced a freedom of expression that was rarely available in other forms of media. Every aspect of the country's film industry was owned and controlled by the government, and so traditional commercial considerations did not

apply. Individual artists such as Wiktor Gorka, Eryk Lipiński, and Jan Lenica worked with a degree of freedom that many of their Western counterparts would have envied—an ironic counterpoint to the prevailing social climate of Poland's generally authoritarian political system.

As the next few pages illustrate, some of the country's foremost artists turned their hands to creating film posters that offered a unique perspective on black culture from several thousand miles away. *The Great White Hope* (1970), for example, presented a fictionalized version of the life story of the first black heavyweight champion of the world, Jack Johnson. White America was devastated in 1908 when Johnson defeated the white champion Tommy Burns in fourteen rounds. He defended his title five times the following year against the best white challengers, resulting in an outcry for a "Great White Hope" to regain the title. When former unbeaten champion, Jim Jeffries, was lured out of retirement, the public viewed his bout with Johnson as a contest between races, and the fight received more attention than any previous sporting event. The so-called "Battle of the Century" took place on July 4, 1910, in Reno, Nevada. Johnson knocked Jeffries out in the fifteenth round, sparking nationwide uproar and race riots in more than a dozen cities. Eventually, Johnson was felled as much by his lifestyle (and especially his passion for white women) than by any weakness in the ring.

James Earl Jones plays the flamboyant and self-destructive boxing legend—reprising the role that had made him a star on Broadway. In the face of a white world that conspired against him, Jones' character is forced to fight racism, hostile fans, and aggressive promoters in the early twentieth century. His towering performance earned Jones an Academy Award nomination for Best Actor.

Opposite: **THE GREAT WHITE HOPE (1970), Polish**

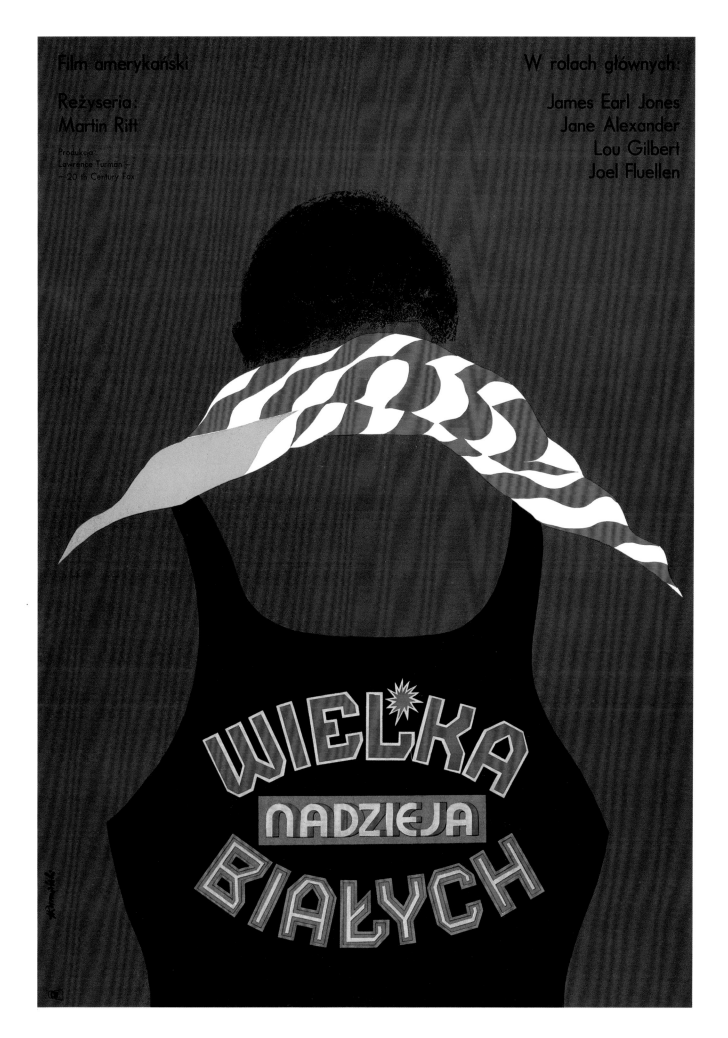

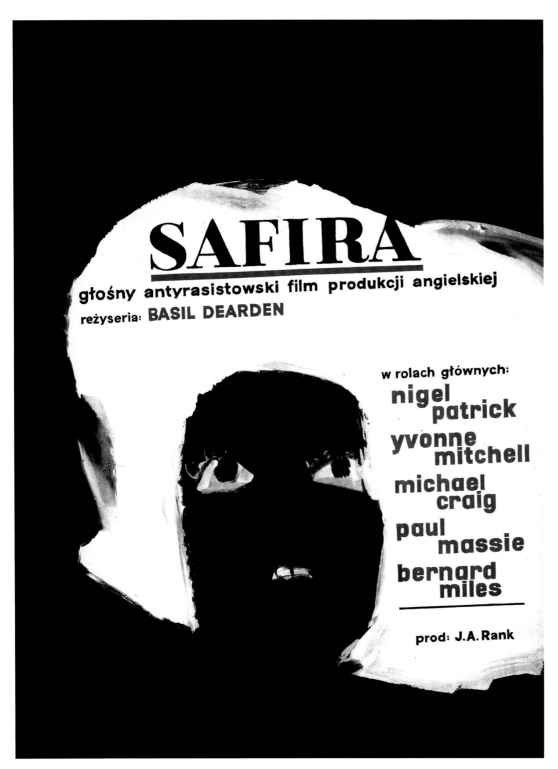

In Basil Dearden's murder mystery *Sapphire* (1959), it was not African Americans who were at the heart of the drama, but another black community who experienced much discrimination: Caribbeans in Britain. At the time the film was released, London was still reeling from a series of race riots stoked up by local opposition, in districts such as Notting Hill, to the black families immigrating from the West Indies. It didn't matter that the West Indians were responding to an official British government campaign asking for people to travel to the United Kingdom because of the country's labor shortage. When working class whites reacted with suspicion and distrust to the new arrivals, racial tension arose.

Sapphire focused on a young woman, an art student, who is found stabbed on London's Hampstead Heath. Like the protagonists in the American problem films *Pinky* and *Lost Boundaries*, Sapphire "passed" herself off as being white. When her real ethnic identity is finally revealed, the articulation of ingrained British racism is unmasked at its most evil—as reflected in the eerie Polish poster design by Waldemar Świerzy.

Black Jesus (1968) explores a very different scenario. It is effectively a biopic (under a fictional name) of the short-lived Congolese freedom fighter, Patrice Lumumba, who was overthrown in a coup three months after becoming Prime Minister when his nation achieved independence from Belgian colonialism. Lumumba was then tortured and killed. American actor Woody Strode stars as a fictionalized martyred revolutionary, Maurice Lalubi, in the film. It was originally released in Italy as *Seduto alla sua destra*, which translates into *Seated at his Right*. According to Strode's autobiography, "Seated at his Right" is a biblical reference to Christ when he says to the high priest Caiaphas, "Hereafter you shall see the Son of man sitting on the right hand of the power of God and coming in the clouds of heaven."

Left: SAPPHIRE (1959), Polish
Opposite: BLACK JESUS (1968), Polish

WŁOSKI
DRAMAT
FILMOWY
reżyseria:
VALERIO ZURLINI
w rolach głównych:
WOODY STRODE
FRANCO CITTI
JEAN SERVAIS
PIER PAOLO CAPPONI
produkcja:
CARLO LIZZANI

SIEDZĄCY
PO PRAWICY

FILM PRODUKCJI WŁOSKIEJ

Reżyseria: Luigi Zampa
Wykonawcy:
ALDO FABRIZI, Ave Ninchi,
Mirella Monti, Gar Moore i inni.

VIVERE in PACE

ERYK LIPIŃSKI-56

PRODUKCJA LUX-PAO

Just two years after the end of World War II, in which Italy and the United States had been enemies, Italian director Luigi Zampa made *Vivere in pace* (1947; known in English-speaking territories as *To Live in Peace*)—a wartime drama which preached that shared humanity was more important than the accidental divisions of race and country. John Kitzmiller played the role of "Joe," a black American who depends on an Italian family to protect him and his white comrade when they are separated from the rest of their platoon behind enemy lines.

Black Orpheus, made in Brazil by French director Marcel Camus in 1959, offered a starkly different view of race—setting a reworking of the Orpheus legend from Greek mythology amongst poor blacks in Rio de Janeiro at Carnaval time. In the exhilarating atmosphere of the festival, Camus' Orpheus and Eurydice fall in love; but Death, in the guise of a persistent suitor in skeleton costume, stalks the girl. Over the course of twenty-four hours, the young couple relive the tragic myth.

As a precursor of Brazilian new wave films, featuring a cast of non-professionals and with the vibrant colors, and delirious dance, costumes, and music of Carnaval, *Black Orpheus* captures in the slums and bay of Rio a poetic infusion of naturalism and fantasy, classicism and voodoo. The film won Camus an Oscar for Best Foreign Language Film, and also helped to introduce the world to the captivating rhythm of the "bossa nova."

Linking the two films—and their Polish posters, by Eryk Lipiński and Anna Huskowska, respectively—is the use of instruments as a form of symbolism as well as a musical motif. The poster for *Vivere in pace* reflects the crucial moment in the drama when a trumpet dissolves the tension when the American soldier and the Nazi meet for the first time, and lay aside their differences to laugh, dance, and, of course, drink. In *Black Orpheus*, children ask Orfeo, "Is it true that you make the sun rise by playing guitar?" The film ends with the children inheriting the guitar after Orfeo's death, the responsibility for the continuation of life passed into their hands.

Left: **VIVERE IN PACE (1947), Polish**
Opposite: **BLACK ORPHEUS (1959), Polish**

The poster contains the following text:

TAMANGO

wg PROSPERA MÉRIMÉE

reżyseria JOHN BERRY

Produkcja: Les Films du Cyclop

Szerokoekranowy barwny film produkcji francuskiej

w rolach głównych

CURD JÜRGENS JEAN SERVAIS DOROTHY DANDRIDGE

W. GÓRKA 59

Adapted from the 1829 novella by the French writer Prosper Mérimée, *Tamango* (1958) is a story of revolt by a group of captured Africans aboard a slave ship in 1820. Although the French had already declared the slave trade illegal in 1818, a ship's captain (Curt Jürgens) buys a group of natives enslaved by a local chieftain. On board, the slave Tamango (Alex Cressan) is determined to fight for his freedom despite the reluctance of his more passive companions. Tensions complicate the revolt, as a result of the captain's deep affection for his concubine, the slave girl Aiché (Dorothy Dandridge), who is torn between him and the freedom of her people.

The film provoked much controversy when it was released, particularly because of the explicit interracial love scenes between the captain and Aiché. It was directed and shot in France by John Berry, the talented Hollywood veteran, who fled overseas after being summoned to appear before the House Un-American Activities Committee, who accused him of being a Communist. It was not until 1974, when he made *Claudine* with Diahann Carroll and James Earl Jones, that Berry was able to return to his directing career in America.

Another view of this despicable trade was provided by *Slaves* (1969), a melodrama directed by Herbert J. Biberman. Ossie Davis stars as a slave who is sold by a kindly owner to a cruel master (Stephen Boyd). His new owner has a black mistress, played by singer Dionne Warwick in her only starring role on the big screen. Ultimately Davis's character sacrifices his life to allow Warwick and several other slaves to escape. Not surprisingly, the film's soundtrack allowed Warwick to perform several songs off camera.

The award-winning artist Wiktor Gorka was responsible for the Polish posters for both *Tamango* and *Slaves*. He had an extraordinary ability to create arresting designs using clean lines and bold colors. The slavery motif at play in both works has a powerful impact on the viewer, enabled, perhaps, by the Polish Gorka's ability to sympathize with the plight of slavery and the struggle for freedom in the US.

Above: **TAMANGO** (1958), Polish
Opposite: **SLAVES** (1969), Polish

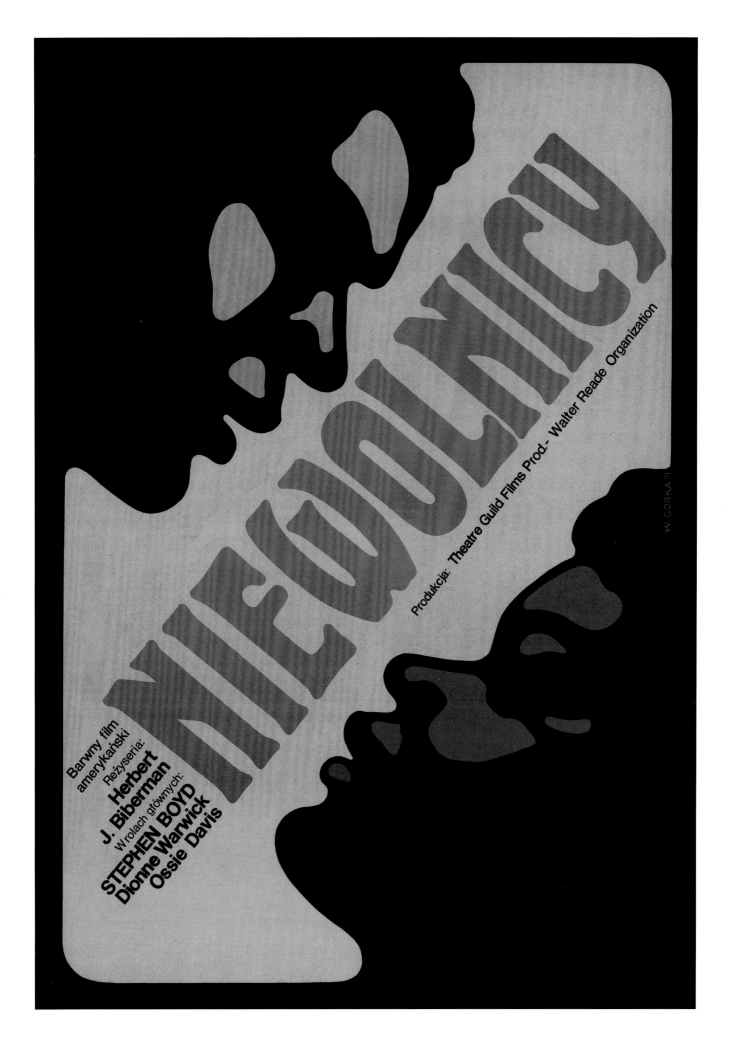

From Book to Film

From *Uncle Tom's Cabin* to *The Color Purple*, literary classics have inspired many of the landmark movies in African-American film history. Over the course of the twentieth century, some of the most interesting and sympathetic representations of black life in cinema derived from literature by authors like Paul Laurence Dunbar in the 1910s and 20s; Langston Hughes and James Weldon Johnson in the 1930s and 40s; Richard Wright in the 1950s; Lorraine Hansberry, Chester Himes, Ernest Gaines, and Gordon Parks Sr. in the 1960s and 70s; Alice Walker and Gloria Naylor in the 1980s; and Terry McMillan and Toni Morrison in the 1990s.

Uncle Tom's Cabin (1852) was Harriet Beecher Stowe's novel of protest against the 1850 Fugitive Slave Act that enforced the return of escaped slaves to their owners. Stowe's Tom suffered tremendous hardships but remained faithful to God as well as to his own principles; and his martyrdom, precipitated by his refusal to betray another slave, was as redemptive as it was tragic.

Stowe's novel sold in huge quantities, especially during and after the Civil War era. The ubiquitous "Tom shows" and Tom spectacles—mounted by showmen like P. T. Barnum—became so popular in the late nineteenth and early twentieth centuries, however, that Uncle Tom was transformed from an exemplary character into a sappy, contented, white-haired plantation slave. Critics of the novel grew rapidly in the twentieth century. Although few doubted the sincerity of Stowe's convictions, many African Americans were distressed at the stereotypical nature of the black characters in her book, especially the eternally passive Uncle Tom. By the time that African-American culture was focused on the calls for civil rights and black power, "Uncle Tom" had become an insult to be thrown at any black figure who was thought by his more militant peers to be too conciliatory towards whites or white-led institutions. The abuse hurled at these men was often ill-considered; so indeed was the criticism of Stowe's book, which needs to be seen in the context of its times. Yet the taint has stuck, making *Uncle Tom's Cabin* one of the more problematic texts in the American canon—an icon that seems to champion the cause of oppressed African Americans while caricaturing them at the same time.

It is not surprising that the early generations of American filmmakers were eager to translate such a notable book into the new medium. In Edwin S. Porter's *Uncle Tom's Cabin; or, Slavery Days* in 1903 through the numerous versions by the Lubin Company (1903), Thanhouser and Vitagraph (1910), Universal (1913), World Film Corporation (1914), and Famous Players-Lasky (1918), Tom's character was significantly distorted and Tom himself reduced from a touchstone for the national conscience to an object of national amusement.

But in 1927, when Carl Laemmle re-filmed the classic story with a record-breaking $2 million budget, director Harry A. Pollard sought to ensure the film's authenticity, even down to the props and sets, which included slave cabins furnished with actual period utensils. Most notably, though, Pollard cast the handsome forty-year-old actor James B. Lowe in the title role—the first time a black actor had assumed the part on screen. Unfortunately, Pollard allowed Eliza, played by his wife, actress Margarita Fischer, to become the film's dominant character. Consequently, Tom's tragedy was subordinated to the exploits of Eliza and the Northern troops, who fought for the emancipation of blacks and gave the familiar story a reassuring, even happy ending. Although Lowe protested the crude and unrealistic way his character was portrayed, his protest made little difference; and he never made another movie.

Still, despite its flaws, the 1927 version had the distinction of being the best of a bad lot of *Uncle Tom's Cabin* films. Although Uncle Tom was parodied in numerous shorts and cartoons, the film was not re-made again until 1965 (by Melodie-Avala, a West German production company). The first American sound version of *Uncle Tom's Cabin*, directed for Showtime TV Network by black director Stan Lathan and starring Avery Brooks and Phylicia Rashad, did not appear until 1987.

Opposite: **UNCLE TOM'S CABIN (1927), Swedish**

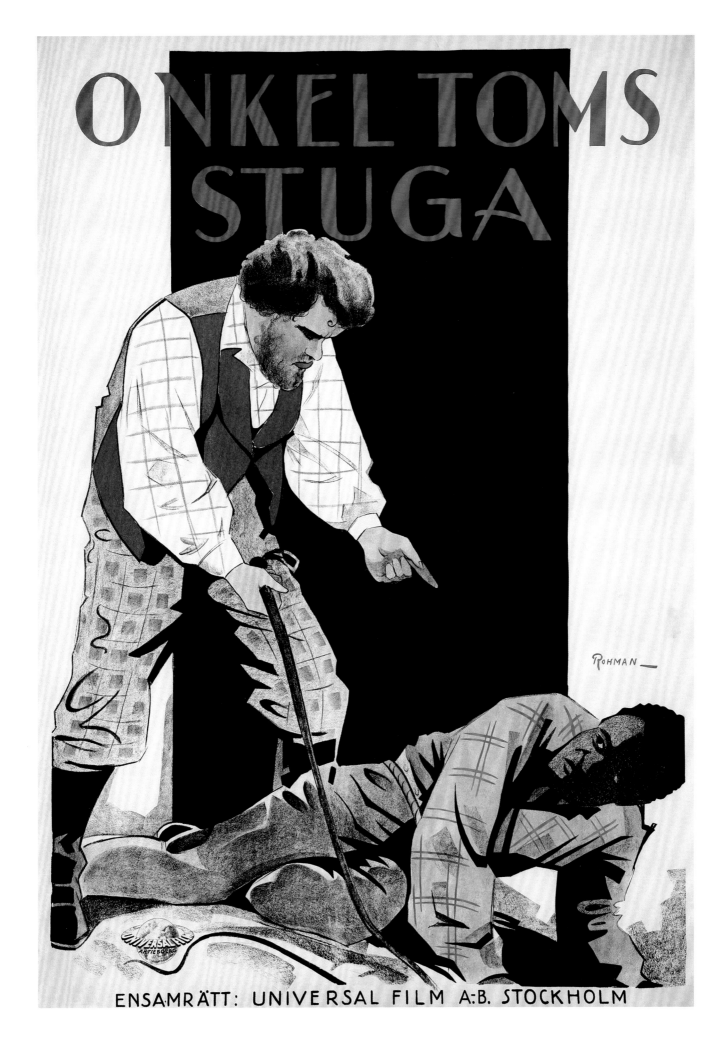

ONKEL TOMS STUGA

ROHMAN

ENSAMRÄTT: UNIVERSAL FILM A:B. STOCKHOLM

Mark Twain's classic, *Adventures of Huckleberry Finn*, has been described as possibly the most American of American novels. Twain's story of the conscience-tormented Huck and his protective, runaway-slave companion Jim, carries the reader through numerous adventures and encounters, as the two escapees float on a raft down the author's beloved Mississippi River, and farther South into increasingly dangerous "slave territory."

Huck's relationship with Jim is at the heart of Twain's morality tale. Both characters are runaways—Jim from the torture of Southern slavery, and Huck from the abuse of his cruel father, social restrictions and conventions. At the same time, however, Huck has to wrestle with his troubled conscience. Should he free Jim from slavery, and therefore be condemned to Hell according to the rhetoric of the local preachers? Or should he return his companion and friend to captivity? Huck's moral awakening to the injustice of slavery, and his ultimate decision, are among the most powerful statements against racism in the history of American literature.

Film versions of Twain's story have been attempted since 1920, in more than a dozen feature adaptations and other spin-offs. None of them, however, capture the true essence and spirit of the story. The different elements of Twain's plot fit together so well that any attempts to shorten or alter it simply sacrifice its truth and meaning.

Filmmakers are usually too conscious of the box-office to risk controversy, and in the case of *Huckleberry Finn*, they have usually opted to avoid offending any part of the audience rather than keeping faith with the novel.

Ironically, when the book first appeared in 1885, puritanical religious Americans condemned it because of Huck's socially unacceptable cigarette smoking and foul-mouthed behavior. More recently, in the wake of the civil rights movement and actions taken by the NAACP, the criticism has focused on the racial issues of the book, particularly the use of the term *nigger*. As recently as 1998, Judge Stephen Reinhardt of the Ninth US Circuit Court of Appeals rejected a lawsuit by an African-American parent, who was also a teacher, demanding that the book be removed from mandatory reading lists in the Phoenix, Arizona, school system. Although the NAACP previously supported various protests against the book, its current position states, "You don't ban Mark Twain, you explain Mark Twain."

Above: **THE ADVENTURES OF HUCKLEBERRY FINN (1960), Eddie Hodges and Archie Moore**
Opposite: **THE ADVENTURES OF HUCKLEBERRY FINN (1960), Polish**

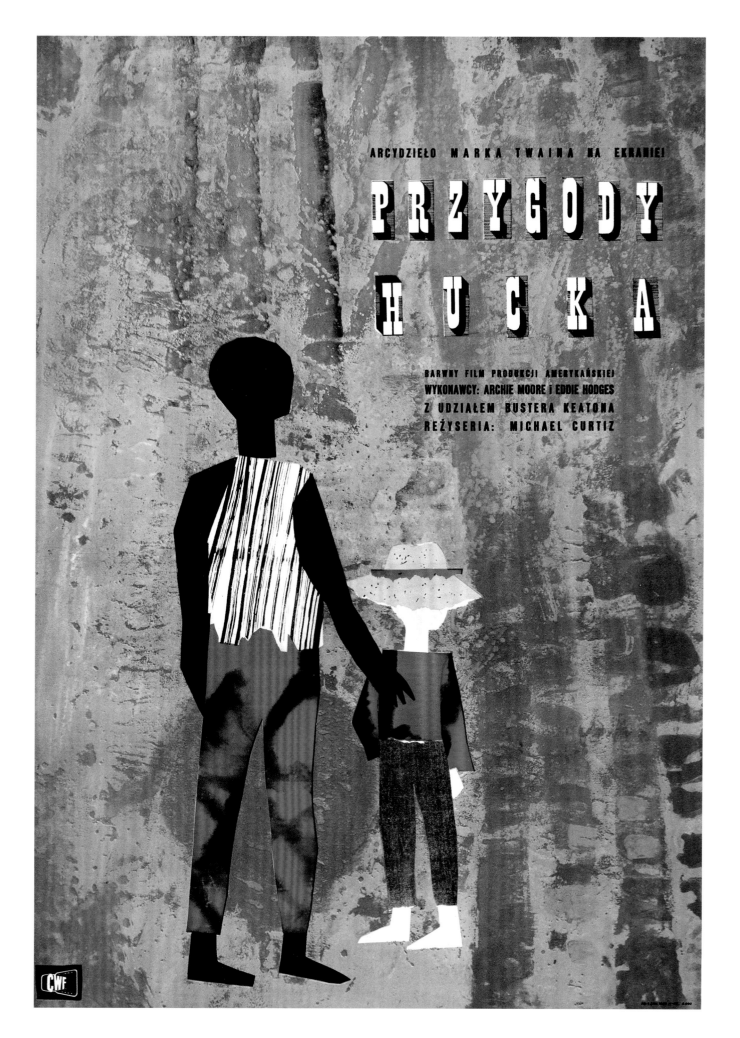

Young, beautiful, passionate and scandalous. She was America in the time of "Ragtime."

RAGTIME

Ragtime is a highly acclaimed, award-winning novel from 1975 by E. L. Doctorow, that uses a mosaic of narrative threads to broadly reconstruct the years in New York during America's Gilded Age at the turn of the twentieth century. By portraying the city's culture, its society, and many of its most influential citizens, the book describes—as the title suggests—the era when ragtime was the predominant form of American popular music.

The novel's adaptation to film, by director Milos Forman in 1981, concentrates on one of those threads: that of Coalhouse Walker (Howard Rollins Jr. in his feature film debut), a successful black piano player whose fanatical pursuit of justice in the face of overt racism and humiliation turns to revenge as he takes the law into his own hands with tragic results.

Forman, who is best-known for his Academy Award-winning direction of *One Flew Over the Cuckoo's Nest* (1975), wasn't the first director tied to the project. Producer Dino De Laurentiis originally hired Robert Altman to direct, Doctorow to write the script, and Randy Newman to compose the score. Unfortunately, when Altman's *Buffalo Bill and the Indians* (1976)—which De Laurentiis also produced—bombed at the box-office, Forman replaced him. With a new script written by Michael Weller, he transformed Doctorow's panoramic view of the era, with its diverse, interacting characters and social issues, into an exercise in liberal integrity; echoing Stanley Kramer in the 1960s.

Though Forman overlooks much of the novel's complex storytelling flavor, he remains true to the times by featuring vignettes of historical characters, such as Teddy Roosevelt, Harry Houdini, Evelyn Nesbit, Booker T. Washington, Henry Ford, and J. P. Morgan—even including the sensationalized murder of celebrity architect Stanford White. The large, noteworthy cast stars Howard E. Rollins Jr., James Cagney (in his final film role), Debbie Allen, Elizabeth McGovern, Mary Steenburgen, Mandy Patinkin, Norman Mailer, Brad Dourif, Moses Gunn, Pat O'Brien, Donald O'Connor, Jeff Daniels, Fran Drescher, and Samuel L. Jackson

Left: **RAGTIME (1981)**
Opposite: **RAGTIME (1981), East German**

RAGTIME

Nach E. L. Doctorows gleichnamigem Erfolgsroman

■ Ein Farbfilm aus den USA ■ Regie: Milos Forman ■ In den Hauptrollen:
Howard Rollins ■ Mary Steenburgen ■ James Olson ■ James Cagney ■ u. a.

A STEVEN SPIELBERG
FILM

The
Color
Purple

Alice Walker's Pulitzer Prize Winning Story

It's about life. It's about love. It's about us.

WARNER BROS. Presents A STEVEN SPIELBERG Film THE COLOR PURPLE Starring DANNY GLOVER
ADOLPH CAESAR · MARGARET AVERY · RAE DAWN CHONG and Introducing WHOOPI GOLDBERG as Celie
Director of Photography ALLEN DAVIAU Production Designer J. MICHAEL RIVA Film Editor MICHAEL KAHN, A.C.E. Music QUINCY JONES
Based upon the novel by ALICE WALKER Screenplay by MENNO MEYJES Executive Producers JON PETERS and PETER GUBER
Produced by STEVEN SPIELBERG · KATHLEEN KENNEDY · FRANK MARSHALL · QUINCY JONES Directed by STEVEN SPIELBERG

PG-13 PARENTS STRONGLY CAUTIONED
Some Material May Be Inappropriate for Children Under 13 · AMBLIN · DOLBY STEREO IN SELECTED THEATRES · Soundtrack on Qwest Records and Tapes · Read the Pocket Book · FROM WARNER BROS. A WARNER COMMUNICATIONS COMPANY

In the 1980s, a new generation of African-American women novelists explored the concepts of family and community within black America in ways that had never been done before. Their female protagonists discovered strength and solidarity in their sisterhood. But their focus on their female characters led some male critics to complain that authors such as Alice Walker, Gloria Naylor, and Terry McMillan were being both sexist and racist in their portrayal of African-American men.

The debate was heightened by the high-profile release of *The Color Purple* (1985), director Steven Spielberg's adaptation of Walker's 1982 Pulitzer Prize-winning novel. The film traced the lives and difficult times of two black sisters and their families in the rural South and in Africa, between 1909 and 1947. It was met with protests, pickets, and demonstrations, even while it was still in production. Critics condemned Spielberg's rendering of the book for its over-simplifications, racial clichés, and Hollywood stereotypes; particularly the film's hostile depiction of its male characters as brutal. Others were disappointed by the way Spielberg underplayed the female characters, whose tragedies Walker had turned into hard-fought triumphs.

And yet there was still something undeniably affecting about the story of Celie (Whoopi Goldberg), a frightened young girl who is abused and impregnated by her father, and then brutalized further by her uncaring husband. She is able to use her victimization, and the strong example of the various women in her life, to find her own voice. Her long odyssey of self-discovery culminates not only in the creation of a successful business, but also in her happy reunion with her sister and with the now-grown son whom her father had given away at birth. The film ends with a shot of the sisters clapping hands once again in a field of purple flowers, bringing the story full circle.

Despite its artistic shortcomings, *The Color Purple* was a commercial success. Yet, to many, it remains an uneven film that melodramatically reduced—or "purpled"—Walker's distinctly feminist message.

Left: **THE COLOR PURPLE (1985)**
Opposite: **THE COLOR PURPLE (1985), East German**

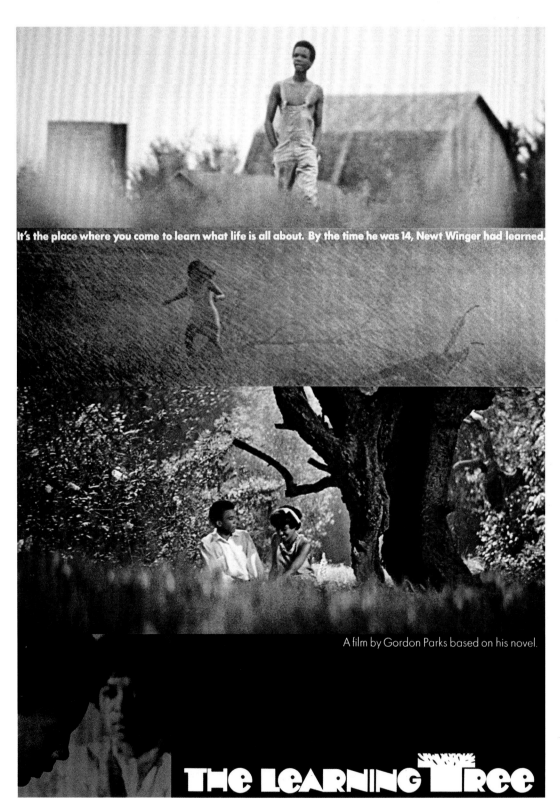

It's the place where you come to learn what life is all about. By the time he was 14, Newt Winger had learned.

A film by Gordon Parks based on his novel.

THE LEARNING TREE

The Learning Tree, a touching coming-of-age film based on Gordon Parks' semi-autobiographical novel about growing up black in a small Kansas town during the 1920s, was one of several black-oriented films released in 1969. But unlike those others—which included *Uptight*, *Slaves*, and *Putney Swope*, and which tended to indict the system and focus on black militancy—*The Learning Tree* succeeded precisely because it was old-fashioned and sentimental, in the best sense of those words.

As the reviewer for *Variety* noted, in the film, "characterizations are broad, tradition and the influence of elders are emphasized, and moral decisions are key plot points." Through his loving and supportive family, the fifteen-year-old protagonist, Newt Winger, learns to cultivate values like honesty and loyalty; from other people in the community, he learns about discrimination, violence, and racism. These youthful experiences serve as his "learning tree," and allow him, at the end of the film, to come forward as a crucial witness in a murder trial, even though his testimony stirs up racial tensions in the town. With its universal theme, *The Learning Tree* was a film about race that paradoxically almost transcended race—which may account for its success at the box-office.

The film was a stunning exhibition of the talents of its creator. Parks, a renowned stills photographer whose work appeared in such prestigious publications as *Life* magazine, not only produced and directed the film, he also wrote and scored the music. *The Learning Tree* was the first film financed by a major studio to have a black director, and it opened Hollywood's doors not only for Parks, who went on to direct even more commercially successful films like *Shaft* (1971), but also for other black moviemakers.

Left: THE LEARNING TREE (1969)
Opposite: THE LEARNING TREE (1969), Czechoslovakian

STROM poznání

Psychologické drama
černého chlapce
Americký film
Režie: Gordon Parks

Although Hollywood was making progress on the racial front by the late 1940s, black moviegoers desired more realistic screen images that did not depict African Americans as the "problem," but rather focused on some of the real problems that they faced.

That kind of social realism was already current in literature, notably in Richard Wright's groundbreaking novel *Native Son* (1940), which eloquently described the racial restrictions and oppression that were the plight of the urban masses. Within a year, the novel was adapted to the Broadway stage. However, numerous attempts to bring it to the screen failed.

Finally, Wright bought back the movie rights and pursued the project himself. Unfortunately, his production was fraught with problems, from dishonest dealings by his investors to Wright's own romantic entanglements on set. His artistic decisions—to film in Buenos Aires, to begin shooting without a final script, and to cast himself in the lead role, despite being much too old for the part—were flawed.

The finished film, released in 1950, was at best amateurish, suffering from some of the same problems that plagued many early independent black productions. The acting was stilted and unprofessional, continuity was minimal, and the extras' Spanish accents were detectable. Then, to satisfy the American censors, the film had to be cut so radically that its remaining artistic integrity was destroyed. Consequently, audience reaction was largely negative. Wright himself came to believe that the film was a total disaster, artistically as well as financially.

Its failings notwithstanding, *Native Son* conveyed a real sense of racial politics and depicted the condemnation and exploitation of the black man by white society. With its portrait of a sensitive young man rebelling against bigotry, it laid down the path for a number of more successful coming-of-age films produced in the 1960s and 70s.

Left: **NATIVE SON (1950), Richard Wright**
Opposite: **NATIVE SON (1950) Argentinian poster**

Richard **WRIGHT**

JEAN WALLACE

GLORIA MADISON
NICHOLAS JOY
GEORGE RIGAUD

DIRECTOR
PIERRE CHENAL
PRODUCCION A CARGO DE
JAIME PRADES

SANGRE NEGRA

("NATIVE SON")

Según la famosa novela de **RICHARD WRIGHT** • *Distribuida por* **ARGENTINA SONO FILM**

PUM EN EL OJO

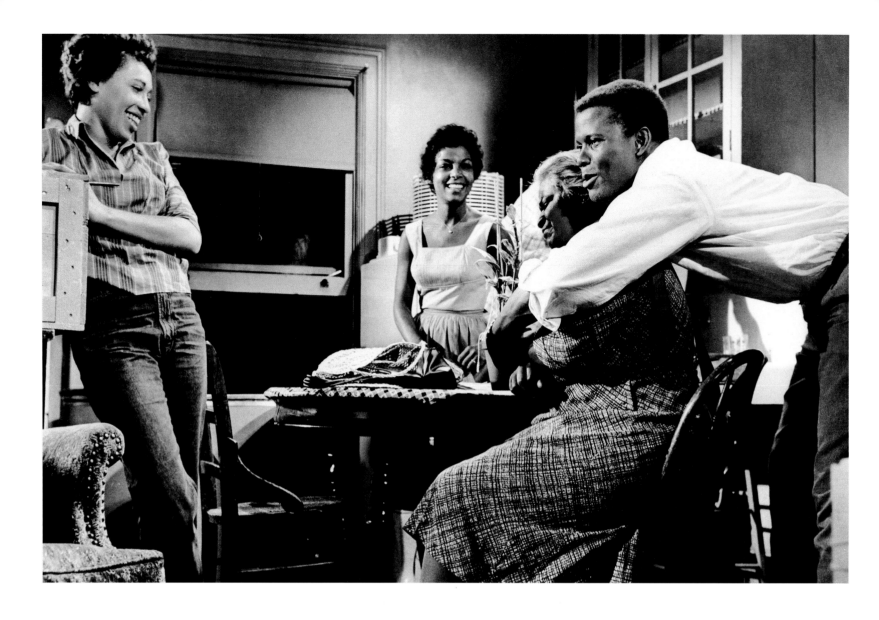

In 1959, *A Raisin in the Sun* was the first play written by an African-American woman to be produced on Broadway. It focused on a struggling African-American family living in the South Side of Chicago in the 1950s. Writer Lorraine Hansberry drew her title from a line in the Langston Hughes' poem *Harlem*, which warns that a dream deferred might "dry up like a raisin in the sun." With its success, the twenty-nine-year-old Hansberry became the youngest American playwright to receive the New York Drama Critics' Circle Award for Best Play.

The 1961 film adaptation, featuring the original Broadway cast, skillfully revealed the aspirations and frustrations of each of the family members, particularly of Walter Lee Younger (Sidney Poitier), a chauffeur to a wealthy white man, who sees only a bleak future of servitude ahead.

After a friend suggests that they open a liquor store together, Walter Lee imagines himself a successful businessman who can afford a better life for his family. When his mother Lena (Claudia McNeil) gives him a portion of his late father's $10,000 insurance policy to open a checking account for himself and a savings account to pay for his sister Beneatha's medical school education, Walter Lee invests the money in the liquor store. Unfortunately, his shady partner absconds with the cash, robbing Walter Lee and leaving him even more bereft of hope. The only way to recoup the loss is to capitulate to the white man who has offered to buy back the house that Lena recently purchased, as a way of keeping blacks out of his neighborhood. At the last moment, Walter Lee salvages his dignity—and regains his mother's trust and family's admiration—by refusing the offer. Knowing that opposition awaits them, the Youngers prepare to move into their new home and start realizing their dreams.

The scenario was partly inspired by Hansberry's own experience. In 1938, her father, Carl, had challenged Chicago's real estate covenants by moving his family into a white neighborhood. With the help of the NAACP, he fought his case successfully all the way to the Supreme Court, which struck down the restrictive covenants in its famous Hansberry v. Lee decision of 1940.

Independently produced by David Susskind and Hansberry's close friend Philip Rose, and directed by Daniel Petrie (who replaced Lloyd Richards, the black director who brought the play to Broadway), *A Raisin in the Sun* introduced many white moviegoers to black family drama. The excellence of the film's ensemble cast, which also included Ruby Dee and Diana Sands, and its depiction of a black working class with aspirations to middle-class respectability, made *A Raisin in the Sun* not just a sensitive, compelling study but also a landmark film.

Above: **A RAISIN IN THE SUN (1961), Diana Sands, Ruby Dee, Claudia McNeil, and Sidney Poitier**
Opposite: **A RAISIN IN THE SUN (1961)**

Columbia Pictures
PRESENTS

SIDNEY POITIER

in

A RAISIN IN THE SUN

WITH

Claudia
McNEIL · DEE
Ruby

Screenplay by
LORRAINE HANSBERRY *from her play*

PRODUCED ON THE STAGE BY
PHILIP ROSE *and* DAVID J. COGAN

Produced by
DAVID SUSSKIND *and* PHILIP ROSE

Directed by DANIEL PETRIE

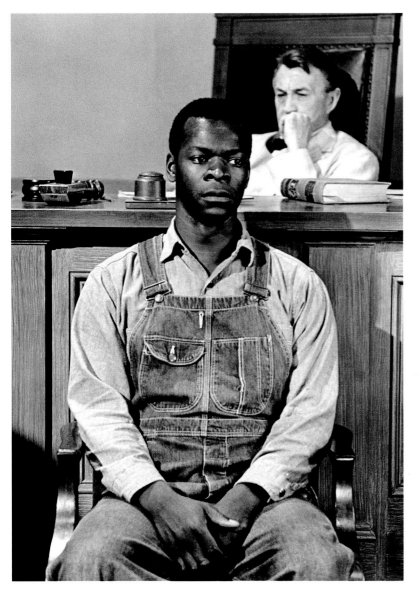

The much beloved American film classic, *To Kill a Mockingbird* (1962), was faithfully adapted from the Pulitzer Prize-winning novel by Harper Lee. Gregory Peck plays Atticus Finch, an idealistic lawyer in the racially divided town of Maycomb, Alabama, in the 1930s. He agrees to defend Tom Robinson (Brock Peters), a black man who is wrongly accused of raping a white woman. Tom, however, is not the only victim of the town's bigotry. In retribution for Finch's racial sympathies, his children—six-year-old Scout and ten-year-old Jem—are attacked and unexpectedly rescued by their reclusive neighbor, "Boo" Radley (Robert Duvall).

Told from Scout's perspective, the film is both a nostalgic portrait of childhood innocence in a small and eccentric Southern town, and an unforgettable coming-of-age tale in which the youngsters learn to see their courageous and principled father in a new light. Harper Lee based the character of Atticus on her own father, Amasa Lee, a widowed attorney; the character of "Dill" on her neighbor and lifelong friend, the author Truman Capote; and her depiction of the ever-curious Scout on her own childhood.

The film, which marked Robert Duvall's film debut, was nominated for eight Academy Awards, and won three, for Best Actor, Best Set Decoration, and Best Adapted Screenplay. It also forged some enduring bonds for Peck: Harper Lee, who was moved and delighted by his performance, presented him with her father's pocket-watch; while Peck's co-star, Brock Peters, delivered the eulogy at the actor's funeral in 2003.

Left: **TO KILL A MOCKINGBIRD (1962), Brock Peters**
Opposite: **TO KILL A MOCKINGBIRD (1962), Polish**

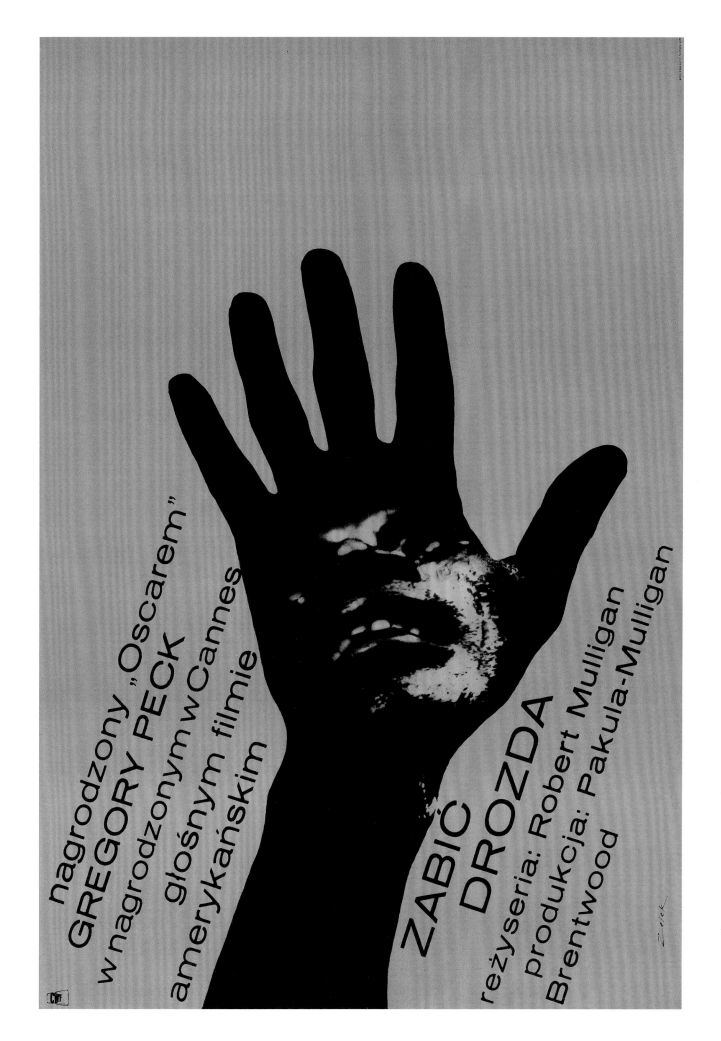

In the late 1950s, white journalist John Howard Griffin took the unprecedented step of becoming "black." By going through extensive and potentially dangerous treatments to darken his skin, he attempted to understand what it meant to be black in the segregated South. This was an unprecedented act of reverse "passing," in order to learn first-hand the definition of "walk a mile in my shoes." *Black Like Me* (1964) was based on Griffin's autobiographical book of the same name.

The film starred James Whitmore as the newly colored, educated and well-dressed John Finley Horton, and is full of experiences that reveal the everyday indignities that confronted African Americans. Taunted by whites, slighted by potential employers, and stereotyped sexually, he discovers more about racial prejudice than he ever imagined possible.

The film is set in the pre-civil rights days of the late 1950s, and therefore depicts practices that probably passed unnoticed by most Southern whites, but were all too familiar to their African-American counterparts. It was an attempt to educate white America about living under the daily oppression, torment and fear imposed by a racist society. Horton is able to feel all of that resentment and depression for himself; although he knows that, ultimately, he is merely "passing" and can return to a white world.

Released in 1964, at the height of the civil rights movement, *Black Like Me* suffered from less than perfect production values, and didn't equal the popularity of Griffin's original book. It was shot in black and white to give it the feel of a documentary; today its style may seem outdated, but its underlying issues do not.

Left: **BLACK LIKE ME (1964), James Whitmore**
Opposite: **BLACK LIKE ME (1964)**

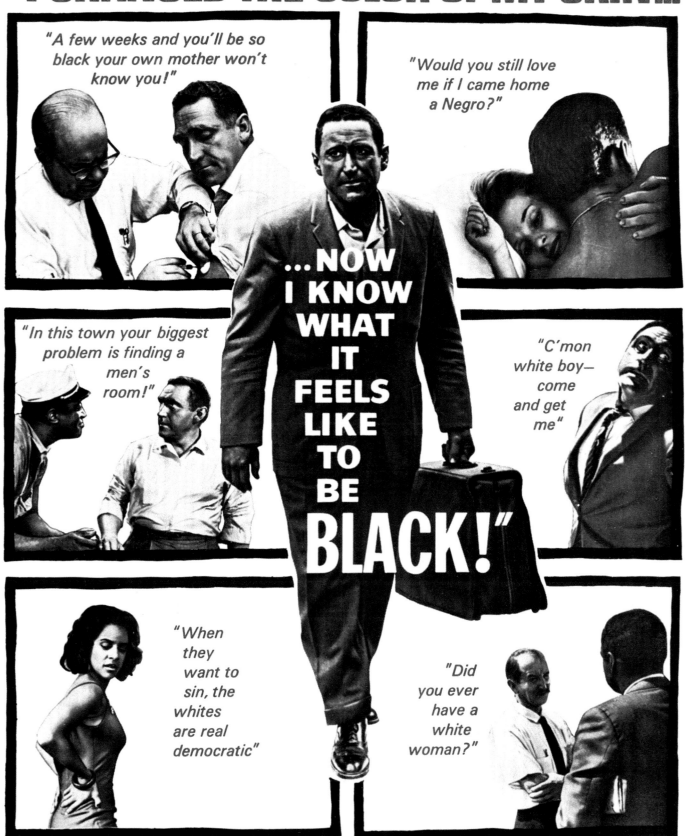

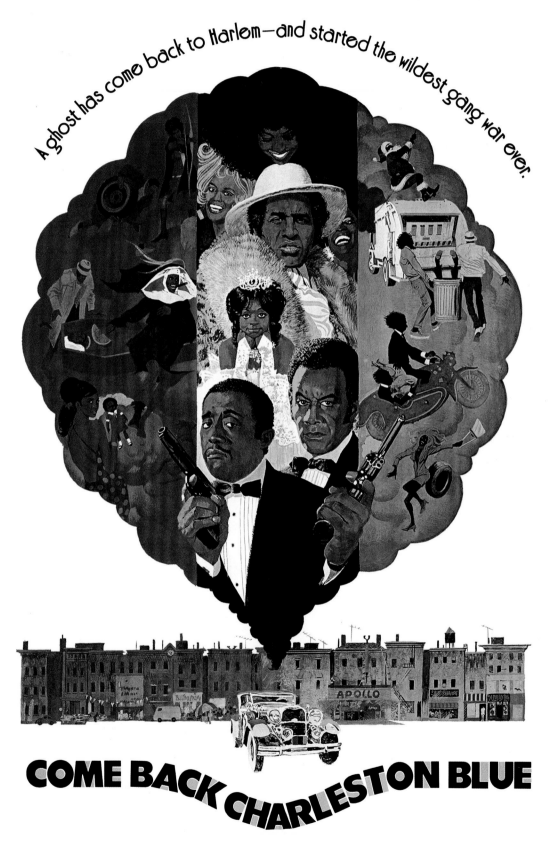

A ghost has come back to Harlem—and started the wildest gang war ever.

COME BACK CHARLESTON BLUE

Based on a novel by Chester Himes, *Cotton Comes to Harlem* (1970) introduced moviegoers to the unforgettable black detectives Coffin Ed Johnson (Raymond St. Jacques) and Grave Digger Jones (Godfrey Cambridge). Their task is to break up a "Back-to-Africa" swindle that is being run by Reverend O'Malley, a corrupt but charismatic black preacher reminiscent of Marcus Garvey in the 1920s.

Although O'Malley pretends that he is building a "black ark" to return his followers to their ancestral land, he is merely scamming the residents of Harlem out of their money. After armed thugs show up at one of his rallies and steal all the cash, Coffin Ed and Grave Digger must expose the deceit and recover the money.

First-time director Ossie Davis, who also co-wrote the script, transformed what could have been a standard detective comedy into a folkloric version of a 1930s race movie. One of the earliest (and still among the best) blaxploitation films, *Cotton Comes to Harlem* was full of ethnic humor that might have been insulting from a white director but was actually suggestive of the freshness that black performers could bring to movies when the tables were turned and the old stereotypes inverted.

The film drew unprecedented numbers of black viewers. Even Southern exhibitors were keen to screen it and capitalize on its grosses. Coffin Ed and Grave Digger were featured again in *Come Back, Charleston Blue* (1972), based on Himes' novel *The Heat's On*, and made a cameo appearance in *A Rage in Harlem* (1991), based on Himes' *For Love of Isabelle*.

Left: COME BACK, CHARLESTON BLUE (1972)
Opposite: COTTON COMES TO HARLEM (1970)

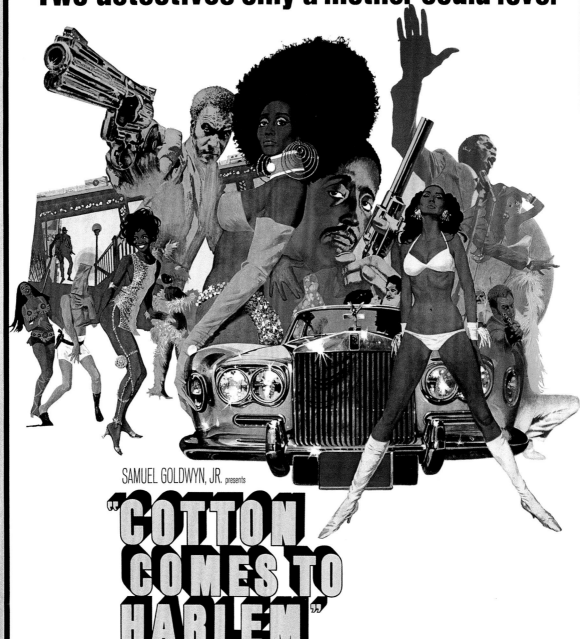

Documentary

The emergence of a flourishing independent film industry in the 1960s coincided with a golden era of documentary moviemaking. The timing was perfect: these were years of enormous social, cultural, and political change in the United States. Nowhere was that more obvious than in the African-American community, whose crusade for equality and freedom would have profound effects on the nation, and on the world beyond.

The civil rights movement of the 1950s and 60s confronted the validity of America's legal principles by challenging the "Jim Crow" segregation laws of "separate but equal." It called attention to the legalized social injustices in the South, and lack of opportunities for advancement in the North. African Americans began to protest against the institutionalized inequality, and organized boycotts, strikes, and demonstrations.

The landmark events of this crusade have assumed an almost mythic stature. Some were prolonged legal struggles, like the Brown v. Board of Education case filed in Topeka, Kansas, in 1951, which, three years later, produced a ruling that it was unconstitutional for American states to impose segregation on school pupils. This, in turn, led to the memorable events in Little Rock, Arkansas, in 1957, when nine African-American students claimed their right to be educated at the city's Central High School, against the violent opposition of Arkansas' Governor, Orval Faubus. The cause of the so-called "Little Rock Nine" was subsequently portrayed in two made-for-TV dramas.

In February 1960, when four black college students sat at a "whites only" Woolworth's lunch counter in Greensboro, North Carolina, and were refused service, their response was simple. They returned the next day with reinforcements, and made the same request. By the fourth day, there were three hundred protestors at the store, and the incident was making national news. The sit-ins spread around the state, and then beyond, and eventually Woolworth's changed its policies of segregation. The award-winning documentary film *February One* (2003) told the story of this non-violent crusade.

Yet violence was a frequent threat to those campaigning for civil rights—or those merely unfortunate enough to have black skin, and be in the wrong place at the wrong time. One of the events that triggered the birth of the movement was the murder in August 1955 of Emmett Till, a fourteen-year-old black boy, because he had dared to speak to a white woman. When his mutilated, decomposed body was pulled from the Tallahatchie River, the case sparked a national outcry. His brutal killing has been the subject of several documentary films, notably *The Untold Story of Emmett Luis Till* (2005).

Of all the crimes committed by white racists during the civil rights struggle, none aroused more shock and disgust than the firebombing of the Baptist Church on 16th Street, Birmingham, Alabama, in September 1963. Four African-American girls, aged eleven to fourteen, were killed, and twenty-two people injured in this hate crime carried out by members of the Ku Klux Klan. Spike Lee's Oscar-nominated documentary, *4 Little Girls* (1997), expertly portrayed the background to the murder, setting it in the context of the national campaign for civil rights. Leading the cause was the Reverend Dr. Martin Luther King Jr., the most visible advocate of non-violence as a method of social change.

Born in Atlanta, Georgia, in 1929, King became an ordained minister by the age of nineteen. He was educated at Morehouse College, Crozer Theological Seminary, and Boston University, where he embraced Mahatma Gandhi's teachings about non-violent protest, and received his PhD degree in Systematic Theology in 1955. As the pastor of the Dexter Avenue Baptist Church in Montgomery, Alabama, King assumed leadership of the 1955 bus boycott that ended segregation on city buses. This successful use of non-violence as a technique in combating discrimination marked his first victory as the leader of the civil rights movement.

Before leaving Montgomery in 1959 to become pastor of the Ebenezer Baptist Church in Atlanta, King participated in organizing the Southern Christian Leadership Conference. The SCLC's purpose was to stage massive non-violent demonstrations and to carry the struggle for equality across the nation. His efforts had mixed success, and a series of demonstrations in Birmingham in 1963 led to his imprisonment, during which he wrote his famous "Letter from Birmingham Jail."

After the assassination of civil rights leader Medgar Evers in Jackson, Mississippi, King decided to bring national focus to the movement by leading a huge "March on Washington." It brought 250,000 people of all races to the Lincoln Memorial, in support of proposed civil rights legislation. The march culminated with King's moving "I have a dream" speech. The Civil Rights Act was passed by Congress in 1964, and King was awarded the Nobel Peace Prize in recognition of his efforts.

His interests gradually widened from civil rights to encompass other social issues, such as the Vietnam War and poverty. Both campaigns had particular resonance among the African-American community. King's plans for a "Poor People's March on Washington" were interrupted by an urgent trip to Memphis, Tennessee, in support of striking sanitation workers. On April 4, 1968, while he was standing on a balcony of the Lorraine Motel in Memphis, King was shot and killed by a sniper.

His assassination provoked riots, looting, killings, and waves of disorder in cities across the United States, with the worst destruction taking place in Washington, DC, just a few blocks from the Lincoln Memorial. The riots subsided within a week, but the anger and frustration that caused them still remained.

King: A Filmed Record ... Montgomery to Memphis (1970) is an Oscar-nominated documentary directed by Sidney Lumet and Joseph L. Mankiewicz. Using news and other archive footage, interspersed with narration by distinguished actors, it explores King's peaceful philosophy, and the triumphant but tragic thirteen-year journey that began with the Montgomery bus boycott and ended in Memphis with a bullet. Narrators and performers in the film include Harry Belafonte, Ruby Dee, Ben Gazzara, James Earl Jones, Burt Lancaster, Elaine May, Mike Nichols, Anthony Quinn, and Clarence Williams III, while there is music from Mahalia Jackson, Odetta, and Nina Simone.

Opposite: **KING: A FILMED RECORD ... MONTGOMERY TO MEMPHIS (1970)**

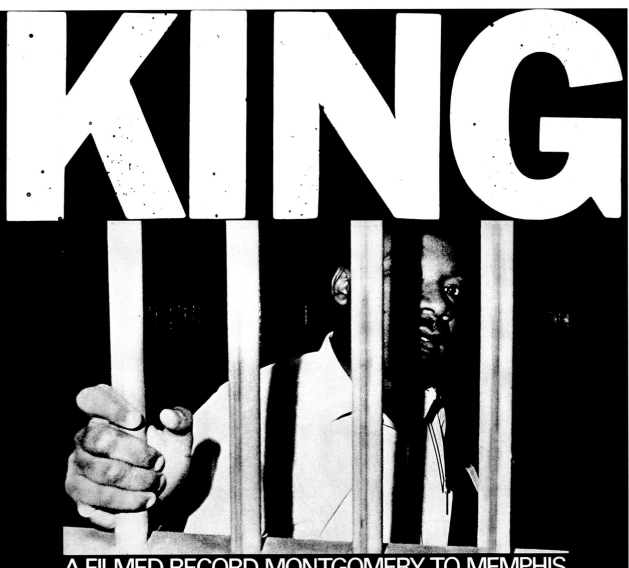

KING

A FILMED RECORD. MONTGOMERY TO MEMPHIS.

One night only.
March 24th 1970, 8 P.M.
Tickets $5.00, tax deductible.
All proceeds to
The Martin Luther King, Jr.
Special Fund.

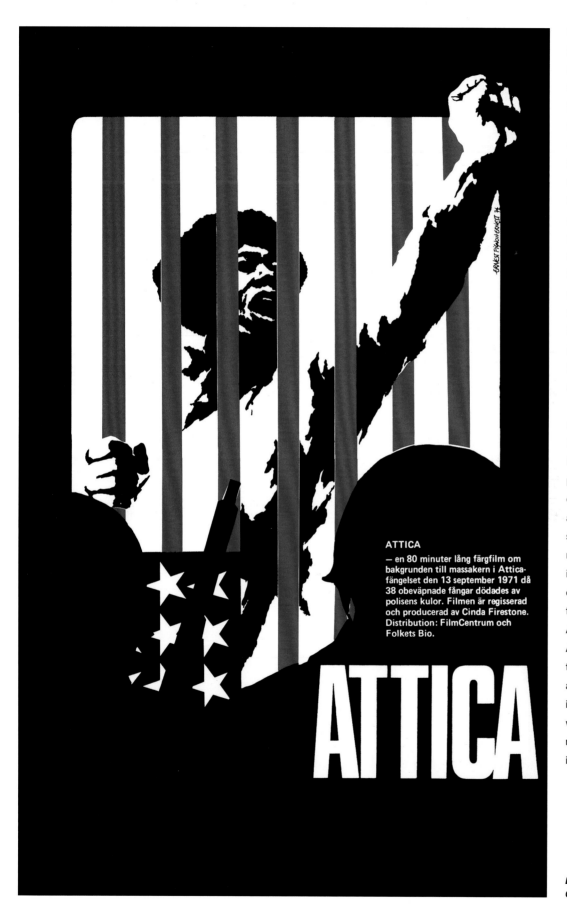

ATTICA
— en 80 minuter lång färgfilm om
bakgrunden till massakern i Attica-
fängelset den 13 september 1971 då
38 obeväpnade fångar dödades av
polisens kulor. Filmen är regisserad
och producerad av Cinda Firestone.
Distribution: FilmCentrum och
Folkets Bio.

ATTICA

While Martin Luther King Jr. and his followers called for civil rights in the mid 1960s, more militant voices demanding "Black Power" were heard in Oakland, California, when Bobby Seale and Huey Newton formed the Black Panther Party For Self Defense. Stressing racial dignity and self-reliance, the Party encouraged African Americans to define, participate and control the world in their own terms. Few counterculture figures of the era were more colorful or more controversial than their spokesperson, the man portrayed in William Klein's 1969 documentary: *Eldridge Cleaver, Black Panther*. Cleaver rejected Dr. King's integrationist, non-violent stance, and in a literal "call to arms" declared that the choice before the country was "total liberty for black people or total destruction for America." Cleaver then fled the country in 1968 to escape an attempted murder charge. It was while he was in exile in Algeria the following year, during the Pan-African Cultural Festival, that Klein shot his film, non-stop for three days, capturing a fascinating sketch of the controversial figure.

The call for black power also reached into America's most notorious penitentiaries. One crusader for the Party, George Jackson, headed up the San Quentin Prison branch of the Black Panthers. Through the publication of his book, *Soledad Brother*, and his own writings on revolution and violence, he became a counterculture icon to the radical left. When guards shot and killed him in an attempted prison break, his murder prompted a riot at the Attica Correctional Facility in upstate New York. On September 9, 1971, more than one thousand prisoners took part, seizing control of the prison and holding thirty-three guards as hostages. After five days and failed negotiations, Governor Nelson A. Rockefeller approved the New York National Guard to end the rebellion by storming the yard with tear gas and firepower. When the smoke cleared, twenty-nine inmates and ten prison workers were dead, with scores wounded in the assault. The Attica killings became a radical cause célèbre in the 1970s, and were chronicled in Cinda Firestone's 1974 documentary, *Attica*.

Left: **ATTICA (1974), Swedish**
Opposite: **ELDRIDGE CLEAVER, BLACK PANTHER (1969), French**

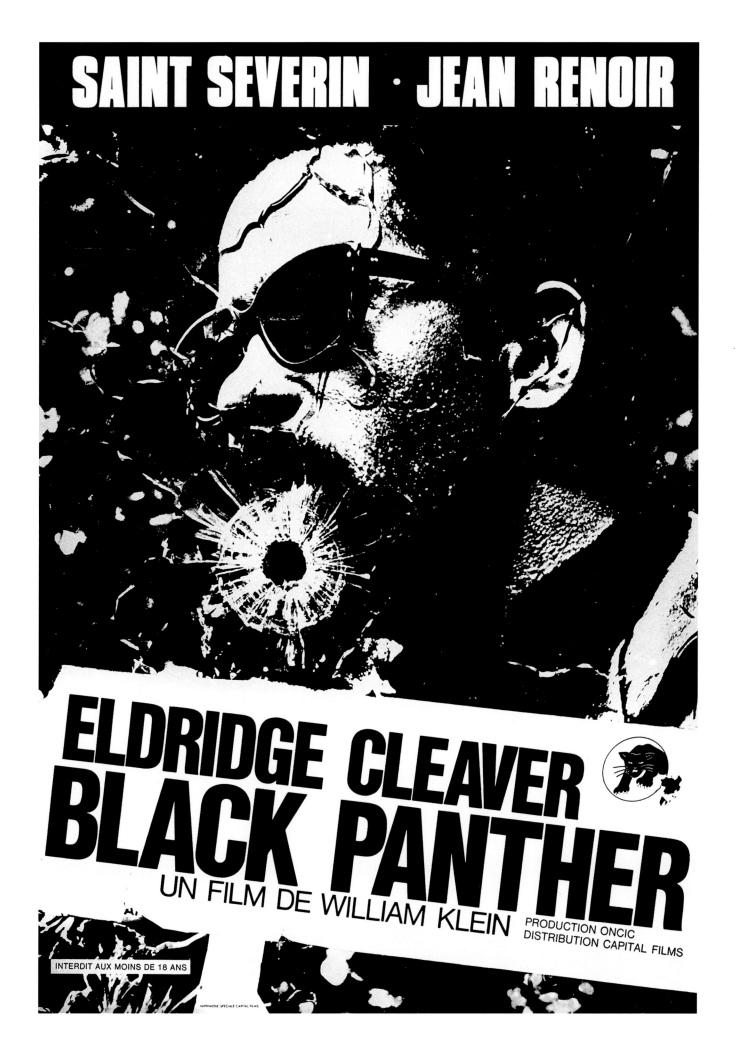

"A HANDFUL OF YOUNG PEOPLE, BLACK AND WHITE, BELIEVED THEY COULD CHANGE HISTORY. AND DID."

THE NEW YORK TIMES

1994 SUNDANCE
GRAND JURY
PRIZE WINNER

FREEDOM On My MIND

a film produced and directed by CONNIE FIELD and MARILYN MULFORD
edited by MICHAEL CHANDLER
a CLARITY FILM production
supported by NATIONAL ENDOWMENT FOR THE HUMANITIES
a TARA RELEASING film

Less than fifty years before America elected Barack Obama as its first African-American president, sections of the country refused to even let blacks take part in the political process, let alone run for high office. Worst affected was Mississippi, a state so segregated in the early 1960s that blacks were effectively barred from voting.

Freedom on My Mind (1994) is Connie Field and Marilyn Mulford's empowering documentary about a courageous group of young black organizers who, with the help of nearly one thousand sympathetic white college students from around the country, strategically set out to form the Mississippi Freedom Democrats during the summers of 1963 and 1964. Their Freedom Summer voter registration drive effectively forced the Mississippi state authorities to concede their black citizens the right to vote. Though the process took several years and was immensely dangerous (several campaigners were murdered), it was ultimately a significant influence behind the passage of the landmark 1965 federal Voting Rights Act signed by President Lyndon Johnson.

In the 1960s and 70s, Swedish filmmakers travelled to the streets of America to explore and document the black power movement, which the US media saw as a violent threat. Thirty years later, this largely forgotten collection of unseen footage and interviews was discovered in the basement of a Swedish television station. It featured some of the greatest revolutionary minds of modern history, including Stokely Carmichael, Eldridge Cleaver, Angela Davis, Huey Newton, and Bobby Seale. *The Black Power Mixtape 1967-1975* (2011) offers the audience a retrospective peek into the genius and profound visions of the movement's leaders, who ultimately became international heroes while traveling the world to publicize their cause.

Left: **FREEDOM ON MY MIND (1994)**
Opposite: **THE BLACK POWER MIXTAPE 1967-1975 (2011)**

"Nothing short of a revelation." - Amy Taubin, *Film Comment*

featuring: Erykah Badu · Harry Belafonte · Elaine Brown · Stokely Carmichael · Eldridge Cleaver
Kathleen Cleaver · Angela Davis · Louis Farrakhan · John Forté · Robin Kelley · Talib Kweli · Huey P. Newton
Abiodun Oyewole · Sonia Sanchez · Bobby Seale · Melvin Van Peebles · Ahmir Questlove Thompson

a film by **Göran Hugo Olsson** The
Black Power
Mixtape
1967-1975

you're either part of the solution or part of the problem.

SUNDANCE SELECTS PRESENTS "THE BLACK POWER MIXTAPE 1967-1975" WRITTEN AND DIRECTED BY GORAN HUGO OLSSON PRODUCED BY ANNIKA ROGELL, STORY AB
CO-PRODUCED BY JOSLYN BARNES & DANNY GLOVER, LOUVERTURE FILMS AXEL ARNÖ, SVERIGES TELEVISION AB GRAPHIC DESIGN STEFANIA MALMSTEN
EDITED BY GORAN HUGO OLSSON & HANNA LEJONQVIST EXECUTIVE PRODUCER TOBIAS JANSON EXECUTIVE MUSIC PRODUCER COREY SMYTH, BLACKSMITH CORP. MUSIC BY OM'MAS KEITH & AHMIR QUESTLOVE THOMPSON

Urban Experience

In late 1982, unemployment levels in America rose to their highest level since the Great Depression of the 1930s. The rhetoric of President Reagan's two-year-old administration was all about a new dawn for the nation's pride and prosperity, but the reality for those living in America's urban sprawl was social decay, soaring drug problems, financial desperation, and the sense of a society on the verge of collapse. Nearly a decade later, the "not guilty" verdicts in the trials of the Los Angeles policemen charged with assault against a black citizen, Rodney King, sparked the worst urban riots since the 1960s, and the loss of fifty-three lives.

During that decade, the racial segregation that had been legally erased from American society in the 1960s was effectively reintroduced through the back door. Many black activists believed that the American government was using poverty as a means of herding poor blacks into urban ghettos, safely distanced and out of sight of their most prosperous white counterparts. In some cities, gated white communities were inserted into run-down black areas, accentuating the social divide.

Cities had once been synonymous with sophistication and wealth. Now, increasingly, the opposite principle applied. In retrospect, it is not surprising that this grim era in modern American history was reflected in the rapid growth of an African-American art form that was starkly realistic and perfectly in rhythm with the mood of the streets. This was the era when hip-hop mutated from being the youth culture of block parties in the South Bronx into a global revolution in style, which left its mark on music, fashion, everyday speech, and social attitudes.

Hip-hop's original blend of freestyle rapping, DJing, and street dance translated quickly into a language that transcended all cultural boundaries and international borders. Its influence was felt in almost every genre of popular music; its stars became global icons; its rhythms were heard in cities on every continent. Like jazz in the 1920s, and soul in the 1960s, hip-hop was black music that cast a spell over a generation of young whites.

Although hip-hop is widely and rightly seen as an African-American art form, many early protagonists were Hispanic, and there was also a strong Caribbean influence. There was a direct connection between the "toasting" of DJs over open-air sound systems in Jamaica and other islands, and the improvised rapping employed by young men who were handling the decks at rent parties or street gatherings in the Bronx. As impromptu experimentation grew into a musical form, there was a creative split between the DJs who provided the musical element of hip-hop, and the rappers whose words—whether playful or incendiary—provided the imagery and ethos for the genre.

Yet hip-hop has always been a collaborative medium, which depends for its impact on its perfectly judged blend of words and music. The role of the DJ at block parties has now been supplanted by that of the producer, whose task is akin to that of the collage artist—representing a culture and a mood through the creative juxtaposition of often starkly different elements. The art of the rapper has much more to do with "flow"—the rush of rhythm, rhyme, and images that can evoke the turbulent, frenetic culture of America's inner cities.

At its most progressive, with the militant anger of Public Enemy, the experimental zeal of Arrested Development, or the unflinching lyrical gaze of Jay-Z, hip-hop can be politically radical and artistically liberated. But like an earlier urban medium, the blaxploitation movies of the 1970s, it can just as easily slip into self-parody—or worse. As the genre's commercial power increased, many hip-hop stars used their fame to proselytize violent and sexist clichés. These negative stereotypes were swallowed whole by many fans, and then seized upon as evidence by those who had a political reason for demeaning popular black culture.

Since the first full-length features about rappers and breakdancers appeared in the early 1980s, such as *Wild Style* (1983) and *Beat Street* (1984), hip-hop has influenced the sound and look of the urban experience on film. New generations of actors and directors have emerged to deliver a credible vision of America's inner city culture to the screen. Just as hip-hop music often exaggerates for effect, and employs familiar stereotypes about "gangstas" and "hoes," so too have hip-hop-inspired movies sometimes been gratuitously violent and rife with sexual exploitation. For every *Boyz n the Hood* (1991), *Juice* (1992), and *Menace II Society* (1993), there have been many more films designed solely to aggrandize their rapper heroes, and caricature the culture from which the music came. Hollywood has yet to deliver the classic hip-hop movie. It is both emblematic and ironic that the film often described as the most accurate cinematic depiction of hip-hop culture is *8 Mile* (2002), which starred the white rapper Eminem. Arguably the most compelling evocation of urban decay and confrontation this century has come not from Harlem or Watts, but from Rio de Janeiro, in the form of the Oscar-nominated *City of God* (2002).

Yet rap and American cinema can combine to startling effect. Marc Levin's 1998 film *Slam* demonstrates how hip-hop can not only provide the backdrop for a movie, but infest it with its soul. The two stars, Saul Williams and Sonja Sohn, take part in poetry duels known as "slams," in which wordsmiths go head-to-head to establish the all-conquering fluency and power of their rhymes and rhythms. Both actors are also poets in real life. The narrative encompasses such cinematic clichés about the inner cities as drugs, violence, and prison, but never defines its characters within those limits. These are real human beings, seeking to maintain their dignity and their freedom of self-expression in the face of everything that a crumbling social order can throw at them.

Opposite: **SLAM (1998)**

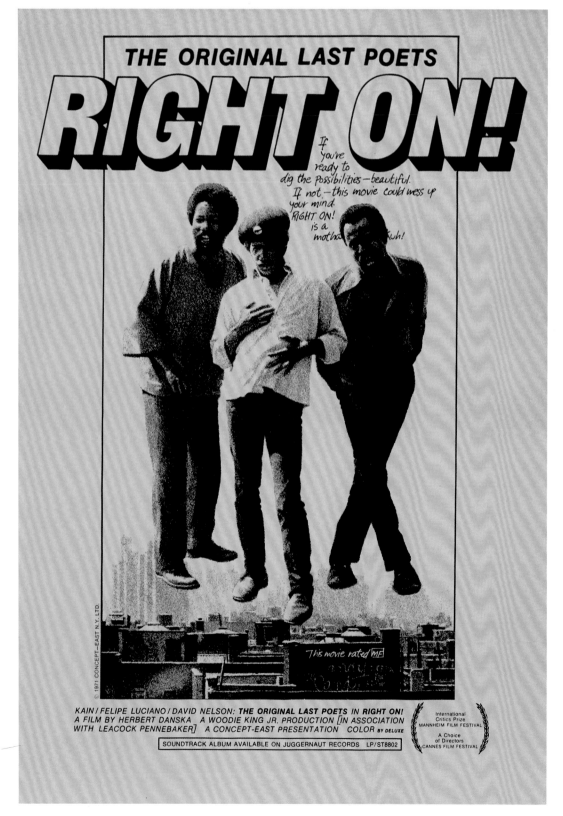

THE ORIGINAL LAST POETS

RIGHT ON!

If you're ready to dig the possibilities—beautiful. If not—this movie could mess up your mind. RIGHT ON! is a motha...kuh!

This movie rated 'MF'

KAIN / FELIPE LUCIANO / DAVID NELSON: **THE ORIGINAL LAST POETS** IN **RIGHT ON!**
A FILM BY HERBERT DANSKA A WOODIE KING JR. PRODUCTION [IN ASSOCIATION
WITH LEACOCK PENNEBAKER] A CONCEPT-EAST PRESENTATION COLOR BY DELUXE

SOUNDTRACK ALBUM AVAILABLE ON JUGGERNAUT RECORDS LP/ST8802

International
Critics Prize
MANNHEIM FILM FESTIVAL

A Choice
of Directors
CANNES FILM FESTIVAL

Hip-hop music can trace its roots back to a dozen different sources; from African chants and slavery work songs to blues and jazz and 1950s beat poetry. But there are a handful of black artists who provided a clear signpost to the future of rap by the way they merged African-American rhythms with lyrics that were both verbally adventurous and stunningly incisive.

Right On! (1970) was a cinéma vérité documentary by director Herbert Danska, in association with Leacock and Pennebaker, the director/producers who had already chronicled influential rock musicians in *Don't Look Back* (1965) and *Monterey Pop* (1967). The Last Poets were a radical poetry ensemble who in the late 1960s and early 1970s used voice and drums as the root of their raps. Uniting contemporary urban slang with ancient, traditional African rhythms, their street raps were full of humor and political rebellion, and reflected their self-described identity as "guerrilla poets." Through founding members Felipe Luciano, Gylan Kain, and David Nelson, and the ever-changing line-up of ensemble members, The Last Poets had significant impact and it became inevitable that rap would become a major musical influence.

If any one person can be said to have hastened the flowering of hip-hop music, it was another poet of politics and the streets: Gil Scott-Heron. His seminal 1971 song "The Revolution Will Not Be Televised" provided a focus for political opposition across racial lines in the 1970s. He was the subject of Robert Mugge's documentary *Black Wax* (1982), which mixed live performance of some of his finest examples of jazz/funk poetry with street footage of him expressing his views on President Reagan and urban deprivation in Washington, DC. The clips feature some of Scott-Heron's best-known songs and poems, including "Whitey on the Moon," "Johannesburg," "Winter in America," and "Angel Dust." He comes across as warm, articulate, and insightful throughout, clearly relishing the opportunity to espouse his frequently provocative views.

Left: RIGHT ON! (1970)
Opposite: BLACK WAX (1982)

"the most dangerous musician alive" —Melody Maker

BLACK WAX

a film by Robert Mugge

featuring Gil Scott-Heron and the Midnight Band

When the first rap singles hit the charts at the end of the 1970s, they were greeted as an ephemeral novelty, like "The Twist" in the 1960s or a dozen later dance crazes, rather than the birth of a new expression of the black experience. But when hip-hop culture showed no signs of fading away, writer/director Charlie Ahearn set out to make a feature film that would reflect what he could see—and hear—was happening on the streets. Warner Bros. initially agreed to finance his movie, but pulled out of the project fearing that nobody would still be interested in rap when the film was finished. So it was left to Ahearn to see it through himself—the result being *Wild Style* (1983).

His film accurately captured the South Bronx culture from which hip-hop was born: the graffiti artists in the New York subway train yards, including the influential style of Dondi (Donald White) and Zephyr (Andrew Witten), who designed the film's logo; DJs manning the decks in every imaginable warehouse space; and the sense of an entire urban generation being drawn together by the rhythm of the music and the fluency of its rhymes.

By the time that *Breakin'* and *Beat Street* hit the screen (both in 1984), Hollywood studios began to realize that this cultural revolution might have staying power. Film and music veteran Harry Belafonte acted as producer for *Beat Street*, with veteran African-American director Stan Lathan. It had something of the excitable flavor of *Fame*; poor urban kids (Rae Dawn Chong and Guy Davis) who use their talents to break out of the ghetto. From these comparatively humble beginnings, hip-hop would become a familiar part of the movie landscape, both as a subject and on the soundtrack of any film trying to establish its gritty urban credentials.

Left: **WILD STYLE (1983)**
Opposite: **BEAT STREET (1984)**

By the time they starred in *Tougher Than Leather* (1988), released simultaneously with their fourth album, hip-hop crew Run-DMC were already established as brand-leaders of the genre. Run (Joseph Simmons), DMC (Darryl McDaniels), and Jam Master Jay (Jason Mizell) grew up in the Hollis neighborhood of Queens and were signed to Def Jam Records, the pioneering rap label formed by Simmons' brother Russell. They released the first "new skool" hip-hop single, *It's Like That*, which became a Top 20 R&B hit.

Early MTV exposure and a groundbreaking collaboration with Aerosmith helped them to achieve an unprecedented commercial profile for a rap group. Their first film appearance was in *Krush Groove* (1985), loosely based on Russell Simmons' maverick career, and also featuring the Fat Boys, Kurtis Blow, LL Cool J, and the, then-unknown, Beastie Boys.

Run-DMC play themselves in *Tougher Than Leather*. Directed and co-written by Rick Rubin, the co-founder of Def Jam, the film offered an exaggerated, cartoonish view of the hip-hop world, heavy on street swagger, drugs, and violence.

Director Kevin Fitzgerald offered a very different perspective on the genre in his 2000 documentary, *Freestyle: The Art of Rhyme*. If Run-DMC's movie was all about image and record contracts, Freestyle focused on rap as an art form with a social, political, and spiritual message. Shot over a period of seven years, Fitzgerald traced rap's roots from The Last Poets in the 1960s to modern improvisational hip hop and spontaneous rhyming. He mixed performance footage and informal interview clips in a film that will stand as a valuable history lesson for future generations.

Left: **TOUGHER THAN LEATHER (1988)**
Opposite: **FREESTYLE: THE ART OF RHYME (2000)**

Buoyed by Spike Lee's successful films of the 1980s, studios and investors began to embrace young male African-American filmmakers. *New Jack City* (1991), Mario Van Peebles' debut as a director, attracted much publicity owing to riots at the theaters screening the film, and gave the movie a provocative aura that publicists could never have manufactured. Ironically, this "gangsta rap" saga had an anti-drug message, and did nothing to encourage gang violence, as the media suspected.

John Singleton's directorial debut was *Boyz n the Hood* (1991), a powerful "ghettocentric" tale about a young man coming of age in South Central, Los Angeles. Because of its compelling, true-to-life script, social context, and strong ensemble cast, it was seen as picking up the public discourse about race where Spike Lee's *Do the Right Thing* (1989) had left it.

Juice (1992), directed and co-written by Spike Lee's cinematographer, Ernest R. Dickerson, was a vehicle for one of the most talented and controversial performers in hip-hop: Tupac Shakur. In the film, he persuades a group of friends to commit a robbery, which goes wrong with tragic consequences. Like his movie character, Shakur would meet his own violent death just four years later.

Tupac was originally set to star in *Menace II Society* (1993), another film based in South Central, but first time directors, twenty-one-year-old twin brothers Allen and Albert Hughes, fired him for allegedly misbehaving on the set. The brothers emerged with something resembling a blaxploitation movie for the era of gangsta rap, its script boasting more profane language than almost any mainstream drama ever released.

The Hughes Brothers returned in 1995 with *Dead Presidents*, an urban crime drama set in the post-Vietnam era. Larenz Tate, who made his debut in *Menace II Society*, stars as a well-intentioned young Brooklyn man who enlists in the Marines in 1968 after high school, but struggles to survive in the ghetto and drifts to crime once he returns from Vietnam four years later. The film's soundtrack featured classic R&B and funk anthems from the blaxploitation era by artists such as Isaac Hayes, James Brown, and Curtis Mayfield.

Left: **JUICE (1992); NEW JACK CITY (1991);**
MENACE II SOCIETY (1993); BOYZ N THE HOOD (1991)
Opposite: **DEAD PRESIDENTS (1995)**

A HUGHES BROTHERS FILM

DEAD PRESIDENTS

THE ONLY COLOR THAT COUNTS IS GREEN.

HOLLYWOOD PICTURES presents In association with CARAVAN PICTURES An UNDERWORLD ENTERTAINMENT Production
A HUGHES BROTHERS FILM "DEAD PRESIDENTS" LARENZ TATE KEITH DAVID CHRIS TUCKER N'BUSHE WRIGHT
FREDDY RODRIGUEZ BOKEEM WOODBINE Music Supervisor BONNIE GREENBERG Co-Producer MICHAEL BENNETT Editor DAN LEBENTAL
Production Designer DAVID BRISBIN Director of Photography LISA RINZLER Executive Producer DARRYL PORTER Story by ALLEN & ALBERT HUGHES and MICHAEL HENRY BROWN
Screenplay by MICHAEL HENRY BROWN Produced by ALLEN and ALBERT HUGHES Directed by THE HUGHES BROTHERS

 Distributed by BUENA VISTA PICTURES DISTRIBUTION, INC. © HOLLYWOOD PICTURES COMPANY

PRINTED IN U.S.A.

Women Behind the Lens

Never underestimate a man with something to say.

TALK TO ME

Inspired by a true story

During the time of Oscar Micheaux and other independent filmmakers of the silent era, Tressie Souders, Zora Neale Hurston, and Eloyce Gist began the long slow path of black women to the director's chair. Their artistic rebellion challenged the old boys' network, breaking racial barriers and allowing successive generations access to more and more cinematic opportunities.

Some directors have recognizable names—Maya Angelou (*Down in the Delta* 1998), Debbie Allen (*Out-of-Sync*, 1995), Kasi Lemmons (*Talk to Me*, 2007), Gina Prince-Bythewood (*Love and Basketball*, 2000), Darnell Martin (*Cadillac Records*, 2008), and Angela Robinson (*Herbie Fully Loaded*, 2005), but many are more obscure.

"I never had dreams of Hollywood," said Julie Dash, who is celebrated for her poetic ancestral homage *Daughters of the Dust* (1991). "I made films because that's what I enjoy to do. You get bitten by this bug and just keep standing up every time you're knocked down."

In 1989, Euzhan Palcy became the first black woman to direct a film for a major studio—MGM's *A Dry White Season*. "People say it is very hard to do films. Yes, that is true. And more difficult when you are a woman," said the inspirational filmmaker. "But if a woman loves film, if a woman wants to be a director, she must fight hard, very hard, to do that."

Familiar, or soon-to-be, directors Ava DuVernay (*Middle of Nowhere*, 2012), Dee Rees (*Pariah*, 2011), Amma Asante (*Belle*, 2013), and Tanya Hamilton (*Night Catches Us*, 2010), are among those that have created a diverse body of work, often tackling firebrand issues like apartheid, civil rights, incarceration, lesbian relationships, and homelessness. Instead of alienating audiences by focusing on our dissimilarities, they seek to remind us that we are all more alike than different. That our experiences are universal, and often what makes us stumble and fall, is also what gives us the strength to rise.

Left: **TALK TO ME (2007)**
Opposite: **A DRY WHITE SEASON (1989)**

John Sayles

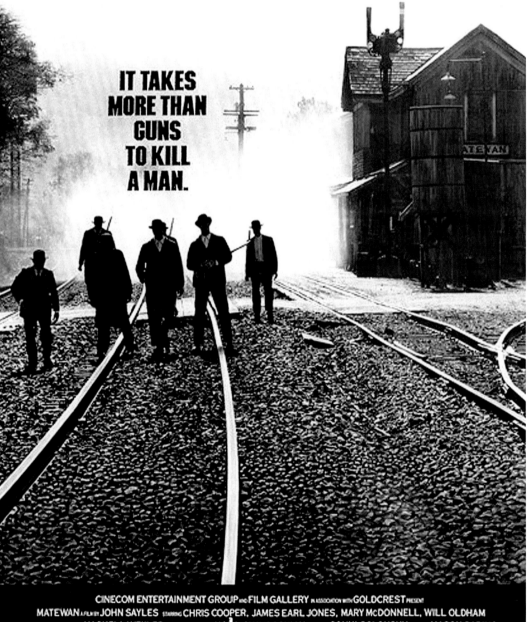

When it comes to making films as a true independent, writer/director John Sayles—and producer/wife Maggie Renzi—carry the torch originally lit by such post-war pioneers as Kenneth Anger, Shirley Clark, Jonas Mekas, and the young John Cassavetes. For over three decades he has financed his own brand of filmmaking by moonlighting as a screenwriter in Hollywood and working entirely out of the studio system; a process that has allowed him to tackle class, race, and gender identity issues in ways that have been both radical and inventive.

In *The Brother from Another Planet* (1984), Sayles offers a social commentary about race relations in America, through the metaphorical blending of a satirical stock premise (the world through the eyes of an alien), with a runaway-slave narrative. The Brother (Joe Morton) is an escaped slave from an unnamed planet who crash-lands his space capsule off New York's Ellis Island. Dressed in ragged clothing, unable to speak, and taken for a homeless black man, the Brother is treated with reactions ranging from pity to contempt by the community but ends up in a Harlem bar where the regular patrons find him very odd, but charming. As the film proceeds in a series of vignettes, it offers a realistic image of racial segregation in urban America.

Race was also central to the scenario of *Matewan* (1987), muddying the waters of what might otherwise have been a conventional drama about corporate greed and the tension (and violence) between workers and bosses during a 1920 coal strike in Matewan, West Virginia. The difference here is that when the company operators dismiss the coal workers who insist on joining a union, the replacements they bring in from out-of-state are African American and Italian. Unbeknown to them, the newcomers are effectively "scabs" in the eyes of the discharged workers. Despite their race initially precluding them from being allowed to join the union, they eventually line up alongside the strikers. James Earl Jones, the veteran of such films as *The Great White Hope* (1970) and *Claudine* (1974) stars as the ragged but dignified leader of the black miners, "Few Clothes" Johnson.

Left: MATEWAN (1987)
Opposite: THE BROTHER FROM ANOTHER PLANET (1984), Japanese

ブラザー・フロム・アナザー・プラネット

1984年 アメリカ映画 カラー 109分　監督＋脚本＝ジョン・セイルズ　主演＝ジョー・モートン　配給＝ユーロスペース

まるで黒人のような宇宙人が、

ハーレムに落ちてきた！

地球もまだまだ捨てたものじゃない。

John Sayles

Quentin Tarantino

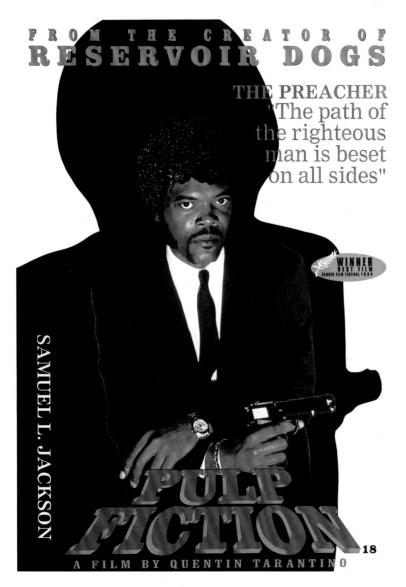

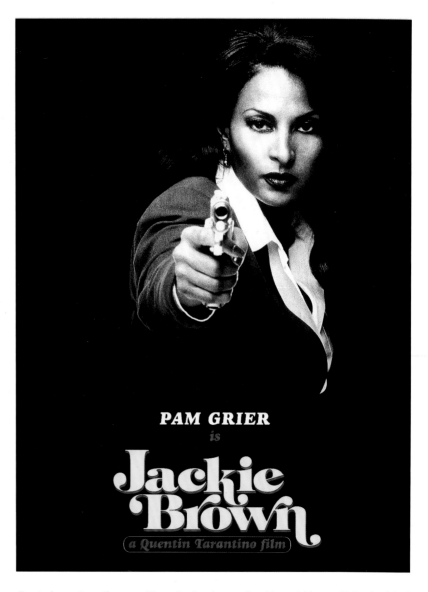

It is Quentin Tarantino's unique fate to have been recognized as a white champion of African-American culture, and yet to have been assailed for racism in his cinematic treatment of blacks. His filmic skills are undeniable: over the past two decades, he has revived the tradition of the exploitation movie genre, gloried in its excesses, and explored the full implications of its obsessions. Some people view him as a genius; others complain that his movies are too violent, sexist, and racist. Nobody, however, has ever accused him of being a dull or conventional filmmaker.

Tarantino's most obvious homage to African-American film history came with *Jackie Brown* (1997). This was clearly a loving recreation of the golden age of blaxploitation movies, with Pam Grier—star of such 1970s epics as *Coffy* and *Foxy Brown*—in the leading role of a flight attendant who operates a side-line as a smuggler for Samuel L. Jackson, who in turn makes his money from trading in illegal firearms. Jackson has been the most regular collaborator in Tarantino's films, since his leading role in the ensemble cast of *Pulp Fiction* (1994), for which he received an Oscar nomination for Best Supporting Actor. The actor has been a firm supporter of Tarantino's work, even when he has been condemned by the African-American community, as well as the media, for his rampant use of the "N-word" in *Pulp Fiction*, *Jackie Brown*, and most recently, the revisionist Southern slavery tale, *Django Unchained* (2012). The

director's most vociferous critics relentlessly question his racial insensitivity. As Jelani Cobb reviewed *Django* in *The New Yorker*: "Had the word appeared any more often it would have required billing as a co-star."

Controversy and his *enfant terrible* status in Hollywood aside, Tarantino continues to be one of the most influential filmmakers in the industry today, pushing stylistic boundaries. And like Martin Scorsese, he is one of the very few directors whose work will be guaranteed to contain a soundtrack as memorable as the film itself. Tarantino characteristically uses music to shape the rhythm of each scene of the film in whatever genre he's working. In *Jackie Brown*, his passion for black music is obvious, and he stuffed it with funk blaxploitation anthems by Bobby Womack, Brian and Eddie Holland, Lamont Dozier, and Roy Ayers. In the case of *Django Unchained*, the scenes are elevated by new and old music from the Italian Spaghetti Western maestros, Ennio Morricone and Luis Bacalov, mixed with soul and R&B stars like James Brown and Tupac Shakur, and modern contemporaries Rick Ross, John Legend, Anthony Hamilton, and Elayna Boynton.

Above (left to right): PULP FICTION (1994), British; JACKIE BROWN (1997)
Opposite: DJANGO UNCHAINED (2012)

Into the Next 100 Years

On March 24, 2002, the Academy Award color barrier was broken when Halle Berry and Denzel Washington made Oscar history by winning Best Actress and Best Actor at the 74th Annual Awards ceremony. As the first African American ever to win Best Actress, Berry was clearly stunned, weeping openly as she accepted the award, saying: "This moment is so much bigger than me. … It's for every nameless, faceless woman of color that now has a chance because the door tonight has been opened."

In his speech, Washington acknowledged Sidney Poitier, who was the first African American to win an Academy Award for Best Actor in *Lilies of the Field* (1963); "I'll always be chasing you, Sidney. I'll always be following in your footsteps. There's nothing I would rather do, sir. Nothing I would rather do. God bless you."

As the twenty-first century dawned, black actors, actresses, directors, writers, and producers established themselves as financial and creative forces in the entertainment industry, demanding as much respect in film history as their white counterparts—whether it was Berry in *Monster's Ball* (2001), or Washington in *Training Day* (2001). That was also the year when Will Smith achieved the near-impossible feat of reincarnating one of the most famous sports heroes on the planet in his prime, in the biopic *Ali*. In 2004, Jamie Foxx performed a similar miracle in *Ray*, Taylor Hackford's biographical tribute to R&B legend Ray Charles, winning the Academy Award for Best Actor in the process. And Forest Whitaker became the fourth African American to win the Oscar for Best Actor for his role as the charismatic but psychotic Idi Amin in *The Last King of Scotland* (2006). More recently, Mo'Nique won the Academy Award for Best Supporting Actress for *Precious* (2009), Lee Daniels' adaptation of author Sapphire's best-selling novel, *Push*, about an overweight, illiterate, and severely abused teen from Harlem.

In the twenty-first century, Hollywood seems more willing to consider many aspects of the black experience. It is possible for a film with a predominantly black cast to openly explore the universal themes of broken hearts, redemption, forgiveness, and the importance of family—as does *Diary of a Mad Black Woman* (2005), written by and starring Tyler Perry (and directed by award-winning hip-hop video director, Darren Grant). Its mix of comedy and drama explores the kind of African-American family rarely seen in cinema: rich and ostensibly happy, at least until a tragic fault-line causes an apparently idyllic marriage to collapse in ruins. This was the first film in Perry's successful 'Madea' franchise, which featured Perry dressed in drag as the matriarchal figure at the heart of the family. Several hit sequels followed, including *Madea's Family Reunion*, which Perry himself directed. While being praised for portraying ordinary lives within the African-American community, and for presenting a strong black woman in the character of Madea, Perry has also been criticized by detractors who claim his films perpetuate old racial stereotypes. What is undeniable, however, is that they are phenomenally popular. Their success has created a multi-million dollar empire for Perry, apart from the studio system, in which he holds an enormous degree of creative freedom. In a similar vein to the early independent films of the 1930s and 40s, his films cater almost exclusively to an African-American audience and may be celebrated as a contemporary reflection of a "separate cinema."

More films are being made today about the black experience in America than ever before. The emerging trend has also allowed for more diverse stories being told by black A-list filmmakers, writers, producers, and actors. Film hasn't seen such an explosion since the 1980s and 90s with Spike Lee's *She's Gotta Have It*, Robert Townsend's *Hollywood Shuffle* or John Singleton's *Boyz n the Hood*. The noticeable shift has certainly been aided by the "Obama effect" that suggests Barack Obama's presidency is partly a catalyst to the current attention and universal consciousness being paid to the African-American narrative. The *New York Times* and other mainstream media declared 2013 would go down in history as the year black film turned a corner. By all accounts, it was a remarkable year. In at least a dozen black themed movies—including both independent and Hollywood produced Academy Award contenders—black talent existed in front of and behind the cameras. Some critics have even compared this to the Harlem Renaissance nearly a century ago.

The year 2013 saw critically acclaimed releases like *12 Years a Slave*, by the black British director Steve McQueen. Based on the autobiography of Solomon Northup, the film presents a raw, uncensored portrait of the deepest scar in America's collective memory. Chiwetel Ejiofor takes the central role of a free black man from Saratoga, New York, who in 1841 was kidnapped off the streets of Washington, DC, and sold into slavery. In the same year, Lee Daniels released his touching family drama, *The Butler*, in which Forest Whitaker and Oprah Winfrey portray husband and wife Cecil and Gloria Gaines. The movie is based on real-life White House butler Eugene Allen who served eight presidents over three decades through Ronald Reagan, coming of age during the civil rights movement, and living to see a black man elected to the White House. Also in 2013, *Mandela: Long Walk to Freedom* was another historical epic, focusing on South African President Nelson Mandela's life story and the decades-long struggle of the black community against Apartheid. Idris Elba stars as the country's revolutionary leader who spent twenty-seven years in prison before becoming President and rebuilding the country's once segregated society.

Opposite: **12 YEARS A SLAVE (2013)**

All of these films more than deserve the critical and public praise they have received. Multiple nominations and awards were plentiful for *12 Years a Slave* (Steve McQueen, Chiwetel Ejiofor, Lupita Nyong'o, John Ridley), *Lee Daniels' The Butler* (Lee Daniels, Forest Whitaker, Oprah Winfrey, David Oyelowo) and *Mandela* (Idris Elba, Naomie Harris, U2). It was a huge achievement and landmark year.

One element that all of these films share, however, is that they offer a historical, rather than contemporary, look at the black experience. As Samuel L. Jackson commented in Britain's *The Times*, "America is more willing to acknowledge what happened in the past … We freed the slaves! It's all good! But to say 'We are still unnecessarily killing black men'—lets have a conversation about that." *Fruitvale Station*, also released in 2013, is remarkable as being one of the only films in recent years to explore the realities of racism in America today. It follows the events leading up to the death of Oscar Grant, a twenty-two-year-old black man shot by a white transit cop in Oakland, California, on New Year's Day in 2009. Directed by Ryan Coogler and starring Michael B. Jordan and Octavia Spencer, it received critical praise and several awards, including the Grand Jury and Audience Awards at Sundance.

Almost a century after D. W. Griffith's portrayal of African Americans in *The Birth of a Nation*, Hollywood movies in the twenty-first century reflect how far American society has come since that travesty. There is undoubtedly still much to be done—including more thought-provoking films about contemporary black life and achieving color-blind neutrality in the casting room. The debate about the pace of change and diversity in film will rightly continue for many years, however, there are great signs of progress.

Left: MADEA'S FAMILY REUNION (2006); PRECIOUS (2009); MANDELA: A LONG WALK TO FREEDOM (2013); FRUITVALE STATION (2013)
Opposite: LEE DANIELS' THE BUTLER (2013)

Afterword by Spike Lee

DA MOVIES

I'm writing this two days after laying Christopher Lee, my brother, to rest at the age of fifty-five years old. Chris was my next sibling under me; I'm the eldest of five children to Bill and Jackie Lee (please check out my film *Crooklyn* and you'll see what I'm talking about). The reason why I'm including Chris is because we grew up together going to see movies. We went to the Lido in Cobble Hill, Brooklyn; and The Duffield, Loews Metropolitan, and The Albee movie theaters in Downtown Brooklyn. There was rarely a Saturday where we didn't go to the movies. Now of course nobody knew anything about how movies were made or anything like that. Chris and I loved movies and on top of that we loved movie posters. We loved them so much we would snatch them off the subway cars (without ever getting caught) and put them up on our bedroom walls. At a very young age Chris and I were attracted to the visual arts, those seeds were sown very early in our development years. In fact, even before I went to NYU Film School, Chris established himself as one of the legendary graffiti artists during the "Golden Age of Graffiti." Chris's tag was "Shadow" and he wrote it inside and outside of the New York City subway cars.

I'm proud to say many of the posters in the Separate Cinema Archive and in this great book are included in my own personal collection hanging on the walls of my 40 Acres and a Mule office. Movie posters are unique art themselves and I'm elated to see our black cinema reflected here. These movies/posters tell the world about the duality that W. E. B. Du Bois wrote about; we are Black and American, where we have been, where we are now and where we might be heading to. I urge everyone to start collecting movie posters. R.I.P. Christopher Lee.

Peace and Love,
Fort Green, Da Republic of Brooklyn, NY
January 7, 2014

Captions

Unless otherwise stated below, all images are either American one sheet posters, 41 x 27 in. (104 x 69 cm), from the original release date, or photographs.

Cover: (front): **Cabin in the Sky** (1943) (poster detail)
Style C, Art by Al Hirschfeld (1903-2003)
(back): **Unemployed Youth Outside Movie Theater**
(c.1940), Photo by Arthur Rothstein (1915-1985),
© Arthur Rothstein/CORBIS

p.2: World premiere of **Carmen Jones**, New York, 1954.

p.4: **Flame in the Streets** (1961) (poster detail)
Polish poster, 23 x 16 in. (58 x 41 cm)
Art by Maciej Hibner (b.1931)

p.6: **Hallelujah** (1929) (poster detail)
American trade advertisement
Art by Al Hirschfeld (1903-2003)

p.8: **Thunder Soul** (2010) (poster detail)
Design by Concept Arts

p.11: (left): **Uncle Tom's Cabin** (c.1910), British stage
production poster, 89 x 40 in. (226 x 102 cm), Art by
Robert Kent; (right): **Bert Williams** (1919), Columbia
Records promotion poster, 27 x 21 in. (69 x 53 cm),
Art by Gordon Hope Grant (1875-1962)

p.12: (left): **By Right of Birth** (1921), American Herald
(right): **Hattie McDaniel**, February 29, 1940

p.13: (left): **Sidney Poitier**, April 13, 1964
(right): **Song of the South** (1946), James Baskett

p.14: (left to right): **Gordon Parks** (1969); **Beloved** (1998),
Danny Glover and Oprah Winfrey

p.15: **Driving Miss Daisy** (1989), Morgan Freeman

p.16: **Caldonia** (1945)

p.19: **Underworld** (1937)

p.20-1: **The Color Purple** (1985)
Photo by Gordon Parks (1912-2006)

p.22: **The Birth of a Nation** (1915)

p.23: **The Birth of a Nation** (1915), Re-release 1921

p.24: **Trooper of Troop K** (1917)
Courtesy of the Charles E. Young Library

p.25: **A Man's Duty** (1919)

p.26: **The Lure of a Woman** (1921)

p.27: **The Flaming Crisis** (1924)

p.29: **The Bull-Dogger** (1922)

p.30: (clockwise from top left):
Regeneration (1923); **The Flying Ace** (1926);
The Green Eyed Monster (1920); **Black Gold** (1928)

p.31: **The Crimson Skull** (1922)

p.33: **Swing!** (1938)

p.34: **The Exile** (1931)
(left): Northern Distribution; (right): Southern Distribution

p.35: **The Exile** (1931)
American three-sheet poster, 81 x 41 in. (201 x 104 cm)

p.36: **Birthright** (1924)

p.37: **Birthright** (1939)

p.38: **The Girl from Chicago** (1932)

p.39: **Murder in Harlem** (1935)

p.40: **Temptation** (1936)

p.41: **God's Step Children** (1938)

p.42: **La revue des revues** (1927)
Austrian poster, 50 x 37 in. (127 x 94 cm)
Art by Atelier Hans Neumann

p.44: **Princesse Tam-Tam** (1935)
Danish poster, 33 x 24 in. (84 x 61 cm)
Art by Svend Koppel (1904-1978)

p.45: **La sirène des tropiques** (1927)
Swedish poster, 39 x 27 in. (99 x 69 cm)

p.46: **Zouzou** (1934)
Swedish poster, 39 x 27 in. (99 x 69 cm)
Art by Eric Rohman (1891-1949)

p.47: **La revue des revues** (1927)
Swedish poster, 39 x 27 in. (99 x 69 cm)

p.48: **Benglia** (1928)
French (personality) poster, 63 x 47 in. (160 x 119 cm)
Art by Paul Colin (1892-1985)

p.49: **Daïnah la métisse** (1931)
French poster, 63 x 47 in. (160 x 119 cm)
Art by Ram Richman

p.51: **Pardon Us** (1931), Stan Laurel and Oliver Hardy

p.52: **The Jazz Singer** (1927)
Swedish poster, 39 x 27 in. (99 x 69 cm)
Art attributed to Alvan "Hap" Hadley (1895-1976)

p.53: **The Singing Kid** (1936), Leader Press

p.54: **Hypnotized** (1932)

p.55: **Check and Double Check** (1930)
British pressbook cover

p.56: **Modern Minstrels** (1930)

p.57: **A Pair o' Dice** (1930)

p.58: **Stepin Fetchit** (1929)

p.59: **In Old Kentucky** (1927)
French poster, 63 x 47 in. (160 x 119 cm)

p.60: **Hearts in Dixie** (1929)
Swedish poster, 39 x 27 in. (99 x 69 cm)
Art by Eric Rohman (1891-1945)

p.61: **Hearts in Dixie** (1929)

p.62: **Hallelujah** (1929)
American insert poster, 36 x 14 in. (91 x 36 cm)

p.63: **Hallelujah** (1929)
Swedish poster, 39 x 27 in. (99 x 69 cm)

p.64: **On with the Show!** (1929), Ethel Waters

p.65: **Rufus Jones for President** (1933)

p.67: **Paul Robeson** (1936)

p.68: **The Emperor Jones** (1933)
Swedish poster, 39 x 27 in. (99 x 69 cm)

p.69: **The Emperor Jones** (1933)

p.70: **Sanders of the River** (1935)
Argentinian poster, 43 x 29 in. (109 x 74 cm)
Art by Osvaldo Venturi

p.71: **Sanders of the River** (1935)
Swedish poster, 39 x 27 in. (99 x 69 cm)
Art by Moje Aslund

p.72: **The Proud Valley** (1940)
Russian poster, 29 x 17 in. (74 x 43 cm)

p.73: **Big Fella** (1937)
British three-sheet poster, 81 x 41 in. (201 x 104 cm)

p.74: **Imitation of Life** (1934), Re-release 1949

p.75: **Life Goes On** (1938), American pressbook cover

p.76: **Harlem Is Heaven** (1932), Bill Robinson

p.77: **Harlem Is Heaven** (1932)

p.79: **Rex Ingram** (1936)
Photo by Clarence Sinclair Bull (1896-1979)

p.80: **The Green Pastures** (1936)
American title card, 11 x 14 in. (28 x 36 cm)

p.81: **The Green Pastures** (1936)
Swedish poster, 39 x 27 in. (99 x 69 cm)
Art by Gösta Bohm (1890-1981)

p.82-3: **The Green Pastures** (1936)
American promotional stills, 8 x 10 in. (20 x 25 cm)
Art by Will Graven, Harold Cox III and Gösta Bohm (1890-1981)

p.85: **Shoe Shine Boy** (1943)

p.86: (clockwise from top left):
Little Black Sambo (1935); **His Mouse Friday** (1951);
Bosco (1933); **Uncle Tom's Cabana** (1947)

p.242: **Malcolm X** (1992)
Advance, Design by Art Sims 11:24 Design

p.243: **Bamboozled** (2000)
Design by Art Sims 11:24 Design

p.244: **25th Hour** (2002)
Design by Eden Creative

p.245: **Summer of Sam** (1999)
Design by Art Sims 11:24 Design and Steve Nichols

p.247: **Dilemma** (1962)
Danish poster, 33 x 24 in. (84 x 61 cm)

p.248: **African Fury** (aka **Cry, the Beloved Country**, 1951)

p.249: **Cry, the Beloved Country** (1951)
British pressbook cover

p.250: **Come Back, Africa** (1959)
British quad poster, 30 x 40 in. (76 x 102 cm)

p.251: **Come Back, Africa** (1959), Re-release 2010

p.252: **Cry Freedom** (1987)
Russian poster, 41 x 25 in. (104 x 63 cm)

p.253: **A World Apart** (1988)
Polish poster, 33 x 23 in. (84 x 58 cm)
Art by Marek Kwiatkowski

p.255: **The Great White Hope** (1970)
Polish poster, 33 x 23 in. (84 x 58 cm)
Art by Tomasz Rumiński (1930-1982)

p.256: **Sapphire** (1959)
Polish poster, 33 x 23 in. (84 x 58 cm)
Art by Waldemar Świerzy (1931-2013)

p.257: **Black Jesus** (1968)
Polish poster, 33 x 23 in. (84 x 58 cm)
Art by Mieczysław Wasilewski (b.1942)

p.258: **Vivere in pace** (1947)
Polish poster, 33 x 23 in. (84 x 58 cm)
Art by Eryk Lipiński (1908-1991)

p.259: **Black Orpheus** (1959)
Polish poster, 33 x 23 in. (84 x 58 cm)
Art by Anna Huskowska (1922-1989)

p.260: **Tamango** (1958)
Polish poster, 23 x 33 in. (58 x 84 cm)
Art by Wiktor Gorka (1922-2004)

p.261: **Slaves** (1969)
Polish poster, 33 x 23 in. (84 x 58 cm)
Art by Wiktor Gorka (1922-2004)

p.263: **Uncle Tom's Cabin** (1927)
Swedish poster, 39 x 27 in. (99 x 69 cm)
Art by Eric Rohman (1891-1949)

p.264: **The Adventures of Huckleberry Finn** (1960)
Eddie Hodges and Archie Moore

p.265: **The Adventures of Huckleberry Finn** (1960)
Polish poster, 33 x 23 in. (84 x 58 cm)
Art by Jerzy Srokowski (1910-1975)

p.266: **Ragtime** (1981) (poster detail)
Art by Paul Crifo (b.1922)

p.267: **Ragtime** (1981)
East German poster, 33 x 23 in. (84 x 58 cm)
Art by B. Krause

p.268: **The Color Purple** (1985)
Art by John Alvin (1948-2008), Photo by Gordon Parks
(1912-2006), Design by Anthony Goldschmidt (b.1942)

p.269: **The Color Purple** (1985)
East German poster, 33 x 23 in. (84 x 58 cm)
Art by Anker

p.270: **The Learning Tree** (1969)

p.271: **The Learning Tree** (1969)
Czechoslovakian poster, 33 x 23 in. (84 x 58 cm)
Art by Karel Vaca (1919-1989)

p.272: **Native Son** (1950)

p.273: **Native Son** (1950)
Argentinian poster, 42 x 28 in. (107 x 71 cm)
Art by Negrin

p.274: **A Raisin in the Sun** (1961)

p.275: **A Raisin in the Sun** (1961)
American drive-in poster, 40 x 30 in. (102 x 76 cm)

p.276: **To Kill a Mockingbird** (1962)

p.277: **To Kill a Mockingbird** (1962)
Polish poster, 33 x 23 in. (84 x 58 cm)
Art by Bronisław Zelek (b.1935)

p.278: **Black Like Me** (1964), Richard Wright

p.279: **Black Like Me** (1964)

p.280: **Come Back, Charleston Blue** (1972)
(poster detail), Art by Robert E. McGinnis (b.1926)

p.281: **Cotton Comes to Harlem** (1970)
Art by Robert E. McGinnis (b.1926)

p.283: **King: A Filmed Record … Montgomery to
Memphis** (1970)

p.284: **Attica** (1974)
Swedish poster, 39 x 27 in. (99 x 69 cm)
Art by Ernest Pignon-Ernest (b.1942)

p.285: **Eldridge Cleaver, Black Panther** (1969)
French poster, 31 x 24 in. (79 x 61 cm)

p.286: **Freedom on My Mind** (1994)

p.287: **The Black Power Mixtape 1967-1975** (2011)

p.289: **Slam** (1998)

p.290: **Right On!** (1970)

p.291: **Black Wax** (1982)

p.292: **Wild Style** (1983)
Logo design by Dondi (Donald White, 1961-1998) and
Zephyr (Andrew Witten, b.1961)

p.293: **Beat Street** (1984) (poster detail)

p.294: **Tougher Than Leather** (1988)

p.295: **Freestyle: The Art of Rhyme** (2000)

p.296: (clockwise from top left):
Juice (1992); **New Jack City** (1991), Design by Art
Sims 11:24 Design; **Menace II Society** (1993), Design
by Art Sims 11:24 Design; **Boyz n the Hood** (1991),
Advance, Design by Dan Chapman

p.297: **Dead Presidents** (1995)
Advance, Design by Randi Braun

p.298: **Talk to Me** (2007) (poster detail)

p.299: **A Dry White Season** (1989) (poster detail)

p.300: **Matewan** (1987)
Photo by Bob Marshak (1951-2005)

p.301: **The Brother from Another Planet** (1984)
Japanese poster, 29 x 20 in. (74 x 51 cm)

p.302: (left): **Pulp Fiction** (1994), British crown poster, 30 x
20 in. (76 x 51 cm), Photo by Firooz Zahedi (b.1949)
(right): **Jackie Brown** (1997), Photo by George Lange,
Design by Tod Tarhan & Robert Rainey

p.303: **Django Unchained** (2012)
Advance, Design by BLT Communications, LLC

p.305: **12 Years a Slave** (2013) (poster detail)
Advance, Design by Ignition

p.306: (clockwise from top left)
Madea's Family Reunion (2006), Advance, Design by
Crew Creative; **Precious** (2009), Advance, Design by
Ignition; **Mandela: A Long Walk to Freedom** (2013),
Advance, Design by Gravillis Inc; **Fruitvale Station**
(2013), Design by Gravillis

p.307: **Lee Daniels' The Butler** (2013)
Advance, Design by InSync+BemisBalkind

p.309: **Spike Lee** (1992)

p.319: **A Raisin in the Sun** (1961) (poster detail)

Index

Titles, names and artists' names in bold are illustrated

ACKNOWLEDGMENTS

Billie, Duke, and Ace Kisch
Nest & John Henry Kisch (in memoriam)
Jeff & Roberta Cole
The Fitzgeralds

Donald Bogle, Edward Mapp, Richard Norman, John Sayles, Maggie Renzi, Wallace & Hodgson, Steven Miller, Robert Joyce & Associates, Joseph Baldassare, Mia Mask, Kevin Ladson, Jason Lampkin, Art Sims 11:24 Design, Paul Crifo, Peter Crifo, Pete Handelman, Gerold Kratzsch, The Mekas Family, Ruby Dee, Ossie Davis (in memoriam), James McDaniel, Ed Holland Jr., David Alan Grier, Ahmad Rashad, Tyler Perry, Morgan Cline, Robert Mugge, Leonard Maltin, Jim Verniere, Richard Johnson, Pearl Bowser, Kevin Mulroy, Linda Mehr, Anne Coco, Howard Kramer, Lonnie Bunch, Dwandalyn Reece, Michele Gates Moresi, Bestor Cram, A. T. Stephens, Marykathryn Briggs, Jeremy Rwakasiisi, Mark Dorsett, Claude Johnson, Kevin Kilgore, Mike Horowitz, Joseph Miles, Jay Blotcher, Douglas Price, Jose Ma Carpio (in memoriam), Joe Burtis, Regina Nepsha, Sam Sarowitz, Stanley Oh, John Hazelton, Daniel Strebin, Bob Depietro, Ron Kreinberg, Gary Goss, Helmut Hamm, Kirby McDaniel, Ira Resnick, Rudy Franchi, Dwight Cleveland, Jacques Hubert, Judy Sullivan, Piotr Dabrowski, Yoshikazu Inoue, Judy Jones, Eric Rachlis, Jonathan Hyams, Rene Aranamendez, James Bloomfield, Annie Segan, Rob Stoner, Kevin Parks, Phill Ritcherson, Daniel Clark, Rodney Reynolds, Gordon Bussey, Jay Levine, Mickey Cohen, Jack King, Mathieu Bitton, Andrew Zack, B. Weldon Murphy, Shannon Malone, Norman Cohen, Simon Morgan, Carolyn Comella, Michael Johnson, Hugh Cornwell, Bobby Slayton, Barrie Dennovich, Jerry Charson, Robert Goldwitz, Elizabeth Cornell, Julie Johnson, Ken Shung, Daru, Thom Wolke, Liza Wherry, Malik Harris, Ben Fishman, Amberly Timperio, Philip Shalam, Jay Dorin, Lisa Henderling, Mark O'Leary, Marvin Bakalar, The Millians, Neal & Donna Grover and Megan & Charles Fells.

First published 2014 by Reel Art Press, an imprint of Rare Art Press Ltd,
London, UK

www.reelartpress.com

First Edition
10 9 8 7 6 5 4 3 2 1

ISBN: 978-1-909526-06-8

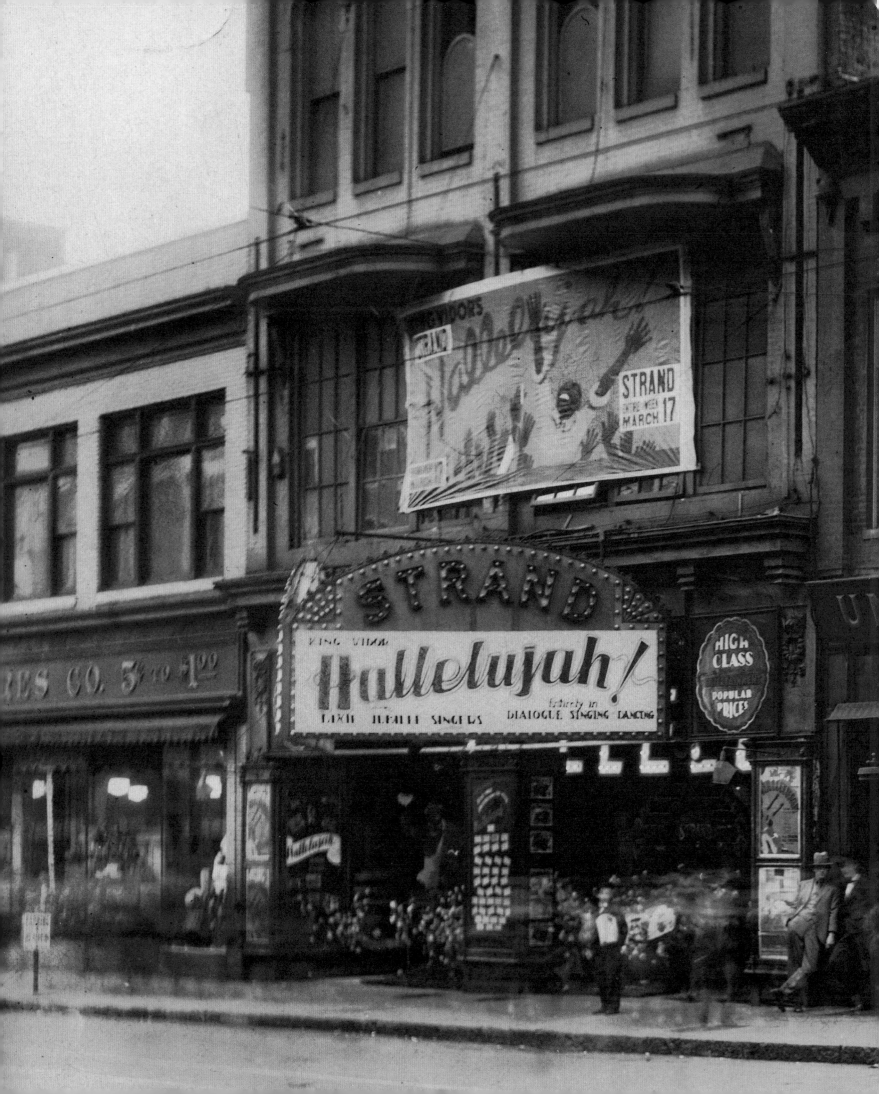